KT-212-343

Theatre and Aural Attention

Theatre and Aural Attention

Stretching Ourselves

George Home-Cook

palgrave
macmillan

UNIVERSITY OF WINCHESTER
LIBRARY

© Andrew George Home-Cook 2015

All rights reserved. No reproduction, copy or transmission of this publication may be made without written permission.

No portion of this publication may be reproduced, copied or transmitted save with written permission or in accordance with the provisions of the Copyright, Designs and Patents Act 1988, or under the terms of any licence permitting limited copying issued by the Copyright Licensing Agency, Saffron House, 6–10 Kirby Street, London EC1N 8TS.

Any person who does any unauthorized act in relation to this publication may be liable to criminal prosecution and civil claims for damages.

The author has asserted his right to be identified as the author of this work in accordance with the Copyright, Designs and Patents Act 1988.

First published 2015 by
PALGRAVE MACMILLAN

Palgrave Macmillan in the UK is an imprint of Macmillan Publishers Limited, registered in England, company number 785998, of Houndmills, Basingstoke, Hampshire RG21 6XS.

Palgrave Macmillan in the US is a division of St Martin's Press LLC, 175 Fifth Avenue, New York, NY 10010.

Palgrave Macmillan is the global academic imprint of the above companies and has companies and representatives throughout the world.

Palgrave® and Macmillan® are registered trademarks in the United States, the United Kingdom, Europe and other countries.

ISBN 978–1–137–39368–5

This book is printed on paper suitable for recycling and made from fully managed and sustained forest sources. Logging, pulping and manufacturing processes are expected to conform to the environmental regulations of the country of origin.

A catalogue record for this book is available from the British Library.

A catalog record for this book is available from the Library of Congress.

Typeset by MPS Limited, Chennai, India.

UNIVERSITY OF WINCHESTER

Für Caroline und Stephan

Contents

Acknowledgements

In writing a phenomenology of (theatre) sound, I have been acutely aware of the need for silence, and have travelled far and wide to find it. During the course of my travels, both intellectual and geographical, a number of people, as well as institutions, have helped me on my way.

First, I must thank Queen Mary, University of London, and the Westfield Trust, without whose financial backing none of this would have been possible. In particular, I would like to express my sincere gratitude to Martin Welton, who has been an inspiration and a guiding light throughout. I must also thank P.A. Skantze and Aoife Monks, whose recommendations have played an important role in finalising the focus and structure of this book. I am also very grateful to Jeanne Bovet, for her invaluable input, and to Nicholas Ridout, for helping me to sharpen my ideas. My thanks, in addition, to those who have kindly offered their feedback and thoughts on selected chapters: namely, Alice Lagaay, Anthony Gritten, Jonathan Burston, Lynne Kendrick, James Hamilton, Kristian Derek Ball, and Adam Alston. I also thank Ross Brown for allowing me to read his book, *Sound: A Reader in Theatre Practice*, prior to its publication, and to Bernhard Waldenfels, for sending me the unpublished notes to his lectures on the phenomenology of attention. Especial thanks also to Bret Jones, not only for his kind words of encouragement, but for giving generously of his time and attention.

A special thank you must also go to Paula Kennedy, Peter Cary and other members of the team at Palgrave Macmillan for all their hard work, and also to Anne Hudson, for helping to add the finishing touches to the manuscript.

Furthermore, I am most grateful to the various theatre companies, theatre practitioners, artists, and scholars whose work is discussed throughout these pages. My thanks, in particular, to Dan Jones of Sound & Fury Theatre Company, for sparing the time to answer my questions, and for allowing me to sit in on *Kursk* (on a number of occasions!). My gratitude, as well, to Gareth Fry and Paul Arditti for sparing their time to reflect on their practice and for permitting me to publish extracts from our interview(s).

Sections of this book have already appeared in print. The material on Robert Lepage's *Lipsynch* (Chapter 2) and some of the material on Complicite's *Shun-kin* (Chapter 2) originate from my essay 'Aural

Acts: Theatre and the Phenomenology of Listening' (see Home-Cook 2011b), published here with the kind permission of Cambridge Scholars Publishing. In addition, some of the discussion of Romeo Castellucci's *Purgatorio* in Chapters 2 and 3 has appeared in French, in an article entitled 'Le purgatoire de l'écoute' (see Home-Cook 2011a), published here with the kind permission of *Théâtre/Public*. Similarly, the discussion of atmospheres in Chapter 4 ('Attending atmospheres') has been translated into German (see Home-Cook 2015). I am also very grateful to Emma Cheshire at Faber & Faber for her assistance and for granting me permission to use selected extracts from the works of Samuel Beckett (*All That Fall* and *Embers*) and Harold Pinter (*A Slight Ache*).

On a more personal note, I would like to express my deepest and most sincere gratitude to Graf Stephan and Gräfin Marie-Caroline von Ledebur-Wicheln, whose unparalleled generosity, loving kindness and unfailing support has touched me greatly. Without their assistance it would not have been possible to complete this project. In recognition of this, I dedicate this book to them. I am also sincerely grateful to Domingo Salgado Guerra, not only for providing me with a quiet place to write, but, most of all, for his friendship. I would also like to especially thank Emily Rigby, for patiently lending an ear (time and time again), and for keeping me going through some difficult times. Special thanks also to my godmother, Claudia Blanchard, for her generosity, and to Arnd Federspiel, John Eade, Mikko Isomäki, and Øyvind Lone for their friendship and support. My gratitude also to Mount Saint Bernard Abbey, where I was provided not only with solace, but with sustenance (not to mention 'atmosphere'). Finally, my love and gratitude to my parents, Martin and Marion Home Cook, and to my late grandparents, Harry and Theffania Home Cook, whose sense of occasion and ceremony I shall never forget, and who instilled in me a sense of the theatrical.

Introduction

Theatre has always been an 'event' that we attend. Yet, what precisely does it mean 'to attend' theatre, what is the nature of (theatrical) attention, and what happens when we pay particular attention to the phenomenon of (theatrical) sound? Sounding out and seeking answers to this set of questions is the overarching purpose of this book.

'Attending theatre' implies far more than the simple fact of being physically present at a given performance event. There is, for instance, a collective, as well as an individual, sense of commitment, discipline and responsibility engendered by the act of attending theatre. Just as pupils are obliged to publicly declare their presence at school by answering to their name, theatregoers make themselves heard, whether willingly or otherwise, by the intersubjective act of attending. Audiences acknowledge and account for their attendance by adhering (or not, as the case may be) to certain protocols, by offering applause, by making the theatre *sound* with the chatter and rumble of pre-show conversation, and, most of all, by engaging in particular acts of attention. 'Theatregoing' might thus be described, at least on one level, as the unconscious act of drawing attention to the fact of one's own theatrical attendance. Conversely, the act of attending theatre is also about 'being in attendance', where one quietens the sounds of the self in order to give one's full attention to an Other. Being in the audience consists of a collective act of *waiting*: audiences wait, expectantly, for the lights to go down, for the actors to speak, for something to happen. Moreover, and contrary to what one might readily assume, this intersubjective act of 'waiting upon' plays a vital role in the manifestation of theatrical experience. Above all, when we 'attend' the theatre we are necessarily required to make an effort, to do something, to *stretch ourselves*.

1

Stretching ourselves

The question of attention in theatre remains relatively unexplored. In redressing this, and contributing to studies in sound, philosophy and theatre phenomenology, this book pays particular attention to the phenomenon of theatrical sound. Moreover, in focusing specifically on the question of theatre and *aural* attention, I not only invite the reader 'to stretch' their preconceptions regarding sound and the senses, but to reconsider the phenomenology of theatrical reception. Despite its etymological origins as a 'place of seeing', the true nature of the *theatron*, as a phenomenon, is not to be found in spectating, nor indeed in audiencing, but in *attending*.

Theatre and Aural Attention is thus about attending theatre, as a matter of attention, as exemplified by and through the act of *listening*. By investigating the phenomenology of theatrical listening we can begin to elucidate what it means to *attend* theatre. Conversely, the theatre provides a very relevant context for a consideration of listening as a theatrical mode of attention. It is thus the phenomenon of aural attention, and the particular ways in which the 'act' of listening presents itself as *theatrical*, that is at stake.

This book has three principal aims. First, to investigate what it means to pay attention to sound; that is, to learn more about the phenomenon of listening. Second, to discover what 'happens' when we pay attention to sound in the theatre; that is, to learn more about the phenomenon of theatrical listening. Third, to shed light on what it means to attend theatre; that is, to learn more about the phenomenon of theatrical attending. Weaving these theoretical threads together, I develop one overarching hypothesis: namely, that 'to listen' is to pay attention to sound(s), and 'to attend' is to *stretch*.

'Attention' is inherently associated with the notion of *stretching*; the verb 'to attend' stems from the Latin, *ad-tendere*, meaning 'to stretch toward'.[1] Importantly, this association has a phenomenological, as well as an etymological, foundation. When we stretch we *move*, both in the sense of bodily movement through objective space, and in the sense of 'making space' through and in this act of embodiment. Likewise, I propose that we reconsider attention as a dynamic, intersensorial, bodily engagement with the 'affordances' of a given environment.[2] More precisely, we must recognise that attention is an 'essentially dynamic' phenomenon (Arvidson 2006: 56). Attention, far from being a 'spotlight', resembles a 'sphere', consisting of three dynamic and interconnected components – theme, context and margin (see Appendix 1 - 'P. Sven Arvidson's "Sphere

of Attention"'). *Stretching ourselves* also foregrounds the sense of *exertion* that the act of attending necessarily entails. In 'paying attention', whether in the theatre or in the world at large, we must work hard: to perceive is to 'grasp', and this act of grasping requires effort. 'Stretching' also implies a sense of *elasticity*, variation, spontaneity, and 'play': attention is *enactive*. Finally, the notion of 'stretching' is specifically intended to refer to the act of 'listening' *as a specialised mode of attention*.

Attention and the act of listening are etymological bed-fellows: the verb 'to listen' stems from the word *hlysnan*, an old English term of Germanic origin, meaning 'to pay attention to'.[3] This association between listening and the concept of 'stretching' is more explicit in French, the expression *tendre l'oreille* meaning 'to stretch the ear' (see Szendy 2008: 13). In alignment with these etymological precedents, and in developing a stretching model of theatrical reception, this book proposes that theatrical listening involves paying attention to *atmospheres*. To be *in* sound is not to be straightforwardly, spherically and passively 'immersed', but rather consists of an ongoing, dynamic and *intersensorial* bodily engagement with the affordances of a given *environment*.

To demonstrate these wider hypotheses, this study hones in on four core aural phenomena: noise, designed sound, silence, and atmosphere. These themes are cumulatively explored over four chapters. Chapter 1 lays the theoretical, argumentative and methodological foundations for a theory of theatrical attending by paying particular attention to the phenomenon of 'noise'. Chapter 2 then proceeds to hone in on sound that has been purposefully *designed*, whilst Chapter 3 broadens the frame by attending to the phenomenon of silence. Stretching out further, Chapter 4 brings the discussion full circle by focusing foursquarely on (aural) immersion and the phenomenology of atmospheres.

Such matters are examined as they have arisen in some of the most sophisticated works of theatre sound design of recent years, including Sound & Fury's *Kursk* and *Ether Frolics*, Romeo Castellucci's *Purgatorio*, Complicite's *Shun-kin* and Robert Lepage's *Lipsynch*. In suggesting how theatre works, both by dramaturgy and design, to shape the audience's aural attention, I also carry out a phenomenological enquiry into radio drama, as a comparative instance of auditory performance.

This is not, however, a book about sound design. Instead, its central concern is with the question of how theatrical *sound*, in all its manifestations, is perceived through the practice of theatrical listening. This study, moreover, by no means provides an exhaustive account of listening and intersensoriality, nor, indeed, does it aim to do so. Instead, its primary focus, at least with respect to the question of (inter)

sensoriality, is with the interconnection between audition, vision, and movement. Indeed, the fact that other senses or sense-combinations are not addressed (at least not in any significant detail) does not imply that these are less important, but merely that such matters lie beyond the scope of the present enquiry. Finally, this is not a book about phenomenology. Rather, phenomenology is the working method by which its claims are exercised. In offering a phenomenology of aural attention in theatrical performance, I aim to elucidate not only how theatrical sound manipulates attention, but also how theatrical experience itself is phenomenally played out, or *enacted*, through and in the intersubjective, embodied attentional enactments of the listener-spectator. To understand theatre we must understand perception and to understand perception we must turn our attention to attention.

Enacting perception: theatre, perception, and the phenomenon of attention

Theatre, as J.L. Styan has declared, is 'something perceived' (1975: 31). Yet, what is the nature of perception, how is theatre perceived, and what role does the theatregoer play in the enactment of theatrical experience? In order to shed light on these questions, I propose that we reconsider the complex relationship between theatre, perception and the phenomenon of attention. As a means of illustrating this interconnection, let us begin with that familiar metaphor – the 'theatre of the mind'.

Adhering to a Cartesian conceptualisation of consciousness, Bernard J. Baars has suggested that perception resembles a theatre where '*the contents of conscious experience*' constitute the '*players*' upon a stage of '*working memory*', all set before 'a vast unconscious audience in the brain' (1997: 41–45). In extending this metaphor of perception-as-theatre, Baars upholds that '*conscious contents emerge when the bright spotlight of attention falls on a player on the stage of working memory*' (1997: 44). According to this conception, not only is the theatregoer figured as an inactive, detached onlooker, but 'attention' (or, more specifically, *theatrical* attention) is depicted as a passive, detached, and essentially ocular-centric operation. Within such a model of (theatre) perception not only is the percipient inert, but (theatrical) attention is rendered inactive and monomorphic. By way of contrast, it is worth noting Merleau-Ponty's conceptualisation of perception as theatre.

For Merleau-Ponty, as Stanton B. Garner explains, '[e]xperience is a "theatre"', that is to say, 'a site of visibility and corporeality, an arena where subjectivity confronts the spectacle – and enacts the performance – of

its own embodiment' (2001: 1). Hence, within Merleau-Ponty's account of (theatre) perception, the spectator/percipient is positioned in *dynamic* and embodied relation to that which is perceived, namely, the perceptual object.

At first sight, we might readily accept Baars's conception of percipience, and the model of theatre perception it presupposes. Indeed, and as Bence Nanay points out, 'the prima facie intuition might be that theatre perception is detached, since there is no action we are inclined to perform whilst sitting in the theater' (2006: 248). In response, Nanay has proposed that theatre perception 'resides in an interstitial stage between detached and action-oriented perception' (2006: 249).[4] Yet, this assertion overlooks the phenomenological fact that 'all perception [...] is intrinsically active' (Noë 2004: 3):

> Perception is not something that happens to us, or in us [...] It is something we do [...] The world makes itself available to the perceiver through physical movement and interaction [...] *What we perceive* is determined by *what we do* [...] We *enact* our perception; we act it out. (Noë 2004: 1)

Alva Noë's conceptualisation of perception (namely, perception as enaction) troubles Nanay's assertion that 'no matter what happens on stage, we do not move' (2006: 248). Whilst the spectator may appear to be sat passively and silently in the auditorium, theatre*going* necessarily entails action, enaction, and, most of all, *movement*. More especially, and as I demonstrate throughout this book, perceptual experience is manifestly shaped by the dynamic enactments of embodied attending: attention plays a key role in the process of *enacting* perception.

The theatre of the mind metaphor presupposes a 'snapshot' model of perception where, as Keith Wilson explains, '[c]onsciousness, in the form of attention, becomes an homunculus, or "little man", that is "looking out" at the sense data just as we are "looking out" at the external world' (2007: 154, 155). However, if we adopt a 'direct access model of perception' (as advanced, for example, by Merleau-Ponty, Gibson, and Noë), then 'the act of perception is itself a form of selective attention towards a world in which the observer is essentially embedded' (Wilson 2007: 156). Within a 'direct access model of perception' the phenomenon of attention is not only rendered dynamic, but given the leading role in the process of enacting perceptual content: or, as Sebastian Watzl puts it, '[a]ttention shapes the phenomenology of perceptual experience' (2010: 38). Yet, how does attention 'shape'

perceptual content and what are the nuances of this process? What precisely *is* attention and what might we learn about this familiar phenomenon by paying closer attention to the practice of attending theatre?

'Attention', as I hope to articulate, is fundamental to theatre. In her recent monograph, *Cognition in the Globe: Attention and Memory in Shakespeare's Theatre* (2011), Evelyn B. Tribble makes the following assertion:

> [I]n many ways theatre is the art of attention. Convincing an audience to attend, to listen, and to orchestrate its focus is absolutely essential to a successful performance; a command of the art of managing audience attention is crucial to the conjurer, the confidence trickster, and the actor. (2011: 36)

Theatre is thus not only an event that we attend, but an 'art' that purposefully directs, and necessarily *demands*, our attention. Yet, despite this inherent (and manifestly apparent) interconnection between theatre and the act of attending, the number of scholarly works dedicated to theatrical attention per se remain few and far between.[5]

Theatre evidently (and often surreptitiously) strives to manage and mould the attention of the audience. However, this act of manipulation, as I shall reveal, is a *two-way* process. Attention is typically conceptualised as an activity of the mind. Yet, such an account of attention necessarily fails to consider the dynamics of embodied attending.

What happens, for example, when we begin to explore the interplay that inevitably exists between the 'art' of shaping 'audience attention' and the actualities of theatrical experience as perceived? What might we learn about attention by examining the various ways in which we perceive, 'listen to', or *attend*, theatrical sound (in all its manifestations)? What happens when we begin to pay closer attention to the notion of 'distraction' and to the nuances of 'noise', and how might such an exercise begin to trouble those familiar and deep-seated beliefs regarding the nature of sound and sensory perception? What about the question of 'self' in attending (theatre)? Finally, what role does 'audience attention' (that is to say, the *intersubjective act of attending*) play in shaping theatrical 'atmosphere'? Such questions remain largely unanswered. Despite some of the important work already carried out in this area, particularly within the field of cognitive science,[6] a *phenomenology* of theatrical attention has yet to be written. *Theatre and Aural Attention* attempts to fill this gap.

In the theatre, as Gerald Siegmund notes, 'what we attend to are the objects, bodies, gestures, voices, words, sounds, and music that clamor

for our attention on the stage or, in a more open performance situation, around us' (2007: 132). Yet, whilst theatre 'demands that we are attentive to the things it presents' (Siegmund 2007: 126), even in the most quotidian and conventional theatrical presentations the 'objects' of theatrical attention, like attentional objects in general, are never fully and unambiguously 'presented' in experience. Indeed, and in stark contrast to the phenomenology of film, where '[e]verything outside the frame has been bracketed from attention' (Carroll 2003: 38),[7] theatre would appear to allow the spectator more room to play with that which is perceived.

In theatre, and again in contrast to film, 'the aesthetic act itself (the performing) as well as the reception (the theatre going) take place as a real doing in the here and now' (Lehmann 2006: 17). More precisely, and as Banes and Lepecki have suggested, 'any body in a performance situation (be it the bodies of the performer or the bodies of the audience) is an inexhaustible inventor of sensorial-perceptual potentials and becomings' (2007: 4). Hence, whilst theatre aims to present 'objects' for our attention, this act of representation, like any other, 'always conveys more than it intends' and 'is never totalizing': theatre 'continually marks the perpetual disappearance of its own enactment' (Phelan 1993: 2, 115). Correspondingly, the theatregoer must work hard to make sense of what is ambiguously given to dis-appear in perception. Theatre is thus not only 'something perceived', but perception itself is inherently *theatrical*: perception, like theatre, is always inherently unfinished, ephemeral and in process. To understand the disappearing act of theatrical performance, along with its analogue, perception, we must reconsider the notion of presence.

Monica Prendergast has maintained that '*presence* is one of the most important qualities of audience in live performance' (2004: 36). Unlike attending a film, or watching television, where 'the performance will continue with or without us', the experience of '[a] ttending a live performance is otherwise', since 'our presence is a key element of the event' (Prendergast 2004: 36; cf. Auslander 2008). The notion of presence, however, implies a sense of completeness that is at odds not only with the ontology of performance, but with the phenomenology of perception at large: theatre not only foregrounds the playfulness of perception, but manifestly highlights the problematics of presence. 'Instead of presence, the theater asks to be approached in terms of *presencing*; theatrical phenomena are multiply embodied, evoked in a variety of experiential registers, refracted through different (and somewhat divergent) phenomenal lenses' (Garner 1994: 43).[8]

In developing this idea, I invite the reader to reconsider the manifold ways in which theatre *presences* perception.

Alice Rayner has suggested that '[t]he workings of theatre art makes it possible to perceive perception' (2006: xix; *sic*). Yet, and as Tim Ingold clarifies, 'the one thing we cannot perceive is perception itself' (2000: 243). Given this, I propose that theatre is a place where the playfulness of perception is phenomenally *presenced* by and in the attentional enactments of its participants. Ultimately, 'the experience of *being* an actor or a spectator [...] is the substance of the theatrical' (Welton 2002: 1). Correspondingly, I maintain that theatrical experience is manifestly played out through and in the embodied, intersubjective act of theatrical attending: in attending theatre we perceive and experience 'the theatrical'. Moreover, by accounting for the embodied particularity of the listener-spectator not only can we gain a clearer understanding of the enworlded and embodied dynamics of theatre perception, but of the synergic nature of perception in general: theatre stages perception.

Sensing sound/sounding the senses

Theatre and Aural Attention pays particular attention to *sound*, in all its manifestations: sound as 'noise', sound as shaped by 'design', sound as 'silence', and sound as an 'immersive', all-encompassing environment, or 'atmosphere'. Moreover, by conducting a phenomenology of (theatrical) listening, I aim to navigate a number of familiar distinctions relating to sound and the senses. These include: vision versus audition, listening versus hearing, attention versus distraction, and sound versus noise. In sensing sound this book seeks to sound out the senses.

The turn to listening, heralded and motivated in the 1960s and 70s by the work of Walter Ong, Don Ihde and R. Murray Schafer, would seem to be well under way: undoubtedly we are beginning to feel the effects of this new 'stress on the auditory' (Ong 1982: 9) resounding throughout many areas of scholarship. Importantly, this 'boom in writings on sound' (Sterne 2013: 1) has led to the emergence of a new field of enquiry: Sound Studies.[9]

A substantial amount of the research carried out within the rubric of Sound Studies has tended to investigate the sociological, historical, and cultural significance of sound and aurality.[10] There is, moreover, a growing trend to reconsider subjectivity and sociality from the perspective of sound and aurality.[11] Yet, whilst the so-called 'sonic turn' (Drobnick 2004: 10) has done much to challenge the hegemony of the spectatorial gaze, by refocusing our attention on the phenomenon of sound and

its perception, it has often served to reinscribe this sensory and critical hierarchy by focusing on or essentialising difference. Although scholars have been careful not to valorise the aural whilst vilifying the visual,[12] and though considerable efforts have been made to unsettle the misguided narrative that equates visuality with modernity, whilst associating postmodernity with aurality,[13] there is, nevertheless, still the need to identify, and to further explore (in phenomenological terms), the complex ways in which the senses coincide.[14] To pay attention to sound does not mean that we should therefore *disattend* the phenomenon of looking. Rather, we should think of the senses not as discrete sensory modalities but as sensory systems (see Gibson 1966).

Such an inference has important implications for the study of sound and aurality in the context of theatrical performance. What is needed is an account of aurality in theatre that acknowledges, accommodates and, above all, begins to explore the role of vision in our experience and perception of theatrical sound.

The 'play' of listening: theatre and aurality

> What does *to be* listening, *to be* all ears, as one would say 'to be in the world' mean? What does it mean to exist according to listening [...] what part of experience and truth is put into play? What is at play in listening [...]? (Nancy 2007: 5)

As Jean-Luc Nancy suggests above, there is indeed much 'at play' in listening. In developing this idea, namely, the *play* of listening, I advance the following overriding hypotheses. First, that listening is, in every sense, an *act*: listening is not only something that we do, but is inherently *theatrical*. As a specialised mode of *attention*, listening both manipulates and is manipulated by the phenomenon of sound, in a dynamic dance from and through which experience is born. Second, that listening is not a one-sense show but necessarily entails a 'double act' where looking always plays a part. Third, to speak of the *play* of listening is also to foreground the sense of dynamism, movement, and polymorphous spatiality that this phenomenon manifestly engenders. Finally, and above all else, the notion of 'play', or aural playfulness, draws attention to the central concern of this book: namely, the phenomenology of listening in the *theatre*.

The question of listening in the theatre, on first reflection, sounds like a no-brainer: in order for a performance to be received we might readily assume that the spectator must be able to hear (and understand)

the speech of the performers, as well as the sound(s) of, and/or within, the designed sonic environment (cf. Kochhar-Lindgren 2006).[15] It seems equally indisputable that an 'audience' consists of a collection of listeners, gathered together for the express purpose of 'paying heed', both collectively and individually, to a particular theatrical event.[16] Furthermore, since we tend to consider theatricality in terms of what we *see*, as opposed to what we hear, we might readily assume that visual perception plays a greater role than auditory perception in the manifestation of theatrical experience. If we listen a little more closely, however, to the phenomenal processes by which we pay attention to theatrical sound(s), we encounter a comparatively uncharted world of noisy, troublesome questions.

What is it to listen in the theatre and how is attention paid by means of theatrical listening? How useful is it to conceptualise listening as attentiveness, whilst depicting hearing as a sense of distraction? What is the phenomenal relationship between the act of listening and that of looking? What happens when we begin to explore the phenomenal tension between sound as *intended* by design and the actualities of sound as *attended* by the listener-spectator? What is the nature of theatrical 'silence' and how is our experience of attending (in) silence *shaped* by designed sound, darkness, and the intersubjective act of attending? Finally, what is it to be 'immersed' in the 'atmosphere' of sound and how do theatregoers sense and make sense of designed theatrical environments? Whilst there have been rumblings that theatre in general is experiencing a major shift towards the aural,[17] such questions remain relatively unexplored.

In Theatre and Performance Studies the question of sound and its reception has been overshadowed by matters of visuality. Until recently, scholarly works devoted to sound in theatre have tended to focus, almost exclusively, on the technicalities, practice and associated effects of theatre sound design.[18] In the last few years, however, and in synchrony with the increased status and technological advancement of sound in theatre practice, a growing number of theatre scholars have begun to consider the question of theatre and *aurality*.[19]

One of the first theatre scholars to recognise the need for a phenomenology of theatrical listening is Bruce R. Smith. In his groundbreaking work, *The Acoustic World of Early Modern England* (1999), Smith provides a 'historical reconstruction' of the experience of Shakespeare's theatre from the perspective of sound (1999: 29). Notwithstanding this, and other related works investigating the socio-historical dimensions of sound and voice in Shakespeare and early modern England,[20] the only other monograph-length study devoted to the subject of sound and aurality in theatre is that of Ross Brown.

Sound: A Reader in Theatre Practice (2010) is the first monograph to attempt to define, conceptualise, and historicise the nature of theatrical sound, both as shaped by design and as experienced by means of listening. In exploring the nature of *'live listening'* (Brown 2010a: 138),[21] Brown provides a pioneering account of theatre's 'aural phenomenology'. However, and as argued in Chapter 1, Brown's account forges too sharp a distinction between attention (listening) and distraction (hearing) and, consequently, overlooks the phenomenal nuances of aural attention as process. Rather than conceptualising 'the practice of listening as an anxious tug-of-war between engagement and distraction', as suggested by Brown (see 2011: 4), we should instead reconsider attention, or, more specifically, aural attention, as an essentially dynamic phenomenon. Such an intervention resonates, to some extent, with Catherine Laws's notion of 'listening as an embodied process' (2010: 1).

In a recent issue of *Performance Research*, entitled 'On Listening', Laws introduces a range of essays that consider 'the messy reality of listening' (2010: 2). In forging a distinction between 'sound as an object and the subject who listens' (2010: 1), this work begins to explore the particularities and ambiguities of auditory perception in theatre. This important distinction between sound as an object (whether designed or otherwise) and sound as a phenomenon also chimes closely with the distinction that I make between *intended* and *attended* theatrical sound. That said, whilst these contributions have done much to develop the field of theatre and aurality, a *phenomenological* investigation of theatrical listening has yet to be undertaken.

In paying particular attention to the phenomenon of sound in theatre, and in navigating the sensory divide, I invite the reader to reconsider theatrical listening, indeed theatrical reception in general, as an intersensorial, intersubjective act of *'dynamic embodied attending in the world'* (Arvidson 2006: 7). More radically, and drawing from the philosopher Michel Serres, I propose that the world of sound is, in fact, phenomenally enmeshed with that of light. Audiences do not 'inhabit two worlds' (cf. Brown 2010a: 6), but make sense of the phenomenal affordances of *one* environment (or 'atmosphere') through a dynamic, embodied and intersensorial process of attending.

From spectating to attending

The presence and existence of the audience is commonly taken as a given; theatrical performance must have an audience in order to exist. Yet, recently, and as Gay McAuley points out, there has been a growing trend within Theatre Studies 'to examine what happens

downstream of performance' (2007: see 'Spectator Studies/event theory' section). This growing interest in the position of the spectator, endorsed by the newly emerging field of Spectator Studies, in many ways reflects the need to reconsider the notion (and the nature) of theatrical *reception*.

Reception Studies has tended to operate within a semiological framework, tending to focus on how 'meaning', whether social, cultural, dramaturgical or otherwise, is manifestly produced by and within theatrical performance. The semiotic approach, however, is let down by 'its implicit belief that you have exhausted a thing's interest when you have explained how it works as a sign' (States 1985: 7). In attempting to accommodate these differences of approach, Christopher Balme has suggested that we understand spectatorship as a spectrum that moves from the particularities of spectating, that is, the 'micro-aspect' of the 'individualized, actual recipient', to the 'ideal or hypothetical recipient', that is, to the 'spectator' as characterised by semiotics, aesthetics, and reception theory (see 2008: 36). Nevertheless, most accounts of spectatorship still tend to operate from the position of an 'ideal' spectator, rather than from the 'actual' experience of theatregoing: hypothesis tends to precede practice. Furthermore, not only has the rise of Spectator Studies crystallised the spectator/audience divide, but 'theatre perception' has been introduced, somewhat surprisingly, as an *alternative* to theatre reception.[22] How does spectatorship relate to being in the audience and how do we overcome the visual/aural, individual/communal distinctions that these terms seem to embody?

By way of response, it is my suggestion that we reconsider spectating in terms of *attending*. Instead of setting perception over and against reception, we should work towards a bridge model of theatrical reception that begins to account for the particularities of perception as played out through the intersubjective, intersensorial practice of attending theatre. This *stretching* model of theatrical reception corresponds, to some extent, with Bert O. States's notion of a 'complementary perspective', where phenomenology and semiotics work together to constitute a 'kind of binocular vision' (1985: 8). According to this conception, 'one eye enables us to see the world phenomenally', while 'the other enables us to see it significatively' (States 1985: 8).[23] Yet, whilst States has urged us to examine the complex processes of theatrical signification, as well as the complementarity of phenomenology and semiotics, I forward the more radical claim that significative meaning is embodied in, and manifestly generated by, the act of attending theatre: significance in the theatre is

sensed and the senses signify. Theatre perception is not an alternative to theatre reception, nor is the semiotic severed from the phenomenal, but, rather, theatrical experience is received *as* perceived. Correspondingly, the phenomenon of theatrical attention can only be properly investigated through the phenomenological practice of attending theatre.

Phenomenology as methodology

Theatre and phenomenology go hand in hand. Indeed, as Garner points out, 'theater "stages," "puts into play," variables and issues that have comprised the special province of phenomenological inquiry from its inception: perception and the constitution of meaning, presence and absence, body and world' (1994: 3). This relationship is not only intimate, but symbiotic: whilst 'theater offers fertile ground for phenomenological enquiry', conversely, 'the phenomenological tradition offers a way of *reembodying* the discourse of theater' (Garner 1994: 3, 26). Yet the number of theatre scholars to have approached theatre from a phenomenological perspective remains surprisingly small.[24] Furthermore, whilst a number of scholars have done much to pioneer theatre phenomenology, these accounts tend to have been hewn from the perspective of an 'ideal' spectator.[25]

'The expression "phenomenology" signifies primarily a *methodological conception*. This expression does not characterize the what of the objects of philosophical research as a subject-matter, but rather the *how* of that research' (Heidegger 1962: 50). The 'true meaning of phenomenology' is thus only to be found in *doing* phenomenology: in other words, '[p]henomenology is accessible only through a phenomenological method' (Merleau-Ponty 2002: viii).[26] However, it is precisely the howness of phenomenological method that has not only come under scrutiny, but been subject to misrepresentation.

Phenomenology is often accused of being an introspective discipline. Indeed, the charge of introspectionism, which accuses phenomenology of doing metaphysics, forms the keystone in the argument that phenomenology harbours either a phonocentric or a masculinist bias, as advanced by poststructuralist and feminist critics respectively (see end of Chapter 1). This criticism, however, is founded upon the misconception that phenomenology operates from an ideal, or abstracted, position. Whilst this presumption may have some validity in reference to Husserlian phenomenology, it overlooks the important ways in which later developments in phenomenological discourse have variously

moved away from Husserl's notion of *'pure intuition'* (1983: 136).[27] As Jane Howarth states:

> The human standpoint is essentially *in* the world. The reduction is partial: one cannot put aside all one's existential assumptions at the same time. However reflective, the philosopher still takes for granted the existence of the armchair. (1998: 344)

Phenomenology is thus not only subject to debate, but continually *emerging*. Like perception itself, phenomenology is necessarily unfinished, contingent and in process. We must therefore be careful not to tar different incarnations of phenomenology with the same brush.

Don Ihde, for instance, has proposed that phenomenology is neither subjective, nor objective, but *relational* (see Ihde 2003). Similarly, Alva Noë has suggested that we move towards a 'not so pure' conception of phenomenology, where experience 'is not a matter of what is happening in a private, subjective, interior sphere', but concerns the dynamic relationship 'between interested active agents and a challenging, meaningful environment' (2007: 232).[28] Thus conceived, '[t]he purpose of the *epoch*é [or phenomenological reduction] is not to enable *introspection* unencumbered by concern with matters of fact, but rather, to enable one to attend to the world in a new way, with an interest in the world as it presents itself for us in experience' (Noë 2007: 238).

The act of phenomenological description is therefore not a perfect transcription of experience. Apart from the fact that there is inevitably a time delay between the moment of perceptual encounter and the act of writing, there are other issues to bear in mind, such as the matter of language and expression, not to mention the question of gender.[29] Yet, far from taking the possibility of knowledge for granted, as suggested by both feminist and poststructuralist critics, we must begin to recognise that phenomenology operates from a comparatively weak position that attempts to describe the world as perceived from a particular point of view. Moreover, we must understand that phenomenology, as a specialist mode of *doing* philosophy, is not only provisional, but pays particular attention to the provisionality of perception. Phenomenology does not seek to retrieve or preserve perceptual content, but instead aims to describe the *process* of its disappearance, its coming into and going away from being, its dis-appearing. Phenomenological description is nevertheless a rigorous and disciplined undertaking, and necessarily so. Indeed, it is in its attempt to provide a clear, accurate, and *situated* description of the disappearing act of perception that its rigour lies.

'For a concrete description of lived experience it seems crucial to ask *whose* sexuality and *whose* bodies are being described' (Butler 1989: 98). In taking note of this, and in accordance with a 'not so pure' conception of phenomenology, this book seeks to describe the world, or more precisely, the world of sound, as experienced by a particular individual, through a number of carefully chosen examples. '[P]henomenology,' as Stewart and Mickunas have remarked, 'has no genuine validity until it is applied - that is, until it is brought to bear on a specific area of investigation' (1990: 141). In paying heed to this dictum, I have adopted a 'messier' approach to phenomenology in an attempt to untangle the 'messy reality of listening'.[30]

Attending (theatre) as practice-based research

Practice-based research has overwhelmingly been conceived as a stage-side concern, tending to focus largely on performance, or the act of performing, whether conceived as performance-art, acting, or being a provocateur. Yet, and as I hope to foreground, the practice of attending (theatre), like acting, also provides us with knowledge *in* as well as of performance.[31]

Generally speaking, practice-based research tends to be processual in nature: that is, it tends to allow the topic, theme or aims of any given project to *emerge* through and *in* practice. Similarly, far from beginning my research with a series of well-chosen case studies, which might have enabled me to 'prove', a priori, a pre-given theory concerning theatre and aural attention, I have sought, instead, to investigate what arises from and *in* the process of attending theatre. Correspondingly, whilst the case studies and phenomenological examples that are herein discussed provide a useful means of adumbrating particular features of experience, they function more as 'tools' than as ends in themselves. It is the phenomenology of theatrical listening that is at stake here, not the wider socio-cultural significance of these performances, or how they may (or may not) variously relate to each other in thematic, conceptual, or representational terms. Indeed, the fact that my examples do not fall into a particular category or 'genre' of theatrical performance only serves to highlight and underpin the processual and quotidian nature of my work, and the model of practice it presents.

Within these pages, as the reader will note, I not only explore the phenomenal nature of sound in theatre, but also pay close attention to theatre that *is* sound. Indeed, in many respects, radio drama is where this story of sound begins.[32]

Being initially interested in the phenomenon of speech, or more precisely, speech as it manifests as *sound*, I was naturally drawn to the radio play, where the spoken word is given in 'close focus' (McWhinnie 1959: 48). I began by listening to two radio plays by Samuel Beckett that explicitly foreground the act of listening and the phenomenon of speech, namely, *All That Fall* (1957) and *Embers* (1959).[33] In listening to these audio works, and in attempting to listen to listening on its own terms, I soon realised that the task of 'bracketing' phenomena requires not only rigour but practice.[34]

Being interested to find out more about how thematic attention is shaped by a wider attentional context, and as a provisional means of sounding out the phenomenon of silence, I decided to listen to Harold Pinter's *A Slight Ache*, a play that sheds considerable light on the relationship between sound, silence and the act of listening. Realising the erroneousness of the commonly held assumption that 'it is characteristic of the radio medium that its means of expression are aural, temporal, nonspatial, and noncorporeal' (Zilliacus 1976: 37), I grew curious to investigate what 'happens' when we listen to speech, sound and silence in an environment where the act of looking would overwhelmingly appear to predominate: namely, the theatre.

The task of conducting a phenomenology of theatrical listening presents more of a challenge than that of carrying out a phenomenology of radio drama. Radio plays are infinitely replayable, and can be listened to at any time and place. Moreover, when subjecting radio plays to phenomenological scrutiny the challenge of thematising perceptual invariances is, to some extent, alleviated by the fact that the radiophonic 'soundscape' is materially immutable. By contrast, in the theatre we are unable to 'pause' or rewind the performance to take note of a particular aspect of attentional life: the theatrical event gets on with its own life, irrespective of our attempt to synchronically and perceptually 'grasp' it. This sense of playing 'catch-up' is compounded by the fact that sound, like performance, is itself intensely ephemeral. To make matters worse, whilst the phenomenologist can re-attend a production, she or he will never be able to encounter the same instantiation of a previously attended performance. For these reasons, I have often found it necessary to attend a performance event more than once, in order to pay closer attention to the peculiarities of a given phenomenon. The act of repetition, or repeat attendance, is a fundamental feature of my practice, and a matter that I shall return to in due course. To emphasise the importance of process in practising a phenomenology of theatrical attending, I have purposefully arranged

the following case studies according to the order in which I was moti-vated to *attend* them.

Being initially interested in how amplification or vocal reinforce-ment can manifestly affect the listener-spectator's perception of the dramaturgical voice,[35] I decided to attend Robert Lepage's *Lipsynch*, a piece that consciously employs playback sound to explore the sonority of voice, speech and language. As one of Lepage's most ambitious and monumental projects to date, *Lipsynch* received its world premiere at London's Barbican Theatre on 6 September 2008. Consisting of nine acts, and with a running time of nine hours, *Lipsynch* certainly called upon the audience to 'stretch themselves'. As well as being aware of the punishing ways in which this performance required the audience to work hard, I was also struck by the particular ways in which the act of listening phenomenally re-shapes that which is perceived. Moreover, *Lipsynch* not only underlined the need to navigate the apparent impasse of the audiovisual divide, but drew my attention to the phenomenon of theatrical *attention*. In pursuing this, and as a means of continuing to investigate the interplay between the dramaturgical voice and the use of vocalic amplification, I decided to attend Complicite's *Shun-kin*.

Inspired by Jun'ichiro Tanizaki, and receiving its UK premiere at the Barbican Theatre in February 2009, *Shun-kin* charts the life of an aristocratic, blind shamisen player (Shun-kin) and her devoted, much-abused, servant and lover, Sasuke. In attending *Shun-kin* I was especially impressed by the intricacy of the design, and by the use of designed sound. In attending *Shun-kin* more than once, and from different posi-tions within the auditorium, I noticed how playback sound, *combined* with the physical and visual particularities of perspective, can radically alter the listener-spectator's perception of the dramaturgical voice. In investigating this apparent tension between the intentions of design and the perceptual realities of theatrical attending, I proceeded to attend a theatrical event that not only unabashedly draws attention to sound *as designed*, but that purposefully uses sound to shape and manipulate theatrical experience: namely, Romeo Castellucci's *Purgatorio*.

Produced by Societas Raffaello Sanzio, and receiving its British pre-miere at the Barbican in April 2009 as part of the Bite09 Spill Festival of Performance, *Purgatorio* was the second part of a trilogy (*Inferno* being the first and *Paradiso* being the last) inspired by Dante Alighieri's *Divine Comedy*. With its hyper-real set, hyper-naturalistic performances and over-amplification of onstage sounds, voices, and extra-diegetic noise, *Purgatorio* forced the audience to pay close attention to every brief word, sound, image and movement. I attended this piece a total of three

times and, whilst my initial intention was to attend to the interplay between playback sound and the voice, my attention was soon drawn to the wider questions of manipulation, sonic immersion, silence, and the phenomenology of atmosphere. In particular, I became increasingly interested in the ways in which this performance sculpts a *purgatorial* space of listening by counterpointing amplified sound with moments of silence or pause. This question concerning the phenomenal relationship between theatre sound design, silence and aural attention originally came to light a few months earlier during my attendance of Sound & Fury's *Ether Frolics*.

Headed by writer/director Mark Espiner, actor Tom Espiner and composer Dan Jones, Sound & Fury Theatre Company has not only acquired a reputation for producing scrupulously conceived, visceral, multi-sensory performance but specialises in 'presenting the audience with new ways of experiencing performance [...] by heightening the aural sense'.[36] Sound & Fury thus seemed to present itself as an obvious candidate for a phenomenological consideration of aural attention in theatrical performance. I first encountered their work in attending *Ether Frolics*, a piece that explores the hallucinatory effects of anaesthesia.

Produced in collaboration with Shunt, directed by David Rosenberg and with the sound designed by Dan Jones, *Ether Frolics* was staged at the Royal London Hospital, Whitechapel in November 2008. Being staged in complete darkness for most of its duration, I took especial note of the manifest ways in which this performance not only manipulated audience attention but shaped theatrical silence. Moreover, and in my quest to find a theatrical performance that would enable me to performatively subject the notion of being 'immersed in sound' to rigorous phenomenological scrutiny, I decided to attend Sound & Fury's subsequent production of *Kursk*.

Written by Bryony Lavery, and co-directed by Mark Espiner and Dan Jones, *Kursk* was first staged at the Cambridge Corn Exchange (which commissioned the piece), before its premiere at the Young Vic in June 2009.[37] The piece offers a gripping account of the loss of the eponymous Russian nuclear submarine which sank to the bottom of the Barents Sea on 12 August 2000, killing all 118 men aboard. Through its innovative and award-winning use of designed sound, and by the ingenious yet simple fact of situating the audience *within* the close confines of a simulated nuclear submarine, *Kursk* created an aural space that invited the audience to re-embody the lived experience of being a submariner and, in so doing, to sound sound(s). From the outset, *Kursk* consciously and manifestly prompted its participants to pay closer attention not only to

the phenomenon of sound, but to ourselves as listening subjects. Yet, my experience of attending this piece was strikingly at odds with the notion of being straightforwardly and statically 'immersed'. Indeed, and as I will later demonstrate, the distinctions that we often make between signal and noise, design and disorder, attention and distraction, begin to disintegrate when set alongside the perceptual realities and peculiarities of theatrical attending. Further still, and as I also discovered in attending Sam Mendes's production of Anton Chekhov's *The Cherry Orchard* at the Old Vic in June 2009, this interplay between sound and noise can be manifestly foregrounded in the most conventional, and otherwise ordinary, theatrical circumstances.

As the above narration attests, whilst initially selecting performances on account of their suitability for an exploration of theatrical sound, a good deal of the questions, themes, or phenomena of interest arose *post hoc* through and in the practice of attending theatre. In other words, although I may have gone to a performance with a view to paying particular attention to a given aspect of aural experience, these foci, or acts of attentive singling out, *emerged* from a wider context of attendance. More especially, and for reasons already given above, the practice of conducting a phenomenology of (theatrical) listening necessarily requires *repetition*.

Most of the performance events discussed and described herein I have attended two or three times.[38] Typically, the first attendance consists of noticing moments of particular phenomenological interest. There is a need to be open to what happens, but equally to pay attention to themes as they arise. Usually, I will take notes during the performance, and often in semi- or total darkness. I then use these initial jottings to reflect upon, and attempt to describe in more robust terms, moments of particular interest. In attending the performance for a second time, I pay closer attention to the phenomenon in question and begin to identify, describe and thematise these structures. Then, if necessary, I return again (and again) in order to review, fine tune, and further elucidate that which is 'given' in experience.

Thus, whilst the case studies that have been introduced above emphasise the *everyday* nature of my theatregoing, it is abundantly clear that my mode of reception-as-perception has been unequivocally extra-ordinary. Bracketing sound and its assumptions, attending to myself listening to sound(s), re-attending the same performance whilst investigating the same questions, all this is necessarily different from an everyday mode of theatrical attendance. It might thus be helpful to understand the present study as a kind of 'assemblage'[39] of different experiences and

examples, hewn from a range of theatrical events, woven together with the same thread in mind, namely, the act of listening as attention.[40] By accretively (re-)examining a range of phenomena, themes and questions as they arise in a number of different theatrical and attentional contexts through a wide variety of phenomenological examples, I aim to bring about an elucidation of the phenomenon of (aural) attention: through and in the practice of attending, knowledge *'worlds up'*.[41]

The structure of the book

This book is divided into four chapters. The first three chapters hone in on 'noise', 'designed sound', and 'silence', respectively. The overriding reason for 'bracketing' these phenomena is to explore the dynamics of listening *as attention*, and thus, to begin to construct a theory of theatrical attending. I should also point out that unintended 'noise' (the focus of Chapter 1) and 'designed sound' (the focus of Chapter 2) have been structurally separated only to demonstrate, at least in perceptual terms, that this distinction (between signal and noise) is, in fact, less certain than we might otherwise assume. This structural division is also intended to give the phenomenal specificity of designed sound the attention that it demands. In addition, and as an effective means of exploring the nature of designed sound (as well as designed silence), the central chapters of the book (Chapters 2 and 3) are prefaced with a consideration of radio drama. Having paid close attention to the phenomenal particularities of (theatre) sound in the first three chapters, the fourth (and final) chapter attends to the broader question of what it means to be *immersed* in the (sonic) environment or 'atmosphere'. Inviting us to stretch our preconceptions regarding the phenomenology of sound and sensory experience, Chapter 4 recapitulates, and *draws together*, many of the themes, arguments, and hypotheses explored throughout the preceding chapters, thus acting as a coda for the book as a whole.

The book begins with a chapter on noise. There are three principle reasons for this prioritisation, all of equal importance. First, the notion of noise provides an effective means of introducing the phenomenology of sound. This initial focus on 'noise' (in the sense of sound of any kind, as well as in the more specific sense of unwanted or disturbing sound) allows the discussion to remain suitably wide-ranging, whilst allowing for a consideration of the particular. Second, 'noise' provides a useful vector for an initial exploration of the phenomenology of listening: noise, by its nature, *clamours* for our attention. Third, in rendering the

phenomenon of noise as attentionally thematic, I begin to unsettle a series of familiar (and interrelated) distinctions concerning the nature of sound and sonic experience.

Chapter 1, *Paying Attention to (Theatre) Noise*, thus sets out to construct a theory of theatrical attending that invites us to reconsider theatre's 'aural phenomenology'. Drawing from my experience of attending Sam Mendes's production of *The Cherry Orchard*, the chapter hones in on that particularly noisy nemesis of modern theatregoing – the mobile phone. Importantly, I reveal that not all instantiations of the phenomenon mobile-phone-sounding-in-the-theatre are perceived as an annoying interruption. By way of explanation, I suggest that the degree to which an instantiation of the phenomenon mobile-sounding-in-the-theatre is perceived as a noisy interruption will depend upon the degree to which we are able to *accommodate* this sound within our 'sphere of attention' (Arvidson 2006: 115). I end the chapter by asserting that if we are to account for theatre's 'aural phenomenology' we must learn to listen *phenomenologically*.

Chapter 2, *Paying Attention to Designed Sound*, attends to sound that has been purposefully *designed*. As an initial means of sounding out the phenomenon of listening, as well as the nature of sound as an aesthetic object, the chapter begins with a phenomenological consideration of radio drama. As well as illustrating the apparent disconnect between the intentions of design and the actualities of perception, I also reveal how the listener's perception of the radiophonic soundscape is manifestly affected by the act of looking. With these insights in mind, the second half of the chapter attends to the phenomenology of designed sound in the *theatre*.

Drawing from interviews with three of the UK's leading sound designers (Paul Arditti, Gareth Fry, and Dan Jones), I proceed to outline some of the ways in which contemporary theatre sound design directs audience attention, thereby shaping theatrical experience. Drawing from my experience of attending Sound & Fury's *Kursk*, Castellucci's *Purgatorio*, and Complicite's *Shun-kin*, I also demonstrate how theatrical attention can often go astray. In proposing that this slippage between intended and unintended meaning is manifested, at least in part, by what we *do*, I go on to consider the role played by vision in our perception of theatre sound design, focusing in particular on how playback sound, combined with the particularities of perspective, can affect our perception of the dramaturgical voice. The chapter ends by demonstrating how (sound) design motivates theatrical attention.

Chapter 3, *Sounding Silence*, attends to the phenomenology of silence. Silence, as a phenomenon, tends to draw our attention to our

surroundings and to the wider parameters of our attentional 'sphere'. Silence, like noise, thus serves as a vector for a phenomenological consideration of aural attention. Arguing that silence is not simply an absence of sound, but is a phenomenon that we manifestly *experience*, the chapter develops a broader conception of 'silence' that includes a consideration of self in attending, listening-in, and muteness, or being silently present. Echoing the structure of the second chapter, Chapter 3 begins with an initial sounding out of silence in radio plays.

Drawing from my experience of listening-in to the 'platform scene' in Beckett's *All That Fall*, I demonstrate that the phenomenon of listening-in not only foregrounds a sense of listening-at-a-distance, but equally presences a sense of self in attending, or, more precisely, a sense of being silently present. As a further means of exploring this, and drawing from my experience of attending the voice of Ada in Beckett's *Embers*, I proceed to examine the phenomenology of radiophonic *acousmêtres*. In particular, I suggest that the phenomenal sense of displacement engendered by such phenomena has an attentional origin.[42] Moving on to address the phenomenon of silence per se, the discussion of radio drama ends with a phenomenological investigation of Pinter's *A Slight Ache*. The second part of Chapter 3 attends to the phenomenology of silence in the theatre.

As an initial means of demonstrating how theatrical silence is shaped by theatrically designed sound, I offer a phenomenological account of *Ether Frolics*, focusing, in particular, on the production's adept use of 'false sound beds'. As a further means of investigating the nuances of attending (in) silence, and drawing once again from my experience of attending *Kursk*, the chapter proceeds to consider how the listener-spectator's perception of theatrical silence is affected not only by the particularities of designed sound, but also by the condition of darkness. The chapter ends by investigating how theatrical silence is shaped by the intersubjective attentional enactments of the audience. Using *Purgatorio* as a suitable example, I examine how attending (in) silence makes us attend more acutely not only to the sounds in our environment, but to ourselves attending those sounds.

Chapter 4, *Sensing Atmospheres*, pays closer attention to the phenomenology of (aural) immersion. Continuing to navigate the aural/visual divide, and shedding further light on the dynamics of (aural) attention, the chapter develops one overarching hypothesis: namely, that (theatrical) listening involves paying attention to atmospheres. Urging us to reconsider (aural) immersion in *dynamic* terms, and challenging the commonly held belief that 'being in sound' is synonymous with

being straightforwardly 'immersed', I demonstrate some of the ways in which designed sound motivates varied acts of *movement*, both actual and imagined. Having demonstrated how the act of looking is as prone to perceptual play as that of listening, and rather than pitching sound against scenography, I propose instead that we begin to explore the phenomenology of designed theatrical environments or 'atmospheres'. Developing this idea, and drawing from Ingold's notion of a 'weather world' (see 2007 and 2011), I offer a reconsideration of the notion of 'soundscape', before going on to shed further light on the nature of listening as a specific mode of attention. Drawing from Vivian Sobchack's phenomenology of film (1990), I also forge a distinction between two modes of aural attentiveness: namely, 'singling out' versus zooming-/listening-in. Chapter 4 ends by taking a closer look at the phenomenon of 'atmosphere' as such, namely, that particular mood, feeling, or presence that is often brought to our attention, in any given place, space, situation, or environment. Using *Kursk* as an example, I propose that atmospheres in the theatre most acutely draw our attention in moments of silence or hiatus, and that by attending, or *sensing*, we play a vital role in their manifestation.

In writing this book, I have attempted to listen more attentively to the phenomenon of theatrical listening. In exploring the resonance between theatre and aural attention, and by providing an initial theoretical framework for a consideration of theatrical attending, I hope that the ideas, thoughts, and examples contained within these pages will resonate with your own practice of attending theatre and act as a sounding board for further enquiry.

1
Paying Attention to (Theatre) Noise

We tend to assume that we pay attention to sound(s) whilst doing our best to ignore noise. Yet, this familiar distinction between listening as a straightforward attentive 'act' and hearing as the passive sensation of sound necessarily shrouds the phenomenal nuances of aural attention as process. For example, as I write I hear the heard-yet-unseen sound of children playing next door. Whilst I am aware of the level of sound that these children are producing, I do not, or rather *try* not to, attend to this sound as such. I try to force myself to attend only to the task of writing. Yet, although my intention is to block out the sound altogether (to listen, if you will, to the sound of nothing), such an act of complete dis-attention proves to be a near-impossibility when the sound field is so ubiquitously shot through with the sounds of children at play. In fact, when I reflect further, what I am actually trying to do, considering how difficult I am finding it 'to hear myself think', is to listen out intently for my thoughts as they momentarily and haphazardly pop into view within this sonic barrage. Whilst I experience this sound as 'noise', in the typical sense of a loud, disturbing sound, I nevertheless attend to this sound event as it *clamours* for my attention. The phenomenon of 'noise' thus provides an effective, if surprising, means of investigating the embodied dynamics of (aural) attention.

The aims and foci of this chapter are inherently interwoven. In the broadest of terms, this chapter pays particular attention to the phenomenon of 'noise', both in the sense of sound of any kind, as well as 'the sounds we have learned to ignore' (Schafer 2004: 34). Moreover, in subjecting the phenomenon of noise to phenomenological scrutiny, I demonstrate that the commonly held distinctions of listening versus hearing, attention versus distraction, and signal versus noise, are less certain than we might otherwise assume. Our central concern here,

however, is with the phenomenology of *theatre* noise. The phenomenon of 'noise' not only offers a useful means of initially exploring the nuances of aural attention, but serves as a *vector* for constructing a theory of theatrical attending. By paying attention to (theatre) noise, this chapter not only invites us to reconsider theatre's 'aural phenomenology' (Brown 2010a: 138), but also begins to construct an initial theoretical framework for an analysis of theatrical attention, thus laying the theoretical, critical and methodological foundations of this book.

'Perhaps the time is right to entertain noise rather than exclude it in, to listen to what it has to say' (Brown 2005: 119; *sic*). Inspired by this proclamation, I will listen a little more closely to that much maligned, though omnipresent, sonic attention seeker – the mobile phone. Whilst it is perhaps far-fetched to state that the sound of a mobile phone is a noise *par excellence*, it is equally an oversimplification to describe the ringtone, at least in perceptual terms, as pure signal: a ringtone may be wanted in some situations and very much unwanted in others. Perception is always contextual and whether or not we perceive a sound as being a disturbance or interruption depends on a complex range of factors, including the degree of congruity between the incursive sound event and the phenomenal particularities of the existing sonic environment. There is, as we shall see, a great deal more to the sound of mobile phones than meets the ear.

The purpose of this chapter, however, is *not* to provide an in-depth investigation of the status of mobile phones in the theatre auditorium; rather, it uses the anecdote of the mobile telephone as a central point of reference for an initial consideration of theatre and aural attention. Paying attention to the seemingly irrelevant, unintended 'noise' of mobile phones in theatre not only enables us to sound out the phonic, but also to consider the role of (aural) attention in the manifestation of theatrical experience. The title of this chapter, *Paying Attention to (Theatre) Noise* also refers to the practice of listening *'phenomenologically'* (Ihde 2007: 43). By listening phenomenologically we can learn much about the specific ways in which listening as a mode of attention phenomenally shapes perceptual content.

Listening to listening

We tend to think of 'listening' as being straightforwardly and diametrically distinct from 'hearing'. The phenomenon of attention, moreover, would appear to lie at the very heart of this distinction.[1]

Nevertheless, and as this chapter's opening example makes clear, whilst listening undeniably entails a sense of attentiveness, the distinction between listening and hearing is not as dichotomous as we might readily assume:

> Is listening more attentive than hearing, or is it the other way around? Both possess an active sense; neither can be consigned entirely to passivity. (Toop 2010: x–xi)

As an initial means of exploring the nuances of aural attention, I now take a closer look at three theories which especially shed light on the relationship between listening and attention, namely, those of Roland Barthes, Michel Chion and Barry Truax.

Roland Barthes proposes 'three types of listening':

> According to the first, a living being orients its hearing (the exercise of its physiological faculty of hearing) to certain *indices* [...] This first listening might be called an *alert*. The second is a *deciphering*; what the ear tries to intercept are certain *signs* [...] Finally, the third listening [...] does not aim at [...] what is said or emitted, but who speaks, who emits: such listening is supposed to develop an inter-subjective space where 'I am listening' also means 'listen to me'. (1986: 245–246)

Taxonomies of listening inevitably overlap. For example, Barthes's notion of 'first listening', namely, 'that preliminary *attention* which permits intercepting whatever might disturb the territorial system' (1986: 247; emphasis added), closely corresponds with Michel Chion's notion of 'causal listening', namely, 'listening to a sound in order to gather information about its cause (or source)' (1994: 25). In turn, Chion's concept of 'causal listening' closely resembles Barry Truax's concept of 'listening-in-search' (2001: 21). Similarly, Barthes's notion of 'deciphering' is synonymous with Chion's 'semantic listening' in which, as he explains, listening 'is purely differential' (1994: 28). Chion's third category, 'reduced listening', is, however, more distinct: reduced listening 'focuses on the traits of the sound itself, independent of its cause and of its meaning' and 'takes the sound – verbal, played on an instrument, noises, or whatever – as itself the object to be observed instead of as a vehicle for something else' (1994: 29). Furthermore, Chion's concept of 'reduced listening' in many ways corresponds closely with what Don Ihde has described as the practice of listening

'*phenomenologically*', that is, to carry out 'a "reduction" *to* listening' (2007: 49, 42).

To listen phenomenologically is to adopt a *particular* mode of attention that 'singles out' the sonorousness of a particular sound or sonic percept. I shall return to the practice of conducting a phenomenology of listening at the end of this chapter. For now, let one thing be clear: attentiveness and the act of listening are inseparably interwoven – whether we 'focus', 'grasp', 'ignore', 'zoom in on', or attend *phenomenologically* to the sound(s) that we perceive, to listen is to pay attention. One of the most important attempts to arrive at a theory of listening-as-attention is that advanced by Barry Truax.

'The traditional assumption,' writes Truax, is 'that listening involves full attention' (Truax 2001: 22).[2] Yet, as he goes on to point out, 'whilst this defintion may apply to foreground listening, it ignores the *subtler process [of listening]*' (2001: 22; emphasis added). In an attempt to address this, Truax proposes 'three "levels" of listening attention' (2001: 21 ff.). First, there is 'listening-in-search', whereby the listener engages in an acute mode of attentiveness in order to single out an aural percept within a wider sonic context (see Truax 2001: 21). Then, there is 'listening-in-readiness', an intermediate mode of listening in which 'attention is in readiness to receive significant information, but where the focus of one's attention is probably elsewhere' (Truax 2001: 22). Lastly, there is 'background listening', where 'sound usually remains in the background of our attention' (Truax 2001: 24).[3] Sounds that lie in the background 'may be singled out for our attention if the need should arise, but normally they aren't specifically noticed' (Truax 2001: 25).

Truax's model of aural attention, however, only goes so far. What, for instance, are the perceptual and attentional nuances engendered by different modes or 'levels' of listening? Martin Welton has suggested that '[w]hat distinguishes the activity of "listening" from the generic faculty of "hearing" is not simple sensitivity but the assumption of an active relation to its object, or at least a readiness for this' (2010: 50). Yet, what does this 'active relation' or 'readiness' toward sound consist of, how is the 'activity' of listening motivated by the world within which we are phenomenally enmeshed, and what role does the act of listening play in the process of shaping perceptual content? Answers to these questions remain sorely lacking. In an attempt to redress this and to bypass the semantic potholes engendered by the listening/hearing binary, I suggest that we begin to reconsider (aural) attention in *dynamic* terms. In proposing this, I draw from the groundbreaking work of P. Sven Arvidson, to whom I am indebted.

[T]he fun begins in the moment that we realize attention is essentially dynamic [...] Although there is always thematic attention, contextual consciousness, and marginal consciousness, the shape of each of these dimensions and the connections between their contents can change substantially and radically in the *process of attending*. (Arvidson 2006: 56; emphasis added)

What happens when we begin to describe the attentional dynamics of listening as 'process' and what might we learn about the phenomenology of theatrical attention by examining the dynamics (or 'process') of attending theatrical sound? What precisely *is* 'noise' and what is it to experience, or 'to pay attention to', noise in the theatre? To this I now turn.

Paying attention to noise

'Noise', as David Hendy has recently pointed out, is typically defined as sound that is 'out of place': noise 'is usually unwanted, inappropriate, interfering, distracting, irritating' (2013: viii). More explicitly, we tend to think of the notion of 'noise' as being in diametric opposition to that of 'sound': noise is 'not sound, not music, not intelligible signal' (see Kendrick and Roesner 2011: xv). This negative association is not only ancient but etymological, 'noise' stemming from the Latin *nausea*, meaning 'a feeling of sickness' or 'sea-sickness'.[4] Nevertheless, and as the philosopher Michael Serres suggests in the following passage, whether defined in its material incarnation as a phenomenon of sound, or, metaphorically, as interference, noise is inescapable:

There is noise in the subject, there is noise in the object. There is noise in the observed, there is noise in the observer [...] There is noise in being and in appearing. It crosses the most prominent divisions of philosophy and makes a mockery of its criteria [...] It is in the real, and in the sign, already. (1995: 61)

There is thus 'noise' even in noise. In sonic terms, for example, the notion of noise is tinged with contradiction. Noise can be experienced both negatively (noise as annoyance) and neutrally (noise as sound of any kind). Moreover, whilst noise may well be the 'evil twin' of sound, these siblings often look so alike that we can get them mixed up (see Brown 2011: 2). '[A]ll of the meanings ascribed to sound [...] might be also noise in certain circumstances: that annoying department in theatre (the "noise boys"); the hell of "fun" ringtones; the anodyne

blandness of Miles Davis cloying your ears whilst you're trying to think; mobile phones "going off" in the theatre' (Brown 2011: 2). Thus, to some extent, noise is relative: one person's noise is another's music. Whilst noise tends to clamour for our attention, it is paradoxically a phenomenon that also remains, unnoticed, in the background.[5] Yet, in today's extraordinarily noisy world the distinction between 'signal' and 'noise' is eroding and, as a consequence, 'noise' is increasingly becoming more meaningful, indeed, *significant*:

> The air around us, it seems, is no longer a reliably transparent medium for sonic signals. It has become saturated with noise to such an extent that the distinction between 'ground' and 'figure' has become uncertain [...] Music can be part of the subjective experience of noisy, environmental randomness; and that same everyday randomness can itself be taken as music [...] This mashed up soundscape of possibility is the liquid atmosphere in which the human post-industrial subject is immersed. (Brown 2010a: 1–3)

In this passage Ross Brown draws our attention to the interconnection between 'soundscape', immersion and the notion of 'atmosphere'. These broader concepts concerning the phenomenology of aural experience are not only highly complex, but require substantial reconsideration, and will be critically explored in Chapter 4. For now, however, I want to focus on the notion of sound as 'possibility': as opposed to attempting to quell, exclude or ignore noise, we must begin to explore its possibilities. How does noise capture our attention and what might we learn about the phenomenology of listening-as-attention by paying attention to 'noise'? There is perhaps no better place to find answers to these questions than in the theatre.

Paying attention to theatre noise

Despite its etymological association with the act of 'seeing', *theatre* has always been an art of sound-ing: no theatre without noise.[6] Recently, the notion of 'theatre noise' has been used to develop a broader model of sound in performance.[7] This trend, in many respects, reflects the ways in which the distinction between 'sound' and 'noise' is increasingly being called into question. 'Theatre noise', nevertheless, might be said to refer to two seemingly distinct, yet phenomenally interwoven, aspects of theatrical sound as experienced. On the one hand, and in the more technical sense, it refers to theatre sound design, that is to

say, the intended or *designed* sonic component of any given theatrical presentation, or what is often, and somewhat problematically, referred to as the theatre 'soundscape'.[8] On the other hand, theatre 'noise' might be said to refer to the totality of aural affordances (whether designed or otherwise) that exist, or rather that are *sensed*, within any given theatrical environment. This chapter is centrally concerned with this latter conception.

The question of noise in theatre

As the bustling theatres of Shakespeare's day strikingly attest, theatre has not always been a hallowed place of silent attendance. Indeed, '[t]he notion of noise in theatre as interference is relatively new' (Kendrick and Roesner 2011: xvi; also see Larrue 2011). It has been suggested that this move from bustling noise to enforced silence is reflective of the broader ways in which modernism has come to demonise noise (see Brown 2011: 10 ff.). Yet, despite these historical attempts to silence the auditorium, the theatre is and always has been a fundamentally noisy place.

> In the theatre, sound is never pure music. Rather, and to its great credit, it is impure music. It is still steeped in what its public embodiment precisely seeks to conceal: the physicality of the performers, the unforeseeable circumstances of the performance, the listeners' more or less noisy and physical attention. (Pavis 2011: xi)

Here, Patrice Pavis urges us to pay attention to the unintended, seemingly unimportant *noise* of theatre and theatrical attending. First, there are those noises that inevitably occur on (as well as off) stage: coughs, crisp packets, mobile phones, props being accidently dropped backstage, the sound of a helicopter flying overhead in an open-air production. Then, more intriguingly, there is 'the listener's more or less noisy and physical attention', by which Pavis is presumably referring to how members of the audience unwittingly contribute to the sonic environment or 'atmosphere' of theatrical performance by their sheer presence, an idea that will be explored in greater detail in Chapter 4. Thus, the visceral, the vibrational, the wings, the wind: all these comprise theatre's 'background noise'. Yet, in metaphorical terms, Pavis's notion of 'noisy' attention might equally be said to refer to the perceptual confusions, ambiguities and playful nuances of the act of listening itself. Noise is something perceived and, as such, is subject to misperception and playful manipulation. One of the key noise makers in the recent drive to take note of theatre's inherent noisiness is Ross Brown.

In his benchmark essay 'The Theatre Soundscape and the End of Noise', Brown proclaims that 'in the techne of the postmodern theatre soundscape, we might now be witnessing not only a new era of aurality but an exploratory modelling of new ways of "ear" thinking which accept meaning in the coincidence of any phenomena that might once have been set in binary opposition as (*wanted*) *signal* and (*unwanted*) *noise*' (2005: 105). Yet, Brown's suggestion that we might be entering 'a new era of aurality', characterised by the gradual ascendance of so-called '"ear" thinking', belies an adherence to a suspect model of percipience that reiterates a certain sonocentric visual prejudice. Furthermore, whilst Brown is right to suggest that 'the theatre soundscape as a feature of our times might be us flirting with the dissolution of signal/noise binaries' (2005: 117), his assertion that 'theatre is signalling the *end* of noise' (2005: 106) is problematic.

As demonstrated above, there is no end to noise: noise is inescapable. Indeed, despite his proclamation of a new era of aurality, Brown accepts that 'noise emanating from outside the frame' is nevertheless still likely to cause offence or to be regarded as an unacceptable disturbance (see 2005: 117). Why is it, for instance, that 'the sweet-wrappers continue to offend?' (Brown 2005: 118). By way of response, I now pay closer attention to another familiar 'noise' that would very obviously seem to lie outside the intended 'frame' of sound design, namely, the mobile phone.

Sounding phones: paying attention to the 'noise' of mobile telephones

Since the late 1990s, when mobile phones became more widely accessible, the indisputable yet infinitely customisable sound of the mobile phone has become something of an aural archetype, a phenomenally striking, almost-ubiquitous, sonic symbol of late modernity. Indeed, the phenomenon of the mobile phone makes its presence felt even in its sonic absence. Go to any library, art gallery, museum, or church. Mobiles are banned but hardly banished from these places. The same can be said of theatre.

In today's theatre, as Amy Strahler Holzapfel has suggested, mobile phones 'are as integral a component to the theatrical audience's experience as the program, ticket stub or exit sign' (2011: 123). It is now customary, for instance, to preface theatrical performance with a fanfare of ringtones played back through the theatre's sound system for the attention of the assembled throng. However, despite these playful attempts to discipline the audience, 'inevitably there comes a time – usually in the

second act, following intermission – when that piercing ring momentarily shreds through whatever willing state of disbelief still lingers in the auditorium' (Strahler Holzapfel 2011: 123). Yet, what, in particular, is it about the phenomenon of a mobile phone 'going off' in the theatre that causes such attentional and social upheaval? In attempting to answer this question, let me begin with an example taken from my experience of attending Sam Mendes's production of *The Cherry Orchard*.[9]

Presented very much within the realm of theatrical realism, *The Cherry Orchard* was staged at the Old Vic in June 2009 as part of 'The Bridge Project'.[10] The performance is prefaced by the voice of an elderly American gentlemen who drily makes the following announcement: 'Ladies and Gentlemen. May I have your attention: Please ensure that you turn ON your mobile phones after the show. Thank you'. During this instantiation of the performance not one but *two* mobile phones 'went off'. Yet, these seemingly similar sonic events were experienced in strikingly different ways.

Sitting in the circle and towards the beginning of Act I, my attention fixes on the figure of Anya,[11] who, amidst the sounds of background music, is sitting upstage centre musing about the passing of time and her servant's hearing loss. Shortly after this moment I notice what I assume to be the atmospheric tones of designed sound, emanating, somewhat ambiguously, from along the row to my right. These sounds are gentle, indeed, almost illusory, and initially escape my efforts to locate them in space, pin them to a source, or to ascertain their identity. In my quest to identify and locate this oddly sublime sound, I scan my surroundings for clues and notice a hazy flicker of light several seats down the aisle to my right. In singling out this light and glancing at the context within which it resides, I notice a young couple frantically trying to turn off a mobile phone. I have momentarily mistaken the sound of a mobile phone for the faint sounds of Anya's auditory imagination being played back into the auditorium as designed sound. Far from being irritated, however, I find that I am able to accommodate these sounds. Weaving dynamically between differing attentional modes I find that I am able to switch from attending the sound as that of a mobile telephone to, at the same time, being able to perceive it as the intended sonic backdrop to the scene on stage. Then, seconds later, another phone 'goes off', but this time there is an audible, almost aggressive, felt reaction within the audience – a collective feeling of dys-attention that seems to scream 'turn that thing off!' In direct contrast to its predecessor, this jarring mobile-phone-like noise is unambiguously perceived as a disrespectful, irritating interruption. Furthermore, the archetypal and aggressively

disturbing sound of the mobile not only makes me aware of the fragility and socio-environmental contingencies of the act of listening but seems to foreground the auditory act as a kind of alien presence.

As this example demonstrates, all mobile telephones have the potential to annoy or disturb, but some phones are more annoying than others. How, then, can these nuances of noise be explained? Typically, we might describe both experiences in terms of 'distraction', the first mobile phone being gently distracting, the second being a more obviously aggressive and distracting *noise*. Ross Brown has proposed that 'theatre audience phenomenology' consists of a dynamic tension between 'engagement' – by which he effectively means 'attention' – and 'distraction' (see 2011: 5, 6):

> Theatre *audience*, as a process, seems better understood not as simple binary attentiveness to a programmatic figure set against a ground of background noise or circumstance of assumed *insignificance*, but as the negotiation between conventional expectation of where meaning is to be found in any given moment of audience, and a constantly dynamic matrix of circumstantial distraction. (2010b: 342)

Whilst this model would appear to 'entertain' the interplay between significance and insignificance, attention and distraction, Brown implicitly adheres to a model of attention that necessarily disavows an investigation of the phenomenal act of attending theatrical performance. To describe my encounter with the two phones during my attendance of *The Cherry Orchard* merely as different instantiations of distraction not only homogenises the phenomenal variations of attentional capture but precludes a consideration of 'what *happens* when we listen' (Douglas 2004: 25; emphasis added).

If we are to properly investigate the particularities and peculiarities of listening as 'process' (in other words, to begin to discover what 'happens' when we listen) we must pay closer attention to the phenomenon of attention. More precisely, rather than understanding theatrical reception as a dialectical relationship between the world of attentiveness set within a wider 'matrix' of distraction, I propose instead that we turn our attention to the phenomenal dynamics of embodied attending. Such a strategy not only allows us to begin to explore the nuances of aural attention, but also enables us to navigate the perennial binaries of sight versus sound, attention versus distraction, and listening versus hearing. Before attending to the phenomenon of attention per se, more must be said regarding the precise nature of *theatrical* listening, or, listening

in the theatre. In particular, it is important to reconsider, as well as to acknowledge, some of the ways in which the phenomenon of theatrical listening has been conceptualised, and, in so doing, to illustrate how this book offers an alternative to these theoretical precursors.

Theatrical listening: reconsidering theatre's 'aural phenomenology'

Scholarly works dedicated to theatre and aurality remain few and far between. My primary intention herein, however, is not to review the extant literature on the subject but rather to hone in on those works that have specifically paved the way for a *phenomenological* considera-tion of theatrical listening. For the purposes of brevity, and notwith-standing other important contributions to this newly emerging field of enquiry (such as the work of Pieter Verstraete),[12] the following discussion focuses on the work of two scholars – who, between them, have done much to pioneer the ear in theatre – namely, Bruce R. Smith and Ross Brown.

In the introduction to *The Acoustic World of Early Modern England* (1999), Smith asserts that to understand listening 'in its totality' we need to move 'beyond the purview of science' and consider three things:

> First of all there is the intractable individual listener, with his dis-tinctive knowledge and experience, her own particular goals and intentions. To understand these factors, we need a *psychology* of listening. Since knowledge and intentions are shaped by culture, we need to attend also to cultural differences in the construction of aural experience [...] We need a *cultural poetics* of listening. We must take into account, finally, the subjective experience of sound. We need a *phenomenology* of listening, which we can expect to be an amalgam of biological constant and cultural variables. (1999: 8)

Evidently, as this passage attests, Smith is concerned less with the micro-level details of what is 'given', immanently, within the moment of perceptual encounter (that is to say, with listening-as-*lived*), and more with the various ways in which 'listening' is shaped by culture. Smith draws from the discourse of phenomenology, together with an extensive range of sources, in order to model the role of sound in the formation of early modern subjectivity. Smith's project is thus one of 'historical reconstruction' (1999: 29). Yet, by reconstructing the aural phenomenology of early modern England, Smith necessarily recon-structs phenomenology itself: or, to be more precise, one might say that

Smith does phenomenology *remotely*, being experientially as well as spatio-temporally 'removed' from the phenomena in question.

'Phenomenology', as I have already underlined, is a philosophy of practice that proceeds through a *particular* methodology. It is thus important to distinguish between what I refer to as a kind of aural archaeology and the practice of conducting a phenomenology of listening per se, further details of which are given at the end of this chapter. Whilst there is clearly a lacuna in scholarship regarding the nature of aural experience in and through history and, hence, a distinct need for cultural historians to listen to our ancestors listening, such an enterprise does not constitute a *'phenomenology* of listening' as such.[13] Moreover, the implications of *applying* rather than practising phenomenology are considerable, Smith being a case in point.

In order to soundproof his model of early modern aurality, Smith forces sound, source and subjectivity to submit to a series of commonly held assumptions. In particular, Smith reiterates the familiar, yet misguided, belief that being-in-sound is synonymous with being straightforwardly 'immersed'.[14] As I argue later in this chapter, as well as in Chapter 4, this familiar model of auditory experience is highly problematic.[15] In short, whilst the phenomenology of listening inevitably consists of 'an amalgam of biological constants and cultural variables' (Smith 1999: 8), this does not mean that we should overlook the particularities of phenomenological *method*. The same criticism can be made of Ross Brown.

In *Sound: A Reader in Theatre Practice* (2010),[16] Ross Brown draws our attention to the profound significance of the insignificant, or, in more precise terms, he urges us to listen a little more closely to anything that seems irrelevant to the straightforward linearities of conventional theatrical reception.

> Theatre convention tends to assume 'eyes front' attentiveness, and to presume that peripheral noise is extraneous and therefore to be ignored in terms of any potential dramaturgical intent [...] but this ideal state of devotion, the famous 'willing suspension of disbelief', is an ideal which forgets the phenomenology of bodily presence within the auditorium. (2010a: 136)

Here, Brown begins to reassess some of the assumptions we often tend to make regarding how we attend and listen to a given theatrical event. In particular, he urges us to attend to the phenomenal, dramaturgical and ontological significance not only of sound but of 'bodily presence

within the auditorium'. In underlining the extensiveness of what he intends by theatre 'noise', Brown invites us to reconsider the notion of 'aurality' in broader terms.

As well as referring to the nature and act of hearing, Brown points out that the term 'aural' (which stems from the Latin word *aura* meaning zephyr or breath) also refers to 'that airborne, tactile, mnemonic sense of place' (2010a: 214). Thus, implicitly, Brown's 'aural phenomenology of theatre' (see 2010a: 138–148) not only attends to the experience of hearing with one's ears, but also to the ways in which we sense the world around us by means of 'the closely interrelated skin/air senses (hearing, smell, touch)' (see Brown 2010a: 214).[17] Yet, whilst striving to account for the complex ways in which we sense our environment beyond the sensory modes of listening and looking, Brown's notion of the 'aural body' presents the sensing body as a body of distraction (see Brown 2010a: 214). As an easily distracted body that picks up the noise of the background, the 'aural body' continually distracts the allegedly linear, detached faculties of listening, looking and thought. Moreover, since the 'aural body' is restricted to the so-called 'aural senses' of hearing, touch and smell, the act of listening itself is subsequently excluded from an account of aurality: listening is cast from its home and thrown into the abstract, no-place of the mind. Being disembodied from the complexities of being-in-the-world and being-in-sound, Brown's concept of the 'aural body' is an *ideal* body that, ironically, 'forgets the phenomenology of bodily presence' (2010a: 136). In order to understand this criticism we must take a closer look at the sharp distinction that Brown makes between hearing and listening:

> In the classical analogy of *theatrum mundi*, all the world is a stage and human life is a spectacle for the gods to watch from on high. It is a detached theatre, a silent theatre for spectators [...] The original Greek *theatron* meant a watching place, but the watching happens within an *auditorium*, the Latin word for listening place, and is done by an audience, a congregation of listeners. Watching is subsumed by hearing; the gaze is immersed in sound. Audiences inhabit two worlds: they *gaze on* and *listen in* to a detached world onstage, while feeling its resonance within its own corporeal presence. (2010a: 5–6)

Whilst striving to distance himself from the problematic notion of a 'detached' theatre, Brown's model of theatrical percipience nevertheless assumes that vision is an abstract, objectivising act of detached watching 'from on high'. In this conception, being a 'spectator' necessarily consists of detached, privileged acts of analysis. Thus conceived, theatrical

spectatorship is guilty, by etymological association, of the objectivising sins of the gaze. Moreover, whilst the above account initially appears to sever listening from looking (the *theatron*, with its remote viewer, being sharply segmented from the *auditorium*, with its 'congregation of listeners'), the subsequent sentences reveal that, for Brown, listening is the mere lieutenant of looking. Furthermore, by eliding listening ('listening in') with the allegedly detached, disembodied, rationalising act of looking ('gazing on'), Brown generates a new binary, namely, listening versus hearing. In Brown's narrative of the senses, which draws from the somewhat suspect formulations of Joachim-Ernst Berendt and is based on the metaphysical principle that 'sound is a philosophical analogy by which existence itself is understood' (2010a: 212), 'ear-thinking' precedes 'eye-thinking', and thus hearing precedes listening (see Brown 2005; and Berendt 1988: 49 ff.).[18] Most important of all, the phenomenon of attention lies at the very heart of this distinction. For Brown, listening and looking are activities of attention, whilst hearing, sensing and touch are activities of distraction (see 2010a: 135–136; and 2011: 4). This familiar distinction between listening (attention) and hearing (distraction) is strikingly evident in the following passage:

> Listening is an activity that makes an *event-object* of the focus of its attention, but hearing, in computer terminology, runs in the background, alerting the user to certain programmed categories of event: the breaking of a twig; the rustle in the undergrowth. Listening is thus *subject* to hearing. Actively 'paid' or 'given' attention is continuously tugged and grabbed by events in the heard environment, the listening brain is continuously diverted from and then reinvested in its object. Sound must therefore be understood as ontologically distracting, and theatre must be understood, not as an uninterrupted programme of reception, but as a continual oscillation between engagement and distraction. (Brown 2011: 5–6)

This statement mirrors Brown's proposition that 'theatre is a place of detached spectatorship and aural participation' (2010a: 6). Yet, since listening requires the enlistment of attention, a 'faculty' which is said to belong to the processes of the eye, listening is not allowed to participate in the 'aural participation' of theatre. Contrary to the above account, listening is not to be construed according to a disembodied, visuocentric, 'searchlight' model of attention, but rather we must begin to understand aural attention, alongside other acts of attending, as a mode of *'dynamic embodied attending in the world'* where the binaries of activity versus passivity, listening versus hearing, attention versus

distraction, are set in *play*.[19] In order to hear what listening has to say, that is, to 'listen to listening', we must pay greater attention to the phenomenon of attention.

Paying attention to attention

As Edward S. Casey has declared, '[t]he scope of attention is vast; it covers most of what we do, so much so that inattention is the exception rather than the rule' (2004: 83). The concept of attention remains a key topic in psychology, cognitive science and sociology, and has recently caught the eye of art historians and cultural theorists.[20] In philosophy, however, the subject has been somewhat sidelined: in short, 'not enough attention has been given to *attention*' (White 1964: preface).[21] Such neglect perhaps results from the fact that the phenomenon of attention is often taken for granted. Moreover, not only do we tend to make a series of assumptions about what attention *is*, but the phenomenon of distraction has been left in the dark.

Leaving distraction in the dark: troubling assumptions about attention

> Every one knows what attention is. It is the taking possession by the mind, in clear and vivid form [...] Focalization, concentration, of consciousness, are of its essence. It implies withdrawal from some things in order to deal effectively with others, and is a condition which has a real opposite in the confused, dazed, scatter-brained state which in French is called *distraction* [...] The eyes are fixed on vacancy, the sounds of the world melt into confused unity, the attention is dispersed so that the whole body is felt, as it were, at once, and the foreground of consciousness is filled, if by anything, by a sort of solemn sense of surrender to the empty passing of time. (James 2007: 403–404)

This much-cited extract from William James provides a useful means of introducing a number of commonly held assumptions regarding the phenomenon of attention. First and foremost, and as James's statement typifies, attention is invariably construed as a particular faculty of the mind and primarily conceptualised through the use of visual metaphors.[22] Second, we tend to define attention as the opposite of distraction. In James's definition, for instance, 'attention' is conceptualised as a noble faculty of light, enlightenment, and order, whilst 'distraction' is conceived as something unwanted, or as a state of confusion and disorder. Attention, thus conceived, consists of an abstract and purely cognitive faculty,

disengaged from embodiment; whereas distraction is characterised by a loss of attention and the usurpation of the mind by the body. A binary is thus set up between the attentive mind and the distracted body.[23]

Such a conceptualisation of attention continues to prevail within critical discourse and to be uncritically assumed.[24] Yet, whilst the concept of attention might seem to go without question, the *phenomenon* of attention leaves many questions unanswered:

> What does it mean to be attentive? What constitutes 'attention' – is it a long held focus, or a glance? What is (are) the motivation(s) in becoming aware of things or others? [...] Are we able only to be attentive to one thing at a time, or are we able to focus on two or more things at once? How is one present to oneself in attentiveness? What happens when we reflect on attention and become attentive to attention itself? Is the philosophical practice itself an attentive one, and if so, what kind of attentiveness is phenomenological reflection? At what point does inattention or distraction arise? How is the origin of distraction given? (Steinbock 2004a: 2)

The traditional model of attention, as promulgated by William James, not only pitches distractedness over and against attentiveness, but fails to give an account of the processes by which the perceptual object is *produced*. Philosophical discussions of attention remain divided concerning 'the extent to which attention is stimulus-driven (*exogenous* orienting of attention) or depends on intentional or voluntary factors (*endogenous* orienting of attention)' (see Brown 2007: 154). In endeavouring to resolve this conundrum, Edmund Husserl declared the need for a systematic 'phenomenology of attention' (1983: 226), which would map out 'the essential connection between attention and intentionality' (1983: 226, footnote 32).[25] Husserl's model, however, is still unable to account for the fact that attention both modifies and is modified by what it attends: his endogenously oriented model of attention necessarily excludes the exogenous dis-orientations of attending. Contrastingly, and in urging us to 'recognise the indeterminate as a positive phenomenon', Merleau-Ponty called for a 'true theory of attention' that not only explores but embraces the ambiguities and indeterminacies of attention *as lived* (2002: pages 36 and 7 respectively).

Articulating attention: Merleau-Ponty's 'true theory of attention'

The art historian Jonathan Crary has asserted that Merleau-Ponty (together with a number of other twentieth century philosophers and

theorists) rejected attention 'as a relevant or meaningful problem' (1999: 33, footnote 59). This assumption would, at first glance, appear to be well-founded: early on in *Phenomenology of Perception* Merleau-Ponty declares that 'the notion of attention is [...] no more than an auxiliary hypothesis, evolved to save the prejudice in favour of an objective world' (2002: 7). Yet, Merleau-Ponty is not rejecting attention per se but taking issue with how the notion of 'attention' has been conceived by two opposing schools of thought: namely, empiricism and intellectualism (see Home-Cook 2011a: 97 ff.).

In empiricist thinking, attention is conceptualised as a kind of 'searchlight that shows up objects pre-existing in the darkness' (Merleau-Ponty 2002: 30). 'Attention', thus conceived, not only 'creates nothing' but 'is a natural miracle [...] which strikes up like sparks just those perceptions or ideas capable of providing an answer to the questions which I was asking' (Merleau-Ponty 2002: 30–31). This conception not only renders attention passive, inert and impotent, but also makes it monomorphic: '[s]ince "bemerken" or taking notice is not the efficient cause of the ideas which this act arouses, it is the same in all acts of attention, just as the searchlight's beam is the same whatever landscape be illuminated' (Merleau-Ponty 2002: 31). Conversely, from the perspective of intellectualism, attention is overwhelmingly virile; and this fruitfulness poses a problem:

> since I am conscious that through attention I shall come by the truth of the object, the succession of pictures called up by attention is not a haphazard one [...] Since in attention I experience an elucidation *of* the object, the perceived object must already contain the intelligible structure which it reveals. (Merleau-Ponty 2002: 31)

For Merleau-Ponty, then, empiricism and intellectualism are both 'in agreement in that neither can grasp consciousness *in the act of learning*, and that neither attaches due importance to that circumscribed ignorance, that still "empty" but already determinate intention which is attention itself' (2002: 33). Thus, far from rejecting the notion of attention, Merleau-Ponty's 'true theory of attention' seeks to bring distraction out of the dark. Correspondingly, we should begin to think of the phenomenon of attention as a dynamic, polymorphous 'sphere'

From spotlight to sphere: attention as a dynamic phenomenon

The subject of attention, as P. Sven Arvidson has pointed out, has generally been approached from two perspectives: 'phenomenologists have been concerned primarily with the 'margin and context of attending',

while cognitive scientists have tended to examine 'the focus of attention' (2010: 99). In offering an alternative approach, Arvidson has urged us to consider 'attention in context' (2010: 99). Accordingly conceived, marginal (and contextual) consciousness is no longer the enemy of (focal) attention but is a vital dimension of, what Arvidson refers to as, the attentional 'sphere':

> Working from the center of the sphere of attention to its outer shell, there are three dimensions [...] *thematic attention* (attention in the dimension of theme or focus), the *context of attention* (consciousness in the dimension of the thematic context), and the *margin of attention* (consciousness in the dimension of margin as halo and horizon). (2006: 1; see also Appendix 1)

Arvidson's 'sphere of attention', which builds on (and substantially reformulates) Aron Gurwitsch's 'phenomenology of consciousness',[26] presents a radical departure from the familiar, near-naturalised notion of attention as a one-dimensional 'spotlight' (Arvidson 2006: 19; 18 ff.).[27] More especially, Arvidson's model (summarised above) not only enables us to examine the phenomenal ways in which attention is paid by means of the act of listening, but also provides a useful means of constructing a theory of theatrical attending. Rather than understanding theatrical reception as a dialectical relationship between linear attentiveness and a wider 'matrix of circumstantial distraction', as suggested by Ross Brown (2010b: 342), we should begin to investigate the phenomenal nuances of *'dynamic embodied attending in the world'* (Arvidson 2006: 7). The familiar sensorial binaries of sound versus sight, hearing versus vision, spectating versus audiencing are not only problematic but unnecessary. Instead, we should begin to consider how the senses correspond with one another, and how the act of attending, whether in the theatre or in the world at large, consists of a dynamic, intersensorial and embodied engagement with the affordances of a given environment.

Stretching reception: towards a theory of theatrical attending

As part of a wider discussion of the phenomenology of presence in theatrical performance, Cormac Power has urged us to consider 'the particular ways in which the theatrical medium constructs objects of attention, and how these objects of attention are *presented* to an

UNIVERSITY OF WINCHESTER
LIBRARY

audience' (2008: 175). Yet, how does theatre 'construct' and present 'objects' for the attention of its audience and what happens when we begin to describe how these intended percepts are manifestly perceived and articulated by means of theatrical attention? Moreover, what happens if we pay closer attention to those attention-grabbing percepts or noises that lie outside the frame of intended, designed or diegetical significance?

In the theatre, as in everyday life, objects of attention are neither 'presented' objectively to an inactive percipient nor are they mere abstractions of the mind but are phenomenally *constructed*, formed and articulated through a dynamic process of embodied, intersensory attending in the world. I now return to the phenomenon of unintended theatrical 'noise', as exemplified by the example of the mobile phone, as an effective means of developing a stretching model of theatrical reception.

Accommodating phones: attentional accommodation

We often speak of how sounds 'grab' our attention; the unexpected and perhaps disconcerting sound of a knock at the door; the sound of a friend's voice at a party, which we hear over our shoulder whilst engaged in conversation; the familiar and ubiquitous buzz of a mosquito that disturbs us whilst we read. These examples of attention-seeking 'noise' might also be referred to as instances of sonic 'incursion' (or '*irruption*'), defined by Augoyard and Torgue as 'an unexpected sound event that modifies the climate of a moment and the behaviour of the listener in a characteristic way' (2006: 65). Yet, what are the particularities of attentional capture and the dynamics of sonic incursion as lived? The following example from P. Sven Arvidson sheds light on this question:

> Suppose that suddenly, as I am writing, the deafening home alarm system sounds – WONK! WONK! WONK! Eventually I will get a thematic grip on this rude sonorous interruption. But the question here is how does this theme enter into attention? When we say it 'captured' my attention, was it first marginal, and then thematic? Or is there just a disconnected gap between the previous theme and the present one, a 'blink' in attention perhaps marked by fright and adrenaline? (2006: 79)

We are inclined to think of noise, in its annoying manifestations, as a phenomenon that we do our best to *disattend* or ignore. Nevertheless, and as Arvidson's example of the alarm exemplifies, some sounds

demand that we pay them attention. By beginning to explore the process by which marginal content becomes thematic, Arvidson provides us with some important clues as to why certain sounds are perceived to be more noisy or 'rude' than others. When we say that something 'captures' our attention it rapidly and aggressively 'inserts itself into thematic attention' (Arvidson 2006: 81). Thus, 'attentional capture' is defined as 'the insertion into the focus of attention (almost at an instant) of something that is (almost immediately recognized as) a part of the world already marginally presented' (Arvidson 2006: 81). Noise, therefore, is only given as 'noise' (that is, as a 'rude sonorous interruption') when an otherwise seemingly insignificant and marginal sound event aggressively displaces thematic content.[28] Yet, the manner in which our attention is oriented by different kinds of sound event varies tremendously. Let us take a closer look at that most noisy of attention seekers – the mobile phone.

Telephones are generally designed to grab our attention. Indeed, the sound of a 'telephone ringing' is an emblematic example of the 'incursion effect': when a telephone rings it 'not only interrupts the present state, but also dictates new behaviour for a given moment' (see Augoyard and Torgue 2006: 65 ff.). Yet, as my experience of attending *The Cherry Orchard* demonstrates, not all instantiations of phones that sound are necessarily given in experience to sound *phoney*, that is, to be unequivocally perceived as the noise of a (mobile) telephone: even mobile phones can escape our attention. Yet, why are some phones given as rude and noisy sono-attentional incursions whilst others can almost escape our notice? In accounting for this perceptual oddity, I would like to introduce the notion of *attentional accommodation*.

In the example, given above, Arvidson is unable to accommodate the excruciatingly loud, insistent and sudden noise of the house alarm within his attentional sphere. Being incongruous to both the theme of attention (namely, the relative silence of thinking about what to write) and the attentional context (namely, the quietude of being-in-thought), the sound of the alarm is unambiguously given as 'a rude sonorous interruption'. Importantly, therefore, it is not the sheer volume or loudness of the alarm per se that rudely captures his attention, but the fact that this loud noise is strikingly incongruous to the pre-existing sono-attentional context: moving almost instantaneously from margin to theme, the 'noise' of the alarm rudely accommodates itself at the very centre of thematic attention.

'When something captures our attention, or when we concentrate or pay attention to something, it is presented within a context' (Arvidson 2006: 1). This important inference not only has far-reaching

implications for our understanding of the phenomenology of sound but also enables us to pay closer attention to the phenomenal nuances of noise. Since 'each moment of attending life is structured into three dimensions, *attention-in-context-with-margin*' (Arvidson 2010: 101), we must always consider how our experience of sound(s), as well as silence, is affected by a wider phenomenal context.

Take, for example, my encounter with the first mobile phone that went off during my attendance of *The Cherry Orchard*. The first thing that struck me about this sound was its sense of ambiguity. Initially I experienced this sound to be *acousmatic*: namely, a sound 'one hears without seeing [its] originating cause' (Schaeffer 1977: 91–99 ff.; cited in Chion 1994: 71).[29] The spatial equivocality of these sounds playfully coincided with their ontological indeterminacy. At first I perceived these sounds to be part and parcel of the intended or *designed* sonic component of the performance, their illusory, dreamlike quality being in accord with and providing an appropriate backdrop to what was going on diegetically, namely, Anya's melancholic musings regarding temporality and the degeneration of her servant's auditory faculties. Yet, being ambiguous as well as acousmatic, I was beckoned to ascertain both its identity and its 'originating source'. This example demonstrates that the distinction between intended (designed) and unintended (non-diegetic) noise is, at least in perceptual terms, not as clear-cut as we might customarily assume. From time to time the sounds of the world extraneous to the intended frame of theatrical diegesis not only slip into our awareness, but are manifestly given *as part of* the intended meaning of the piece. In such moments of aural ambiguity, where sound defiantly yet equivocally resists the taxonomic machinations engendered by 'listening-in-search', the attention of the listener is not only captured but also variously disorientated. Our ability to accommodate unintended sounds within the frame of intended meaning depends, in part, on the correspondence and coincidence between intended sound and unintended noise. Being somewhat enigmatic, the sound of the first mobile phone was not perceived to be stereotypically and overtly 'phoney'. Moreover, it was the phenomenal way in which this sound, in the moment of its instantiation, *coincided* with the intended meaning that not only brought about an experience of equivocation but also allowed me to accommodate these seemingly unwanted sounds within the diegesis.[30]

In developing Arvidson's notion of context 'enlargement', where the 'material relevancy [of a given thematic context] is enlarged' (see 2006: 60),[31] I suggest that the extent to which a particular unintended sound event is given to cause disruption

will depend upon a) the degree to which this sound coincides with and is relevant to the diegetical 'frame' or theme at any given moment, and b) the degree to which the listener-spectator is able, either consciously or otherwise, to accommodate these unintended sounds within a temporarily enlarged attentional context. Furthermore, and in accordance with a stretching model of reception, it is also important to explore how equivocal (and unintended) visual phenomena can be performatively accommodated in (theatre) perception. To demonstrate this, I draw from my experience of attending Sound & Fury's *Kursk*.

At the very beginning of the performance, where the audience is plunged into quasi-darkness, something beckons me to turn my head towards the balcony rail, positioned up to my right and several metres above where I am standing. I am aware of a tinkling sound, not unlike the sound of a child's mobile (in this case, the toy as opposed to the telephonic variety). Coinciding with this sonic percept, I notice a flickering light emanating indeterminately from the balcony. At first, it seems as if I am seeing things, as when one closes one's eyes and detects the phantom-like flickerings of non-existent light. However, on performing an audiovisual double-take, I discover, much to my surprise, that the object of my attention is not part of the lighting design, nor part of the intended diegesis, but a young businessman, texting on his mobile phone.

Notably, it was the *visual* as opposed to the sonic presence of the mobile phone in this example that gave away the existence and location of both the phone and its user. Furthermore, the visual presence of the mobile telephone was not entirely unwelcome. Being able to accommodate this sensory happening within my attentional sphere, this mysterious spectre of vision caught my attention in ways that enhanced my experience of the 'event'. This was partly because the ambiguous presence of the unidentified flickering light unintentionally coincided with the dreamlike and equally ambiguous (though *intended*) tinkling sound of a child's toy mobile. This situation was only disambiguated later on when I discovered that high up above, in an area that had been completely obscured from view because of where I had been standing, a mini-scene was being played out involving a toy mobile dangling from the ceiling, lit with low-level lighting.

Thus, in the theatre our ears *and* eyes can lead us astray. Yet, such unintended instances of audiovisual ambiguity and coincidence are not necessarily technical or perceptual problems to be 'solved' but rather are to be savoured, or even sought after. Indeed, and as the above examples illustrate, not only does ambiguity lie at the heart of the theatrical

phenomenon but theatre's inherent equivocality is (to some extent) brought about by and *in* acts of theatrical attending.

Having illustrated some ways in which the listener-spectator is able to momentarily stretch the parameters of intended (or diegetic) significance, let us now consider those sonic events in theatrical performance that are unequivocally experienced as *unaccommodatable* noise.

Unaccommodating noise: sonic incursion and the dys-appearing body

As my experience of attending *The Cherry Orchard* attests, there is a point where the context of attention forces thematic attention to change its theme: the attentional context, in other words, can only be stretched so far. In offering an explanation for why certain sounds 'continue to offend' in the theatre, Ross Brown has asserted that '[i]t is not the sonic intrusion but the owner's disrespect for convention that makes the noise' (2005: 118). For Brown, therefore, it is not the *sound* of the mobile phone that offends but the fact that this sound breaks the conventions of theatregoing. However, the phenomenal disruption that is often caused when a mobile phone 'goes off' in the theatre cannot be explained solely in terms of the ethics of audiencing. There is, for instance, a *somatic*, as well as a sonic, explanation for why certain sounds are perceived as 'noise'.

In attending theatre we are invariably invited, and in some cases forced, to attend to the body as 'lived', or, if you like, to pay attention *to* ourselves as we attend.[32] In philosophy, it is commonly assumed that 'attention to attention is irrelevant to the task of attention' (Arvidson 2006: 121). Yet, and as P. Sven Arvidson has upheld, it is important to develop a model of attending that '*includes* subjectivity as a function of the sphere of attention' (2006: 9). Indeed, the experience of self in attending (or of experiencing ourselves as an attending body) is intrinsic to attention as a phenomenon:

> Because attention implies both sensory engagement and an object, we must emphasize that our working definition refers both to attending 'with' and 'to' the body. To a certain extent it must be both. To attend to a bodily sensation is not to attend to the body as an isolated object but to attend to the body's situation in the world. (Csordas 1993: 138)

Thomas Csordas's concept of 'somatic attention' resonates, in many respects, with Catherine Laws's concept of the 'performativity of

listening' (2010: 1). The 'performativity of listening' not only describes the sense in which listening contributes to 'artistic experience', but also attempts to account for those moments where '[w]e concentrate on what it is to listen, rather than on the subject that speaks or the object that produces sound' (Laws 2010: 1). The performativity of listening thus refers to a certain *presencing* of the embodied act of listening itself. Relatedly, Martin Welton has suggested a link between 'bodily self-awareness' and the phenomenon of stage fright (see 2010: 50). More specifically, Welton's account seems to suggest that the experience of stage fright is not purely psychological but is brought about by a moment of attending *to* the body, where the lived body itself is fore-grounded as attentionally thematic. One might venture to say that such thematisations of the lived body are experienced, like pain, as a kind of *'absence of an absence'* (Leder 1990: 91):

> At moments of breakdown I experience *to* my body, not simply *from* it [...] In contrast to the 'disappearances' that characterize ordinary functioning, I will term this the principle of *dys-appearance*. That is, the body *appears* as thematic focus, but precisely as in a *dys* state – *dys* is from the Greek prefix signifying 'bad,' 'hard,' or 'ill,' and is found in English words such as 'dysfunctional.' (Leder 1990: 83–84)

Whilst it would be far-fetched to claim that the bodily and ontological dys-appearances caused by the sonic incursion of a mobile phone should be equated to actual pain or *dys*-ease, my enquiry suggests that during such moments the body is momentarily thematised, to different degrees, as an 'alien presence' (Leder 1990: 83). The 'rude sonorous interruption' of the second mobile phone (that sounded during my attendance of *The Cherry Orchard*) brought about a temporary and particularly uncanny state of self-attending where the *fact* of audition was involuntarily fore-grounded as attentionally thematic. Not being able to 'close' the ears in the same way that we can 'shut' our eyes, in such moments of sonic incursion the act of attention is not only forced back on itself but the listener is forced to listen to an incursive noise that overpowers thematic attention and, in so doing, the body of the listener *dys-appears*.

Moreover, and in ways strikingly similar to Arvidson's example of the alarm, in my encounter with the second mobile phone I experienced a kind of 'blink' in attention (see Arvidson 2006: 79). Like blinking, these moments are not only short-lived but also entail a degree of perceptual and bodily adjustment as the lived body tries to gather itself together. The body, as Merleau-Ponty has proposed, is continually 'polarized by

its tasks, of its *existence towards* them, of its collecting of itself in its pursuit of its aims' (2002: 115). As such, the body is never fully absent, nor, indeed, is it ever fully present to itself – the body always leaves something behind. This absent-bodiedness of the lived body may well explain the manifestation of such corporeal and spatial dys-appearances.

'[W]hile in one sense the body is the most abiding and inescapable presence in our lives, it is also essentially characterized by absence. That is, one's own body is rarely the thematic object of experience' (Leder 1990: 1). In the emblematic case of pain, however, 'the painful body emerges as an *alien presence* that exerts upon us a *telic demand*' (Leder 1990: 73). Moreover, being non-volitional, pain affects 'our manner of being-in-the-world'; it 'reorganizes our lived space and time, our relations with others and with ourselves' (see Leder 1990: 73). Hence, although pain is experienced subjectively, it can nevertheless have important intersubjective consequences. Correspondingly, when a mobile phone goes off in the theatre the corporeal dys-appearance or 'blink in attention' is felt *intersubjectively*. On hearing the sound of the second mobile phone that suddenly went off during my attendance of *The Cherry Orchard* I not only experienced an acute sense of 'bodily self-awareness' but equally sensed an intersubjective state of collective annoyance, displacement and disorientation.

Being present as a theatregoer means to participate through a process of intersubjective attentional enactment. A model of theatrical attending should thus also examine how theatrical experience is shaped by the intersubjective, collective act of theatregoing. Yet, to understand the role played by the act of attention in shaping perceptual experience we must first attend to the question of how perceptual content is variously manipulated through *individual* acts of attending.

Enacting theatrical experience: attention as creative response

'Attention', as the philosopher Bernhard Waldenfels has proposed, is characterised 'as a double and intermediary event' (2009: 1, 'Section 2'). Like the double bind engendered in the act of touching, attention consists, inseparably, of two parts. The first part (*auffallen*) 'has to be characterised as something happening to me, as something touching or affecting me, as a kind of pathos' (Waldenfels 2009: 1, 'Section 2'). The second part (*aufmerken*) 'has to be taken as a sort of *response*, articulated by an answer that I give or refuse. Response means an *event* coming to be transformed into an *act* or an *action*' (Waldenfels 2009: 1, 'Section 2'). What is often overlooked, however, and as Waldenfels goes on to remark, is that the 'event' of attention consists of an ongoing

'process of responsive creation' in which 'everything which we are affected by (*wovon*) and responding to (*worauf*) is transformed into something (*etwas*) that we mean or treat as something (*als etwas*) following certain rules (*wonach*)' (Waldenfels 2009: 2, 'Section 5'). Yet, what is this 'process of responsive creation' of which Waldenfels speaks, and what are the phenomenal features of this event as it is played out through the act of listening?

Perceptual experience, as I have already suggested, is shaped by the enactments of aural attention, which are as diverse as they are nuanced. On encountering the acousmatic, equivocal sounds of the first mobile phone that went off during *The Cherry Orchard*, I found that I was able to alter my perception of this sound depending on the particular mode of attention I chose to adopt. Having singled out the mobile phone as an attentional theme I was able to zoom out from this theme, thus enlarging the attentional context in which it was given to manifest. This dynamic act of contextual enlargement momentarily enabled me to weave the mesmerising, though objectively unintended, tones of the mobile into the wider attentional context of intended significance. Commenting on the role of listening in the perception of contemporary laptop music, Caleb Stuart offers the following example of what he refers to as 'aural performativity':

> When listening to this work the audience is immersed in sound. The sound appears to be emanating from the walls and ceiling. At points it seems to be coming from inside the ear. If one moves their head slightly the sound field shifts with it. The ear entering the wave patterns at different angles changes the perceived sound of the piece. This is the aural performative. The act of listening, not seeing, creates the performativity of the piece. A receptive audience, listening with *attention* and concentration receives the performance not by watching Niblock play a piece of music but by listening to the compositions in space. (2011: 3; emphasis added)

Stuart's description highlights the phenomenal ways in which the act of listening shapes perceptual experience. Moreover, the above description suggests that it is not the act of listening per se that manifestly results in such 'performativity' but rather listening-as-*attention*. Yet, whilst it is appropriate to consider the phenomenon of listening in terms of 'performativity', this demarcation has its limitations. First, there is a spatial dimension to listening-as-lived that that more extended notions of performativity begin to dilute: being a listener at once entails both a sense

of being in space and of sounding space. Second, we must not underestimate the role of vision in shaping our experience of sound. Listening, even in the case of listening to radio plays, is never an isolated act but entails an *intersensorial* engagement with the affordances of a given environment where looking is inseparably and dynamically co-opted.

Stretching (in) sound: sonic experience and the dynamics of embodied attending

Despite Jim Drobnick's assertion that 'to postulate a sonic turn [...] is more than just a matter of adroitly exchanging one trope, one sense modality, for another' (2004: 10), there is still a strong tendency within scholarship to set sound against sight, audition against vision, listening against looking. Sound, for example, is commonly conceptualised through tropes of immersivity whilst the sense of sight is invariably conceptualised through tropes of detachment, distance and objectification. This familiar manoeuvre, that dichotomises the senses, is strikingly evident in the following passage from Walter J. Ong:

> Sight isolates, sound incorporates. Whereas sight situates the observer outside what he views, at a distance, sound pours into the hearer [...] I am at the center of my auditory world, which envelops me [...] You can immerse yourself in hearing, in sound. There is no way to immerse yourself similarly in sight. (1982: 72)

Here, vision is vilified as a distancing, objectifying sense whilst sound is valorised as having unique access to the interiority of being. Within Theatre Studies this classical notion of sonic experience is equally prevalent.[33] Earlier we saw how Ross Brown has sought to trouble the notion of theatrical spectatorship as 'silent' detachment from the 'scene' (see 2010a: 5). Yet, since his model of theatre's 'aural phenomenology' is hewn from a misguided conceptualisation of percipience, he nevertheless perpetuates 'the classical analogy of *theatrum mundi*' from which he strives to distance himself (see 2010a: 5). For Brown, the world of sight is characterised as a detached world-at-a-distance. In stark contrast, the phenomenon of sound, as conceived by Brown, 'is *in totum* an immersive environment' (2010a: 132). To drive such a strict segmentation between vision and audition, however, necessarily disavows a consideration of how listening and looking correspond with one another. More precisely, we should move towards a *stretching* model of theatrical reception that navigates the familiar binaries of sight versus sound, looking versus listening, and attention versus distraction.

Why does vision continue to be vilified, whilst sound has been afforded such ethical and ontological prominence? Why has vision been unanimously blamed for the perceived ills of modernity? Tim Ingold offers the following response:

> [T]he primacy of vision cannot be held to account for the objectification of the world. Rather the reverse; it is through its co-option in the service of a peculiarly modern project of objectification that vision has been reduced to a faculty of pure, disinterested reflection, whose role is merely to deliver up 'things' to a transcendent consciousness. (2000: 253)

The objectification of vision has a long history. Most notably, the visual sense, classically speaking, has been elided with the Euclidian concept of space, particularly the notion of 'perspective'. Euclid, a mathematician, held that geometric space consists of three dimensions all equally emanating from a fixed point in objective space.[34] Perspective is accordingly produced by looking out upon space from this fixed 'point of view'. In the case of vision, the viewer is, like the object being viewed, just another object in three-dimensional space. The viewer is spatially *at a distance* from the object and the object can only be perceived from a particular perspective. According to a Euclidian concept of perception, as Alva Noë has pointed out, 'we only see part of the object since the rest, its backside, is not available or present to us (2006: 411). Thus, whilst Euclid provides us with a very clear, systematic and practical means of modelling objective space, his schema proves both inadequate and inaccurate when it comes to accounting for the phenomenological particularities (and peculiarities) of what Merleau-Ponty has referred to as 'bodily space' (see 2002: 115 ff.).

In placing the body, bodily movement and embodied experience at the centre of percipience, Merleau-Ponty advocates a direct access model of perception that dismantles monomodal accounts of sensory perception. Correspondingly, and in demolishing the familiar binaries between sound and light, listening and looking, and destabilising established notions of percipience, self and world, Tim Ingold has proposed that 'perception is not an "inside-the-head" operation, performed upon the raw material of sensation, but takes place in circuits that cross-cut the boundaries between brain, body and world' (2000: 244). Indeed, for Ingold, the age-old binary between sound and light or hearing and sight is essentially unnecessary since the sensory modes of listening and looking are 'interchangeable' (see 2000: 276 ff.).[35] Ingold concludes

that 'the perceptual systems not only overlap in their functions, but are
subsumed under a total system of bodily orientation' (Ingold 2000: 261;
see also Gibson 1966: 4, 49–51). In demonstrating this point Ingold pro-
vides an example. Approaching a railway crossing whilst out walking,
Ingold makes the following observation:

> [T]he notice beside the railway tracks did not advise the pedestrian to
> 'stand, see and hear'. It advised him to 'stop, look and listen': that is,
> to interrupt one bodily activity, of walking, and to initiate another,
> of looking-and-listening [...] In what, then, does this activity con-
> sist? Not in opening the eyes, since these are open anyway; nor in
> opening the ears, since they cannot be closed save by stopping them
> with my fingers. It consists, rather, in a kind of scanning movement,
> accomplished by the whole body – albeit from a fixed location – and
> which both seeks out, and responds to, modulations or inflections in
> the environment to which it is attuned. (2000: 243–244)

When paying attention to the strange sound that I perceived during my
attendance of *The Cherry Orchard* I engaged in a dynamic act of listen-
ing and looking that manifestly involved movement. In sensing the
strangely equivocal sound of the mobile phone, and whilst sat, appar-
ently statically, in the stalls, I was motivated to 'scan' the environment
within which I had become 'attuned'.[36]

Listening-as-attention thus not only involves an embodied sense of
movement but operates by means of the continual adoption of par-
ticular modes of comportment and motility. This act of stretching (in)
sound, moreover, is radically at odds with the notion of sonic experience
as typically conceived, namely, that of being statically and amniotically
'immersed'. This is not, however, to say that we should dispose of the
notion of immersion altogether. Rather, we should challenge reductive
notions of immersion, and seek to find new ways of understanding this
familiar yet highly complex phenomenon. Given its complexity and
importance, I will attend to the concept and phenomenology of 'immer-
sion' in Chapter 4, and will postpone offering a critical review of the
term until then.

As my experience of attending *The Cherry Orchard* attests, our ability
to *sound out*, locate and identify sonic phenomena is phenomenally
affected by the act of looking. Vision is commonly conceived in terms
of an abstract, detached, objectifying 'gaze'. Similarly, within Theatre
and Performance Studies there is a tendency to default to a God's-eye
view of spectatorship.[37] Visual perception, however, is as dynamic and

as ambiguous as perception itself. Just as the phenomenon of sound has a tendency to momentarily evade the encrustations of classification, the phenomenon of light can also catch our attention in surprisingly playful ways: there is 'noise' not only in listening but in looking.

'When attention is shifted from the signifying body to the body as it is lived, the disembodied field of visibility reenters the dynamics of perception and habitation as these are engaged in the "seeing-place" of actual bodies, where even the eye is "living"' (Garner 1994: 45). A theory of theatrical attending must thus attend to the ambiguities of *visual*, as well as aural, perception.[38] As my encounter with the sound of the mobile phones elucidates, the phenomenal experience of attending theatre is a far cry from the strictly demarked, oppositional model of percipience that continues to be commonly endorsed and legitimated. Looking and listening constitute the same basic act, namely, '*dynamic embodied attending in the world*' (Arvidson 2006: 7).

'Philosophy, in the theater, must unfold itself, literally, as a *thinking of the body*' (States 1985: 133; emphasis added). Similarly, in order to understand, at least in experiential terms, what it means to *attend* theatre we must practise a phenomenology of theatrical attending. In foregrounding the importance of phenomenology as my working methodology, and as a prelude to Chapter 2, I shall end this chapter by saying a little more about what it means to pay *particular* attention to the phenomenon of sound, that is, to conduct a phenomenology of listening.

Paying (particular) attention to sound: phenomenology and listening

Phenomenology is now over a hundred years old and, despite various attempts on its life, has refused to die. Indeed, it would appear that phenomenology is alive and well. My intention here is not to provide an overview of phenomenology as a philosophical field of enquiry, but rather to shed light on the specific practice of listening '*phenomenologically*' (Ihde 2007: 49). Before attending to the specifics of phenomenological method, I will first briefly address some of the ways in which phenomenology has been subject to critique.

According to its founder, Edmund Husserl, phenomenology consists of 'a *purely descriptive* discipline, exploring the field of transcendentally pure consciousness by *pure intuition*' (1983: 136). Phenomenology, therefore, at least as conceived by Husserl, 'operates exclusively in acts of reflection' (1983: 174). Taking issue with this, Jacques Derrida asserts that 'transcendental consciousness is *nothing more and nothing other* than

the psychological consciousness' (1973: 13); in other words, that the 'transcendental ego' and the 'natural [or] human ego', contra Husserl, is 'distinguished by nothing' (see 1973: 11–12). Furthermore, Derrida maintains that Husserl's enterprise harbours a 'phonocentric' bias;[39] that it is founded on the a priori assumption that voice, or rather the inner voice of consciousness, allows us unmediated access to being.[40] Hence, for Derrida, since 'voice *is* consciousness' (1973: 80), and the voice is, by its nature, transcendent, the phenomenological reduction activated by the transcendental ego is *necessarily* absolute; consequently, and as David Allison explains, 'objects [are presented or brought-forth] to an immediate and self-present intuition' (see 1973: xxxiii). Thus, according to Derrida, phenomenology is not only guilty of phonocentrism but founded upon it: 'phenomenological critique is metaphysics itself' (1973: 5).

Where poststructuralist critique has tended to focus on Husserlian phenomenology, much of the criticism levelled at phenomenology by feminist critics has centred on the work of Merleau-Ponty, whose account of perception, embodiment and sexuality is said to harbour a masculinist bias.[41] Such scepticism is longstanding.[42] However, whilst feminist critics have sought to account for the particularity of female embodiment, motility and sexuality and thus to highlight some important lacunae in Merleau-Ponty's account of perception, the notion of a 'universal body' is in need of review. In particular, and building on the work of Silvia Stoller, I take issue with the tendency to equate Merleau-Ponty's concept of the 'anonymous body' with a neutral body and, thus, to conceptualise phenomenology itself as *'neutral thinking'* (Allen 1993: 245).[43]

In responding to the above criticisms, namely, that phenomenology is an introspectionist enterprise that harbours a phonocentric or masculinist bias, I invoke the following statement from Merleau-Ponty: 'The most important lesson which the reduction teaches us is the impossibility of a complete reduction' (2002: xv). Similarly, rather than adopting a *universalising* attitude to phenomenology where 'phenomenology' is tarred with the same brush, we should begin, instead, to think in terms of *phenomenologies*.

In alignment with an 'integrated' conception of phenomenology (see Noë 2007: 234 ff.), phenomenological reduction does not attempt to bracket the world altogether but instead brackets 'a *mundane* attitude toward the world' (Steinbock 2004b: 40). That is, it is the 'givenness' of perceptual experience as particularised through the specialised attentional act of phenomenological reduction that is the phenomenologist's

primary concern. Yet, what does the phenomenological reduction con-
sist of and what happens when we attempt to 'bracket' or pay particular
attention to the phenomenon of sound?

F. Joseph Smith has claimed that 'the heart of phenomenology is
sound and *listening*' (1979: 19). Such a pronouncement must, however,
be contested for two overriding reasons, each of equal importance.
First, to conceptualise the phenomenological attitude as being in align-
ment with a certain aural subjectivity is an act of sonocentrism that
reinstates a series of age-old beliefs, encapsulated by Jonathan Sterne's
'audiovisual litany' (2003: 15). Indeed, far from prioritising one sensory
register over and against another, as F. Joseph Smith suggests, phenom-
enology attempts to unravel and describe how the senses are *interwoven*.
Second, the phenomenological attitude is not 'one of *listening*', as Smith
maintains (1979: 17), but rather, and as Garner has proposed, consists
of 'a particularizing mode of attention' (1994: 5).

Phenomenology *attends* to the 'contents of consciousness', however
indeterminate; it attempts 'to seize the meaning of the world or of his-
tory as that meaning comes into being' (Merleau-Ponty 2002: xxiv).
There is, moreover, something particular about '*phenomenological* atten-
tion' (Garner 1994: 4; emphasis added), as the following statement from
Aron Gurwitsch clarifies:

> On account of the phenomenological reduction, the attention of the
> phenomenologist is no longer engrossed by things as real existents.
> He takes, conversely, a reflective turn upon the acts of perception
> and the manner of presentation in which the perceived appears
> through those acts [...] Thus objects as they really are must be taken
> for *objects presenting themselves and experienced* as '*objects as they really
> are.*' (1964: 182; *sic*)

In performing the phenomenological reduction we must attend not
only the phenomenon in question but to the *particular* manner in
which it becomes 'a phenomenon-for-me' (see Casey 2000: 23).[44]
Attention thus not only lies at the heart of phenomenology but is the
very means by which it operates.

Phenomenological reduction advances through two steps: first, one
'brackets'; then, one 'describes'. It is the former stage that I want to
focus on here. For Husserl, 'the entire world [...] must be assigned the
index of *dubitability*' (1999: 23). Moreover, since the world's existence
'remains undecided' (Husserl 1999: 23), we must perform an *epoché*.
The epoché consists of the act of suspending judgement or 'bracketing'

the natural attitude to the world. The 'natural attitude', as defined by Husserl, 'is not concerned with the critique of knowledge' (1999: 15) but unquestioningly assumes that knowledge of the world is possible. Phenomenology, conversely, 'brackets this assumption' (Howarth 1998: 343), that is, it puts 'the world between brackets' (Husserl 1929: 700).

The exercise of bracketing corresponds in many ways to that particular mode of attentiveness that Arvidson has referred to as 'singling out' (2006: 74 ff.). '[S]*ingling out* is when a constituent of a theme is attended to thematically, so that this constituent becomes the theme itself' (Arvidson 2006: 74). In other words, when 'singling out' a particular constituent of a theme a *new* theme emerges with an altered thematic context (see Arvidson 2006: 74). Attention, therefore, is transformative and the phenomenological reduction discloses the given-ness of phenomena when under phenomenological scrutiny. In light of this, what can now be said concerning the phenomenology of *aural* attention? The following example from Sebastian Watzl sheds light on this question:

> Suppose that you are listening to a jazz band. You will have a different kind of phenomenology when you focus your attention on the sound of the saxophone and a different phenomenology when you focus your attention on the sound of the piano. (2010: 38)

Here, Watzl illustrates how perceptual experience is affected by the enactments of attention: by 'singling out' different aspects of a given field of sound one can substantially alter the phenomenology of this sonic melange.[45] The nuances of listening as process, however, are more complex and varied than we generally assume. There is, especially, much to learn regarding the phenomenon of *theatrical* listening. Phenomenology, I suggest, provides an effective means of redressing this. Phenomenology not only helps to elucidate the nature of listening (as attention) but, in more general terms, allows us to explore the dynamics of embodied attending. Yet, what is it to *practise* a phenomenology of listening and what 'secret is at stake when one truly *listens*'? (Nancy 2007: 5).

Few scholars have done more to unearth the secrets of auditory experience than Don Ihde, whose book, *Listening and Voice* (2007), offers a systematic 'working manual' of how to *do* a phenomenology of listening. To listen '*phenomenologically*', as Ihde explains, 'is more than an intense and concentrated attention to sound and listening, it is also to be aware in the process of the pervasiveness of certain "beliefs" which intrude into [one's] attempt to listen "to the things in themselves"'

(2007: 49). These 'beliefs', or near-naturalised set of assumptions, regarding sonic experience are so widely sung and so unquestioningly assumed that Jonathan Sterne has aptly referred to them as the 'audio-visual litany', which is given (in full) below:

- hearing is spherical, vision is directional;
- hearing immerses its subject, vision offers a perspective;
- sound comes to us, but vision travels to its object;
- hearing tends towards subjectivity, vision tends towards objectivity;
- hearing is concerned with interiors, vision is concerned with surfaces;
- hearing involves physical contact with the outside world, vision requires distance from it;
- hearing places us inside an event, seeing gives us a perspective on the event;
- hearing is a primarily temporal sense, vision is a primarily spatial sense;
- hearing is a sense that immerses us in the world, vision is a sense that removes us from it. (2003: 15)

These are some of the unsound sonic assumptions that a phenomenology of listening seeks to subvert. My practice began with an initial investigation of listening to radio plays, a medium which would appear to provide the perfect context and conditions for conducting a '"reduction" *to* listening' (Ihde 2007: 42). To discover how differing modes of aural attention affect perceptual experience, I decided to 'single out' the specific ways in which the phenomenon of speech manifests as *sound*, details of which are explored in more in detail at the beginning of the next chapter. In investigating the particularities of 'singling out' as an attentional mode, Arvidson provides the following example:

Listening to a speech, one can single out the point of the speech or an accent or the nasal tonality. In each singling out the new theme establishes a new center of reference for a thematic context, the latter may be a continuation of the previous context or it could be new. (2006: 74–75)

Whilst the idea of bracketing speech-as-sound seems straightforward enough, the practice of bracketing this particular constituent of speech, as a discrete *theme*, is in fact exceptionally difficult.[46] We can listen to the soundedness of speech but do we ever stop trying to listen to the

content of the spoken word? Even when listening to a foreign language wholly alien from our own, and of which we have no understanding, we nevertheless automatically search for linguistic meaning by listening out for differences in intonation, tone and pitch: in short, and as Merleau-Ponty reminds us, '[t]he perceptual "something" is always in the middle of something else' (2002: 4). Such a realisation does not, however, give us cause to abandon phenomenology but is the messy and ambiguous world of perception that phenomenology strives to explore.

In paying particular attention to (theatre) noise, this chapter has begun to explore the dynamics of listening as process, thus laying the foundations for a theory of theatrical attending. Building on this groundwork, the remaining chapters of the book attend to the phenomenology of designed sound, silence, and immersion, respectively. Beginning with an examination of radio drama, Chapter 2 attends to the tension between the intentions of (sound) design and the actualities of (aural) perception.

2
Paying Attention to Designed Sound

'A *designed* auditory occurrence is always a different experience than is auditory experience in day to day life' (Bracewell 1993: 201). Yet, what precisely is designed sound and what is it to experience 'a *designed* auditory occurrence'?

The word 'design', both as a verb and as a noun, is not only inherently associated with intent, but with trickery, deception, and *manipulation*.[1] As well as referring to the act of handling or manhandling an object, thing, or person, to 'manipulate' is to ingeniously bring about a particular effect or action through the use of underhand persuasion or dextrous contrivance. Designed *sound* is thus not only sound that has been carefully crafted, but that is intended to shape or manipulate the experience of the percipient. My 'intention' here, however, is not to give an overview of designed sound at large, but rather to attend to the phenomenological specificities of sound designed for radio drama, and, subsequently, within the context of theatrical performance. We are therefore dealing with sound that has been designed to be perceived *aesthetically*, that is, with sound as an aesthetic object.

There would appear to be an inherent, and inherently dynamic, interconnection between aesthetic experience and the phenomenon of attention, as the philosopher Mikel Dufrenne makes clear below:

> In aesthetic experience the entire attention of the subject is oriented toward perception and the materiality of the object is destined to elicit their perception and to efface itself before the triumphant sensuous element. (1973: 215)

Attention and aesthetic experience are thus intimately interwoven. Indeed, what distinguishes the 'aesthetic object' from the 'ordinary

object' is precisely that it *'demands* attention' (Dufrenne 1973: 166; emphasis added). Moreover, and as Richard W. Lind makes clear, '[a] esthetic objects are not merely illuminated by attention; their very structure and texture are both *constituted* and *made intelligible* by discriminating attention' (1980: 131). 'Attention', in other words, 'does not merely illuminate the objects of experience but *creates* them by articulating indeterminate data into figures against a ground' (Lind 1980: 132). More especially, '[s]ince the process is in continual flux, attention might best be described as *the dynamics of phenomenal emergence*, i.e., the manner in which phenomena continuously appear and disappear with contrastive degrees of intensity, whether they be sensory or imaginary, concrete or abstract' (Lind 1980: 133). This inference has important implications for our understanding of the phenomenology of theatre sound design.

Theatre sound design not only 'demands' but manifestly manipulates our attention, and, in so doing, plays an important role in *shaping* theatrical experience. The verb 'to shape' comes from the Old English *scapan*, meaning 'to create, form, or destine'.[2] Theatre sound design is thus not only 'destined' to be perceived, but specifically *intends* to direct the attentional focus of the audience. Conversely, and as this chapter argues, the intended meaning of theatre sound as designed is invariably subverted by the creative articulations of theatrical sound as *attended*. '[A]ny *kind* of object may be aesthetic, though obviously not every *particular object* will be' (Lind 1980: 142). Likewise, and as we have already seen in Chapter 1, when attending a theatrical performance what we attend to aesthetically is not always that which is aesthetically or dramaturgically intended. Moreover, this slippage between intention and perceptual actuality is not limited to auditory perception. Indeed, not only does the act of looking play a vital role in the process of enacting perceptual content, but often moments of equivocality, ambiguity and manifest theatricality occur as a direct result of the displacing effects of *where* one is positioned in the theatre. Hence, whilst the sound designer man-handles sound in such a way that it manipulates and directs audience attention, correspondingly, the act of attending plays a key role in phenomenally (re)shaping the percipient's perception of designed sound.

As an effective means of initially investigating this phenomenal tension between designed sound and the 'dynamics of phenomenal emergence', I will begin with a phenomenological consideration of radio plays, the *sine qua non* of designed sound.

(Re)shaping the radiophonic soundscape: listening to radio plays

Nothing seems more apparent about the medium of radio than the fact that it comes to us solely as sound, consists primarily of the spoken word, and is broadcast, by means of a speaker or headset, within a given space. We might just as easily make the same assumptions about the phenomenology of radio *drama*. Consisting purely of sound and thus lacking a visual element, we might assume that radio plays are received through acts of listening *alone*, that vision has no role to play in radiophonic reception. We might further surmise that the radio listener's attentional journey and experience will be somewhat circumscribed or conveyed. Such assumptions are understandable: 'radio listening is such a mundane, effortless act that we have become oblivious to its complexities' (Douglas 2004: 26). Despite the recent interest in the study of radio and the important work already carried out in this field, a phenomenology of radio drama has yet to be written.[3]

As my phenomenological investigation of radio drama reveals, the listener, by paying attention, plays a vital role in the process of (re)shaping the radiophonic 'soundscape'.[4] Whilst radiophonic sound may well be meticulously designed, autonomous and objectively distinct, this pre-given structure is nevertheless subject to perceptual variation and phenomenal reshaping. What we perceive is phenomenally dependent on the particular mode of attention that we adopt, and radio drama is no exception to this: attention shapes aesthetic experience. Somewhat more surprisingly, my phenomenological enquiry into radio drama also suggests that the act of looking plays a vital role in this process of perceptual enactment.

'The goal of good audio design is to effectively engage the listener in active and attentive listening' (Ferrington 1993: see 'Summary', n.p.). Being ephemeral and thus more prone to perceptual ambiguity, radio drama must work hard to capture, direct and maintain the listener's attention. Every sound, noise, utterance, silence or pause must therefore be meticulously rendered in order to achieve a particular experience. Further still, radio plays must be designed to stand alone, without the aid of visual clues. In this respect, the radiophonic 'soundscape' might be said to be *autonomous*. When listening to a radio play we only know what is happening or what certain sound events mean as a result of the particular manner in which sound has been meticulously *designed*.

Radio drama, as the radio producer Donald McWhinnie explains, consists of three elements: namely, 'words', 'sound', and 'silence' (1959: 126).[5]

These elements are carefully woven together in order to create what Alan Beck has described as a 'fictional' soundscape (see 1997). In developing this idea, Beck draws from Gary Ferrington's description of 'real-life' soundscapes (see Ferrington 1994: under a section entitled 'The Soundscape', n.p.).[6] The notion of a 'soundscape', as I have already suggested, is somewhat problematic. However, for the sake of argument and in order to stick to task, I shall suspend my critique of the term until later on (see Chapter 4 for further details).

When experiencing 'real-life' soundscapes the 'sound figures can be natural in occurrence or selected by the will of the listener' (see Ferrington 1994: 'The Soundscape', n.p.). By contrast, when listening to a radio play 'the redundancy and noise we experience as hearers in real-life interaction are eliminated, sound is split from image, and fictional sound events are skilfully layered in a hierarchy where dialogue predominates' (Beck 1997: section 1.1). The soundscape of radio plays is thus not only fictional but 'ideal' (see Beck 1997: section 1.1). That is to say, the 'selection' of what is to be attended to at any given moment 'has already been made by the director and playwright' (Beck 1997: section 7.1). Thus conceived, the attentional journey of the listener would appear to be both conveyed and predetermined. Demonstrating his alignment with this idea, Erving Goffman makes the following statement:

> A basic feature of radio as the source of a strip of dramatic interaction is that transmitted sounds cannot be selectively disattended. For example, at a real cocktail party, an intimate conversation can be sustained completely surrounded by a babble of extraneous noise. A radio listener, however, cannot *carve out his own area of attention*. (1974: 145; emphasis added; *sic*)

To suggest, however, that the 'radio listener' is somehow coerced to listen to particular sounds within the dramatic structure, whilst straightforwardly *disattending* others, is to oversimplify the phenomenology of radiophonic reception. In particular, such an account overlooks the apparent disjuncture between the intentions of audio design and the actualities of auditory perception. As phenomenological investigation reveals, there is an inherent tension between directorial intent and the phenomenology of audience attention. The 'radio listener', in other words, *is* able to 'carve out [their] own area of attention'. To demonstrate this and to begin to explore '*the dynamics of phenomenal emergence*' (Lind 1980: 133), let us listen a little more closely to that most infamous of attention seekers – the phenomenon of radiophonic speech.

Speech: the centre of attention?

According to McWhinnie, speech (or rather the 'spoken word') lies at 'the heart of the radio experience' (1959: 44). There is, of course, much to support this idea. Radio plays are, for instance, specifically designed according to a 'strict hierarchy' where speech prevails.[7] This is achieved largely through the use of mixing and microphone placement. The phenomenon of voice in radio drama is thus exquisitely brought to our attention: being 'made up wholly and solely of sound', radio 'concentrates attention on language as a spoken medium in which the voice is an instrument in the creation of meaning' (see Frost 1987: 110). Thus, in radio drama, the phenomenon of speech would appear, in every sense, to take centre stage.

The spoken word, as Andrew Crisell reminds us, is not only radio drama's 'primary code', but its chief means of 'transcodification' (1994: 149). In radio, 'the object must be *heard* [...] But if this is impossible or unhelpful the object must be rendered by means of an "artificial" sign or signs – symbols called *words*, and this process is known as transcodification' (Crisell 1994: 149). Radiophonic speech thus not only brings us things but is a thing in itself: namely, a voice, a speaking-sounding being, a speech body. Indeed, it is precisely this sense of duality inherent in speech as a phenomenon of sound that complicates the idea of speech being at the centre of the listener's attention.

The attention-grabbing quality of the voice is primordially connected with its unique linguistic and sociological significance. Voices innately 'carry and demand attention' (Coyne and Parker 2009: 103). That said, the phenomenal voice both points to itself and to the linguistic meaning that it conveys. Hence, although 'it is the dialogue that absolutely dominates the sonic flow' of radio plays (Beck 1997: section 1.4), this does not therefore mean that speech is necessarily and unambiguously always at the centre of the listener's attention. Whilst radio plays use speech, sound, and silence to shape the listener's attention, the listener is nevertheless able to perceptually reshape that which is *intended*.

Radio plays, as Elissa Guralnick points out, 'are supposed to be [...] "finished" as plays never are on the stage' (1985: 92). We might thus assume that the listener's attention is directed by the manifold ways in which sound in radio plays is *shaped*. Alan Beck, for instance, holds that 'the director fills the role of ideal "ears," selecting, focusing and designing' whilst 'the audience actively play their part in the construction of the "second play" in their heads' (1997: section 1.2). Yet, are there really two plays going on concurrently, and what role does the listener play in the process of shaping radiophonic experience? How precisely

does speech (re)direct the attention of the listener, and to what extent is our perception of speech in radio plays shaped by the particular mode of attention we happen to adopt? In short: what does it mean, in phenomenological terms, to 'seize', 'use', and (re)'shape' the radiophonic 'soundscape'? (cf. Hughes 1934: 7). To shed some light on these questions, I now offer a phenomenological account of speech-as-sound in Beckett's *All That Fall*.

Singling out speech-as-sound in *All That Fall*

> In radio drama, even more forcibly than on the stage, the word is first revealed as sound, as expression, embedded in a world of expressive natural sounds which, so to speak, constitute the scenery. (Arnheim 1936: 27–28)

This observation, from art critic Rudolf Arnheim, would appear to be well founded. In radio drama the soundedness of speech is, in every sense, *amplified*. Yet, what is it to listen to the spoken word and what happens when we attempt to 'single out' or pay particular attention to the phenomenon of speech-as-sound in radio plays?

'Listening,' as McWhinnie points out, 'is a difficult business', and the 'spoken word', in particular, 'is hard to catch, it is gone as soon as it is formed' (1959: 21). The task of bracketing the spoken word in radio drama, however, presents a *particular* challenge in that speech is implicated in our perception of the sonic mise-en-scene as a result of the ways in which it indexes and semantically shapes the sounds within which it is enmeshed. Let me illustrate this with an example taken from Beckett's *All That Fall*.

Produced by Donald McWhinnie and with the role of Maddy Rooney being played by Mary O'Farrell, *All That Fall* was first broadcast on the BBC Third Programme on 13 January 1957. Set in the sleepy world of a semi-rural landscape, the play charts a day in the life of an old woman, Mrs Rooney, as she journeys back and forth from her house to a train station. The following excerpt is taken from the opening scene:

> *Rural sounds. Sheep, bird, cow, cock, severally, then together.*
> *Silence.*
> MRS ROONEY *advances along country road towards railway station. Sound of her dragging feet.*
> *Music faint from house by way. 'Death and the Maiden.'*
> *The steps slow down, stop.*

MRS ROONEY: Poor woman. All alone in that ruinous old house.
[*Music louder. Silence but for music playing.*
The steps resume. Music dies. MRS ROONEY *murmurs, melody.*
Her murmur dies.
Sound of approaching cartwheels. The cart stops.
The steps slow down, stop.]
Is that you, Christy?
CHRISTY: It is, Ma'am.
MRS ROONEY: I thought the hinny was familiar.
(Beckett 2006: 172)

On listening to the above excerpt for the first time I make no attempt to perform a phenomenological reduction of the experience, my attention being focused, as is naturally the case, on the narrative meaning inscribed in the sound(s) that I perceive. The action is apparently taking place in a rural environment, the hammy sounds of humanly impersonated animals being something of a giveaway. The words 'Poor woman, all alone in that ruinous old house' are heard first and foremost as information, despite the fact that Mrs Rooney's voice is the first voice to enter the sound picture. The arrival of Christy and his 'hinny' confirms that I am listening to a play set in a rural landscape. It is also evident that I am listening to these sound events from Mrs Rooney's perspective, her voice being louder and more close-up than Christy's.

In listening to the same extract again, however, and with the expressed aim of bracketing or 'singling out' speech-*as-sound*, my experience of the above fragment was not only radically different but phenomenally reshaped.

The first thing I notice is the sound of the farm animals. I pay less attention to their man-made origin and more to their rhythmical and percussive nature. After a short pause, I hear the sound of footsteps, accompanied by the groans of a woman. Then, in the background, I hear the faint sound of instrumental (string) music, which I later recognise as Schubert's *Death and the Maiden*. I initially perceive this sound to be merely incidental, providing the attentional and sonic context to the groans and shuffling noises. Indeed, even when the music is faded-in, the footsteps still remain thematic. In other words, I notice the music merely for its increase in volume rather than for its increased significance. It is only through the proceeding sentence, once sounded, that the music takes on an altogether different meaning, briefly becoming the new attentional theme. On hearing the words 'Poor woman' I experience an instant and dramatic tugging at my attentional coat-tails.

For a moment I experience speech purely as sound: the words 'Poor woman' sound in the air, seamlessly emerging from and beautifully according with the sounds of *Death and the Maiden*. Following the emergence of this sublime theme, and by the time I hear the words 'All alone', something uncanny occurs: it is clear that the music is spatially and ontologically distinct from the sounds of speech that I hear in the middle of my attentional field. Whilst the words 'All alone in that ruinous old house' are perceived as sounding very similar to the words 'Poor woman' they are given very much as a *voice*. Due to the perceived nearness of this voice, it is not only evident that another consciousness has entered the 'soundscape', but that the soundscape itself is mediated via this invasive presence.

Then, my attention is suddenly pulled in another direction, towards the music. At approximately the moment when the words 'All alone' are uttered, the volume of the music continues to increase, and, by the time the word 'house' has sounded, the music continues alone for a few seconds, becoming a sound-figure or character in its own right. Yet, as soon as it has taken on this thematic status the music transforms again, this time becoming the music that I perceive to emanate from a house by the road: the music has transformed into a constituent of a new theme, namely, woman-in-an-old-house. When the speech body of Mrs Rooney returns, my attention is still firmly fixed on the house, her sighs being perceived, for a moment, as mere 'background noise'. Speech not only transforms my perception of the thematic context, in this case the sound of Schubert's *Death and the Maiden*, but in doing so, relocates this newly significative sound to the centre of my attentional sphere, thus temporarily displacing its own thematic primacy.

The above experiential example is a classic case of 'how context shifts in attending' (see Arvidson 2006: 58). The entry of the words 'Poor woman' into the designed fictional 'soundscape' were given as a sonic incursion that nonetheless resided in accord with its context, the strains of Schubert. More especially, the emergence of this new theme was not instantaneous; there was a certain lull as my attention stretched to accommodate the ontological and attentional displacement brought on by this rupture of what had previously been thematic. Hence, although a sound event may be centre stage in material terms, it does not necessarily follow that this same sound event will be, at that precise moment, the focus of thematic attention. 'Amidst interruptions of thematic attention of the most abrupt kinds, there is still a continuity between the ongoing and the incoming with respect to the theme' (Arvidson 2006: 81). The succession of margin to theme,

in other words, is never entirely without tension; there is always a 'phenomenal resistance or inertia that must be overcome' (Arvidson 2006: 80). The example demonstrates that at the centre of the phenomenon of attention is a dynamic tension between theme and context or, in the case of attentional capture, 'between the marginalization of the present theme and the encroaching marginal gestalt' (Arvidson 2010: 114).

When listening to the above extract, the words of Mrs Rooney not only enlarged the context of the attentional theme within which they were given, namely the sound of Schubert's *Death and the Maiden*, but through a process of transcodification brought about its metamorphosis. This phenomenon can be explained by drawing from Arvidson's notion of contextual elucidation. 'Elucidation' entails a particular act of attending that leads to a 'clearing, to some extent, of an obscurity in the thematic context' (Arvidson 2006: 63). As opposed to contextual enlargement, which 'broadens the thematic context along the lines dictated by the theme-thematic context gestalt connection of relevance', elucidation 'clarifies what is already presented contextually' (see Arvidson 2006: 60, 63). What singles out the above example, however, is the fact that the process of contextual elucidation led to the transformation of the thematic context and the emergence of music as a new theme. By means of speech I was prompted to pay attention to the music differently and in such a way that elucidated its significance.

Thus although the spoken word in radio drama is designed to grab the listener's attention and is positioned, both sonically and attentionally, at the centre of the 'soundscape', speech contains within itself the potential for attentional flux, tension and playfulness.[8] In other words, although radio plays are designed to guide the listener's attention according to a strict schema, the act of listening always has the ability to subvert, manipulate and reshape the intended meaning and experience of sound as designed. That said, and as my next example demonstrates, without the co-option of looking, the dynamics of aural attention (or listening) are attenuated, as a result of a partial restriction in the body's ability to effectively engage with its environment.

Opening our eyes (to radio drama): playing with perspective in *All That Fall*

Of all the tools at her disposal, the microphone is one of the most important means by which the radio drama director is able to direct the listener's attention. On one level, the microphone operates as a

magnifier in the process of producing radio drama, zooming in on a particular voice or sound to provide a sort of 'close-up' for the listener.[9] In this respect, and as McWhinnie has suggested, the radiophonic microphone performs an equivalent role to that of the camera lens in television and film (see 1959: 34). Like the camera lens, the microphone magnifies the 'illusion' for the listener, 'not in physical size, but in subtlety and depth of focus, so that the writer can speak literally into the ear of his listener' (McWhinnie 1959: 34; *sic*). Yet, as well as magnifying the subtleties of language as sounded, the microphone also plays a crucial role in generating a sense of perspective.

In radio drama the 'spatial distance' of the actors/characters is not only designed but must be *heard*.[10] The closer the actor is to the microphone and the more the volume is increased, the greater sense the listener has of being close to the voice in question. Conversely, if the director wants to create a sense of perspective, she or he will often record the actor's voice at a distance from the microphone and perhaps lower the volume or change the acoustics of the sound with the intention of altering the way in which the listener perceives this speech body. The 'illusion of space' in radio plays is thus created through the use of 'selective focus', as Gary Ferrington explains below:

> An individual attending a typical office party, can easily isolate relevant conversations from the constant din of background noise. The creation of this same experience in an audio production is difficult and requires the director to *focus the listener's attention* [...] Selective focus begins with prioritizing the sounds to which a listener's attention must be given. (1993: 'The elements of audio design', n.p.; emphasis added)

Yet, just as the sound design of radio plays often attempts to play with our sense of perspective, as well as with our perception of space in general, it is equally the case that the act of listening itself allows for a degree of playfulness, particularly with respect to perspective-as-perceived. Moreover, and as my phenomenological investigations suggest, the listener's ability to manipulate their experience of designed spatial distance is only brought about by the co-option of the sense of vision. To demonstrate this, I now turn to another scene from *All That Fall*, which, by virtue of its inventive use of 'point of audition' sound, purposefully plays with the listener's sense of perspective and the relative spatial distance between two characters, Mrs Rooney and Mr Slocum, who, during the course of the scene, appear to 'swap places'.

[*Sound of car coming up behind her. It slows down and
draws up beside her, engine running. It is* MR SLOCUM,
the Clerk of the Racecourse.]
[...]
MR SLOCUM: May I offer you a lift Mrs Rooney? [...]
[...]
MRS ROONEY: [*With exaggerated enthusiasm.*] Oh that would
be heavenly, Mr Slocum, just simply heavenly. [...]
MR SLOCUM: [*Switching off engine.*] I'm coming, Mrs Rooney [...]
[...]
[*Sound of* MR SLOCUM *extracting himself from driver's seat.*]
[...]
[*In position behind her.*] Now, Mrs Rooney, how shall we do this?
MRS ROONEY: As if I were a bale, Mr Slocum, don't be afraid.
[*Pause. Sounds of effort.*] That's the way! [*Effort.*]
[...]
Oh! ... Lower! ... Don't be afraid ... We're
Past the age when ...There! ... Now! ... Get your
Shoulder under it ... Oh! ... [*Giggles.*] Oh glory! ... Up!
Up! ... Ah! ... I'm in! [*Panting of* MR SLOCUM.]
(Beckett 2006: 177–178)

I decide to listen to this fragment several times with my eyes closed and
again with my eyes open. On listening to this fragment with my eyes
closed, I am immediately struck by the way in which sound suddenly
enters my perceptual field. I hear the obviously recorded sound of an
old car, the volume of which noticeably increases over time. I try to
attend to the spatial dimensions and location of this sound object, but
my attention resists such a manoeuvre. Then, the sound of the car is
quickly replaced by a much more prominent phenomenon: speech (in
this case the voice of a grumpy, slightly sleazy old man). Not only am
I overwhelmingly conscious of the sheer materiality and physical pres-
ence of these vocalic phenomena, but I also find myself in a position
of passivity. In particular, I notice how this exogenous foregrounding
of speech-as-sound radically attenuates my imagination. Whilst I am
aware of the existence of imaginal content (for example, the two prin-
cipal sound figures, which seem to pop up in two-dimensional cartoon-
like form), these imaginings are attentionally displaced by the constant
presencing of the spoken word. Although I try to fix the voices to
imaginal bodies within an imagined scene, this process of simultaneous
attending proves almost impossible. Furthermore, and far from giving

me a sense of a change in perspective, the foregrounding of voice and its materiality makes me continually aware of the original means by which these voices are produced; namely, by actors, in a sound studio, using no more than a couple of microphones. This phenomenon most abruptly captures my attention at the moment when Mr Slocum (or rather Patrick Magee) physically switches places with Mrs Rooney (Mary O'Farrell). As opposed to having the sensation that Mr Slocum is now positioned behind Mrs Rooney (and that I am now listening to this scene through Slocum's ears), the reticence of my attention to disattend the phenomenon Patrick-Magee-swopping-places-with-Mary-O'Farrell-in-a-studio results in a rupture of my imagined perspective and, consequently, my experience of this moment of the scene.

In listening to *All That Fall* with my eyes closed, not only was my perception of space essentially two-dimensional and static but my ability to play with my perception of the relative spatial arrangement of these sound figures was drastically diminished. The soundedness of speech, moreover, was so overwhelming that it attentionally marginalised the imaginal content manifested by the speech body itself. When listening to the same excerpt with my eyes open, however, my experience of sound and its spatiality was altogether different.

In opening my eyes to listening I notice that, far from being separate entities, the voices of Mrs Rooney and Mr Slocum exist contingently within a sonic mise-en-scene that is partly made up of speech-as-sound. In deciding to pay particular attention to the spatiality of sound, I notice that Mrs Rooney and Mr Slocum are not only 'placed' within my attentional field but related *proxemically*: in moving towards these sound-characters, I can sense and distinguish their relative position in space. Moreover, I notice a certain movement in attending as I playfully alter my imagined point of audition. Indeed, even when Mr Slocum is very obviously sonically foregrounded (for instance, at the moment where he utters the words 'Now, how shall we do this Mrs Rooney?'), I nevertheless find that I am able to 'hear' this sound as if from Mrs Rooney's perspective.

Clas Zilliacus has maintained that 'it is characteristic of the radio medium that its means of expression are aural, temporal, nonspatial, and noncorporeal' (1976: 37). Yet, the above experiments suggest that sound, or rather speech-as-sound, can be experienced, even if unstably, as a thing existing in space. Those who assume that radio drama lacks a spatial dimension might suggest that the above scene from *All That Fall* creates an *illusion* of space through its use of varied volume levels and point of audition sound. However, when listening to the above extract,

I not only *experienced* sound to be spatial (if only contingently), but my experience of the spatiality of sound varied significantly depending on the mode of attention that I chose to adopt: listening with eyes open, literally, opens up a world.

Despite the apparent ways in which the act of looking is implicated in auditory perception, critical accounts of radiophonic reception have overwhelmingly tended to assume that radio is perceived by means of one sense alone, namely, that of audition.[11] Radio, correspondingly, is still generally referred to as the 'blind' medium.[12] William Stanton, for instance, has maintained that 'unlike the acts of reading or spectating, in radio drama there is no object for our gaze [...] we are not engaged in the specular but the oral and aural and we are required to use our imagination in a different way from any other kind of performance' (2004: 95). Yet, whilst the physical environment within which a particular radio play is received may well be unrelated to its content, it is erroneous to make the assumption that radiophonic reception does not entail an engagement with the 'specular'. Indeed, and as Tim Crook makes clear, not only is radio drama 'psychologically visual', but it is experienced by most people 'in *physical visual space* as well as acoustic space' (Crook 1999: 64; emphasis added). More especially, we should not lose sight of the bald fact that the vast majority of people who listen to radio drama listen to it with their eyes *open*.

If we assume that radio drama is received purely by what we hear and by what 'takes place' within our minds, then one might further assume that the experience of listening to a radio play would be *impaired* by listening to it with one's eyes open.[13] Yet, astonishingly, quite the reverse seems to be the case: when listening to *All That Fall* with my eyes open, not only was my aesthetic experience enriched, but I was able to perceptually reshape the radiophonic 'soundscape'.

In illustrating how hearing is activated by the act of looking, Tim Ingold draws from the reflections of composer Igor Stravinsky:

> I have always had a horror of listening to music with my eyes shut, with nothing for them to do. The sight of the gestures and movements of the various parts of the body producing the music is fundamentally necessary if it is to be grasped in all its fullness. (cited in Ingold 2000: 277)

As this anecdote suggests – and as Ingold proceeds to conclude – we hear less well with our eyes closed, since the act of watching 'gives shape and direction' to our experience of hearing (2000: 277). Without being

able to see the bodily movements that produce specific sounds 'musical sound appears abstract and incorporeal'; whereas 'once we open our eyes [...] we cease to be mere consumers of sound, and join silently in the process of its production' (Ingold 2000: 277).

In the case of radiophonic reception it is, of course, materially and temporally impossible for us to experience the *production* of sounds. Yet, and as my experience of attending the Slocum scene in *All That Fall* discloses, the question of whether the *original* source of the sound is visually present, at least in the case of radio drama, is something of a red herring. Passive hearing is transformed into active listening when vision, in itself, is incorporated into the process of auditory perception (see Ingold 2000: 277). Similarly, when listening to the Slocum scene with my eyes open I sensed that I was engaging with a 'world' situated neither in my mind, nor within physical space, but one where imaginings, thoughts, and speech bodies seemed to co-exist – a sort of sonic heterotopia. Moreover, by playfully manipulating the relative positions of Mr Slocum and Mrs Rooney within the sound picture I experienced an acute sense of movement.[14] In short: without the aid of vision, listening is left to fend for itself and, consequently, its theatricality is radically curtailed.

With these insights in mind, I now turn to the central focus of this chapter, namely, the phenomenology of designed sound in the *theatre*.

Paying attention to designed sound in the theatre

Sound in the theatre, in stark contrast to radio, is designed for and within a particular space, for a particular performance, and for a particular audience, who, by means of their attendance, contribute to the phenomenal nature of the sonic environment. The theatregoer, furthermore, is usually positioned at a fixed point in theatrical space. This, importantly, is strikingly different from the phenomenology of radio (drama), where the listener is not only free to roam within the confines of their own listening environment, but where the listener's 'perspective' (within the sound picture) is dynamic, and constantly subject to change. Yet, as demonstrated later in this section, not only is the theatregoer able to vary their sense of perspective in perceptual terms, but sometimes the particularities of where one is positioned in the theatre can phenomenally affect the intended significance of sound as designed. Whilst contemporary theatre sound design is becoming increasingly more sophisticated in its intent, theatrical sound can never be completely and autonomously *intended*. In the theatre, and unlike

in the case of radiophonic reception, there is always the inevitable possibility for sound to go astray.

Nevertheless, one thing is certain: not only has sound design come to replace the era of 'noises off' and 'sound effects', but our experience of sound in theatre is invariably one of *designed* sound.[15] Yet, what is theatre sound design, how do sound designers use sound to manipulate audience experience, and how has the reception of designed sound in theatre been conceptualised? As a means of beginning to unpack these questions, the following discussion draws from interviews held with three of the UK's leading sound designers: Paul Arditti, Gareth Fry and Dan Jones.[16]

Manipulating sound: theatre sound design and the manipulation of attention

Theatre critic Maxie Szalwinska has proclaimed that theatre is undergoing a 'revolution in sound design' (2008: n.p.). Such a pronouncement is indeed well founded. Technologically speaking, theatre is rapidly catching up with film: surround sound, Dolby and digital technology, and hi-fidelity playback sound are increasingly becoming standard features of contemporary purpose-built theatres.[17] The much mocked 'techie', or sound technician, has metamorphosed into a stylish, sophisticated designer of theatrical 'soundscapes'.[18] Theatre sound design, accordingly, is increasingly created from a process of collaboration. This *devised* approach to sound design reflects the current trend for devised theatre and performance, as exemplified by Complicite.[19] The concept of 'theatre sound' is, indeed, very much in process.

The seeds of theatrical sound design were first sown in the late 1950s, by American composer Harold Burris-Meyer, theatre's first official sound designer. Burris-Meyer recognised the importance of sound's musicality in the production of meaning and affect: sound effects, he writes, 'create, reinforce, or counterpoint the atmosphere or mood; reveal character; or contribute to the advancement of the plot' (1959: 20). In the early 1970s, John Bracewell, a student of Burris-Meyer, started to move away from the notion of 'sound effects', defining 'design' as 'the attempt to arrange patterns of sensory events in ways that will create an emotional response and, subsequently, the development of aesthetic meaning' (1993: 200). Bracewell identifies three elements of contemporary theatre sound design: 'environmental ambience, music and electroacoustic reinforcement' (1993: 207). Bracewell's notion of 'environmental ambience' (1993: 207) not only invokes a sense of sound in the environment, but a sense of sound *as* an environment.

The age of theatre sound design is thus mutually an era of the theatre 'soundscape'. Theatrical sound is no longer thought to be merely 'incidental' to the action, but has come to take on a significance of its own. Lending support to this idea, the theatre director Peter Sellars makes the following declaration:

> Very late in our day, the technology has become available to allow sound to begin to occupy the place in theatre arts that it occupies in our lives [...] We are in a position to completely reorient the relationship between performer and audience, to transform a theatrical space, to create distance or sudden proximity, to create a densely populated zone or an endless arid expanse [...] Sound is no longer an effect, an extra, a *garni*, supplied from time to time to mask a scene change or ease a transition [...] but part of a total program of sound that speaks to theatre as ontology. (2013: viii–ix)

Sellars's schema of theatre sound makes a number of assumptions. First, that contemporary sound design enables theatre to authentically replicate the aural experience of being-in-the-world. Second, that our day-to-day experience of sound is one of total immersion. And lastly, that sound somehow provides unique access to (and is intimately associated with) the nature of being. These criticisms aside, twenty-first-century theatre sound design undeniably has the capacity to 'manipulate' the perception of the audience in unprecedented ways.[20] Mark Lamos has even gone so far as to suggest that theatre sound design is changing the way we listen:

> We hear differently now [...] We need to focus the ears of the watchers just as acutely as the lighting design focuses their eyes [...] Sound design can build suspense, can focus a spoken moment, and can direct the ear to listen with more care. (2013: xvii–xviii)

Correspondingly, Dan Jones uses sound as a 'canvas'[21] to still the audience, and to cleanse the theatre of aural distractions, thus creating 'a space in which the audience are more likely to listen' (2009: n.p.). Operating within a logic of realism, where the spoken word, the text and the actor take centre stage, Jones uses sound to create 'a horizon within which the spoken voice is absolutely crystalline' (2009: n.p.). Yet, how does sound design direct attention and how accurate is it to conceptualise theatre sound design in terms of distraction?

In his essay 'Sound Design: The Scenography of Engagement and Distraction' (2010b), Ross Brown proposes that 'to notice the sound

design *is* to be distracted, but at this cultural moment, perhaps, it is appropriate to subject audiences to distracting circumstances' (2010b: 341). Brown suggests that '[t]he auditory experience of theatre can be influenced by design in two ways':

> The first is the aural attention focused on *the organisation of noises within the mise-en-scene according to the dramaturgy*. This organisation might be made in a semiologically functional way (the doorbell or the birdsong that denotes 'outside in the country') or [...] sound (maybe music) that underscores or offers ironic counterpoint to the emotional vectors of the performance. The second is the organisation of the audience's hearing: the subtle modification of the auditorium acoustic or ambient presence using artificial reverberation, the subliminal use of ambient effects or subtle electroacoustic reinforcements of certain elements of the performance, all of which subtly changes the audience's psychoacoustic disposition towards the mise-en-scene. (2010b: 342)

In this more nuanced version of his earlier work (cf. Brown 2005), Brown moves away from the idea of a 'simple binary attentiveness to a programmatic figure set against a ground of background noise or circumstance of assumed *insignificance*' (2010b: 342). Nevertheless, he continues to equate attentiveness with the objectifying, abstracting acts of looking and listening, whilst conversely figuring hearing as 'the sense of distraction' (2010b: 341). Instead of conceptualising theatre sound design as a 'matrix of distraction' (Brown 2010b: 342), where attentiveness (listening/looking/being removed) is set in dialectical relation with distractedness (hearing/being immersed), we should begin to investigate how designed sound in theatre both manipulates and is manipulated by the dynamics of theatrical attending.

Sonic stealth: false sound beds and 'theatrically organised hearing'

Sound has a unique ability to put perception in play as a result of its propensity to go unnoticed. Operating undercover, or 'by stealth', sound creeps in through the back door of perception, stealing our experience from under our ears. To 'steal' means both to take without permission and to move without making a sound. The notion of stealth, as exemplified by the iconic Stealth Bomber of the Cold War era, engages in the latter to achieve the former. Contemporary theatre sound design, so it would seem, is moving in a similar direction. Paul Arditti, for instance, remarks that the sound designer 'can sneak things

up on audiences under cover of what [they] are seeing' (2009: n.p.). One of the most popular and sophisticated means by which designed sound in theatre is used to shape the audience's auditory experience is through the use of 'false sound beds'. Gareth Fry explains:

> I often use playback air-con to create a false sound bed. We're sub-consciously aware it's there but we don't notice it, it's only when there's a change in background sound that our attention is drawn to it [...] So, I'll scratch out these air-conditioning sounds at a significant moment in the plot; for instance, when a gun goes off. Because the gun shot is dramatically significant, it draws our attention away from the fact that this sound that we have been actively filtering out has dropped away [...] the audience suddenly becomes aware that there's been some big shift in the world [...] You can't put your finger on it because you weren't consciously attentive to either its presence or the moment it disappeared. (2011: n.p.)

Whilst the audience notices that something has changed after the gun 'goes off', the cause and nature of this ontological and phenomenal shift remains indeterminate. Fry's example not only provides a useful means of demonstrating the interplay between 'dramaturgically organised noise' (the sound of the gunshot) and 'theatrically organised hearing' (the use of a false sound bed), but also problematises a straightforward distinction between attentiveness and distraction. (For further details of Brown's interrelated concept of 'dramaturgically organised noise' vis-à-vis 'theatrically organised hearing', which I refer to and develop herein, see 2010b [esp. 342].) In Fry's example, it is the sound of the gunshot that draws attention away from the act of scratching out the false sound bed, designed foreground and background sound thus working *together* to manifest a particular register of experience and to bring about a particular mode of attentiveness.

Attention would thus seem to play a central role in the efficacy of sonic stealth. False sound beds are created by playing back a recording of the ambient sounds of environmental space that we tend, ordinarily, not to notice. Since background noise is, by its nature, usually on the fringes of our attentional radar, we tend to forget that it exists altogether. Hence, when this manufactured or *false* ambient sound is suddenly 'switched off', a range of intriguing, and highly dramatic, registers of experience are brought into being. The reason for this, I suggest, is connected to the relationship between thematic attention and its wider attentional context. Our experience of sound as an aesthetic object is always dependent upon the phenomenal and attentional context in which it is given to reside. As my experience of attending Sound & Fury's *Kursk* illustrates,

not only does theatre sound design 'direct the ear to listen with more care', as Lamos asserts (2013: xvii), but can play with the very workings of attention and, as a consequence, manifest a sense of dys-ease, unfamiliarity and tension.

Confusing sounds: (un)intended aural ambiguity in Kursk

Staged from the perspective of a British submarine stationed in the Arctic Circle, *Kursk* centres on one mission: to monitor the operations of Oscar II Class nuclear submarine 'Kursk' – 'the submarine for the 21st Century'.[22] Whilst the quality of the script, the accuracy and detail of the technical jargon, and the quality of the acting did much to situate the piece, it was the design that did most to get the audience affectively and attentively 'on board'.[23] Through the surreptitious use of designed sound and by situating the audience within the disciplined listening environment of a sonically represented submarine, 'the most advanced listening machine in the world' (Hemming 2009: n.p.), *Kursk* prompted both crew/cast and audience alike to carry out acts of sonic surveillance. Yet, despite the intentions of design, such acts of stealthy listening inevitably lead to sonic coincidence and confusion.

During *Kursk* there are three occasions, each increasingly tense, where a strange, unidentified rhythmical clicking sound is brought to our attention. Eventually, it comes to light that this spatially indeterminate, indefinite noise is actually the sound of the Navigator knocking his wristwatch against the wall of the lavatory cubicle whilst masturbating. More especially, and as revealed below, the sense of aural ambiguity that this sound sets in motion is embodied in the act of listening.

Standing to the left of a shower unit placed in front of a row of bunk beds that lie against the wall behind me, I suddenly find myself at the centre of spectatorial attention: shower time.[24] Being at the near-deafening epicentre of Coldplay's 'Yellow', to which the sailors sing along in unison, I am suddenly jostled out of the way by Donnie Mac, the radio operator (played by Gareth Farr) and by planesman NewDadMike (played by Tom Espiner), who barge pass me and jump into the shower.[25] After a moment of banter, I notice a strange clicking sound, teetering on the boarder of thematic attention. At first, there is a sense in which the sound of the sailors singing, the familiar strains of Coldplay, the sound of the shower, together with this new arrival (the strange clicking sound), form a sonic ensemble. Finding myself attending to nothing in particular, I am momentarily caught up in the general euphoria: I am, so to speak, 'one of the boys'. Then, glancing to my right, I notice the submarine's commanding officer, otherwise known as 'The Boss' (played by Lawrence Mitchell), trying to tell us something.

I stumble upon the words 'clicking sound ... stop the singing'. As commanded, I begin to pay closer attention to this seemingly banal sonic percept. All of a sudden, it seems as if every perceptible sound has been 'switched off', except one – that regular metallic clicking sound. This sound seems to engulf the whole space, and the more I listen, the more monstrous it becomes. At this moment, I notice that my thematic attention is occupied by the co-existence of *both* the clicking sound and the source-of-the-clicking-sound, which is ambiguously present as absent. For a second, I experience a kind of attentional dyspraxia; it feels as if my body, not unlike the clicking sound, is everywhere and nowhere at the same time.

This example demonstrates the ways in which theatre sound design can manifest theatrically effective experiences, such as a sudden feeling of uncertainty and equivocation. It is important, however, to recognise the specificity of sonic effects. In this case, the strange clicking sound was not only ubiquitous, but momentarily produced an experience of ubiquity. As Augoyard and Torgue have elucidated, whilst all sounds that seem 'to come from everywhere and nowhere at the same time' can be described as ubiquitous, they do not necessarily create a 'ubiquity effect' (2006: 131).[26] Throughout *Kursk*, for instance, there was a constant background drone of the submarine underway. I experienced this sound to be ubiquitous since I knew that there was no localisable source. Moreover, since I had no reason to question the location of its source, this sound did not produce a ubiquity effect *as such*. The ubiquity effect, in other words, 'is based on the paradoxical perception of a sound that we cannot locate, but which we know is actually localized' (Augoyard and Torgue 2006: 131). Furthermore, '[t]he uncertainty produced by a sound about its origin establishes a power relationship between an invisible emitter and the worried receptor' (Augoyard and Torgue 2006: 131). Correspondingly, it is my suggestion that the clicking sound only became a truly *strange* sound as a result of the ways in which my attention was phenomenally manipulated at this moment by the specific use of designed sound.

Background sounds can momentarily become experientially ubiquitous where 'there is an erasure of other sounds', such as, for example, 'the reappearance of the drone at night when neighbouring sounds fade' (Augoyard and Torgue 2006: 131). Consequently, 'a background sound will only produce a ubiquity effect at the moment of its emergence' (Augoyard and Torgue 2006: 131). Similarly, the clicking sound in the above scene was only given to 'sound strange' as a result of the sudden and *intentional* changes to the sonic environment within which

it co-existed. More precisely, the clicking sound only produced a 'ubiquity effect' as a result of the ways in which it caught my attention at the moment of its emergence, that is, at the moment when the prevailing sound field (consisting of the sound of the shower, singing, talking, and so on) was instantaneously, and stealthily, 'faded out'. Thus, above all, the example demonstrates how thematic content (in this case, my perception of the strange clicking sound) is phenomenally shaped by a wider attentional and material context (in this case, the background sounds of the sub underway). In short: the incursive emergence of the strange clicking sound not only piqued but put a spanner in the workings of attention.

In striking contrast to the uncanny sounds of the first mobile phone that went off during my attendance of *The Cherry Orchard*, the strange, indeterminate sound that was heard during this moment of *Kursk* was, unambiguously, an intended sonic component of the designed theatrical environment. More specifically, from the moment of its emergence, and assisted by the performed reactions of the cast/crew, it was clear that the clicking sound was *designed* to be ambiguous, and, as such, its ambiguity was experienced intra-diegetically. However, by exploiting the spatial and ontological ambiguities of aural perception and by training us to listen more attentively to the sounds that we hear, contemporary theatre sound design actually *increases* the chances of rendering unintended 'noise' as meaningful.

For instance, at several moments during the performance, including the period of time when the captain and crew were listening out for the strange unidentified clicking noise, the sound of various creaks and groans could be heard, emanating indeterminately from various parts of the vessel. 'When an audience cannot be entirely certain whether a siren, or a drip, or an appliance hum or noise, or even an echo, is a "real" part of the auditorium environment, it enjoys the performance in a heightened, bristling state of aural attentiveness to its surroundings' (Brown 2010a: 137). Similarly, being genuinely confused as to whether these metallic creaking sounds were part of the sound design, I scanned the environment for clues. Upon discovering that these sounds were, in fact, the sounds of the gantry, straining under the weight of the audience, I was nevertheless able to accommodate them within my attentional sphere. By sheer coincidence, these unintended creaks made a significant, though serendipitous, contribution to the meaning of this moment.

Theatre sound design promotes the rhetorical belief that the sound designer 'is responsible for everything the audience hears'.[27] Such a

position is, however, unsustainable, since aural ambiguity and attentional playfulness are present from the moment of sound's conception and perception. Indeed, it is precisely this equivocality between sound as *intended* and sound as *attended* that makes theatre sound theatrical. Whilst a sound designer might attempt to purge the performance space of such irrelevant, unwanted noises, it is these ambiguous, confusing sounds that often serve to heighten theatrical experience.

In alignment with this noisier approach to theatrical sound, the composer Scott Gibbons not only uses sound to prompt the theatregoer to listen more attentively, but often makes a conscious effort to draw attention to the *phoniness* of theatrical sound. Gibbons's sound design, which intentionally foregrounds the conceit of this taken-for-granted element of theatrical '*techne*',[28] motivates the theatregoer to attend to the processes by which we attend to things, or, more precisely, to listen to ourselves listening. This phenomenon was especially evident in his work on Romeo Castellucci's *Purgatorio*.

Playing with the phoney: experiencing 'dramaturgically organised noise' in Purgatorio

With *Purgatorio*, Romeo Castellucci opts, somewhat uncharacteristically, for a hyper-realistic style. Set upon a vast stage, with no expense spared, and with everything immaculately laid out to give the impression of the exact replica of a kitchen, living room or bedroom, in *Purgatorio*, as Alan Read remarks, 'we are decidedly at "home"' (2010: 255). Yet, this picture of normality, this facade of happy families, is quickly revealed to be a conceit. As my encounter with the piece attests, there was something inherently false or sinister that seemed to lurk behind this mask of realism. Through its inventive and sophisticated use of playback sound, and by amplifying the 'reality' of what was available to hear, *Purgatorio* paradoxically presenced a sense of the *phoney*.

It seems likely that the notion of 'phoniness' arose at around the same time as the invention of the telephone and phonograph, and thus perhaps stems from a more pervasive and general suspicion of the voice, especially the voice-as-mediated.[29] Masquerading as the voice of an absent (speaking) body, the mediated voice fools us into believing that it is the actual voice, the very being of the person from whom it has been stolen. Quite literally 'voiced from afar' (tele-phoned), the mediated voice succeeds in suspending our disbelief. In Purgatory, however, such beliefs and long-harboured falsities are painfully and slowly dismantled, forcing us to attend to the conditions and means by which we perceive the material world. Correspondingly, *Purgatorio* created an attentional

environment that invited the audience to pay *particular* attention to the processes of perception itself. This state of perceptual limbo, moreover, was perhaps most effectively and acutely materialised through the use of carefully designed sound.

The sound design for *Purgatorio*, devised by Scott Gibbons, was manifestly musical: there was a distinct sense of tempo, disharmony and orchestration to the sounds heard. More especially, through the use of a high-tech sound system, and by employing myriad imperceptibly placed microphones to detect and amplify the slightest sound made on stage, *Purgatorio* performatively drew attention to the seemingly banal and undefined 'noise' of everyday existence.[30] The noise of the scene changes, for example, was not only heard but manifestly *staged*. Through the use of reverb and pick-up microphones, the familiar thumps, rustles, creaks, and sense of movement engendered by the act of changing scenes were purposefully played back through a series of speakers for the audience's attention. Hence, far from being moments of mere transition, the scene changes in *Purgatorio* were experienced *sonically*. Furthermore, the heightened amplification (especially of the hydraulic sounds of the stage being elevated) made the scene changes especially noisy, and this noise was used to create a particular register of experience. Created in real time, these knocks and echoes were given as a kind of sonic slough, unintentionally cast off by the actions of the set-shifters. In blurring the distinction between sound as a designed aesthetic object and sound as noise, the scene changes manifested an acute sense of uncertainty, which was *embodied* in the act of attending itself. Scene 1 provides another example of this phenomenon.

Scene 1 is set within a vast kitchen. The mother, played by Irena Radmanovic, is seen preparing supper for her son, played by Pier Paolo Zimmerman. Neither character utters a word. Acting as a counterpoint to this, and punctuating the silence that ensues, the audience is left with little else but the sound(s) of vegetables being cut and dishes being washed, all of which are acutely amplified for our exquisite (if unsolicited) attention.

In attending this moment, I notice how these trivial and nondescript noises catch my interest precisely *on account of* their everydayness. I am especially struck, moreover, by how my perception of these sounds is phenomenally shaped by the wider sono-attentional context in which they are given to reside. In particular, I note how the relative silence, or absence of speech, somehow intensifies and accentuates the materiality of these mundane sounds that I find myself forced to attend.

'[T]he absence of speech,' as Ross Brown observes, 'seems to focus attention on material circumstances' (2010a: 78). Similarly, when

attending Scene 1 of *Purgatorio*, within which not a single word was uttered, the absence of dialogue motivated me to pay particular attention to the already sonically foregrounded sounds of domestic life. Moreover, in inviting me to search for significance amidst these seemingly insignificant sounds of the everyday, I found myself listening out for things that might not be there: in paying attention to the mundane sounds of vegetables being cut, or to the extraordinary sound of scenes being changed, a sense of doubt and indeterminacy slipped in. Importantly, and unlike the example of attending the strange clicking sound in *Kursk*, in *Purgatorio* this sense of 'doubt' was trans-diegetic.[31] Where *Kursk* plays with the ambiguities of intra-diegetic sound, *Purgatorio* takes the idea of entertaining noise one stage further by using sound to make one question the processes of one's own perception. Through its use of hyper-realistic (yet obviously *designed*) 'dramaturgically organised noise', and in heightening the (otherwise marginal) sounds of the everyday, *Purgatorio* motivated the audience to sound themselves out in an atmosphere of purgative and embodied purification.[32]

Theatre, as Cormac Power has suggested, is a place where 'presence is subjected to playful manipulation', and where 'objects of attention' are rendered in complex and ambiguous ways (see Power 2008: 198, 188). Yet, whilst the theatrical medium manipulates presence, and consequently stretches the attentional workings of the theatregoer, this process of 'manipulation' is far from one way.

'[S]ome things, by virtue of their nature, have an unusual degree of self-givenness on a stage' (States 1985: 30). In the case of 'running water', for example, 'something indisputably real leaks out of the illusion': running water 'retains a certain primal strangeness: its aesthetic function does not exhaust its *interest*' (States 1985: 31; emphasis added). 'Interest', however, and as Richard W. Lind has suggested, 'is a function of attention; *how* attention behaves is the form of interest we take' (1980: 131). If, for instance, we pay particular attention or 'interest' to the phenomenon of running water, different facets of the phenomenon 'running water' will necessarily be elucidated. Thus, not only is theatre unable to completely control and constrain the production of significative meaning, but this phenomenal leakage between intended and unintended meaning is motivated, at least in part, by what we *do*.

Whilst it is undoubtedly true that contemporary theatre sound design increasingly strives to manipulate the audience's aural attention, correspondingly, the percipient is able to manipulate and play with the affordances of this aural environment by engaging in dynamic acts

of attention. Moreover, we should recognise that sound in the theatre 'is not isolated or capable of being taken in isolation' (Pavis 2011: xi). Unlike in the case of radio drama, where sound *is* the radio play, in the theatre sound is (nothing more and nothing less than) a *component* of the overall experience. In the theatre, sound and scenography are phenomenally enmeshed, and what we *see* plays a vital role in shaping our perception of what we hear.

As a means of exploring the role of vision in our perception of theatrical sound, and in continuing to explore the disconnect between directorial intent and the perceptual actualities of theatregoing, I will now consider some of the ways in which the use of playback sound, the particularities of audience perspective, and the intersensorial act of theatrical attending can affect our perception of the dramaturgical voice.

Manipulating the voice: playback sound and the perception of voice in theatre

The voice of the actor has always taken centre stage in the theatre. 'Listening', correspondingly, 'is not simply auditory; it is a framing of speech' (Rayner 1993: 20). Take, for example, the phrase 'lend thine ear', which we often hear in the plays of William Shakespeare. This expression is not only directed towards the character *within* the diegesis, but is also aimed at the audience, who are beckoned to listen-in on the secrets of intimate, close-hand utterance. Theatrical listening is thus inherently tied up with the act of theatrical speech. Theatre, traditionally conceived, is established by the ability of an actor, principally through acts of speech, to convey and signify a particular melange of linguistic, poetic and embodied meaning to a group of listeners, namely, an audience. The actor's voice is thus noticeably and necessarily trained. Before the days of 'natural reinforcement' theatres had to rely on sounding boards, acoustics, and the actor's ability to project their voice to the furthest reaches of the auditorium. In a sense, this practice of projecting the voice, brought about by the expert training of breath, bodily resonance and diaphragmatic control, represents a kind of sound design in itself.

Theatre has always taken care to draw attention to voice as a phenomenon of sound, as well as its function as a vehicle for linguistic meaning and communication. The theatre architects of the ancient world, as the Roman architect Marcus Vitruvius Pollio (c. 75–25 BCE) notes, 'endeavoured to make every voice uttered on the stage come with greater clearness and sweetness to the ears of the audience' (1914: 139). Moreover, and as Vitruvius's account suggests, the theatres of ancient

Greece were often equipped with bronze vases, known as *echeai*, which were designed not only to improve audibility and intelligibility, but to 'give pleasure to the audience' (1914: 145):

> The voice, uttered from the stage as from a centre, and spreading and striking against the cavities of the different vessels, as it comes in contact with them, will be increased in clearness of sound, and will make a harmonious note in unison with itself. (1914: 143)

Greek theatres were thus designed not only to make the voice intelligible, but to draw attention to its existence as a phenomenon of sound.[33] Similarly, the 'Wooden O' theatres of early modern England were built primarily as 'instruments of the production and reception of sound' (Smith 1999: 207). Being cylindrical in shape, consisting entirely of wood, and being more intimate than the theatres of ancient Greece, Elizabethan theatres were not only theatres in the round but, quintessentially, theatres of sound.

As these historical precedents make clear, theatre has always been a place where sound, and especially voice-as-sound, has been subject to material and perceptual manipulation. Whilst the voice of the actor conveys linguistic meaning, it equally draws the listener's attention to its existence as *sound*: 'the dramaturgical voice,' as Don Ihde remarks, 'amplifies the musical "effect" of speech' and 'fills the stage with amplified sounded signification' (2006: 170, 173). Yet, the contemporary use of playback sound, combined with the displacing effects of where one is positioned in the auditorium, not only troubles the notion of 'projection', but also our understanding of how the dramaturgical voice is perceived. Not only can playback sound phenomenally manipulate the listener-spectator's perception of the dramaturgical voice, but the act of listening as attention can manipulate the theatregoer's perception of designed sound. It is, indeed, this slippage between directorial intention and audience attention that, to some extent, constitutes theatricality itself: theatre, in short, is a phenomenon characterised by moments of 'extreme equivocation' (Ridout 2007: 211).

P(l)aying attention to voice-as-sound in Lepage's *Lipsynch*

In theatrical performance the sonorous dimension of voice is manifestly brought to our attention not only as a result of actorly technique, but also as a consequence of the specialised listening environment that theatre uniquely affords. 'Theatre,' as Liz Mills has declared, 'offers an invitation to hearing the voice as distinct in itself or to "reading" the

text that is the sound of sound' (2009: 400). It is, therefore, perhaps unsurprising that a growing number of theatre practitioners have consciously sought to explore the phenomenon of voice-as-sound,[34] an emblematic example being Robert Lepage's *Lipsynch*.

Lipsynch, as Lepage explains, 'is a voice show' and one that 'is given more a sound expression, rather than a visual one'.[35] Thus, with *Lipsynch*, Lepage would appear to depart from his usual modus operandi, being better known for his breathtaking *visual* theatrical prestidigitations.[36] This is not the first time, however, that Robert Lepage has experimented with the sonorous dimensions of vocalic and linguistic phenomena.[37] Lepage's interest in the sounding of language, or, more specifically, how voice and language function as music, is, for example, clearly evident in *Tectonic Plates* (1990), a performance that experimented with many different languages and where sound took precedence over linguistic content. *Lipsynch* might therefore be seen as a harmonic continuation, or rather as a subsequent development, of these earlier explorations with sound and aurality.

Whilst interspersed with fairly regular intervals, *Lipsynch* required the listener-spectator to sit through a nine-act epic lasting nine hours. In many respects, therefore, and as James Reynolds has suggested, the task of attending *Lipsynch* was tantamount to 'torture' (2008: 132).[38] *Lipsynch* was indeed 'hard work' (Reynolds 2008). Yet, the arduousness of this performance lay not only in its marathonic duration, and the consequent struggle to piece it together to form a coherent narrative (see Reynolds 2008: 132),[39] but was also felt at an *attentional* level: *Lipsynch* not only demanded, but *stretched* our attention. More precisely, by intentionally inviting the audience to pay attention to the sonic nuances of the vocalic, *Lipsynch* motivated the listener-spectator to *p(l)ay* attention to the voice.[40]

Liz Mills has maintained that 'the embodied sounding voice is heard, first and foremost, as a signal of the phenomenological presence of the actor as person as well as an acoustic image of the subjectivity of the person who chooses to act or perform' (2009: 398). However, due to the technological machinations of theatre sound design, the phenomenal voice can be cut loose from its corporeal and subjective origins to such an extent that it is given not only as sound but, more specifically, as the sound of music.[41] At the beginning of Act 5, subtitled 'Marie',[42] and through the use of playback sound, microphones, projection and voice recording, a sequence of 'dramaturgically organised noise' was produced that not only transformed the vocalic utterance of the performer into a kind of musical 'score', but also motivated varying acts of aural juggling.

Marie is seen sitting at a table, centre stage, and looking at a laptop. Having recently received brain surgery, her doctor informs us that she is left with aphasia and, hence, unable to speak. Behind her, a voice-graph is projected from her laptop onto a huge projection screen. In the sequence that follows, the audience experiences the creation of a curious composition composed in real time. Marie begins to make a series of vocalic ejaculations, resembling something between singing and speaking. These sounds, which are recorded and passed through her laptop, are not only heard but *seen* in their visual/scientific (re) incarnation as frequencies on the voice-graph. With this initial 'base-line' laid, Marie stops recording and starts again, using this sonic back-drop, or *cantus firmus*, as the basis for producing a descant upon which it is overlaid. This is repeated two more times so that, by the fourth time she improvises over this vocal score, a piece of four-part harmony is produced.

This section of *Lipsynch*, like so many other moments in the perfor-mance, not only manifested the voice itself as an 'acoustic image',[43] but equally invited the audience to attend to the role played by listening in the *shaping* of perceptual experience. Furthermore, by performatively staging the relationship between voice, speech, and language, *Lipsynch* invited the listener-spectator to engage in complex, and inherently playful, attentional manoeuvres.

In attending the above section from Scene 5, I was motivated to engage in varied acts of what might be referred to as 'aural juggling', where a number of aural percepts are simultaneously 'in play'. This phenomenon, in some respects, resonates with what Augoyard and Torgue have referred to as the 'metamorphosis' effect; namely, '[a] per-ceptive effect describing the unstable and changing relations between elements of a sound ensemble' (2006: 73). As they go on to explain, '[a]n absence of perceptive attention allows each sound to be heard simultaneously, with no preference or particular attention'; that is, 'it prevents the listener from fixing his or her attention on a particular sound source' (Augoyard and Torgue 2006: 75). Similarly, in paying attention to voice-as-sound in the above example, I experienced the aural jouissance of switching from attending the sound sequence as a sonic melange, whilst *simultaneously* paying attention to the individual components within this orchestration. I also experienced what I refer to as the *play* of listening: I was aware of movement not just at the level of temporality (namely, the music/sound passing through time), but also on a physical level. Moreover, the existence of the visual embodi-ment of the sounds played a crucial part in the experience of listening.

'[I]t is the very incorporation of vision into the process of auditory perception that transforms passive hearing into active hearing' (Ingold 2000: 277).

The act of listening is never alone: looking, as we have already seen, always has a role to play in auditory perception, even in the seemingly 'blind' medium of radio. There are, however, some obvious phenomenological distinctions between the two media which inevitably affect how we perceive the phenomenal voice. Firstly, when attending the theatre we look-and-listen from a particular *perspective*. In radiophonic reception, however, our perception of sound remains unaltered irrespective of any *objective* changes in position. In this respect, radio drama is materially perspectiveless. Moreover, when listening to a radio play we do not, indeed cannot, experience the *actual* production of the sounds we hear since the originating source of the sound or voice is necessarily and unequivocally absent. In the theatre, however, *where* we are positioned in space (combined with the phenomenal particularities set in play by the techne of 'dramaturgically organised noise') can affect our ability to experience the *production* of sound. This is especially true in the case of voice.

As my account of attending Complicite's production of *Shun-kin* illuminates, the perspective of the listener-spectator can bring about permanent or temporary occlusions to our visual encounter with the source of the dramaturgical voice, which, combined with the ambiguating nature of vocal amplification and reinforcement, can lead to uncanny instances of acousmatisation. Not only can our ears deceive us but sound design itself can go awry.

Disembodying the dramaturgical voice: experiencing theatrically dis-organised noise in Shun-kin

Sometimes when attending a theatrical event we find that despite being able to hear the voice that we perceive, we are unable to locate its source. Furthermore, whilst we may be able to see the source to which a given sound supposedly corresponds, we do not always *experience* designed sound as being produced by or at its source. The following discussion will focus on two factors that, *in combination*, tend to bring about such instances of aural equivocation: namely, the use of playback sound and the particularities of perspective.

When we attend the theatre, not only are we situated within the same space as the performance; we are also usually required to attend from a *particular* 'point of view'. Moreover, where we are physically positioned relative to the stage can play an important role in shaping theatrical experience. Such complications regarding the nature of theatrical

perspective seem to acquire an even greater degree of relativity when we turn our attention to the phenomenon of theatrical sound, and even more so when we consider the perception of the dramaturgical voice. As my experience of attending Complicite's *Shun-kin* reveals, not only is the dramaturgical voice embodied in complex and surprising ways, but the act of looking plays a crucial role in our perception of voice in theatrical performance.

The sound design for *Shun-kin* was arranged by means of a series of speakers, placed on either side of the stage. Each actor, in turn, was fitted with a wireless microphone, attached to their head. Having worked with Complicite for over a decade, Gareth Fry points out that with previous productions, such as *Mnemonic* (1999–2003), radio miking 'had become a kind of standard starting point because it allowed us to work with that dislocation' (2011: n.p.). In *Shun-kin*, however, radio microphones were only used in order to tackle 'audibility issues', and hence, were primarily employed to provide 'natural reinforcement' (Fry and Home-Cook 2009: n.p.).

A key remit of every sound designer, especially where the use of microphones is concerned, is to ensure that the voice of the actor is heard or perceived to derive from its source. 'Sourcing,' as Paul Arditti comments, 'is a difficult business' and, consequently, is none other than the 'holy grail of sound design' (2009: n.p.). In the theatre, and unlike in the case of radiophonic reception, the voice is not only heard – its source can be *seen*, and this, as Gareth Fry explains below, poses problems for the practice of theatre sound design:

> It's partly to do with the size of the space; it gets more difficult the larger the auditorium because you're getting less of the acoustic sound of the performer and because they're visually less significant [...] If I'm sitting this far away from you and you're speaking the fact that your mouth is moving and is occupying 80% of my point of view means that there is no ambiguity. But in the Barbican if you're in the back of the upper circle that mouth is maybe a fifth of the size of my little finger nail and that combined with lack of acoustic means that it gets really tricky. (2011: n.p.)

Hence, whilst vocal reinforcement is intended to improve audibility and intelligibility, there is always the possibility for the audience to *misperceive* the dramaturgical voice. Such moments of misperception, moreover, invariably arise precisely *as a result of* this act of amplification. To demonstrate this, I provide the following experiential example, taken

from the beginning of *Shun-kin*, where Sasuke, as an old man, slowly walks forward to address the audience.

Sitting right at the very top of the Barbican, and with a vertigo-inducing drop to the stalls below, I am placed about as far away from the stage as it is possible to be. This sense of being-at-a-distance is compounded by the sonic particularities of my position. Directly in front of me, and framing my line of sight, is a concrete rim, which dampens the quality of the sounds I hear coming from the auditorium. Consequently, I have the sensation of being cocooned within a sound-world that is somehow discrete from the sonic environment of the theatre at large. The lights dim. I peer down at the stage far below. A figure of a man stands out, as he walks forward from up-stage centre. At around this moment, I hear the voice of an old man, emanating from the far right hand corner of the auditorium. At first, I assume that this voice is either of contextual or marginal significance to the attentional theme, namely, the bearded man that I see on stage. This voice, nevertheless, vies vehemently for my attention. Motivated by this curious phenomenon, I scan the stage and the surrounding region for clues as to its source. Then, on paying particularly close attention to the facial movements of the actor on stage, I realise, somewhat incrementally, that this disembodied voice belongs, *at least originally*, to Yoshi Oida, the actor playing Sasuke as an old man. Yet, despite my newfound knowledge as to its originating source, my perception of this voice is still tainted with a degree of spatial and ontological uncertainty.

In distinguishing the dramaturgical voice from the voice in general, Don Ihde makes the following statement:

> The actor amplifies the sounding voice, he *projects* voice into the recesses of the theatre. This resonant voice is an auditory aura that im-presses in sound. The auditor is not merely metaphorically impressed, but in the perception of the other he experiences the embodiment of the other as one who fills the auditorium with his presence. (2006: 176; *sic*)

Ihde also states that 'in the voice of embodied significance lies the *what* of the saying, the *who* of the saying, and the *I* to whom something is said' (2006: 168). Yet, in the example described above, all three of these indexical characteristics were absent from my first 'impression' of the strange voice-as-perceived: I knew not what the voice said (being in Japanese, the actor's utterance was almost entirely incomprehensible to me), from whom it derived, nor, indeed, for whom the voice was

intended. Far from having a sense of *embodying* the actor's voice or
'presence', I felt, instead, an acute sense of flux, ambiguity and uncer-
tainty regarding the originating source of this vocalic being. Thus, even
without the use of playback sound, there is still the possibility for sound
to come unstuck from its source. Voice is no exception. As a phenom-
enon of sound, voice is always on the move, and flows through a given
environment in irregular ways. The same is true of voice in theatre.[44]

Rick Altman has maintained that in theatre 'we never have any doubt
whatsoever about who is speaking. Our ears tell us' (1992: 22). Yet,
Altman's description of the dramaturgical voice is based on the assump-
tion that the actors on stage are voicing naturally, that is, without the
aid of amplification. In instances where actors' voices are increasingly
amplified through complex speaker configurations, even our ears can
get it wrong. Whilst the use of wireless (or 'radio') microphones and
playback sound is intended to ensure that the actor's voice reaches the
ears of the audience sitting in the most aurally occluded regions of the
theatrical environment, sometimes 'natural reinforcement' can *increase*
the chances of misunderstanding.

In light of this, I introduce a third category to Ross Brown's aural phe-
nomenology of theatre sound design: namely, *theatrically dis-organised
noise*. This concept accounts for the unintended, ambiguous and cha-
otic 'noise' that arises precisely as a result of the ways in which sound
has been organised. In the theatre, unlike in the case of radio drama,
our perception of an actor's voice is affected by our ability to hear and
see its source, namely, the actor's mouth. In attending the opening
scene of *Shun-kin*, I was temporarily unable to hear and see the originat-
ing source of this uncannily disembodied vocalic phenomenon. This
temporary sensory occlusion and moment of ambiguity came about as
a result of the displacing effects of playback sound, combined with the
fact of being positioned in 'the Gods', far away from the source of the
voice. Furthermore, the example demonstrates how the senses necessar-
ily work together in order for the percipient to 'experience the produc-
tion sounds' (Nudds 2001: 218).[45]

As a result of the spatial discombobulations brought about by the use
of playback sound, I was unable to experience the production of the
unknown voice that I encountered in attending the opening scene of
Shun-kin. Indeed, even when I finally realised that the uncanny voice
coming from somewhere else originally derived from the actor on stage,
I still did not experience the *production* of this sound, since my visual
perception of the originating source (the actor's mouth) was limited as
a result of my remote position. Being cocooned in a concrete pod at the

top of the Barbican, I had almost no perception of the unmediated voice of the actor. Moreover, the voice I heard was perceived to emanate from an altogether different location to that of its source.

When listening to a radio play, it is spatially and ontologically impossible for the listener to experience the *actual* production of the sounds presented for their attention, the sounds being 'detached' or abstracted from their originating source (whether actor, dog, bus, gun, etc.). 'When one hears an object on the basis of pure auditory experience one does so by hearing the sound that it produces, but one does not hear it as producing that sound' (Nudds 2001: 222). Conversely, in the theatre there is usually the possibility of experiencing the production of sounds. More especially, by endeavouring to make the spoken word both audible and intelligible, 'natural reinforcement' can sometimes set in motion another kind of equivocality – the spatially and ontologically equivocal phenomenon of the *acousmêtric* voice.

De-acousmatising the dramaturgical voice: paying attention to theatrical acousmêtres

Michel Chion's notion of the *acousmêtre*, a portmanteau derived from the phrase *être acousmatique*, or 'acousmatic being' (1999: 21), originally stems from the phenomenology of film:

> When the acousmatic presence is a voice, and especially when this voice has not yet been visualized – that is, when we cannot yet connect it to a face – we get a special being, a kind of walking and acting shadow to which we attach the name *acousmêtre*. (1999: 21)

A quintessential example of a filmic *acousmêtre* is the voice of 'Hal', the spaceship's computer, in Stanley Kubrick's acclaimed *2001: A Space Odyssey* (1968). The omniscient, somewhat malevolent voice of Hal is at the very centre of the action and yet its source is always kept, teasingly, just out of shot. The *acousmêtre*, then, as Steven Connor explains, is 'to be distinguished on the one hand from the "natural" (though in fact synthesized) voice which is simultaneously seen and heard, and on the other hand the *acousmatique* voice, which is heard but does not emanate from the action on the screen (for example, the voice-over or narrating voice)' (1997: 222). In other words, the *acousmêtre* 'is neither inside nor outside the image' (Chion 1994: 129). Whilst experienced as being present at the very centre of the image, the source of the *acousmêtre* is strikingly absent; in this respect, the *acousmêtre* does not lie inside the image. Conversely, the *acousmêtre* does not exist *outside* the image, since

'it is not clearly positioned offscreen in an imaginary "wing" [...] and it is implicated in the action, constantly about to be a part of it' (Chion 1994: 129). Paradoxically, therefore, the *acousmêtre*'s presence is based on its 'very absence from the core of the image' (Chion 1994: 129).

Acousmêtric experience is, however, considerably nuanced. For instance, the generic phenomenon of the 'off stage voice' (that is, a voice heard but whose source is unseen) is rarely experienced *acousmêtrically*, since the voice emanating from the wings does not demand that we search for its source, namely, the actor. By contrast, the strange voice that I heard at the beginning of *Shun-kin* motivated me to ask the question, 'what and to whom does this voice refer?' Yet, whilst this voice might be described as *acousmêtric*, it was not experienced as an *acousmêtre* as such, since it was not perceived as emanating from the centre of the action but came from elsewhere, residing ambiguously on the margins of intended meaning.

The *acousmêtric* voice, by its nature, catches our attention by surprise. When this uncanny sonic percept enters experience, the listener is suddenly struck by a voice that appears to come from nowhere. When sound is dislodged from its source our ability to single out its originating location is adversely affected. Consequently, thematic attention often becomes fragmented and dispersed. When attending the disembodied voice of Sasuke, not only was my sphere of attention stretched, but signal and noise were set in flux. It was not so much that I was 'distracted' by this uncanny vocalic phenomenon, but rather that the sudden uncertainty concerning its originating source manifestly registered at the very centre of thematic attention: marginal *and* thematic content momentarily seemed to co-exist in a state of acute equivocality. Our particular perspective relative to the mise-en-scene, combined with the spatial confusions that are sometimes caused by playback sound, can thus alter our perception of what we hear. Whilst theatre's frame boundaries are less absolute than those of film, it is nevertheless possible, as my next experiential example attests, to experience the voice in theatre as an *acousmêtre*.

In attending a moment when Sasuke is surrounded by his advisors, my attention is especially drawn to the way in which the bright colours of their kimonos match the colourful tones of their dialogue. Then, as if within an instant, the colourful crowd loses its attentional crown and becomes the mere context of an omnipotent and mysterious thematic usurper, namely, the attention-grabbing sound of an elusive, disembodied voice. Having been puzzled by the presence of this phenomenon I feverishly glance around for clues as to its source. As I listen more

intently, I notice that its spatial characteristics are somewhat indeterminate. On the one hand the voice appears to come from the very centre of the crowd, whilst on the other its source is altogether uncertain, appearing to emanate from the speakers on either side of the stage as well as from within the auditorium itself. Being drawn, once again, to the centre of the crowd I begin to zoom in on the actors' faces, trying to fit their movements to the implacable sound of the disembodied voice. The actors being silent, I notice, for a moment, that the theme to which my attention is directed is not the crowd *as such*, nor the voice-within-the-crowd, but rather that uncanny absencing in thematic attention that occurs when one riffles through a particular environment searching for something that is simply not there. In conducting this search-and-find operation I notice that my attentional focus, namely, 'the source of the voice', is presented as absent within the broader context of all that I survey.[46] The mute mouths of the Japanese men in the crowd only intensify this sense of the uncanny. This moment of equivocation is, however, short-lived. Like the sun emerging magnificently from a moment of total eclipse, the source of the mysterious voice is disclosed: Sasuke emerges from the crowd. Having, momentarily, been visually occluded by the other actors, Sasuke comes into view and the voice is once again sutured to its source.

'De-acousmatization', as Chion formulates, consists of '[...] a sort of enclosing of the voice in the circumscribed limits of a body – which tames the voice and drains it of its power' (1994: 131). Interestingly, this process of vocalic 'embodiment' (Chion 1994: 131) would appear to correspond closely with Arvidson's concept of attentional 'elucidation', namely, the 'clearing, to some extent, of an obscurity in the thematic context' (2006: 63). Yet, in the case of the example described above, it was the *theme* which was elucidated by the attentional and material alteration in the thematic context. The visual emergence of Sasuke within the crowd brought about a radical elucidation of the *acousmêtric* voice. This elucidation in thematic content did not come about as a result of a change in my mode of attention, but instead resulted from a physical or perspectival alteration of the perceived environment. The physical disclosure of Sasuke not only de-acousmatised the voice but disclosed, or rather *elucidated*, its identity: a voice 'from nowhere' became the voice of someone. Sasuke re-emerged not as a figure-within-a-context but was, in every sense, disclosed as a phenomenon of sound: for a moment, the voice did not just belong to but *was* Sasuke.

To understand the phenomenal dynamics motivated by instances of *acousmêtric* experience, it is helpful to take a closer look at Augoyard

and Torgue's notion of the 'ubiquity effect' (2006: 130). Like the *acous-mêtre*, the ubiquity effect is experienced in degrees. A 'major variant' of the ubiquity effect 'expresses the difficulty or impossibility of locating a sound source [...] sound seems to come from everywhere and nowhere at the same time' (Augoyard and Torgue 2006: 130). Correspondingly, as concerns the minor variant of the ubiquity effect, 'sound seems to come simultaneously from a singular source and from many sources' (Augoyard and Torgue 2006: 130). Accordingly, the above example of the *acousmêtric* voice in the crowd would seem to lie somewhere between these two variants: whilst I had some perception of the voice deriving from the centre of the crowd it equally appeared to come from somewhere else, and its location generally could not be disambiguated. There is thus 'a fundamental link between sound and ubiquity' (Augoyard and Torgue 2006: 131). Sound, whether designed or otherwise, has a unique ability to manifest experiences of space and spatiality that are equivocal, contradictory, and infinitely playful. There is also something about the ubiquity effect that 'supposes active listening rather than a simple stimulus/answer schema' (Augoyard and Torgue 2006: 135). The ubiquity effect might therefore be said to consist of an act of stretching out through space in search of a sound source that remains out of one's attentional grasp.

Importantly, the experience I encountered above was not intended but manifested as a result of my own particular and peculiar act of theatrical attendance. From the moment of its emergence as an attentional theme, the voice manifested not as a speaking being but as the voice of an Other whose identity was unknown. This sense of alienation was intensified by the fact that the voice was that of a man speaking in Japanese, a language of which I know very little. Importantly, I did not attend to the voice as an object, nor as the conveyor of linguistic meaning, but rather was acutely concerned with locating its originating source. Moreover, although I perceived the voice to stem, ambiguously, from the centre of the diegetic frame, I was unable to experience its *production*, its originating source being momentarily out of view. In contrast to hearing the strange voice at the beginning of *Shun-kin*, this voice was not initially heard to be diegetically irrelevant or spatially marginal but seemed to emanate directly from the centre of the diegetic and scenographic frame (namely, the crowd of vying advisors). At the same time, however, and unlike the voice of old Sasuke in my previous example, this voice was not merely acousmatic but was perceived as being *acousmêtric*, that is, as an uncanny absent presence that set both listening and looking in flux.

Usually, as Altman observes in the following extract, we are able to identify the precise location of an actor even when placed in total darkness on account of the spatialising and honing characteristics of auditory perception:

> Imagine that there are two actors on our stage, one facing the audience, the other facing backstage. The lights are low; the audience cannot always be sure of seeing which actor's lips are moving. Yet, we never have any doubt whatsoever about who is speaking. Our ears tell us. (1992: 22)

An altogether different account of auditory experience is, however, brought into being when actors' voices are played back through a series of speakers throughout the auditorium. If, for instance, Yoshi Oida had not been radio-miked in the scene with his advisors, my perception would have been noticeably less equivocal. Furthermore, when attending the voice that appeared to come from nowhere, I experienced a mode of spatiality as dynamic as the acoustic phenomenon that brought it about, namely, the *acousmêtre*. As the example attests, the act of paying attention to sounds whose source cannot be identified motivates a kind of spatiality that contradicts and reaches beyond Euclid's notion of perception, space and perspective. Yet, can the same be said of visual perception, and how does our perception of sound in theatre correspond with that of our encounter with theatre's visual dimension?

The phenomenon of sound, as we have seen, is never perceived in isolation: the act of looking always plays an important role in the process of enacting auditory perception. There is thus a need not only to rethink the relationship between sound and scenography, but to pay closer attention to the phenomenal particularities of theatrical design as experienced. There are, for instance, occasions where theatrical design, or more precisely the *co-use* of sound and scenography, manifestly creates a particular sense of movement in attending.

Motivating attention: looking and listening to the birds of *Shun-kin*

In the final scene of *Shun-kin* a flock of large white birds flies up from stage level all the way up to the top of the theatre. This moment re-enacts an aspect of Shun-kin's life that she forever holds dear: her passion for birds. Several times during the performance, Shun-kin can be seen walking up to the roof, opening the birdcage and setting her larks free. The moment of bird-release at the end of the performance is,

however, particularly significant. Without warning, Shun-kin expires, her spirit, along with her birds, being released up to the heavens. The final flight of the larks is thus a moment of release and elevation. This sense of elevation, moreover, was not only signified, but *felt*.

On the stage rests a birdcage, which is carefully opened by Shun-kin. At this moment, the sound of flapping wings can be heard. This incredibly lifelike sound is produced by a piece of paper attached to the performer's arm, which, when moved in a particular manner and with a particular rhythm and energy, also produces the visual effect of a bird flapping its wings. Then, with a graceful, strong, upward movement, the performer casts her hands towards the skies. This phenomenon of light, sound and movement gives way, almost imperceptibly, to a projection of what appears to be five or six large birds, which rise up from the back of the stage on an enormous cyclorama the height of the Barbican. Being played below the 24 frames per second standard, this edited footage is noticeably irregular and, consequently, adds a certain incremental, fluttering quality to this rising motion. In synchrony with this moving image, the sound of a flight of birds is played back through a tier of speakers, positioned on either side of the stage. This sound begins at stage level and rises up to the ceiling, 70 feet or more above. This moment is also beautifully lit, the birds appearing as white silhouettes set against the darker shade of the cyclorama. Yet, it is the quality of the sound and the extraordinary way in which sound and light appear to fuse as one phenomenon of experience that especially catches my attention.

In perceiving the birds, I do not encounter objects so much as *movement*. Far from perceiving objects on a screen, I experience motion itself. Correspondingly, not only do I perceive these birds as sound, but sound is perceived as an experience of birds-in-motion – the birds are sounded and sound birded. Moreover, this acoustic quality, brought about by the complex sequencing and spatial arrangement of hi-fi speakers, plays a crucial role in shaping my perception. In paying attention to the sound as it moves up from ground level into the 'sky' above, I not only experience a profound sense of movement, but am made acutely aware of the phenomenon of listening-at-a-distance, that is, of listening-*in*.

In paying attention to the birds of Shun-kin, I experienced a sense of elevation, motivated by the upward movement of designed sound. Indeed, it was not the visual and aural representation of a flight of birds that made this moment of *Shun-kin* stand out, but the phenomenal ways in which the design *motivated* a sense of elevation, or, more precisely, of what it feels like to perceive a-flock-of-birds-in-flight. Moreover, in stretching out through and in space to grasp these phenomena, I was unable to detach my experience of the birds as sound from my experience

of them as visual phenomena. Interestingly, my experience of attending the birds of Shun-kin resonates strikingly with Tim Ingold's description of experiencing a thunderbird in flight:

> The thunderbird [unlike the cuckoo] is not a thing of any kind. Like the sound of thunder, it is a phenomenon of experience. Though it is by thunder that the bird makes its presence heard, this sound is not *produced* by the thunderbird as the cuckoo produces its call. For the thunder *is* the bird, in its sonic incarnation. (2000: 279)

Upon perceiving a thunderbird, looking and listening are merged. Similarly, the birds of Shun-kin were not perceived as things but rather as 'a phenomenon of experience'. The sound of the thunderbird is not experienced as being produced by (or to come from) the bird but '*is* the bird, in its sonic incarnation'. Similarly, the birds of Shun-kin *were* the sound they made as they traversed the space: scenography sounded and sound was seen. The example thus not only troubles more traditional conceptions of sensory perception, but complicates the age-old question of where sounds are perceived to be located.

According to Viktor Zuckerkandl, sound is experienced as a 'from-out-there-toward-me-and-through-me' (1956: 277). Thus conceived, audition is passive and sounds are located not at their source but at the ear. Conversely, Casey O'Callaghan proposes that sounds are located at their source (see 2010). However, as I attended the birds as they fluttered up at the end of *Shun-kin*, my body not only traced the route of these beings as they sounded through space but moved with them: I was, in all senses, *moved*.

Importantly, this sense of outward movement was motivated by the act of attending. Indeed, it is precisely this dynamic dance between self and world that characterises the phenomenon of attention itself. The perceptual object both motivates, and is motivated by, the 'knowledge-bringing event' of the attentional act (see Merleau-Ponty 2002: 35 ff.).[47] To attend, in other words, is to be *motivated*, admittedly to varying degrees and with varying degrees of awareness, by any given object of perception. This process of perceptual articulation is dynamic since the act of 'taking an interest' in the perceptual object phenomenally and simultaneously shapes our experiencing of that percept.

> The connection between being 'interesting,' as a disposition to attract attention, and 'interest,' as a disposition to act, lies, then, in the *motivating* capacity of attention. The more attention spontaneously discriminates its object, the more one's body tends to perform

those habitual activities by which the attractive item may be maintained by focus [...] Attention and habitual movement are thus integrally associated. (Lind 1980: 134)

As I attended with 'interest' the birds of *Shun-kin* I experienced sound to be located neither at a fixed source, nor at my ears, but rather within a heterotopic zone, a no-space which was constantly *on the move*. As the sound design at this moment 'panned up'[48] from the stage to the ceiling, I felt a sense of being pulled away from where I was sitting and pulled upwards and towards the birds as they took flight.

As this chapter has strived to illustrate, our perception of designed sound, whether in the context of radio drama, or in the theatre, is phenomenally affected by what we *do*. Although theatrical sound design endeavours to manipulate, direct and motivate audience attention, our perception of designed sound is nevertheless affected by the particular mode of attention that we adopt. Indeed, even in the case of listening to the highly circumscribed fictional sonic environment of radio drama, the percipient is nonetheless able to performatively reshape that which is given. Furthermore, the act of looking, or rather the fact of having one's eyes open, plays a critical role in this process of perceptual enactment. In the theatre, this is further complicated by the fact that the listener-spectator attends the performance, at least customarily, from a fixed 'point of view'. As we have seen, the particularities of perspective, combined with the displacing effects of playback sound, can often result in instances of acute and acutely theatrical equivocality. Moreover, and in stark contrast to the phenomenology of radio plays, in the theatre, sound is subject to an infinite variety of subtle, though crucial, acoustic variations that are, at least in part, determined by the intersubjective embodied enactments and sheer presence of its participants. Nowhere else is this more strikingly apparent than in the case of theatrical silence.

Having focused thus far on the question of how perceptual content is manifestly shaped by the individual attentional enactments of the listener-spectator, Chapter 3, *Sounding Silence*, begins to explore the question of attention and (inter)subjectivity. With its innate tendency to broaden the parameters of thematic attention, as well as to pique our aural attentiveness, the phenomenon of silence not only allows for a further consideration of what it means to listen, but invites us to attend to ourselves as attending subjects.

3
Sounding Silence

As Salomé Voegelin observes, '[w]hen there is nothing to hear, so much starts to sound. Silence is not the absence of sound but the beginning of listening' (2010: 83). Thus, in every sense, one might say that silence *sounds*. In developing this idea, and as a means of tackling the apparent paradox that it engenders, this chapter pays particular attention to the various ways in which 'silence' is *experienced*.

'Experience,' as Aron Gurwitsch points out, 'always presents us with objects, things, events, etc., within certain contexts and contextures, and never with isolated and scattered data and facts' (1964: 1). Similarly, our experience of silence is phenomenally shaped by the material conditions and sonic context from and within which silence emerges. A phenomenology of silence is, thus, necessarily a phenomenology of sound: 'silence is noise' (Brown 2011: 9). Not only does the phenomenon of silence sound, but moments of 'silence', stillness, and hiatus phenomenally motivate us to engage in acts of *sounding*. Silence, in other words, not only prompts us to listen more attentively, but beckons us to sound out the sonic affordances of the environment within which silence rests. Conversely, silence also has a tendency to make us readily aware of our own existence, as attending subjects, within that environment. Take, for instance, the experience of attending the 'minute's silence' on Remembrance Sunday, or when noticing the silence that descends during snowfall. As these examples attest, silence not only draws attention to the wider parameters of our attentional sphere, but is invariably attended by a distinct, though marginal, sense of self in attending. In this respect, one might say that silence is *theatrical*. As well as being a phenomenon that we *perceive*, silence prompts us to attend to the nature of experience itself: in silence, the play of perception is dynamically disclosed. The phenomenology of silence is thus as complex as it is mysterious.

What secrets are to be found in sounding silence? What is it to attend (in) silence and to experience ourselves to be silently present? What are the phenomenological and material differences, as well as similarities, between radiophonic and theatrical silence? What does it mean to *experience* 'silence' and what can we learn about the phenomenology of listening by paying attention to its 'noise'? In seeking answers to these questions, this chapter develops a broader understanding of silence that not only attends to the phenomenon of silence per se, as in the perceived absence of sound, but also includes an investigation of the phenomenology of absence, muteness, and the perplexing question of how one is 'present to oneself in attentiveness' (Steinbock 2004a: 2). Silence is thus both the object and the vehicle of my enquiry: in *sounding* silence, I aim to shed further light on the phenomenal particularities of aural attention.

Listening in (to) silence: sounding out silence in radio plays

'[R]adio,' as Andrew Crisell has remarked, 'endows [silence] with a peculiar potency' (1994: 159). The reason for this 'potency', as Crisell indicates below, has to do with the fact that silence in radio plays, unlike theatrical silence, is 'visually unfilled' and, therefore, seemingly 'absolute' (1994: 159):

> Sounds, the very essence of radio, exist in time and constantly evaporate. If they are not renewed silence imposes itself. This also occurs in the theatre or in the cinema but it is not important, since these media provide images which exist in space and which therefore endure through both sounds and silences. (1994: 159)

There are indeed some important distinctions to be made between radiophonic and theatrical silence. When experienced in the context of radio, silence is not only particularly noticeable, but also especially acute: when speech and sound are momentarily withdrawn from the radiophonic 'soundscape', silence *speaks*. Furthermore, and unlike in the case of theatre, where silence is phenomenally *shaped* by the material and sonic particularities of the performance environment (including, of course, the felt presence or 'noise' of the audience), radiophonic silence is materially immutable. Yet, whilst we might assume that silence in radio is given in pure form, the phenomenology of radiophonic silence (as my investigation of silence in radio drama

illustrates) is in fact highly nuanced, and subject to considerable perceptual variation. To understand this, we must recognise that our experience of silence, whether in the context of radio plays, theatre, or in the world at large, is manifestly shaped by the phenomenon of sound.

> During silence, things happen invisibly, in the minds of the players and in our imagination; we are drawn through the shimmer of words into a world in which there is another level of existence apart from what is merely *said*. In fact, silence adds a dimension; sound comes from it, sound returns to it, words have their being surrounded by it, it is the cloth on which the pattern is woven [...] In radio, silence like a magnet draws us deep into the heart of the experience. (McWhinnie 1959: 89)

As well as demonstrating how sound (in particular, the sounded word) interpenetrates with silence, this extract, from Donald McWhinnie, seems to suggest that there is something about radiophonic silence that demands our attention. Yet, what is it to be 'drawn into silence' and what are the nuances of radiophonic silence as lived?

Moments of 'silence' in radio drama, as I shall reveal, are as phenomenally perplexing as they are powerful. Our experience of radiophonic silence, moreover, is not limited to the perceived absence of sound. Sometimes, for example, a character's muteness, or state of being temporarily silent, is experienced by the listener to be co-present with the thematic content presented by the 'sound picture'. Silence, like a mirror, makes us attend to that which is otherwise attentionally marginal: the self that remains silent, the *silentric self*.

The aims of this section ('Listening in (to) silence') are manifestly interwoven. First, my aim is to listen *into* silence, that is, to investigate silence as a phenomenon. As well as attending to silence per se, I will also explore the phenomenology of absence. This broader conception of silence includes a discussion of the absent presence imposed by the phenomenon of the radiophonic *acousmêtre*, together with the present absence manifested by its inverse, the *silentre*. Let us begin, however, by paying closer attention to that familiar though somewhat under-thematised phenomenon: 'listening-in'. The phenomenon of listening-in not only provides an effective means of exploring what it means to be 'silently present', or mute, but also allows us to consider the question of subjectivity, or presence to self, in attending.

UNIVERSITY OF WINCHESTER
LIBRARY

Being silently present: listening-in to the platform scene in *All That Fall*

The concept of *listening-in* is as familiar as it is enigmatic. It is what we do when we surreptitiously tune in to someone's conversation in a café or restaurant. It is what we do when we silently audit, or spy on, someone's private discourse. It is what we do when we listen to the radio. As a verb, to 'listen-in'[1] means either to 'tune in' to the radio, or, in a broader sense, to 'eavesdrop'. 'Eavesdropping', in its original sense, refers to the act of standing or hiding within the 'eavesdrop'[2] of a house or building 'in order to [...] listen secretly to private conversation'.[3] Hence, to listen-*in* is to actively *zoom in* on someone's conversation or to pay close attention to a particularly curious sound that exists within the sonic environment. Listening-in thus consists of a specific mode of listening, characterised by a particular and dynamic experiencing of space, perspective and self in attending. In listening-in, moreover, we have a sense, however marginal, of ourselves as being silent or mute. Whilst '[t]he mute object stands "beyond" the horizon of sound', it nevertheless remains 'silently *present*' (Ihde 2007: 50). As an initial means of exploring this relationship between listening-in and the phenomenology of being 'silently present', I now turn to the platform scene in Beckett's *All That Fall*.

Throughout most of *All That Fall* Mrs Rooney takes centre stage: not only do we hear the world of the play through her ears, but the action is driven by what she says and does, that is to say, by her dialogue and interaction with the other characters. In the following scene, however, Mrs Rooney is momentarily placed 'out of focus', the focus being held on the trialogue taking place between Miss Fitt, Mr Tyler and Mr Barrell:

MR TYLER: You have lost your mother, Miss Fitt?
MISS FITT: Good morning, Mr Tyler.
MR TYLER: Good morning, Miss Fitt.
MR BARRELL: Good morning, Miss Fitt.
MISS FITT: Good morning, Mr Barrell.
MR TYLER: You have lost your mother, Miss Fitt?
MISS FITT: She said she would be on the last train.
MRS ROONEY: Do not imagine, because I am silent, that I am
not present, and alive, to all that is going on.
MR TYLER: [*To* MISS FITT.] When you say the last train –
MRS ROONEY: Do not flatter yourselves for one moment,
because I hold aloof, that my sufferings have ceased. No.
The entire scene, the hills, the plain, the racecourse with

its miles and miles of white rails and three red stands, the
pretty little wayside station, even you yourselves, yes, I
mean it, and over all the clouding blue, I see it all, I stand
here and see it all with eyes ... [*The voice breaks.*]
[...]
MR TYLER: [*To* MISS FITT.] When you say the last train [...]
(Beckett 2006: 185)

In contrast to the Slocum scene discussed in Chapter 2, where 'selective focus'[4] is used to direct the listener to pay greater attention to one voice over and against another, in the above scene, sound is designed to give the listener the impression of listening-at-a-distance, or, more specifically, of 'eavesdropping'. This effect is achieved by lowering the level of the three sound characters.

In listening to this fragment, the 'thereness' that I encounter as I attend the sonic melange Mr Tyler/Miss Fitt/Mr Barrell is ambiguously given as an experience of being-at-a-distance, not only from myself as listener/witness but from Mrs Rooney, through whose consciousness (or rather point-of-audition) I co-perceive the scene. As I listen-in, both with and to Mrs Rooney as she, in turn, eavesdrops upon the quotidian discourse of those people 'over there', I feel myself to be silently present in the background, yet at the centre of subjectivity. Indeed, this shared act of listening-in is noticeably coloured with an intense sense of liminality. Listening-in to this scene from the margins, I have a sense of being not only spatially distant from these characters, but ontologically removed from their world. In paying closer attention to my perception of this sonic trialogue, I notice a curious duality in attending. I have the vertiginous sensation of momentarily existing within a kind of attentional no-man's-land, finding my attention to be stretched between attending the trialogue as such, whilst, at the same time, perceiving these sounds through the silent consciousness of Mrs Rooney.

Then, the otherwise familiar sound of Mrs Rooney's voice re-emerges. This presencing catches me by surprise, and consequently her voice registers as a quasi-*acousmêtre*, namely, as a voice that, though familiar, seems to intrude upon the proceedings in an authoritative and ubiquitous fashion. In paying greater heed to this speech body, I notice a kind of perceptual paradox. On the one hand, I perceive this voice from the perspective of the sonic trialogue Mr Tyler/Miss Fitt/Mr Barrell. Yet, at the same time, I sense that I am looking-and-listening with Mrs Rooney upon the scene as perceived through her eyes-and-ears. Hence, although by the time Mrs Rooney utters the words 'Do not flatter

yourselves' I no longer experience her as a quasi-*acousmêtre*, there is nevertheless a degree of uncertainty as to for whom her monologue is intended. Whilst it seems as if she is talking directly to me, the listener, she could equally be talking to either herself, or to her three fellow travellers. During her long speech there is a kind of *hiatus*, a curious freezing of time and action, within which I am motivated, like Mrs Rooney, to reflect upon my own condition as a silent, yet attendant, witness to 'all that is going on'.[5]

In discussing the nature of perception, Aron Gurwitsch invokes the following example, and one which is especially apposite to the present discussion:

> In perceptual experience, let us say, a cabinet in my room is given. I perceive it as something that confronts me; I am *here* and look at it standing *over there* [...] The being-over-against, which comprises the sense of objectivity, signifies that I always dwell at a distance from my surroundings. This confrontation occurs in the mode of being-at-a-distance. (1979: 40–41)

Perception, then, is inherently spatial. Yet, what is particular about the phenomenon of listening-in is that the spatialising nature of listening as a mode of attention is partially foregrounded in perception.[6] Moreover, it is not only a sense of space that is manifestly present in the act of listening-in but a sense of self.

'In much attention research, the self is "transparent"' (Arvidson 2006: 116; see esp. Metzinger 2003). In proposing that subjectivity is 'never absent from the sphere of attention' (2006: 121), Arvidson has suggested that there are at least three categories of attention and subjectivity: '*the ever-present self*'; '*attentionality*'; and '*reflective attention*' (2006: 120). In each case, the degree to which the self is present or presenced in attending becomes more prominent. The first category – 'the ever-present self' – refers to 'the weak sense of self or subjectivity co-present with every moment of thematic attention' (Arvidson 2006: 120). At the other end of the spectrum lies 'reflective attention' – 'the strong sense of self, the ego as an object in attending without appeal to something (homunculus, soul, etc.) outside of the attending process' (Arvidson 2006: 120). 'Attentionality' lies at an interstitial point between these two extremes; namely, 'the distance or distinction between what is often called the object and the subject; between the content attended to as theme and the process of allowing content to be attended to as theme' (Arvidson 2006: 120). Correspondingly, and as the platform scene of *All That Fall*

performatively plays out, the phenomenon of listening-in would appear to foreground the subjectivity, as well as the spatiality, of attentionality. When engaged in the act of listening-in our attention is stretched between attending 'the content attended to as theme', which resides 'over there', whilst simultaneously being aware of 'the process of allowing content to be attended to as theme', which happens 'over here'.[7]

In listening to the above fragment from *All That Fall* my thematic attention was split between attending the voices that I heard in the middle distance, and simultaneously attending a self that remained silently present in the background. In objective terms, the voices were all there was to be perceived at this moment. In perceptual terms, however, these voices were *attended* by the silent, or mute, presence of Mrs Rooney. This indeed is what is so particular about this scene: its represented significance resonates with and is embodied in the act of listening itself – in listening-in to this scene, I experienced what it is to be like Mrs Rooney, all alone on the platform, temporarily absent, though not forgotten. The example also strikingly demonstrates that even in the most acute focal attention there is always a tension between thematic content and its surrounding context, a phenomenon which Jean-Luc Petit touches on below:

> The thing is there, right at the centre of our attention. We are directed toward it [...] Even though we remain fully alert we are, so to speak, deflected, torn away from ourselves. In not being present to ourselves we are for this very reason both absent from ourselves and present to something which is not our self. (2003: 284)

In the case of listening-in this sense of being 'torn away from ourselves' is brought into attentional relief. When eavesdropping on someone's conversation our presence to ourselves is not materially relevant to the theme. Conversely, the act of eavesdropping itself is by no means *irrelevant* to the theme. Arvidson's notion of the 'marginal halo' (2006: 122; *see also* 'Appendix 1') is helpful here.

As Arvidson formulates, an intrinsic characteristic of the phenomenology of the 'marginal halo' is its liminality with respect to relevancy. 'As related to the theme, though not materially relevant under the current perspective, [...] the marginal halo is that which is *in-between* relevance and irrelevance in the sphere of attention' (Arvidson 2006: 124). Similarly, when listening to the platform scene, whilst Mrs Rooney was not materially present or relevant to the attentional theme, namely the trialogue, her presence as a newly deceased speech body was,

nevertheless, co-present with thematic content. According to Arvidson, the marginal halo is none other than 'the existential locus of being', the 'peripheral living-through of embodied attending in the world' (2006: 124). Likewise, and as she stands in silence listening-in to the anodyne trialogue of those beside her, it is precisely within this region that Mrs Rooney resides, both as a character and as an attentional object.

The manner in which the mute object may present itself, however, depends upon the conditions and context within which it is received. For example, when a character in a radio play fails to speak or to make any discernible sound, silence becomes tinged with an altogether different ontology, and one from and within which *silentres* manifestly emerge. To understand the phenomenal nature of the *silentre*, and its manifestation in the context of radio plays, we must first attend to its inverse, the *acousmêtre*.

Attending Ada: *Embers* and the phenomenology of radiophonic *acousmêtres*

The question of the *acousmêtre* in radio drama remains almost entirely unexplored. One exception to this is Tim Crook, who asks: 'Is there something truly acousmatic in the sound and radio medium alone?' (1999: 86). In suggesting that there is, Crook maintains that 'an acousmatic presence is established in radio drama in a production or script which has not defined the character visually' (1999: 86).[8] The phenomenology of radiophonic *acousmêtres* is, however, more complex than Crook's account suggests. To demonstrate this, I now draw from my experience of attending Ada, the *acousmêtre*, in Beckett's *Embers*.

Produced by Donald McWhinnie, and with Jack MacGowran as 'Henry' and Kathleen Michael as 'Ada', *Embers* was first broadcast on the BBC Third Programme on 24 June 1959. In contrast to *All That Fall*, where the audience is provided with a clear sense of locale and narrative structure, *Embers*, Beckett's second piece for radio, takes place within the mind of its central character – Henry. Within this fragmented, ghostly world of sounds, auditory imaginings, and hallucinations, very little is certain. All we know is that Henry is sitting alone on a beach, talking to himself and to those figments of his imagination that he either hears or invokes. Indeed, the only sound that unambiguously emanates from *outside* Henry's mind is the ubiquitous and continual sound of the sea, which fills the play's multitude of pauses. Apart from a series of vocalic memories, presented as a series of fragmented sounds-from-the-past (replayed eerily in the present), the only other voice we hear, other than Henry's, is that of Ada.

In every sense, Ada *attends* Henry. Ada (Henry's deceased wife) makes her presence felt as a ghostly, distant, disembodied voice from the past. Her sense of being 'with him', however, is, both spatially and ontologically, very much in doubt. As an absent presence, Ada's sense of 'being in attendance' is equivocal and uncanny. She appears, on the one hand, to be attentive; attending patiently, though somewhat coldly, to his every word. Yet, on the other hand, there is something about her voice, as well as her 'attendance', or, her state of *listening in silence*, that forces Henry, and hence the listener, to doubt whether or not she is altogether 'there'.

> HENRY: [...] Ada. [*Pause. Louder.*] Ada!
> ADA: [*Low remote voice throughout.*] Yes.
> HENRY: Have you been there long?
> ADA: Some little time. [*Pause.*] Why do you stop, don't mind me. [*Pause.*] Do you want me to go away? [*Pause.*] Where is Addie?
> [Pause.]
> HENRY: With her music master. [*Pause.*] Are you going to answer me today?
> ADA: You shouldn't be sitting on the cold stones, they're bad for your growths. Raise yourself up till I slip my shawl under you. [*Pause.*] Is that better?
> HENRY: No comparison, no comparison. [*Pause.*] Are you going to sit down beside me?
> ADA: Yes. [*No sound as she sits.*] Like that? [*Pause.*] Or do you prefer like that? [*Pause.*] You don't care.
> (Beckett 2006: 257)

In listening to this fragment I note how these two speech bodies are experienced in distinctly different ways. Henry's identity and location as a speech body appears to be fairly clear; his voice, being rich, rough, and gravelly, seems somehow *grounded*. Consequently, I have a sense of him being 'near me', both sonically and ontologically. By contrast, Ada's voice sounds artificial, overly smooth, monotonal, and otherworldly. Floating, unanchored, in space, and appearing to exist within the main-frame of the scene whilst at the same time being elsewhere, Ada seems both removed from and intimately connected with Henry's world. In paying attention to this vocalic/sonic phenomenon, and finding it very difficult, if not impossible, to 'place' her, I find (perhaps unsurprisingly) that my attention is disorientated.

My experience of Ada as an *acousmêtre*, as the above account suggests, resulted more from my inability to *place* her than it did from my inability to visualise her as a character. In stark contrast to Mrs Rooney's momentary existence as a quasi-*acousmêtre* in the platform scene in *All That Fall*, Ada was neither here nor there. Moreover, it was precisely this radical sense of *displacement*, as opposed to disembodiment, that not only continually tugged at my awareness of Ada-as-theme, but that was also embodied in the act of attending itself. In attending Ada I was forced to attend to her in the same way in which she *attends* Henry. Like Henry, I found it impossible to hold her in grasp for long, and yearned to have some sense of her being there. Indeed, how else can Ada's sense of displacement and disembodiment be accounted for? Why does Ada sound so 'wrong'? (Worth 1981: 206).

The first and most obvious reason for Ada's apparent groundlessness is that the listener encounters her solely as a voice. As Germaine van Oene explains, 'no sound effects accompany her movements, attesting to her "existence"' (1978: 48). Moreover, and as van Oene goes on to remark, this absence 'is all the more noticeable since Henry's footsteps on the shingle and other activities sound out more realistically' (1978: 48). There is, in other words, something about Ada's voice which, when placed contiguously to that of Henry, heightens its sense of disembodiment and displacement.

Until Ada's arrival all there is to be heard, save for the sound of the sea, and the out-of-frame traces of memory, is Henry's voice and the voices he mimics or impersonates. Thus, when a voice not 'done' by Henry enters the 'soundscape' it is 'a sign that we have moved into another order of reality' (Worth 1981: 205): Henry's stumbling, cumbersome, and corporeally overloaded voice is suddenly juxtaposed with the comparatively weightless, faultless, and bodiless voice of Ada. More especially, and as my experience suggests, Ada's entry into the sound/mindscape is not experienced as a sonic or attentional incursion, but rather it is her sense of displacement itself that is rendered as attentionally thematic.

Having explored the phenomenology of muteness or being silently present, as well as some of the ways in which the absent presence of the *acousmêtric* voice is experienced in the context of radio plays, I now attend to the phenomenon of silence per se, or more specifically, to how silence can manifest as a *silentre*, a phenomenon that I first encountered and identified in listening to Pinter's *A Slight Ache*.

Sensing *silentres*: listening-in to silence in *A Slight Ache*

Written by Harold Pinter and produced by Donald McWhinnie, *A Slight Ache* was first broadcast by the BBC Third Programme on 29 July 1959.

Set within and around a large detached house in rural surroundings, the play explores the dreams, desires, and fears of a middle-class, late-middle-aged couple, Flora, played by Vivien Merchant, and Edward, the protagonist, played by Maurice Denham. The play centres on Edward's fear of the unknown, his worries concerning aging, and his fear of the Other. The third character in the play, the Matchseller, fails to utter a single word, and is consequently experienced as a surprisingly potent being of silence.

In the platform scene of *All That Fall* Mrs Rooney is mute but there is nevertheless something to be heard, namely the voices of the trialogue. In *A Slight Ache*, however, the existence and identity of the mysterious figure of the Matchseller is brought into question by the fact that he fails to make a sound of any kind, and, above all, fails to make any audible response to the barrage of questions he receives when in the company of either Edward or Flora. Indeed, the Matchseller is only brought into existence as a result of what Edward and Flora *say*: together, they provide the listener with a rich array of information as to the Matchseller's appearance, demeanour, and character. In the following extract, taken from the end of the play, Edward is heard slipping into mental and physical collapse, whilst the Matchseller, though still silent, seems more present and prepossessing than ever:

> EDWARD: [...]
> But then, the time came. I saw the wind. I saw the wind, swirling, and the dust at my back gate, lifting, and the long grass, scything together ... [*Slowly, in horror.*] You *are*
> laughing. You're laughing. Your face. Your body. [*Over-whelming nausea and horror.*] Rocking ... gasping ... rocking ... shaking ... rocking ... heaving ... rocking
> ... You're laughing at me! Aaaaahhhh!
> *The* MATCHSELLER *rises. Silence.*
> You look younger. You look extraordinarily ... youthful.
> [*Pause.*]
> [...]
> [*With great, final effort – a whisper.*] Who are you?
> (Pinter 1991: 183)

In listening to this fragment, I am immediately struck by the sound of Edward's voice, which appears tired and strained, and how certain words are especially emphasised, such as the 'are' in the expression 'You *are* laughing'. Then, I find my attentional focus switching to the auditor of Edward's utterance – namely, the unseen-unheard, but nevertheless

perceptible, figure of the Matchseller. This imaginal content is continually, though not instantaneously, modified by Edward's utterance. I notice, for instance, how thematic content metamorphoses as Edward utters the words 'Your face. Your body'. As Edward progresses towards his exasperated cry, and before silence ensues, I notice a progressive constricting of my perception of these sounds. By the time Edward roars 'Aaaaahhhh' I have almost completely dis-attended the Matchseller-as-phenomenon and perceive Edward's utterance almost entirely as sound, or rather as *noise*. Then: silence.

This, however, is no ordinary silence. This is not a mere soundless pause, but rather is a silence that has something to hide. At this moment I notice the mnestic traces of the sounds of Edward's voice, slowly giving way to the stillness. Yet, it is silence itself that dynamically occupies my attentional theme. Moreover, I find myself listening to this silence in a variety of ways. On one level, with the sonic absencing of Edward's voice, I note the emergence of 'silence' per se. In this sense, I find myself listening *to* silence. On another level, however, I find my attention drawn to what lies *within* this silence. Like the Matchseller, to whom I partially direct my attention, I find myself to be a silent-yet-present listener, listening-in to the silence of someone else. On yet another level, this act of listening-*in* to silence entails a frantic, yet ultimately fruitless, scanning of silence, marked by a dynamic sense of movement. Importantly, it is not sound that I aim to detect in these attentional search-and-find sorties, but rather the *source* of the silence that I perceive. There is, in other words, something about the particular nature of this silence that not only forces me to listen-*in* to it, but that remains indeterminate. Indeed, it is this very equivocality that makes this silence *silentric*: silence is not given as mere soundlessness but is manifestly perceived as a thing in itself, as a *silentre*.

In many respects, the *silentre* is the inverse of the *acousmêtre*: where the *acousmêtre* is an absent presence (a sounded-being whose presence somehow indicates an absence), the *silentre* is a present absence (a silent being whose absence somehow indicates a presence). Moreover, like the *acousmêtre*, the *silentre* disorientates attention, seeming to float between the realms of theme, context and margin.

Silentres, as with *acousmêtres*, can be perceived with varying degrees of acuteness and ambiguity. In listening to the above section from *A Slight Ache*, especially at the moment when Edward utters the pivotal question 'Who are you?', I noticed how my attention was directed not so much to the *identity* of the Matchseller but rather to the ontological and material status of this silent being. The phenomenology of silence

is thus not only shaped by the particularities of what we do, but by the context from and within which 'silence' stems.

> Since silence conveys nothing on its own, it is usually sensitive to context. Depending on the circumstances, silence can convey assent, dissent, or uncertainty. Its message is heavily context-dependent. (Sorensen 2009: 135)

The context of radiophonic silence is exclusively one of sound. This sonic context, moreover, is dominated by the sounding word. Speech, as my phenomenological enquiry attests, affects the listener's perception of silence in several ways. Words when spoken, especially in a purely aural medium, have a notorious tendency to outlive their own death. Speech is a phenomenon of sound, and speech-as-sound continues to resonate in the silences that it leaves behind. In broader terms, this phenomenon is an example of what Augoyard and Torgue have referred to as 'remanence', that is, the 'continuation of a sound that is no longer heard […] the mnestic trace of barely subsided sound signals' (2006: 87).

Remanence is not necessarily characterised by a distracting presence within attention. Nor is it presented at the centre of any given attentional theme. Instead, remanence is experienced *simultaneously* with thematic content. Remanence is thus inherently about simultaneity, or co-presence. As Aron Gurwitsch points out, '[h]eterogeneous and indifferent to each other as the contents might be which fill two consecutive phases of conscious life, there is, at least at the beginning of the second phase, a certain awareness, though vague, dim, and indistinct, of what has just gone' (1966: 302). It is important, therefore, not only to consider 'data which are experienced as simultaneous, but also those which are simultaneously experienced, though not as simultaneous' (Gurwitsch 1964: 2). In demonstrating this broader model of co-presence, Gurwitsch offers the following example, which, coincidentally, happens to be an emblematic example of remanence:

> [S]uppose that a musical note no longer resounds but is still retained as just having resounded. The note thus retained belongs to the total field of consciousness experienced at the moment under consideration. (1964: 2)

The phenomenon of silence is, similarly, invariably marked by the traces of the spoken word, as either sound or significance of a different order. *A Slight Ache*, however, presents a special case. In listening to

the above sound-clip, the words of Edward not only resonated within the innumerable pauses and silences that define his ongoing encounter with the Matchseller, but brought about the very existence *within* this silence of this elusive and ontologically indeterminate figure. The Matchseller, in other words, is a phenomenal product of the innate indexing capacities of spoken language: by continually pointing to the existence of the Matchseller, by means of the transcodifying nature of language-as-spoken, Edward is the maker of his own demise. However, whilst this account has undoubted validity on a representational level, it overlooks the inherent indeterminacy of the piece, a characteristic that is only revealed in the act of listening itself. The fact that my attention continually wavered between knowing and not knowing the nature and source of the silence that I encountered manifested a profound sense of unease and uncertainty. This uncertainty was not felt or realised cognitively, but rather was continually re-embodied as a result of the dynamic enactments of attention. The indeterminacy of *A Slight Ache* is played out in listening itself as the listener listens in (to) silence and, in so doing, discovers a world where nothing is certain.

John Cage has famously maintained that 'there's no such thing as silence' (cited in Kostelanetz 2003: 70). Such a position, however, and as Roy Sorensen has suggested, is 'misguided'.[9] Silence, like sound, is something which we *hear* (see Sorensen 2009).[10] Moreover, and as the above experiential example illustrates, our perception of silence varies dramatically depending on the sonic and attentional context within which it emerges.

In listening to the above scene from *A Slight Ache*, 'silence' was given as manifestly indeterminate since I was unable to ascribe it to a source.[11] The status and source of the silence that I heard was continually in flux: I found myself struggling to juggle my perception of a thing that existed *in* silence with my perception of something that existed *as* silence. Furthermore, by eavesdropping on a self that remained silent and by wondering where and to whom the silence belonged, I was effectively mirroring the actions of the play's protagonist: the ontology of the silence being uncertain, I was motivated to listen-in to silence *itself*. 'When sound that should be present is absent, this is frightening. Through silence we come face to face with ourselves' (Toop 2010: xv).[12]

Having initially sounded out the phenomenon of silence, *silentres* and silentric subjectivity in the context of radio plays, what can now be said of silence in the theatre?

The act of listening-*in* to radiophonic silence, as the expression suggests, consists of a listening that takes place remotely, or from a

distance. Furthermore, although the listener's perception of silence in radio drama will vary according to the particularities of the sound field, radiophonic silence nevertheless remains *materially* unaffected by the listener's presence or attentional participation. In this respect, one might describe radiophonic silence as being autonomous or materially immutable. By contrast, theatrical silence is not only manifestly sculpted by the manipulations of designed sound, as well as by the particular conditions within which it is experienced (such as darkness), but is also phenomenally shaped by the particular enactions, exertions and sonic idiosyncrasies of that collective gathering commonly referred to as an 'audience'.

Being in the silent crowd: shaping theatrical silence

Unlike in the case of listening to a radio play, where we can vary and control the conditions and mode of reception, *theatre-going* consists of 'a series of complex behaviours that regulate the way spectators behave to each other and to the performance and performers on stage' (Balme 2008: 37). Theatre, as Martin Welton points out, 'places social and physical constraints on its participants' (2002: 187). Moreover, '[t]hese constraints not only play a part in determining the behaviour of the participants (actors *and* spectators), but are crucially also shaped by them' (Welton 2002: 187). This inference has important consequences for our understanding of the phenomenon of theatrical silence.

Theatre not only takes place in a specialised reception environment, but this environment is populated by an 'audience' that, by its very presence and existence as a 'silent crowd', manifestly contributes to the event as it plays out. The 'silent crowd', as conceptualised by Maurice Maeterlinck, is that 'great active silence [...] the silence of many – silence multiplied – [...] whose inexplicable weight brings dread to the mightiest soul' (1897: 7–8). It is this state of being in the silent crowd that plays a vital role in shaping theatrical silence.

Since the late nineteenth century, theatre has not only required the audience to attend in darkness, but to attend in silence. The 'silent crowd', of course, is never really silent. Indeed, it is precisely the *sound* of the audience silencing itself, or holding itself together, that manifestly shapes the phenomenology of theatrical silence. In the theatre, and in stark contrast to the phenomenology of radio, the sound(s) of the audience, however subtle, discreet or seemingly unimportant, phenomenally contribute to the sonic environment within which meaning is embodied: as Gareth Fry reminds us – 'you can never achieve actual

silence' (2009: n.p.). That said, and even in cases where there is clearly something to hear, (theatrical) silence is nevertheless a phenomenon that we manifestly *experience*.

Theatrical silence is not only a phenomenon that we 'notice' (cf. Crisell 1994: 159),[13] but, like any other 'phenomenal object', is subject to considerable perceptual variation and nuance.[14] Take, for example, those instances in the theatre where the audience is plunged into abject darkness through the use of 'blackout'. Not only does the condition of darkness (or the seeming absence of light) prompt us to pay closer attention to the sound(s) of silence, but this act of attending (in) silent darkness is also invariably attended by the experience of being silently present, as a silent self, within a silent crowd. Before shedding further light on the phenomenal nuances of attending (in) silent darkness and attending (in) silence, we must first take a closer look at how theatrical silence can itself be shaped by *design*.

Manipulating silence: designed silence and the manipulation of attention in *Ether Frolics*

It is common practice for sound designers to 'create a sense of silence using noise' (Fry and Home-Cook 2009: n.p.). One means by which this can be achieved is through the use of false sound beds. To demonstrate this, and to explore how our perception of theatrical silence is shaped by the sono-attentional context in which it resides, I now turn to the example of Sound & Fury's *Ether Frolics*.

Aside from the meticulous use of designed sound, one of the most effective and longstanding means by which Sound & Fury have sought to pique the aural attentiveness of the audience is through the use of 'blackout'. With the exception of *Kursk*, the vast majority of Sound & Fury's work has been staged in partial or complete darkness. In their first show, *War Music*, a piece based on the Trojan War and staged as part of the 'Playing in the Dark' season at the Battersea Arts Centre (BAC) in 2000, the actors had to rely solely on overhead ropes to navigate the space, together with the dexterity of their voices to tell the story. Following the success of *War Music*, Sound & Fury's second production, *The Watery Part of the World*, a piece inspired by *Moby Dick* and performed at the BAC in 2003, was staged in total darkness for the majority of its 70-minute running time. What makes Sound & Fury's production of *Ether Frolics* especially noteworthy, however, is the particular ways in which false sound beds were used to manipulate the workings of aural attention and the audience's perception of theatrical silence. As the following experiential example makes clear, even silence does not escape the prestidigitations of design.

At the very beginning of *Ether Frolics* there is a total blackout. I can see nothing but an LED light purposely placed on the ceiling of an especially intimate performance space. Simultaneous with this, I find myself faced with a relentless barrage of noise, a range of cacophonous sounds (voices, equipment, electro-acoustic noises), which eventually die down, giving way to the 'silence' of the space. Then, after some time, something remarkable happens: the silence that I thought I had been listening to is suddenly 'switched off'; what I had been listening to was in fact a false sound bed. Having been abruptly removed, the false sound bed gives itself away in its very disappearance: by ceasing to sound, the fake background noise, which I had previously considered to be the actual sound of the room, resoundingly reveals itself to be 'phoney'. Yet, the sound, or rather the 'silence', that this sonic pretender leaves behind feels equally, if not more, uncanny. Having been physically present yet perceptually absent, the stealthy sound of the false sound bed gives itself away through its abrupt disappearance, somehow stealing its own stealthiness by going *out of* existence. The newly deceased false sound bed, moreover, leaves its mark on what remains: the false sound of silence somehow makes silence itself sound strange. By disappearing, the false sound bed momentarily transforms silence into silence personified; the silence that is left behind somehow takes on the persona of itself but this mask is tainted with the sound of another actor who remains silent-yet-present.

This example demonstrates how different forms of sonic stealth exploit and motivate the dynamic and polymorphic nature of attention. In attending the above scene, what had previously been resting on the margins of my attentional sphere suddenly and overwhelmingly became the focus of thematic content because of the incursiveness of its very disappearance. Being both the theme and context for the newly disclosed 'silence', the false sound bed was momentarily rendered as attentionally thematic *and* attentionally contextual. Consequently, 'played-back' silence and *actual* silence seemed to precariously co-exist within thematic content. Not only was my attention *stretched* between two themes, but these themes simultaneously provided the thematic context for one another. Thus, above all, this moment of the performance was engendered with a sense of attentional play, or, more precisely, of listening *to* silence. Hence, far from being of marginal importance to theatrical experience, silence plays a central role in the manifestation of theatrical experience. More especially, and as revealed above, the phenomenology of theatrical silence is shaped not only by the machinations of designed sound, but by the condition of darkness.

'The gesture of silence,' as Roy Sorensen affirms, 'can be amplified by darkness' (2009: 135). When perceived under such conditions, silence is not only a phenomenon that we notice, but one that invariably takes centre stage. Theatrical silence, furthermore, is inherently *phoney*: moments of 'silence' in the theatre are inevitably filled with sound and, hence, are resoundingly deceptive. Interestingly, the same can be said of theatrical darkness, as Stanton B. Garner makes clear below:

> [T]heatrical darkness is never total, never fully itself [...] Like silence – which is always rendered virtual by the inescapable sounds of a peopled auditorium – theatrical darkness is always, if only slightly, an illusion. Theatrical darkness may be a fiction, but the amount of actual darkness sufficient to signal 'darkness' nonetheless engages responses that draw upon those provoked by darkness in its absoluteness [...] We may know that stage darkness is not fully 'real,' that it is (like everything else in the play) in part sleight of hand, but this quasi darkness nonetheless draws on the phenomenon of actual darkness, engaging its experiential displacement and its distinctive perceptual unmooring. (1994: 40–41)

This extract is important for a number of reasons. First, whilst theatrical darkness, along with theatrical silence, may well be 'an illusion', theatre is a place where 'darkness' and 'silence' are nevertheless manifestly *experienced*. Furthermore, as well as drawing our attention to how phenomenal objects are perceived, Garner sheds light on the intriguing interconnection between silence and darkness in theatrical performance.

Attending (in) silent darkness: corporeal dys-appearance and the silentric self in *Kursk*

> Bodily space can be distinguished from external space and envelop its parts instead of spreading them out, because it is the darkness needed in the theatre to show up the performance, the background of somnolence or reserve of vague power against which the gesture and its aim stand out, the zone of not being *in front of which* precise beings, figures and points come to light. (Merleau-Ponty 2002: 115)

'Darkness' is used here as a metaphor for describing the necessary role that bodily space plays in the manifestation of experience. The audience in the theatre, as typically conceived, is both silent and invisible: placed in darkness, the audience attends the 'world' that unfolds before

them. Yet, as Merleau-Ponty makes clear, in order for the world to 'stand out' as a phenomenon, as something that appears, there must first be a silently present *background*, namely, the domain of the lived body. In going about its tasks, the lived body anchors itself to the perceptual object without making a sound. That said, there is an inherent tension present in the act of perception, a constant push-pull between the perceptual object and the attending subject. The 'zone of not being', in other words, is more metaphorical than literal: in the auditorium there is always 'noise' of some kind, however slight, seemingly insignificant or near-imperceptible – there is always noise in the silent 'darkness' of the audience.

'[T]he brightness of the stage and the darkness of the auditorium remain subject to some historical uncertainty' (Ridout 2006: 50). On the one hand, the evidence suggests that the pervasive trend for placing the audience in a darkened auditorium coincided with the emergence and predominance of naturalism.[15] However, whilst the invention of electricity and the rise of naturalism undoubtedly played a key role in the progressive darkening of the auditorium, it has also been suggested that the convention of enforced darkness only really came into force as a result of the development of cinema (see Schivelbusch 1988).

Despite these uncertainties, one thing seems apparent: as auditoria have become progressively darker, the audience, correspondingly, has become progressively quieter (see Welton 2012: 57).[16] There is, in other words, something about the condition and practice of attending in darkness that manifestly stills or *silences* the audience. Yet, what are the phenomenal nuances and peculiarities of being in theatrical darkness? What is 'the zone of not being', the zone of bodily space? Where do we find ourselves in theatrical darkness and what role do the senses of listening and looking play within this *zone*? How does the condition of darkness shape our perception of the sound(s) of silence and our awareness of ourselves as attending subjects? In short: what is it to attend (in) silent darkness? In responding to these questions, I now offer a description of one of the most poignant scenes from *Kursk*: the moment when the audience is plunged, seemingly in abysmal and abject darkness, into the ninth compartment of the ill-fated submarine, as it lies, imperilled, along with its crew, at the bottom of the Barents Sea.

Standing in front of the control room, directly beneath the lighting rig, my eyes fix on the action taking place in the sailors' mess, twenty or so feet away in the far left-hand corner of the space. Sitting at the table, and holding a mug of tea, Donnie Mac toasts a line of Russian dolls placed on the table. Then, after a slight pause, the lights go out.

For a split second, it feels as if I have been plunged into absolute silent darkness. Indeed, the darkness is so pitch-black that it is momentarily disorientating. This corporeal dizzying, however, quickly recedes, as my eyes, although seeing nothing, continue to look and to look hard. Having begun to acclimatise to these new conditions, and in paying greater attention to the wider context of my attentional sphere, I notice that what I had momentarily perceived as absolute silence is, in fact, full of noise. I hear the sounds of water dripping intermittently from every corner of this strange void-like hole, I hear water against metal and water against itself, the kind of sounds one might hear when taking a bath in an old iron bathtub. These sounds seem to echo around the unseen 'walls' of the environment. There is, however, something ontologically uncertain about this locale and my sense of being here. On the one hand, it is obvious that I am still in the Young Vic's Maria Theatre, surrounded by other members of the audience, who, like me, are left to feel their way around in the dark. On the other hand, it is clear (at least in diegetical terms) that this newfound setting is designed to transport us to a seemingly unimaginable place: namely, the dank, freezing conditions of the imperilled submarine.

Whilst seemingly 'immersed' in this strange watery abyss, I notice the presence of a strange ontological distancing occurring, as I strive to make sense of this environment. More precisely, I have an uncanny sense of listening-in on a scene from the margins: I find myself to be listening-*in* to a particularly confined kind of 'place'. Yet, there is something about the place, and the sound within it, that seems illusory and distant: whilst everything sounds very 'real', there is something about being here, in the darkness, that borders on the surreal.

As I listen more acutely, I notice a trembling, pulsing breathiness sounding somewhere in the darkness. Then, a voice appears from nowhere, washing over all of the other sounds. Whilst still present, the sounds of drips, creaks, and water are instantly marginalised by the force, amplitude, and corporeal fleshiness of this tragic yet beautifully sonorous speech body: being in complete darkness and speaking in Russian, a language of which I understand very little, this voice is overwhelmingly given as *sound*. Far from indexing a body or an unseen source, this voice *is* the body, soul and mind, indeed, *the person*, of the imperilled Russian sailor. I experience this speech body to exist dynamically in space, my eyes helping me to locate it. This uncanny figure of sound is ambiguously grounded within an audiovisual setting: all around me, the sounds of water and drips merge with imaginal content; I see the grey surface of the icy water as it envelops the speech body,

I see-and-hear the cold, black, metallic walls of the submarine creaking and groaning under pressure of collapse. After some delay, another voice enters the sound field. Whilst being loud, these voices speak in hushed, short, quivering sentences. One voice sounds, followed by an indeterminate self-presencing pause. These pauses seem to get longer and longer, as the voices of the sailors slowly fade away. Conversely, the sounds of shivering, drips, and creaks gradually increase, both in volume and intensity. This dark crescendo rises to an uneasy and uncomfortable pitch, like a passage from Stravinsky's *Rite of Spring*. Then, as in the final moments of death, a sense of calm descends. The shivers diminish and quieten, until, finally, they expire. With the voices now gone, the audience is suddenly, and in every sense, left in the dark – left in the void of silence. Resembling the kind of silence one finds at funerals, the silence of remembrance, I notice an intersubjective sense of loss, alienation, and self-reflection; a sense of being in 'the zone of not being'; a sense of existing as a *silentre*. Finally, and all of a sudden, this poignant, unforgettable moment is punctured by the audiovisual incursion of Eminem's 'The Real Slim Shady', together with the ultimate wake-up call: light.

We might assume that the experience of being in theatrical darkness, like that of being 'immersed' in sound, consists of a certain three-dimensional, all-encompassing stasis. One might also assume that, under such conditions, one would have to rely almost entirely upon the auditory sense, the eyes presumably being made redundant. One might further surmise that the experience of being placed in pitch-black darkness might approximate, or, indeed, be synonymous with, the 'world' as experienced by the blind. Such assumptions, however, are unfounded.

In narrating his own journey from the onset of sight loss, John Hull provides the following description of the 'world of sound' (1990: 61) as he experiences it:

> Mine is not a world of being; it is a world of becoming. The world of being, the silent, still world where things simply are, that does not exist. The rockery, the pavilion, the skyline of high-rise flats, the flag-poles over the cricket ground, none of this is really there. The world of happenings, of movement and conflict, that is there. The acoustic world is [...] a world which comes to me, which springs into life for me, which has no existence apart from its life *towards me*. (1990: 63; emphasis added)

As Hull's account suggests, the 'world of sound', as experienced by people with sight loss, acts exclusively *upon* the percipient. To exist within

this fleeting, ever-changing world of becoming is to be a passive, somewhat static, receiver of sound. Importantly, Hull's phenomenological account of blindness differs significantly from my experience of attending (in) silent darkness in Sound & Fury's *Kursk*. Whilst my sense of spatiality was to some extent compressed by the condition of darkness, I was nevertheless able to *sound* space.

The reason for this, I suggest, is related to the manifold ways in which the senses co-opt one another, thus enabling the percipient to engage dynamically with his or her surroundings. In attending the above scene in *Kursk*, the fact of having my eyes open, or rather of being able to *see* in darkness, played a vital role in my ability to dynamically engage with the affordances of the theatrical environment: being able to see, whether in darkness or in light, activates listening and renders it dynamic. For those with sight loss, however, this sense of movement in perception is dramatically cut short, or, as Hull puts it, '[o]ne loses territory' (1990: 40). The experience of being blind is, thus, *not* synonymous with the experience of being in the dark.

Theatrical darkness, like theatrical silence, is subject to perceptual variation and nuance. In attending the above scene, I became aware of myself as a silently present attending subject: I experienced myself to be 'the background of somnolence', the darkness within the darkness. More especially, this experience of attending *from the margins*, or of being in 'the zone of not being', was materialised, at least in part, by the particular ways in which the designed theatrical environment (with its displaced *acousmêtric* voices and sounds) stretched and disorientated my attention.

Whilst the scene described above may not appear to be the most 'silent' of scenes, there was, nevertheless, something about the use of designed sound at this moment that manifestly adumbrated an experience of being-silent, or, more specifically, of being silently present. This particular mode of subjectivity in attending, moreover, was tinged with a distinct feeling of displacement and alienation, the voices and sounds appearing to be strangely 'out of reach'.

Our experience of silence, as phenomenological investigation reveals, is distinctly affected by the sono-attentional context in which it is phenomenally enmeshed. In particular, speech or the phenomenon of voice can shape our perception of silence in complex and surprising ways. Indeed, what made the moment of prolonged silence at the end of the scene described above particularly poignant was the manner in which silence, pause and sounds dynamically co-existed alongside the ghost-like voices of the Russian submariners.

Most of the sounds heard throughout *Kursk*, the voice included, were mediated in some way.[17] What made the sounds in the above scene especially noteworthy, however, was that they appeared to belong *elsewhere*, and seemed somehow exaggerated and overly enlarged. Rather than registering as a cacophony, however, these drips, creaks and groans were noticeably intermittent, making their presence felt within the silent pauses of the dark. Emanating from this dark, watery, and ever-present sound-world, the voices of the imperilled submariners resounded, continually drawing my attention to their mediated character. Moreover, it was not the fact of their mediation *as voice* that brought their ontological status into question, but rather the particular, indeed peculiar, ways in which this scene *motivated* my imagination.

Edward S. Casey has suggested that imagining, as a mental act, occurs in three ways: 'imaging', 'imagining-that' and 'imagining-how' (2000: 41 ff.). Of these latter two forms of imagining, Casey provides the following distinction:

> Imagining-how [...] is to imagine *what it would be like if such-and-such a state of affairs were to obtain* [...] [whereas, 'imagining-that' involves] entertaining an imagined state of affairs in which he [...] is envisaged as *himself an active and embodied participant* [...] In other words, there is a sense of *personal agency*, of the imaginer's own involvement in what is being imagined. (2000: 45; *sic*)

In the above example, I was required to imagine-that the voices that were being played back for our attention were, in fact, emanating from the ninth compartment of the *Kursk*. One might assume that this task would not be too difficult to enact: the audience, being *amongst* the voices of the Russian sailors, were placed at the very centre of the diegesis. Similarly, and like the imperilled submariners, the audience was plunged into pitch-black darkness. Yet, and as Martin Welton notes, 'it is relatively rare that darkness endures as the state within which both audience and actors find themselves for the majority or totality of the duration of the performance. Rarer still is the actuality of darkness per se; light simply abounds' (2012: 52). On every occasion that I witnessed this scene (seven in total) there was always a speck of light emanating from somewhere in the performance space, whether the light of an LED, the greenish light seeping out of an incompletely cloaked Exit sign, or the light emitted from someone's mobile telephone. All this served to remind me that

theatrical darkness, like silence, is never absolute. Thus, and despite the assertions of one of its critics, this production *did* invite the audience to 'imagine the unimaginable' (cf. Rees 2009). Furthermore, what made this moment of the performance especially interesting is that the particular state of being that was manifested in attending this scene was not only sensitive to the plight of the submariners, but also instilled it with a sense of theatrical poignancy, and most of all a sense of being silently present.

The directors decided not only to use the recorded voices of two Russian actors, but to make these voices and the corresponding sonic environment sound slightly alien; that is to say, they created a sonic heterotopia within which the audience were paradoxically both present at the centre and absent on the margins. As a result of the specific use of designed sound and by placing the audience in darkness, this moment motivated a kind of phenomenal and ontological bracketing within experience. Far from experiencing myself to be 'immersed' at the centre of the 'soundscape', instead I felt alone and abstracted, existing as a *silentric* self.

In developing the notion of the 'auditory self', Steven Connor has suggested that '[t]o begin to experience *oneself* as an acousmêtric phenomenon could either be anguish or enlargement, or both' (1997: 219, 222). What, then, might it be like to experience ourselves as a silentric phenomenon? Whilst the *silentre* can neither be seen or heard, its presence, or rather its absence, can nevertheless be 'felt'. Indeed, felt absence is fundamental to its phenomenology: to experience ourselves *silentrically* is to have the uncanny, equivocal sensation of being present *as* absent.

When attending the voices of the submariners, and in resonance with my experience of listening to *All That Fall,* it was almost as if, at times, I was simultaneously listening-in on the inner consciousness and conscious experience of an Other. Although sonically and diegetically 'grounded' within a defined spatio-sonic setting, these voices nevertheless seemed somehow 'out of place', or somehow not altogether 'there'. This sense of displacement was brought on by the fact that their place, both sonically and materially, was not altogether ours: whilst it may have seemed as if we might momentarily co-habit or share the same space as these voices, in reality, the audience, like the British submarine and her crew, were so close and yet so far.

The silentric self is thus characterised by feelings of estrangement, loss, dys-placement (as in a feeling of spatial uncertainty or indeterminacy), as well as a feeling of being presently absent. For Jean-Luc Nancy,

listening consists not so much of a presence, but rather 'a presence of presence' (2007: 16). Yet, and as my encounter with *A Slight Ache* attests, in the case of the silentric self one encounters a presencing of one's own ontological *absence*; one has a feeling of 'listening-*in*', as opposed to an unimpeded and direct sense of 'listening to'. To listen silentrically is therefore to experience the uncanny, dynamic and contingent experience of being in 'the zone of not being'.

We perceive the world by means of the lived body. In perception, as Merleau-Ponty explains, 'we do not think the object and we do not think ourselves thinking it, we are given over to the object and we merge into this body which is better informed than we are about the world, and about the motives we have and the means at our disposal for synthesizing it' (2002: 277). In perceiving, in other words, we enter the space of a kind of 'virtual body', which exists dynamically in relation to its perceptual tasks (Merleau-Ponty 2002: 291 ff.). However, in the scene described above, the relationship between the perceptual body and the perceptual object was, in all senses, *troubled*. There was something about the voices of the submariners that meant that I experienced myself as being only partially (and thus incompletely) given over to the object(s) of my attention. It felt as if I was in two places at once, existing precariously between two ontological stools. This analogy works better than the notion of ambiguity, since experiencing oneself as a silentric phenomenon is to experience and to exist within the tensions and contradictions of this phenomenal paradox: namely, being present as absent, or being present *as an absence*. Hence, silentric experience might be described as experiencing the profound disjuncture of being there *by* not being there. By experiencing oneself to be ontologically and corporeally displaced from the object of perception one experiences the silent, silentric state of being-away from Being. Indeed, it is this state of corporeal absence that this moment of *Kursk* manifestly foregrounds. More precisely, this silentric state of being arose as a result of the particular ways in which the above scene manipulated, stretched and temporarily dys-placed the lived body.

> In the modes of disappearance [...] the body is away from direct experience. This could be called a *primary absence*. It is the self-effacement that first allows the body to open out onto a world. In dys-appearance the body folds back upon itself. Yet this mode of self-presence constitutes a *secondary absence*; the body is away from the ordinary or desired state, from itself, and perhaps from the experienced 'I' [...] No longer absent *from* experience, the body may yet

surface as an absence, a being-away *within* experience [...] One is a mode of silence, the other a manner of speech, yet they are complementary and correlative phenomena. (Leder 1990: 90–91)

Earlier I described a phenomenal dys-juncture that attending *Kursk* made manifest: the voices of the Russian sailors were so close sonically, yet so far ontologically. In attending this dys-juncture by means of scanning the environment, I was called upon to navigate, accommodate and make sense of that which was 'given'. Moreover, in attending this moment I experienced the kinds of '*secondary absence*' characterised by bodily dys-appearance. The quasi-*acousmêtric* nature of the sailors' voices and the silent pauses within which these speech bodies *dys-appeared*, generated an uncanny sense of 'being-away *within* experience' (Leder 1990: 91). As Leder points out, in the usual modes of disappearance, the lived body is 'alien-as-forgotten' (1990: 91), indeed, silent. Yet, when the lived body dys-appears it becomes alien 'as-remembered' (Leder 1990: 91). Similarly, in experiencing this unforgettable moment of silence, my lived body, the body that had otherwise been in the background, been in 'the zone of not being', began to *dys*-appear. Indeed, to some extent, this self-presencing of the body that occurs in silence, as well as in darkness, *is* the 'sound of silence'.

Don Ihde has maintained that '[s]ilence is the horizon which is reached but never given' (1970: 22. Yet, whilst defined as an absence of sound, 'silence' is nevertheless a phenomenon that we manifestly *perceive*.

As I listened in silence, in the dark, to the fading voice of the Russian sailors, I noticed how my lived body was foregrounded as an alien presence that, in turn, manifestly drew attention to the co-existence of a silentric self, a self that registered as a present absence. Not only was I quite literally 'in the background' at this moment, but this sense of *being* in the background was strangely brought to the fore, and tempered with a distinct sense of dys-placement and loss. Importantly, these ontological and phenomenological manifestations of listening served only to punctuate the inexpressible meaning of the piece: namely, the acute and agonising sense of helplessness that must have been felt by the British submariners as they listened in vain, and in silence, to the sound of the *Kursk* on her death bed.

There is therefore often a correspondence between represented meaning and meaning as embodied by the act of theatrical attending. In developing this idea, and as a means of further investigating the phenomenology of attending (in) silence, I return once again to my experience of attending Castellucci's *Purgatorio*.

Attending (in) silence: intersubjectivity and the purgatory of listening in *Purgatorio*[18]

In *Purgatorio*, 'Purgatory' is not only staged but *embodied*. Through the use of pause, stillness and silence, and by filling this void with the over-amplified sounds of the everyday, *Purgatorio* stretches our perception of time, and, consequently, makes us wait. In so doing, Castellucci creates an attentional environment that coerces the listener-spectator to embody and experience precisely what he seeks to represent: purgatory – the pain of waiting for pain or the tortuous experience of confronting the inevitable and predetermined consequences of our actions. The condition of waiting is of course fundamental to Purgatory, as Castellucci suggests below:

> In *Purgatorio* a displacement is experienced: the feeling of being in a waiting zone, an interval, a middle ground of some sort between being and not being, between thoughts and language, in a realm of hallucination of the unconscious, brandished with force in the fullness of a presumed possible narration. (2009: n.p.)

This sense of waiting was brought into particular relief during the scene changes, the sounds of which echoed in such a way as to resemble the purgatorial recesses of the mind. The amplified 'noise' of the scene changes was counterpointed with a phenomenon of surreal beauty: the silent movement of the curtain. Indeed, almost everything in *Purgatorio* would seem to have been amplified except for the curtain. Within an otherwise noisy world, the silent and effortlessly serene movement of the curtain stood out, for a moment, as an attentional theme. Being completely silent (so silent, in fact, that it was endowed with a spooky, even ominous quality), I became transfixed by its movement. Whilst I could see this vast, velvety wall of opulent red slowly moving downwards towards the stage, the *sonic* dimensions of this movement remained perceptually, though not attentionally, absent.

> Like the human body, theatre is a noisy organism, and theatre sound is the sound of that noisy organism holding itself still [...] Theatre buildings are sonically alive in their managed airflows; in their thermodynamically expanding and contracting materials; in their permeability to outside noise and in the living bodies which they contain. A potent presence lurks in this organic architecture of noise. (Brown 2010a: 78)

It is this 'potent presence' of ambient noise that *Purgatorio* exploits to manifest a purgatorial experience. To speak of Purgatory is of course to speak of that in-between place or state of excruciating limbo, boredom, waiting, self-reflection and purgation that is said to exist betwixt heaven and hell. Purgatory is a place of purification and temporal torture, where we are forced to suffer the agony of confronting ourselves and our shortcomings for an indeterminate period of time in a state of active passivity, from which there is no escape and to which there is seemingly no end.

> Purgatory exists in the interval of atonement of the expiating souls found, from time to time, in the feverish awaiting to show a bond, yet to be undone, with the world of the living. (Castellucci 2009: n.p.)

What, then, might a purgatory of listening sound or feel like? To experience the *purgatory of listening* is to be forced to be in attendance: to wait upon, to wait silently, or not so silently, in the background; to wait upon every word and sound in an agonising state of temporal indeterminacy and uncertainty. Following on from this, listening can often be painful or excruciating: in the theatre, as well as in life, we are sometimes called upon to listen to unbearable acts being performed on or offstage, to 'eavesdrop' upon the sounds of pain, suffering and violence: this is the anguish of helplessly attending (in) silence to the troubled cry for help of an Other, or, if you will, of helplessly listening-in on Sin. Then, there is the pain of having to endure unbearably loud sound or noise. Correspondingly, there are those moments of 'awkward silence' where the sound of ourselves as dysfunctional intersubjective beings screams from a speechless and pervasive silence. Finally, listening can be *purgative*: listening often prompts us to attend to the ways in which we perceive the world. In listening we stand back from ourselves as we attend; we perform a partial phenomenological reduction from which a purer sense of self, and our own contingent unfinished nature, emerges.

'[I]mmersing yourself in silence,' writes Michel Serres, 'is a form of healing' (2008: 88). Listening can thus not only resemble a kind of purgatory, but can also create a purgative space. In the theatre, especially during moments of lull, silence, hiatus or limbo, listening creates a space of self-reflection where the meaning of the piece exists, in part, in our embodied collective attendance. In the case of attending *Purgatorio*, this was most notably felt in moments of 'silence' or where one was made to listen-in on the unseen sin of an Other.

From the very beginning of *Purgatorio* there is an atmosphere of fore-boding; somehow, all is not well within a family that seems to have everything except love, peace and happiness. In the first scene, the 'phoney', heightened sounds of domesticity are severed by two utterances: the unanswered caring call of a mother (who asks her child if he has 'another one of [his] headaches') and the solitary, ominous question posed by her son who asks 'is he coming home?'. The cries of abuse, suffering and pain sound out from behind this mask of visual opulence.

The agony of Purgatory is, in part, its predetermined temporal indeterminacy: it is preordained that it will last for an indeterminate period of time. This is the essence of waiting and as I sat with my fellow theatregoers waiting in the auditorium I could do nothing else but attend, more and more acutely, and from a position of active passivity. This state of being reached its zenith when the moment that I had been waiting for, but could not bear to watch, was played out offstage, thus forcing me to watch-with-my-ears.

The father, 'La Troisième Étoile' (played by Sergio Scarlatella), comes home and asks for his hat, so that he can play cowboys and Indians once again with his son. The mother at first resists, pleading with him to swim against the tide of perverse and obscene desire. The father ignores the cries and tears of his powerless wife, and calmly takes his son's hand, leading him upstairs into an undisclosed, unknown room. Then, for what seems like an eternity, the audience is made to sit and listen to the muffled groans and grotesque sounds of a child being sexually abused: we are forced to listen-in on Sin, to silently attend the unseen-yet-audible sin of an Other, to experience the purgatory of listening. This torture of the stretcher is extended by the agony of time. Moreover, this moment of silent listening draws attention not only to listening as act, but to the sense of listening-in *together*.

As I attend this scene, I can sense the collective responsibility of being witness to this unseen-yet-heard act of offstage violence. Whilst being subjected to the intermittent offstage sounds of abuse, two words appear on an invisible gauze that separates the audience from the stage: 'The Music'. This device not only provokes a hideous juxtaposition between the seen (the beauty implied and embodied in the idea of 'music') and the heard (the unspeakable sounds of abuse), but underlines the horrendous contrapunctuality of this moment. The disturbing sounds of abuse are not continuous, but are instead *counterpointed* and interspersed with periods of silence. In the silent pauses that counterpoint the sounds of abuse we are made to sit, wait and listen to the sounds of silence and to the sound of ourselves as we attend (in) silence.

Theatrical silence is thus *shaped* not only by the subtle (or sometimes not so subtle) manipulations of sound design, but also by the particular ways in which such intended sonic affordances are attended by the intersubjective enactions of the audience. Unlike the case of attending radio drama, the act of attending theatre not only entails an act of collective and embodied participation but is one that plays a vital role in shaping the conditions, behaviour and, ultimately, the experience that is engendered and motivated by the theatrical event itself. Radio drama, unlike theatre, as McWhinnie rightly points out, 'cannot offer the sheer physical release, *the social experience of the theatre*' (1959: 43; emphasis added). By contrast, and as my experience of attending *Purgatorio* attests, the presence of the listener-spectator within the theatrical environment plays a critical role not only in shaping theatrical experience, but in shaping the audience's perception of theatrical sound.

As Ross Brown has upheld, 'a sonic environment is, to an extent, *produced by the subjectivity* of its inhabitants' (2010a: 128). More especially, and as he goes on to point out, 'the relationship between the individual conscious *attention* and the environment changes continuously during the course of a live theatre performance, and has a modulating effect on the way sound is perceived' (Brown 2010a: 130; emphasis added). A model of theatrical attending, however, must accommodate the *intersubjective*, as well as the 'subjective', dimensions of the theatrical phenomenon. The act of theatregoing, unlike that of listening to radio plays, is not a solitary activity but is something which is done *collectively*.

As suggested earlier in Chapter 1, theatregoing would appear to consist of a curious contradiction or tension between being part of a group of people who collectively hear (namely, an 'audience'), and simultaneously being an individual onlooker who sees (namely, a 'spectator'). Yet, this division only serves to highlight the ways in which theorisations of theatre have placed the sensory modalities into discrete boxes. Listening is not discrete from looking, and, likewise, audiencing is not discrete from spectating, rather they comprise the same activity: '*dynamic embodied attending in the world*' (Arvidson 2006: 7). Moreover, to conceptualise hearing, or the act of audiencing, in collective terms, whilst restricting the act of theatrical looking to a singular, solitary act, is to neglect the phenomenal nuances and intersensorial dynamics of being a listener-spectator. So, why is it that the act of 'spectating' is depicted in individualistic terms, whilst 'audiencing' is said to be a collective activity? Part of the reason for this division has to do with the nature of auditory perception and the phenomenology of sound.

We commonly refer to the space where the audience attend as the 'auditorium', partly because it is necessary to sit quietly as a group in order to give the performance our fullest attention. If the audience sat there and made a fearful din, the theatregoers would still be able to perceive, unhindered, the visual aspects of the presentation before them. In other words, we do not need the phenomenon of sound in order to see things in the medium of light. Conversely, the listener's ability to hear discrete phenomena, or to single out particular sound events within a given sonic environment, depends upon the degree of noise, or thematically irrelevant sound, within that environment. If the audience do not quieten themselves before, as well as during, a theatrical performance, their ability to perceive the meaning as inscribed and conveyed by theatrical sound will be adversely affected. That is, in order for members of an 'audience', or a group of theatregoers, to attend a performance they must quieten themselves as a group in order to be able to hear as individuals. This intersubjective act of quietening, moreover, plays a vital role in the process of shaping theatrical silence.

Silence in the theatre, as the above example from *Purgatorio* illustrates, is not only a phenomenon that is noticed, but one which, to varying degrees, is manifested and maintained as a result of this intersubjective act of noticing. Theatrical 'silence', in other words, is not only characterised by the phenomenal emergence of an absence of meaningful sound, but is itself manipulated (or held in grasp), by all concerned, in such a way as to endow it with a particular hue, effect, or significance. Indeed, the intersubjective act of attending (in) silence is more nuanced than we might otherwise suspect. In the scene described above, for instance, Castellucci takes full advantage of that well-known yet largely under-thematised phenomenon: the awkward silence.

Materially speaking, there is nothing inherently 'awkward' about silence. Rather, it is the particular semantic, sociological and sonic context in which a given moment of silence materialises that can manifest feelings of awkwardness-in-silence. In moments of awkward silence we are made acutely aware not only of the fact of silence itself, but also of our own uncomfortable existence as silently present subjects within a larger collectivity of silent selves. 'Silent listening,' as Ross Brown has suggested, 'is socially anxious and anxiety is like noise' (2011: 11). Likewise, in attending the above moment of *Purgatorio*, I was not only required, along with my fellow theatregoers, to listen (in silence) to the sounds, cries and excruciating pauses of an unseen-yet-heard heinous act of depravity, but was also forcibly made to endure, and

consequently to *attend*, the silences that punctuated and framed these unthinkable sounds.

Silence, or the relative absence of sound, affects attention in curious ways. First, there would appear to be something in particular about the phenomenon of silence that motivates us to *sound out*, or pay greater attention to, the wider parameters of our environment.[19] More precisely, phenomenal experience seems to suggest that in moments of silence, pause or comparative quiet, thematic attention is not only piqued, but the context of attention, or the wider 'sphere' of attentional significance, is *enlarged*.[20] In attending the above scene from *Purgatorio*, for example, I was made acutely aware of my existence within a broader 'congregation of listeners' (Brown 2010a: 6). In the silent pauses that counterpointed the sounds of abuse, the audience was obliged to anxiously sit, wait and listen, not only to the sounds of silence, but also to the sounds of ourselves attending *in* silence. Furthermore, and as I have already suggested elsewhere, this intersubjective act of attending (in) silence was attended by a particular 'atmosphere' (see Home-Cook 2011a).

In describing the abuse scene in *Purgatorio*, Stamatia Neofytou-Georgiou notes that 'the alternation of silence and the boy's voice with the sounds that are heard compose a really pressing atmosphere' (2010: 14). However, the 'pressing atmosphere' of which Neofytou-Georgiou speaks was generated not only as a result of the particular employment of designed sound (whether music, silence, speech, or other sonic phenomena), but also by the audience. As I demonstrate in the next chapter, whilst designed sound plays a crucial role in the manifestation of 'atmosphere', theatrical atmospheres are materialised as a result of the interplay between the material conditions of the designed theatrical environment *and* the intersubjective attentional enactments of the listener-spectator. Yet, what does it mean to *sense*, or make sense of, the designed theatrical environment or 'atmosphere'? What is it to be *in* sound, and how accurate, or indeed useful, are the notions of 'immersion' and 'soundscape' for conceptualising this experience? These are the broader questions, relating to aural experience, percipience and dynamic embodied attending, that Chapter 4, 'Sensing Atmospheres', seeks to explore.

4
Sensing Atmospheres

> We know that we live immersed in a vast but invisible
> ocean of air which surrounds us and permeates us and
> without which our life must necessarily escape us [...]
> But the air that is breathed is not neutral or lifeless,
> for it has its life in *sound* and *voice* [...] For the human
> listener there is a multiplicity of senses in which *there
> is word in the wind*. (Ihde 2007: 3–4)

We exist within an *atmosphere*, 'a sphere of vapour',[1] within which we
are inescapably 'immersed'. Furthermore, this 'atmosphere' is filled,
indeed flooded, with noise. Yet, what is it to be *immersed* in the 'atmos-
phere' of sound and what is the phenomenal nature of (aural) immer-
sion as lived?

Being all-encompassing, ubiquitous and inescapable, the notion of
immersion, like that of atmosphere, is as elusive as it is familiar. Take, for
instance, the notion of being 'immersed in sound'. Whilst sound, like the
air we breathe, would seem to surround us, it also invades us, appearing
to make contact with our very being. Similarly, whilst the listener resides
in the medium of sound, this medium must be attended, explored and
travelled through. Being-in-sound, like being-in-the-world, does not con-
sist of a static, passive and spherical existence, but is characterised by a
dynamic, three-dimensional, ongoing engagement with any given sonic
environment: *sound is sounded*.

The world of sound is thus only 'spherical' in the sense of being
three-dimensional. The phenomenon of immersion, in other words,
like attentional life in general, consists of a dynamic *tension*. We are
immersed in an 'atmosphere', yet, at the same time, 'atmospheres' are felt,
noticed, and *sensed*. Whilst we exist inescapably within an environment,

131

we also, and of necessity, continually pay attention *to* that environment. Indeed, in many respects, immersion *is* 'dynamic embodied attending in the world': to be immersed, whether in sound or in the world at large, is to *live through* the flows, tensions, and perceptual peculiarities that are continually played out within our attentional 'sphere'. Such an inference not only challenges preconceived notions of sonic experience, but of percipience at large.

At first sight, visual perception would appear to engender a sense of detachment; sound 'incorporates' (or 'immerses') whilst sight 'isolates' (see Ong 1982: 72). This commonly held distinction is, however, undermined by the fact that we are as 'immersed in air and *light*' as we are 'immersed in sound' (Serres 1995: 7; emphasis added). Indeed, and as Tim Ingold has questioned, 'why do we so readily assume on the one hand that we see things rather than light, but on the other that we hear sound rather than things?' (2005: 98). In tackling this problem, Ingold urges us to reconsider perceptual experience and our encounter with the environment using metaphors drawn from meteorology:

> [L]ooking out at the sea we saw a world in movement, in flux and becoming, a world of ocean and sky, a weather-world. We saw a *world without objects* [...] Far from being disclosed to us as targets of perception, waves, wind and sky were present as an all-encompassing experience of sound, light and feeling – that is, an *atmosphere* [...] The breaking waves *were* their sound, not objects that make a sound; the wind *was* its feel, not an object touched; the sky *was* light, not something seen in the light. (2011: 131, 134)

Ingold's notion of a 'weather world' not only navigates the tendency to pitch sound against sight, but also invites us to explore the multifarious ways in which we make sense of the environment or 'atmosphere' within which we are 'immersed'. Yet, what is it to be immersed in the environment, and is this state of being-*in* synonymous with the notion of immersion as straightforwardly conceived? What does it mean to be immersed in sound and how appropriate is the notion of a 'soundscape' as a means of describing our engagement with the sonic environment? What is it both to sense and make sense of the *theatrical* environment or 'atmosphere'? What precisely are atmospheres, how are they perceived, and what role does the listener-spectator play in their manifestation? In seeking answers to these questions, this chapter invites the reader to reconsider the notion of immersion in *dynamic* terms.

To be 'immersed' (in the 'atmosphere') is not only to be 'plunged'[2] *into* the world, but to make sense of it. Likewise, our experience of being-in-sound is not one of straightforward immersion, but consists of an ongoing and dynamic process of embodied attending.

Immersion and immersive theatre

The notion of immersion would appear to be the buzzword of the moment.[3] Not only is there an increasing tendency to describe and configure works of art, exhibitions, computer games, concerts, and performance events in terms of 'immersivity', but the trope of immersion has been invoked as a new paradigm for conceptualising twenty-first-century culture and subjectivity. Ross Brown, for instance, has suggested that we might be entering a new era of immersed subjectivity as a result of 'the increasingly opaque omnipresence of noise in our daily lives' (2010a: 1). In many ways, Brown's claim is indisputable: noise – indeed, sound of any kind – affects and shapes the way we act. Hence, given the sociological, phenomenal and ontological impact that sound has on our lives, why should we call into question the notion of aural 'immersion'?

Derrida once spoke of his aim to 'make enigmatic what one thinks when one understands the words "proximity," "immediacy," [and] "presence"' (1976: 70). Likewise, and far from advocating a wholesale rejection of 'immersion', my intention is to render unfamiliar the familiar notion of being 'immersed', or, more specifically, of 'being immersed in *sound*'. Moreover, since we are concerned with the nature of immersion as both staged and experienced within the context of *theatrical performance*, immersive theatre naturally presents itself as a useful testbed for such an investigation. My primary intention, in other words, is not to provide an analysis of immersivity as a socio-cultural trend, nor is it my aim to engage with current debate concerning the nature of 'immersive theatre' as a newly emerging style or brand of performance. Rather, immersive theatre is used as a *vehicle* for exploring the phenomenal dynamics of immersion.

If one were to identify a key trend in British theatre in the last few years one might well point to the rise of immersive theatre.[4] '"Immersive theatre",' as Gareth White has remarked, 'has become a widely adopted term to designate a trend for performances which use installations and expansive environments, which have mobile audiences, and which invite audience participation' (2012: 1). The concept of immersive theatre has been invoked to describe a 'diverse' range of performance work.[5] This diversity not only reflects the slipperiness and

all-encompassing nature of 'immersion' as concept, but also illustrates some of the ways in which immersive experience has become commoditised. In contrast to the alleged passivity and detachment of conventional spectatorship, immersive theatre claims to break down (or even to annihilate) the audience/stage divide, and to invite the audience to actively participate in the theatrical event. Immersive theatre thus not only promises, but *trades on* its ability to provide a particular (though paradoxically undefined) all-encompassing, multi-sensory, participatory 'experience'.

Theatre that advertises itself as 'immersive' lays claim to a greater degree of viscerality, immediacy and authenticity of experience than bulk standard non-immersive productions: immersive theatre claims to be able to 'plunge' the audience not only into the world of the performance, but into the world of experience. To be more precise: immersive theatre is about manifesting an experience of *being immersed*, and one of the most readily apparent and effective means by which this new brand of theatre attempts to realise this state is through the use of sound.

Whenever a performance deploys sound in ways that go beyond a straightforward programmatic usage, critics are quick to label the piece under the rubric of 'immersive theatre', an emblematic example of this being Sound & Fury's *Kursk*. Yet, if we are to use the term 'immersive' or 'immersion' to describe the particular experience that is supposedly encountered in attending certain kinds of theatrical performance, then we must do so critically.[6] Moreover, if we are to use the concept of 'immersion' in any meaningful way with respect to experience more generally, then we must begin to account for its phenomenology.

What precisely do we mean when we speak of being immersed and what is it to be immersed in sound? What does it mean to describe a piece of theatre as being 'in all senses, immersive'[7] and what can we learn about the phenomenon of 'being immersed' by attending immersive theatre? In seeking answers to these questions, the next section investigates the nature of 'immersion' as embodied by and experienced in Sound & Fury's *Kursk*.

Being below the waves: investigating immersion in Sound & Fury's *Kursk*

There is a natural tendency to conceptualise our experience of being-in-sound through the use of aquatic metaphors, such as, being bathed or 'immersed'. Interestingly, this watery association is inscribed in the

word 'sound' itself.[8] As well as referring to the emanation of sound produced by an object when caused to resonate, 'to sound' means to investigate, dive, or, more specifically, to ascertain the depth of water. Indeed, it is this age-old fraternity between sound and water that Sound & Fury's *Kursk* not only exploits, but manifestly *stages*. By situating the audience within the sonic environment of a submarine (a vessel which itself is not only submersed in water but that engages in acts of sounding), *Kursk* invited the audience to experience what it feels like to be below the waves, to be 'immersed in sound'.

Kursk has been heralded as a benchmark example of immersive theatre.[9] Although the quality of the script, the accuracy and detail of the technical jargon, and the quality of the acting did much to situate the piece, arguably it was its design that did most to get the audience affectively and attentively 'on board'.

Through its meticulous use of scenography, *Kursk* attempted to replicate, as far as possible, the material conditions of being aboard a British Hunter-Killer Trafalgar Class nuclear submarine.[10] The set, designed by Jon Bausor, consisted of a steel gallery running around the top of the theatre, and an open-plan performance space below, comprising a captain's cabin, a sailors' mess, sleeping quarters, showers, lavatories, a torpedo tube, and a control room (complete with periscope, conning tower, computer screens, extended lead microphones and a chart table). The space was also often dimly lit, thus intensifying the experience of being within the gloomy, confined, underwater world of a nuclear submarine. Being forced to share these conditions with the crew/cast, the audience was given the choice of either perching, uncomfortably, on bus-stop-style steel lintels from the upper gallery, or of descending into the control room, where one could either sit or stand amidst navigational screens, wires, and scaffolding. In *Kursk*, there was no division between audience and performer, auditorium and stage, no 'off-stage' as such, merely gallons of unimaginable water.

Yet, despite going to great lengths to situate the audience within the fictionalised space of a British submarine, one must question the extent to which the scenography, along with the performance space in general, offered the audience an 'authentic', or 'full-on', immersive experience of being aboard such a vessel.[11] For one thing, there was far too much space surrounding the audience to create anything like the close, claustrophobic conditions found within the mess or control room of an actual submarine. Whilst the set gave a very clear and detailed impression of where we were, there was an incompleteness to the

setting that nevertheless required the audience to work with what they were 'given'. Indeed, *Kursk*'s ability to foster a sense of 'being immersed' within the world of a submarine lay not so much in its use of scenography, but in its award-winning use of *sound*.[12]

Through its sophisticated use of multi-channel playback sound technology, *Kursk* attempted to create the 'sonic equivalent of a virtual submarine' (see Sound & Fury website).[13] The sound system consisted of no fewer than eighteen speakers: four in each corner of the space facing inwards; four overhead (which were used, for example, to create the helicopter sound at the end); eight small speakers embedded within the set; and two large subwoofers (or 'subs'), which 'rumbled almost throughout, being turned off only at the North Pole' (Jones and Home-Cook 2009: n.p.). This intricate and carefully constructed sound system was designed this way for a number of reasons, as Dan Jones explains below:

> The eight small speakers within the set were a realism driven attempt to realise the communications system and electronics of a real submarine. We actually realised software that acted as a switchboard to pipe the actors' voices from one speaker to any other part or all parts of the submarine on demand. The system overhead and round the four corners was more the canvas or envelope so to speak – or you might say the horizon or container. (2009: n.p.)

Thus, in *Kursk*, the audience was not only placed within the same physical environment as the actors, but wrapped or 'enveloped' within the same 'sound world' (Jones and Home-Cook 2009: n.p.). In contrast to the sound designer 'who might put his speakers over the front of the stage, facing out', Jones prefers to 'allow the actors to share that environment', and, consequently, for 'the perimeter of the space that is shared by the actors and by the audience to be broken down' (2009: n.p.). Moreover, by placing speakers *in*, as well as *around*, the performance space, Jones created a designed sonic environment where the distinction between 'sound field' and the sonic events or objects contained within that environment was manifestly staged. This purposeful attempt to replicate, or mimic, the phenomenal specificities of 'real-life' sonic environments is central to Jones's work, and reflects his zealous adherence to an aesthetic of 'realism':[14]

> The guiding principle is to start with reality, in as realistic a form as possible and then see what happens. The premise is to try and

do justice to the detail of a real version, not a fantasised version of the world and if you want to heighten it you can. For example, there's real air conditioning sound, there's the real atmosphere of a sub that's underway, there's real hydraulic sound, there's lots of stuff that's really real that's just reproduced as clearly as possible. (2009: n.p.)

This onus on realism, or rather the realistic use of designed sound, undoubtedly played a key role in 'immersing' the audience in the strange world of a nuclear submarine. Indeed, one only needs to take a cursory look at the reviews to realise the importance given to sound in manifesting such an experience. Michael Coveney (of the *Independent*), for instance, speaks of being 'immersed in the sounds of the sea' (2009: n.p.). Similarly, Nuala Calvi, of *The Stage*, comments on how *Kursk* allows Sound & Fury 'to flex their aural muscles', and how 'every bleep of machinery, groan of the engines and echoey ocean noise plunges us convincingly into this watery world' (2009: n.p.).[15] Thus, by situating the audience *within* the close confines of a sonically simulated nuclear submarine, *Kursk* created an aural space that not only invited the audience to re-embody the lived experience of being a submariner, but to *sound* sound(s); that is, to listen more attentively not only to sounds per se but to ourselves as listening subjects.

Earlier, in Chapter 3, I described a moment in *Kursk* where the audience was 'plunged' into seemingly pitch-black darkness. One might readily assume that, as far as 'immersive theatre' goes, this is about as immersive as it gets. First, and in diegetical terms, the voices of the submariners (and, by implication, the audience) were plunged in darkness, whilst immersed in icy water, within the close-quartered confines of a compartment of a vast submarine, itself submersed by unfathomable amounts of water. Second, the audience was made to share the same material conditions as the imperilled submariners: the audience was not only situated in pitch-black darkness but in sound, the immersifier *par excellence*. Yet, and as my account of attending (in) silent darkness has already revealed, there is a great deal more to the phenomenon of 'being immersed' than we might readily assume. How does the metaphor of immersion correspond with the phenomenal realities of being-in-sound? What happens when we begin to describe the ways in which we feel our way around the theatrical environment, whether 'immersive' or otherwise, and how might such an investigation allow for an elucidation of the nature of theatrical attending?

In responding to these questions, the following subsections focus on two examples, each drawn from my experience of attending *Kursk*. The first demonstrates how the phenomenon of movement allows for a reconsideration of aural immersion. The second develops a broader model of immersion that begins to explore how the listener-spectator makes sense of the designed theatrical environment.

Moving (in) sound: the dynamics of aural immersion

One of the most memorable moments during *Kursk* was when the British submarine finally enacts its ultimate mission: to daringly steal beneath the fated Russian sub-aquatic vessel, gathering as much photographic intelligence as possible. As the following description illuminates, this sequence was manifestly characterised by *movement*, whether actual, perceived, or imagined.

Having announced that we are moving into position for an 'underwater look at master contact 001 Oscar II Class submarine', aka *Kursk*, the commanding officer ('The Boss') orders the crew to 'assume ultra quiet state'. The engines are reduced to a faint hum, the air-conditioning is switched off, and all other extraneous noise is quelled. In staggered synchrony with the subsiding sounds of the sub, members of the audience begin to modify their deportment, hushing each other, or getting in a final stretch or yawn before things get too serious. With a sudden change in illumination, an impending sense of danger begins to fill the air; suddenly, the whole space seems glazed with a shroud of action-stations-red. The ops officer gives range of target as '1800 metres'. Then, from the silence, four words ring out: 'we are getting closer.' These whispered words, uttered by The Boss, are accompanied by the faint, yet ominous, rumble of a machine-like sound, emanating far off to my right and high above: a sound-in-the-distance. The countdown begins: '800 metres ... 600 metres.' The distant sound is now noticeably both louder and nearer. '400 metres.' The once distant drone has now grown into the fully recognisable, awe-inspiring growl of a gigantic sub-aquatic vessel. '200 metres.' The space resounds with the sound of this vast beast above us. 'Underneath propellers.' Then, silence. Not a word, or a sound, from anyone. Just the sound of the commanding officer taking photographs using a button attached to the periscope, together with the silent sound of a group expletive, mouthed by the crew as they look up, like us, in wonderment.

In juggling between attending to what is happening on board and simultaneously attending to the sound of the *Kursk* (that lies diegetically and spatially above me), I notice the important role played by my

imagination in this process. More especially, whilst the sounds that I hear motivate a range of imaginal content (such as the image of the stern of a vast submarine, with titanic propellers, surrounded by darkness but coming closer into view), these imaginings do not exist in a separate compartment of experience, but dance about within the lived space of listening-and-looking within which I move. Moving with the sound of the *Kursk*, as it, in turn, moves across the space, I not only have the sense of being aboard a submersed ship, but of stealthily moving beneath an unimaginably large, not to mention dangerous, Russian nuclear submarine. Then, on The Boss's report that we are 'underneath keel' and 'clear of bow', the sound of the *Kursk* slowly disappears off to my left, beyond the walls of the theatre, into the fathomless expanses of imagined space. Having waited upon 'Big Bertha', having listened and watched her every move and paid her abject attention, I feel momentarily displaced, as I try to reacclimatise myself to the contrastingly static space in which I am left aground.

In the sequence described above, sound moved in at least three ways. First, as is naturally the case, sound travelled through space, from a series of sources (in this case, some very powerful loudspeakers); second, the sound source continually changed position with varying degrees of amplification, thus moving my aural attention in a super-slow sweep from right to left; lastly, the act of keeping track of the percepts set in play by this double-move was not only attended by a sense of movement, but motivated subtle, though nevertheless actual, alterations in bodily comportment. Indeed, in many respects, it was the experience of movement and the imagined experience of moving beneath the *Kursk* that brought this moment alive.

The sense in which listening as a species of attention entails an embodied movement in and through environmental space has important ramifications for our understanding of the phenomenology of aural experience. To illustrate this, more must first be said regarding the apparent interconnection between sound and being.

The phenomenon of sound appears to provide unique access to being. When perceived, sound not only appears to be undeniably present, but also manifests a sense of being-present. The perceived correspondence between sound and being relies on the preconceived Parmenidean notion that being, like being-in-sound, is 'complete on every side, like the mass of a well-rounded sphere, equally balanced in every direction from the centre' (Parmenides: Fragment B8, lines 42–44; quoted in Ihde 1970: 16). 'Being', thus conceived, is immanent, self-present, all-encompassing, and 'immersed'. Indeed, the notion of immersion

seems to gather all of these assumptions together in one concept: to *be* immersed is to be statically, straightforwardly, and homogeneously situated at the centre of a spherical subjectivity. Correspondingly, we tend to assume, a priori, that 'being-in-sound' is synonymous with 'being immersed'; in other words, that sound is *round*. Indeed, since the notion of a perfectly formed 'sphere' would seem to provide the ideal description of aural experience, few have contested its veracity. However, and as the above experiential example attests, the phenomenology of auditory space is too nuanced to be conceptualised in terms of a 'sphere', as simplistically defined.

First and foremost, we must understand that 'immersion', both as a concept and as a lived experience, consists of an inherent paradox.[16] On the one hand, 'being immersed' connotes a sense of being completely enclosed within the world of experience, where self-consciousness is relinquished. On the other hand, immersion refers to a sense of plunging or sinking into a (particular) state of mind, where one is deeply involved or absorbed in 'some action or activity'.[17] 'Immersion' thus simultaneously consists of a profound sense of passivity and an acute sense of concentration: immersion, in other words, entails both a temporary cessation and a radical seizure of consciousness.[18]

In the case of sound, the body is not simply immersed, centrally, within a given sonic environment, but is in dynamic tension with that which is aurally perceived. Sound does not comprise 'spherical objects within a spherical subjectivity', as Ross Brown has maintained (2010a: 138), but is characterised, above all, by *movement*. Sound both motivates and is motivated by the myriad and complex ways in which we attend to the sonorous: sound is *sounded*. In developing this idea, and to return to the question of listening, or rather aural attention, I once again invoke the work of Don Ihde, whose pioneering study of the phenomenology of sound remains unparalleled.

In striving to complicate the 'sound is round' dictum, Ihde has suggested that *'sound comes in two primary spatial dimensions* [...] *Sound is directional and sound is encompassing'* (1970: 17). To illustrate this and to demonstrate that 'neither dimension is lacking in any given experience of sound' (1970: 17), Ihde provides the following example of listening to the sound of a clock:

> The ticking of the clock, though coming from the dresser, also surrounds me. By merely shifting the focus of my attention I can note, within limits in this case, the dimension of encompassing which the ticking displays. (1970: 18)

Here, Ihde demonstrates the phenomenological tension between Sound as field and sounds as entities within that field. More specifically, his example troubles the assumption that we hear *Sound* and listen to *sounds*: that is to say, that the encompassing spatial dimensions of sound pertain to the passive, distracted world of hearing, whilst the directional spatial dimensions of sound pertain to the active, fully attentive domain of listening. This familiar distinction is evident in the following passage from Ross Brown:

> The phrase 'immersed in sound' evokes some kind of ethereal trip or amniotic ambience but my experience of aural immersion consists in the uneasy relationship between listening and hearing. If I am aurally immersed it is an anxious dialectic between engagement and distraction [...]. (2011: 7)

Whilst Brown has rightly sought to complicate the conception of sonic experience to which he adheres, namely, that sound is round, his notion of aural immersion as an 'anxious dialectic' between listening (engagement/attention) and hearing (distraction) is in need of review.

First and foremost, and as I have already suggested, the notion of distraction is not only an unhelpful means of conceptualising aural experience, but also disavows a consideration of the dynamics of listening as process. Second, the spatiality of listening is not dialectically opposed to the spatiality of hearing. Lastly, and as Ihde's example of the ticking clock illuminates, our experience of sound, in this case, its complex spatiality, is continually *shaped* by the dynamic enactments of aural attention.

The paradoxical and polymorphous registers of lived spatiality that auditory perception necessarily motivates are illuminated by Jean-Luc Nancy in the following extract:

> To listen is to enter that spatiality by which, *at the same time*, I am penetrated, for it opens up in me as well as around me, and from me as well as toward me: it opens me inside as well as outside, and it is through such a double, quadruple, or sextuple opening that 'self' can take place. (2007: 14)

As Nancy's description makes clear, the registers of lived spatiality that are manifestly motivated in the process of attending sound are at odds with a Euclidian conception of space: in listening, space, sound and self are set *in play*. Aural immersion, as I have already suggested,

not only consists of a variety of attentional acts, but is inherently characterised by movement: sound *moves* and we move in sound. The experience of being immersed in sound is thus not only dynamic but *polymorphous*.

Thus, whilst immersion, as conceived along Parmenidean lines, provides the perfect means of conceptualising the notion of being-for-itself (Being as a static, unchanging, complete, and self-contained 'sphere'), it fails to account for the experiential and spatial complexities of being-in-the-world. To illustrate this further, let us take a closer, if brief, look at the phenomenology of imagination.

Traditionally, imagination has been conceptualised as a faculty of the mind, pertaining exclusively to the realm of abstraction, and thought to be primarily visual in form and content. This disembodied conception of imagination is embodied in the Cartesian notion of the 'mind's eye'. Yet, as the phenomenologist Edward S. Casey has proposed, and as the previous phenomenological example from *Kursk* suggests, 'we imagine *with* our bodies and *in* place, never without the ingredients and the co-operation of both' (2000: xi). Imagination is thus not only embodied, but 'takes place' within our perceptual environment. Moreover, since imagination is 'directed towards the immediate situation and environment' it is not only *'sensual'*, but 'has "objective" concerns' (Welton 2002: 195 ff.). Imagination is enworlded: w*hat* we imagine, our imaginings, are not derelict, pointless trifles of fantasy, but help us to make sense of the world.[19]

Such a realisation has important consequences for our understanding of theatrical reception. Imagination, as suggested above, helps us both to sense and to make sense of the designed theatrical environment. Furthermore, and as my encounter with Sound & Fury's *Kursk* attests, imagination is not restricted to the act of looking, nor to the realm of the mind, but rather consists of a complex and continuous interplay among the senses of touch, audition, vision and proprioception.

In imagining (or rather in *sensing*) the *Kursk*, I was, in every sense, required to stretch myself. The sound of the *Kursk* was first sensed as a faint sound or rumble in the distance. On hearing this sound for the first time, I stretched out to its perceived source, fumbling around in the dark. These fumblings entailed a stray attentiveness 'over there', whilst being based paradoxically with my fellow attendants 'over here'. As the sound of the *Kursk* became clearer and felt closer, these attentional sorties into no-man's-land were replaced by the ever-emerging attentional context of 'moving beneath the *Kursk*'. The ever-emerging thing-of-becoming that I took to be the *Kursk* was thus a bricolage of

actual sound, embroidered with visual imaginings, and the subjective experience both of movement and of objects in motion.[20] Objectively speaking, of course, there were no objects in motion at all. I was standing statically in a black box theatre whose foundations were, to my knowledge, pretty robust, and the only 'thing' that *moved* in visual terms was the periscope. However, such an account operates from a strictly objectivist perspective. We must begin, instead, to understand imagination as an embodied and, most of all, *enworlded* act, and to develop a notion of immersion that accommodates such polymorphous, cross-sensory phenomena.

The trouble with describing a piece of theatre as 'immersive' is that the category fails to provide an adequate account of what it means to *be* a listener-spectator. More precisely, the trope of immersion, whether used in connection with theatre or in general, tends to assume an audio-visual severance: we (the audience) are supposedly 'immersed' in sound, whilst being somehow 'detached' from the scene/seen. Far from segmenting the senses, we should look towards a dynamic model of immersion that not only explores the phenomenal interplay between aural and visual perception, but that also begins to describe how the listener-spectator makes sense of the designed theatrical environment. Rather than pitching listening over and against hearing, attention over and against distraction, and the seen/scene against the heard, we should focus instead on the dynamics of embodied attending, and, in so doing, begin to discover what it means to *sound* scenography.

Sounding scenography: making sense of the designed theatrical environment

As sound design has become more intricate and increasingly vital to the overall conception, programme and experience of theatrical events, the theatre 'soundscape' (so-called) has come to be conceptualised in terms of scenography. In questioning the notion of sound-as-scenography, Ross Brown has asserted that if we are to conceptualise sound design scenographically, then 'it is a scenography of engagement *and* distraction rather than of the semiological "gaze"' (2010a: 132). This assertion is based on the premise that sound, *contra* vision, operates outside the 'empire of signs'; 'sound is not "read" for meaning like a cryptic crossword clue; its "meaning" is relational' (Brown 2010a: 131). Yet, whilst Brown has provided theatre scholars with an invaluable theoretical starting point for investigating theatre's 'aural phenomenology', his conception of the phenomenology of visual

and aural design suggests an adherence to a model of percipience that demands further consideration.

> [W]ith visual theatre design [...] sense is derived on the basis of detachment from the scene. Sound, however, whatever events the courses of individual sounds might represent, is *in totum* an immersive environment. One cannot stand back from it and see the entire picture; one's aural attention does not have the equivalent of sightlines; the theatrical mode of listening does not gaze uniformly, but is, by nature, a state of continual omnidirectional distraction. (2010a: 132)

As this statement attests, Brown's main difficulty with categorising sound design within the rubric of scenography is that '[s]cenography is traditionally associated with perspective, whereas sound immerses not just the psychoacoustic mind, but the whole body' (2010a: 134). Yet, is vision really as disembodied, dull, detached, and undynamic as the above statement seems to suggest? Is our experience of aural and visual design in theatre quite so departmentalised? As my phenomenological account of attending the opening scene of Sound & Fury's *Kursk* demonstrates, the act of looking is not as detached, nor indeed as straightforward, as we might assume.

In entering the performance space for the first time, I find myself standing on a metal scaffold (about three metres above ground level and two-thirds of a metre wide), which extends indeterminately in front of me. I am in the far right-hand corner of the Young Vic's Maria Studio, a very large black box theatre. Sonically speaking, this environment consists of a melange of electroacoustical voices and indeterminate mechanical noises. The sound field is made up of male voices, technologised and mediated through microphones. Although these sounds appear to be distinct they nevertheless continually slip out of my attentional grasp. The distinction between sounds and Sound being blurred, these sounds in-between speech and voice figure not only as an index to a world (the world of the submarine control room down below), but also as an all-encompassing sonic glaze, that seems to colour all that I survey. I proceed to skirt my way along the narrow, creaky gantry that corners the top of the space. Peering to my left, I look upon a world that seems, in some ways, as hard to grasp as the world of sound within which I find myself. My eyes gaze down at the set below but give me fleeting impressions, glimpses and flashes of insight. Noticeably, my perception of sound seems to match my perception of

the seen/scene: I hear the sounds of speech rather than words, and see the world at once. I also notice that my visual thematic content is always glazed by the sounds of the environment. I try, for example, to pay particular attention to the periscope, which, apart from being partially occluded by the lighting rig, is seemingly well within my ocular reach. Yet, however hard I try to scrutinise this object, to hold it in grasp as a clearly demarked attentional 'theme', this thematic content is continually affected, or coloured, by the murmuring gesture of the sounds-of-the-submarine. The attentional 'margin' of sound not only impacts on my visual attentional theme, but seems to leave its mark on all that I behold.

As Tim Ingold has proposed, and as the above experiential example confirms, 'the environment that we experience, know and move around in is not sliced up along the lines of the sensory pathways by which we enter into it. The world we perceive is the *same* world, whatever path we take, and each of us perceives it as an undivided centre of activity and awareness' (2007: 10). Correspondingly, in entering the strange submersive world of *Kursk* I noticed how sound and scenography, at least in phenomenological terms, were inextricably interwoven: sound was, quite literally, *in* the scene/seen. More especially, any attempt to 'bracket' the visual world as an attentional theme was continuously impeded by the presence of designed sound, consisting of speech and the drones of language. Furthermore, as well as being 'given' inseparably, the sonic and visual aspects of the designed theatrical environment appeared to phenomenally 'co-opt'[21] one another. As I entered *Kursk*, and gazed down at the set below, whatever I looked at seemed to *sound* – the visual world seemed strangely ephemeral, fleeting and dynamic.[22]

Vivian Sobchack, in examining the use of sound in Dolby trailers, highlights some of the ways in which (objective) sound can affect our (subjective) experience of the seen (see 2005). Similarly, it is my suggestion that the designed sonic environment of theatre not only brings the visual to light, but also invites us to *sound out* the world of vision.

Ross Brown has maintained that 'sound design rarely "says" anything unequivocal, in the way that a set and costume design might within one consistent, visual concept' (2010a: 131). Yet, we must not overlook the dynamics of visual perception as lived. Indeed, the act of looking, as phenomenological enquiry reveals, is as prone to perceptual play as that of listening: gazing is never *just* gazing; or, as Edward S. Casey puts it, '[n]o *seeing without glancing*' (2007: 164). As described in the above example, whilst my eyes may have been directed towards a particular

object in space, this object was not necessarily given at that particu-
lar moment as the attentional theme: what we *see*, in other words, is
invariably glazed and shot through with shards of Other attendances.
Furthermore, far from being 'distracted' by the multiplicity and per-
vasiveness of what I encountered, I experienced a real sense of being
stretched by the phenomenal slipperiness of what was given. When
stumbling across the periscope, for example, I had to do more than sim-
ply point my eyes in a particular direction and sit (or rather *stand*) back
and watch. Instead, I had to 'cast my eyes' upon the object of my atten-
tion. Whilst the periscope may have been objectively and steadfastly
'fixed' in Euclidian space, it only became 'a phenomenon-for-me'[23]
through a process of bodily engagement.

Scenography thus requires the theatregoer to 'grasp' that which is
given. This act of grasping, moreover, inherently entails a degree of
slippage, freedom, and phenomenal movement. Whilst a set may be
spatially at a distance, scenography nevertheless motivates us to 'reach
out', to *stretch ourselves*.

'Theatrical space,' as Stanton B. Garner has proposed, 'is "bodied" in
the sense of being comprised of bodies positioned within a perceptual
field, but it is also "bodied" in the more fundamental sense of "bodied
forth," oriented in terms of a body that exists not just as the object of
perception, but as its originating site, its zero-point' (1994: 8). The field
of performance therefore consists of 'an ambiguity between the percep-
tual and the habitational, in which space and object oscillate between
visual objectification and phenomenal embodiment' (Garner 1994: 4).[24]
Garner's conception of theatrical space and the phenomenology of
embodiment corresponds, in many respects, with Merleau-Ponty's
notion of the 'virtual body':

> What counts for the orientation of the spectacle is not my body as
> it in fact is, as a thing in objective space, but as a system of possible
> actions, a virtual body with its phenomenal 'place' defined by its
> tasks and situation. My body is wherever there is something to be
> done. (2002: 291)

The perceptual act does not take place at a distance, but, on the contrary,
is characterised by an inherent sense of motility. Similarly, when attend-
ing *Kursk* the aural and visual world were not only enmeshed but given
at a glance. Whilst slipping from one attentional theme to the next,
there was always a sense in which each theme was coloured and shaped

by its attentional and phenomenal surroundings. Thus, as opposed to conceiving theatrical spectatorship in terms of visual detachment versus aural immersion, it seems more fitting to conceptualise our encounter with the theatrical environment, indeed the environment at large, using metaphors drawn from the fluxes and flows of meteorology.[25]

In re-evaluating the notion of landscape, Tim Ingold asks: 'what happens if we regard the land from the point of view of the sea? What if, instead of land-ing the sea, we try sea-ing the land?' (2011: 131). In response to this question, Ingold suggests that 'to sea the land [...] is to disclose a world without objects whose solid forms are, to varying degrees, overwhelmed by the fluxes of this atmospheric medium' (2011: 132). Here, Ingold draws from Deleuze and Guattari's distinction between 'striated' versus 'smooth' space (see Deleuze and Guattari 2004: 524–525).

'Striated space,' as Ingold explains, 'is homogenous and volumetric: in it, diverse things are laid out, each in its assigned location. To look around in striated space is, as the original meaning of *skopos* implies, to shoot visual arrows at their targets' (2011: 132). Contrastingly, 'smooth space,' as Ingold goes on to exposit, presents 'a patchwork of continuous variation, extending without limit in all directions' (2011: 132). Thus, '[t]he eye, in smooth space, does not look *at* things but roams *among* them, finding a way through rather than aiming for a fixed target' (Ingold 2011: 132). Similarly, and as my experience of attending the opening scene of Sound & Fury's *Kursk* suggests, to *be* a listener-spectator consists of an ongoing, intersensorial bodily *engagement* with the affordances of the theatrical environment.

These inferences not only urge us to reconsider what it means to *attend* theatre but also call into question those metaphors and models that we unthinkingly use to describe auditory space and the sonic environment, most notably, the notion of 'soundscape'. As Ingold has advanced, given the ways in which the senses are manifestly *enmeshed* we should begin to think of the sonic environment not so much as a 'soundscape' but as a 'weather world'.

From soundscape to 'weather world': (aural) immersion reconsidered

The notion of a 'soundscape' is now almost as ubiquitous as the phenomenon that it supposedly describes. Originally coined in the 1960s by Pierre Schaeffer, and subsequently developed by R. Murray Schafer,

the term 'soundscape' refers to the givenness of sounds in their environment, as well as to the dynamic relationship between sound and self. 'Like a landscape, a soundscape is simultaneously a physical environment and a way of perceiving that environment; it is both a world and a culture constructed to make sense of that world' (Thompson 2002: 1). Contrary to this definition, there is nevertheless a tendency to automatically associate the idea of a 'soundscape' with a certain kind of immersive, all-encompassing experience.[26] This near-naturalised (though inherently troublesome) concept has, however, been subjected to critical review,[27] and most noticeably by Tim Ingold.

In his essay 'Against Soundscape', Ingold asserts that although 'the concept [of a 'soundscape' originally] served a useful rhetorical purpose for drawing attention to the sensory register that had been neglected relative to sight' it has now 'outlived its usefulness' and thus should be 'abandoned' (2007: 10). Anxious that 'we might lose touch with sound in just the same way that visual studies have lost touch with light', Ingold proposes that the soundscape is not a separate world from any other kind of 'scape' (2007: 10). Indeed, and as he points out, '[t]he power of the prototypical concept of landscape lies precisely in the fact that it is not tied to any specific sensory register – whether vision, hearing, smell or whatever' (Ingold 2007: 10). Likewise, to force sound to submit to a monosensory, static *scaping* necessarily cloaks the phenomenal realities of intersensoriality.[28]

Importantly, Ingold also objects to the familiar and long-established tendency to set sound over against sight, and audition over against vision. Contrary to this assumption, Ingold points out that 'the ears, just like the eyes, are organs of observation, not instruments of playback. Just as we use our eyes to watch and look, so we use our ears to listen as we go forth in the world' (2007: 11). Furthermore, and as Ingold upholds, '[i]t is of course to light, and not to vision, that sound should be compared' (2007: 11). Following on from this, Ingold conjectures that sound 'is neither mental nor material, but a phenomenon of *experience* – that is, of our immersion in, and commingling with, the world in which we find ourselves' (2007: 11). Sound, in other words, is manifestly 'given' by and through our enactive and ongoing engagement with the particular sonic environment within which we are immersed. Moreover, Ingold makes the bolder claim that '[s]ound is not *what* we hear, anymore than light is what we see' (2007: 11). In Ingold's view, sound 'is not the object but the medium of our perception. It is what we hear *in*. Similarly, we do not see light but see *in* it' (2007: 11). Before providing further details of Ingold's notion of a 'weather world'

as an alternative means of conceptualising the experience of being in the environment, further attention must be given to his conception of *immersion*.

Ingold's notion of being immersed, or what he also refers to as 'participation', is set in dynamic relation to observation, as the following excerpt reveals:

> Rather than thinking of ourselves only as observers, picking our way around the objects lying about on the ground of a ready-formed world, we must imagine ourselves in the first place as participants, each *immersed* with the whole of our being in the currents of a world-in-formation: in the sunlight we see in, the rain we hear in and the wind we feel in. Participation is not opposed to observation but is a condition for it, just as light is a condition for seeing things, sound for hearing them, and feeling for touching them. (2011: 129; emphasis added)

Here, Ingold draws our attention to the fluxes and flows of sound and light as media within which we are 'primordially immersed' (2007: 12). That said, his distinction between 'participation' (that is, being '*immersed*') and 'observation' is in need of review. Immersion, as commonly conceived, implies a sense of a-spatiality and passivity. Space, however, is not only a phenomenon that we encounter but one that must be travelled through. This dynamism is implied in the above extract but requires clarification.

Viewed from an attentional perspective, being '*immersed* with the whole of our being in the currents of a world-in-formation' is, to all intents and purposes, synonymous with living through and in the sphere of attention. To distinguish between participation (being in the medium of sound or light) and observation (paying attention to things within that medium) is to suggest that attention is only concerned with things. However, immersion does not consist of a stasis but a paradox. Immersion is what it means to experience the push-pull between the attention-capturing affordances of a given environment and the dynamic state of being an embodied percipient within that environment. As already suggested, when we speak of being *in* sound, this sense of being immersed is not experienced as a static, three-dimensional fixity but consists of a dynamic tension. Indeed, this tension, which is the essence of attentionality itself, is inherent to immersion, both as a concept and as a phenomenon. 'Observation', therefore, is not separate from the state of being immersed, but a necessary aspect

of its dynamism: participation (or immersion) is not only a 'condition' for 'observation' but is itself characterised by dynamic acts of embodied attending.

A reconsideration of immersion from the perspective of attention allows for a more nuanced conception of immersivity. For instance, whilst our sense of being-in-sound usually registers as marginal, there are times when our sense of being enveloped by sound can momentarily become thematic. The spatiality of sound engenders a paradox: we are in space, seemingly spherically, yet we stretch out into and towards sound as we follow its flows. As Murray Schafer's notion of sound as a 'hemisphere' prompts us to consider (see 1985), sound inhabits space somewhat enigmatically: the shape of sound, in other words, is not round, but more erratic, incomplete and dynamic.

Notwithstanding these clarifications, Ingold's notion of a 'weather world' not only provides a useful alternative to the notion of a 'soundscape', but also allows for a more nuanced means of conceptualising the lived spatiality of the body in its environment.

> In order to understand the phenomenon of sound (as indeed those of light and feeling) we should [...] turn our attention skywards, to the realm of the birds, rather than towards the solid earth beneath our feet. (Ingold 2007: 12)

In correspondence with this move from landscape to meteorology, Ingold makes an important comparison between sound and the phenomenon of wind: '[s]ound flows, as wind blows, along irregular, winding paths, and the places it describes are like eddies, formed by a circular movement *around* rather than a fixed location *within*' (2007: 12). This analogy manifestly resonates with the kind of ambiguity, indeterminate spatiality and phenomenal flux that I experienced when attending the birds of *Shun-kin*.

Sound not only flows through space but is usually perceived to come *from* somewhere. Conversely, the phenomenon of sound has an inherent tendency to drift away from its source, producing states of uncanny equivocality and sonic serendipity. Whilst we may find ourselves seemingly 'immersed' *in* sound, this immersion necessarily motivates us to participate in acts of *sounding*. Like the experience of being in the wind, or of being '*enwinded*', the body, as it exists and actively engages with sound, is also '*ensounded*' (see Ingold 2007: 12 ff.). To be '*ensounded*', like being in the wind, is '[t]o follow sound, that is to *listen* [...] to wander the same paths' (Ingold 2007: 12). The act of listening thus

inherently entails an ongoing and embodied dynamic between self and world, between endogeneity and exogeneity, which, as I have suggested, is rooted and embodied in the phenomenon of attentionality. To 'pay attention' to sound(s), or to phenomena that are materialised by and within the *medium* of sound, is not to sit back and listen but entails an inherent sense of *tension*:

> Attentive listening, as opposed to passive hearing, surely entails the very opposite of emplacement. We may, in practice, be anchored to the ground, but it is not sound that provides the anchor. Again the analogy with flying a kite is apposite. Though the flyer's feet may be firmly planted on the spot, it is not the wind that keeps them there. Likewise, the sweep of sound continually endeavours to tear listeners away, causing them to surrender to its movement. It requires an effort to stay in place. And this effort pulls *against* sound rather than harmonizing *with* it. Place confinement, in short, is a form of deafness. (Ingold 2007: 12)

Ingold's analogy of kite flying tallies closely with the sense of push-pull that I experienced when attending the bird sequence in *Shun-kin* and, in particular, resonates with the phenomenon of listening-in that this moment of the performance manifestly motivated. Even in more traditional, proscenium arch-style modes of spectatorship, the listener-spectator nevertheless makes sense of environmental space through and in movement, that is to say, by *stretching*. Moreover, and in alignment with a dynamic conception of immersion, it is vital to recognise that different acts, or 'modes', of aural attention engender different experiences of spatiality and self in attending: indeed, the pathways by which and within which we perceive sound vary greatly. To demonstrate this, and in paying *closer* attention to the birds of *Shun-kin*, I will now illustrate the important differences between two seemingly similar yet discrete attentional modes, namely, 'singling out' and 'zooming-in'.

Listening/zooming-in in the theatre: paying (closer) attention to the birds of *Shun-kin*

The act of listening – as Ingold's analogy of flying a kite sets in motion – takes effort, exertion, and even balance. More especially, and like flying a kite on a particularly stormy day, listening entails a *tension* between being drawn by the constant flows of the 'weather world' within which one is 'immersed' and, at the same time, being very much grounded,

at a fixed position, within that environment. Furthermore, Ingold's analogy of flying a kite especially resonates with the phenomenology of listening-*in*, which, as a particular mode of 'attentive listening', is characterised by an acute and particular sense of moving through space, whilst attending from a distance.

There is, in other words, nothing 'static' about listening at all. Indeed, it is precisely *because* of movement that we are able to listen effectively. As illuminated by my phenomenological investigation of listening to radio plays, the context and mode of listening can radically alter the listener's perception of designed sound. When listening to radio plays through headphones, for instance, I experienced a certain attenuation of my experience. The reason for this, I suggest, is related to Ingold's notion of 'place confinement'. Having one's ears cocooned by head-phones confines sound, and hence the listener, in two directions. First, sound is not free to roam, but rather is directly 'conveyed' into the ears. Second, headphones not only physically envelop the ears, but this envelopment brings about a radical, if not total, cessation of aural motility. Moreover, and as suggested by phenomenological enquiry, this radical confinement of the listener's ability to move within and through the sound they perceive results in an acute attenuation of the transformative and creative act of auditory attentiveness: 'Place [or space] confinement [...] is a form of deafness' (Ingold 2007: 12). Furthermore, what is interesting about the case of listening through headphones is that the act of opening or closing one's eyes makes very little difference to the sense of confinement that this mode of listening manifests. This indicates that it is not the fact of listening with our eyes closed that sharpens and enlivens our attentional apparatus, but rather the fact of being able to *move*. That is to say, it is not the act of looking in itself that activates listening, but rather the sense of unconfined, free-to-roam attentional movement that the mode of listening-with-eyes-open brings about.

Where listening in the theatre is concerned we might assume that the notion of being 'free to roam' within the mixed medium of sound and light is a little far-fetched. Such an assumption is easy to make given the motile restrictions and attentional harnessing that a proscenium arch-style theatre, such as the Barbican, necessarily enforces. Yet, although usually seated somewhere with a particular point of view, the listener-spectator is nevertheless free to move within the 'weather world' of the theatrical environment.

Movement, as I have thus far strived to demonstrate, plays a key role in perception: indeed, '[t]o imagine a truly inert perceiver is to

imagine someone without the sensorimotor knowledge needed to enact perceptual content' (Noë 2004: 17). Similarly, the phenomenon of sound does not simply invade our ears but must be 'grasped' by means of actual bodily movement. The bird sequence in *Shun-kin* was phenomenologically distinctive, however, in that this sense of 'being stretched' was acutely *felt*. Furthermore, there is another dimension to Ingold's analogy of kite flying that also especially resonates with my experience of attending *Shun-kin*: namely, the sense of moving *with* sound.

When attending the birds of *Shun-kin*, and unlike in the case of listening-in to Mrs Rooney on the margins in *All That Fall*, I was physically present within the same environment as that in which the sound was being produced and, hence, had a sense of moving through *physical* as well as imaginal space. In the platform scene in *All That Fall* the characters' voices were heard statically from a marginal perspective. Contrastingly, the sense of *listening-in* that I experienced when attending the birds of *Shun-kin* entailed a sense of moving *with* designed sound as it travelled through space.

In describing the bird sequence in *Shun-kin*, Gareth Fry speaks of how the sound 'panned up' with the image of the birds (2011: n.p.). This filmic term is congruent with the particular register of spatiality I experienced in attending this moment. In other words, there would appear to be a correspondence between the phenomenon of listening-in in the theatre and that felt sense of movement experienced in film where the camera lens *zooms-in on* a given theme, person or aspect of the visual frame. Indeed, the notion of 'zooming-in', or, as Arvidson prefers to call it, 'singling out' (see 2006: 74 ff.), is often thought to be 'wholly synonymous with attention' (see Arvidson 2006: 74). The notion of 'singling out', however, relies on 'suspect metaphors of attention such as spotlight [...] zoom-lens [...] window [...], and so on', all of which are drawn from the modality of vision (Arvidson 2006: 74). As we saw earlier towards the end of Chapter 1, singling out is a particular mode of attention and a specific species of attentional transformation. Singling out, as Arvidson explains, brings about a more radical transformation of attentional content than other modes of attentiveness 'since the changes are not simply accomplished within one dimension (intra-thematic) but are inter-dimensional (theme and context)' (2006: 75). Whilst the notion of zooming-in has been invoked as a synonym for the phenomenon of 'singling out' (see, for example, Metzinger 2003), I suggest that we reconsider zooming-in as a discrete *mode* of singling out.

'*Singling out*,' as mentioned earlier, 'is when a constituent of a theme is attended to thematically, so that this constituent becomes the theme itself' (Arvidson 2006: 74). The crucial difference, however, between singling out and zooming-in is that although the action of singling out resembles a certain sense of 'closing in on' the percept in question, this sense of movement is only felt on the very horizon of the attentional sphere. There is, in other words, nothing intrinsic to the mode of singling out that necessarily draws attention to the inherent motility of the attentional act. In the case of zooming-in, however, the spatial, motile and ontological tensions inherent in the phenomenon of attentionality are dynamically *foregrounded*. Moreover, the key thing to bear in mind in the case of zooming-in, or listening-in, is that thematic content is not necessarily given to contain an object as such, but rather it is movement itself that is rendered thematic. Zooming-in is not, therefore, straightforwardly synonymous with singling out but, rather, is singling out with spatial complications – a singling out that discombobulates the body's spatial concerns.

In an important essay that challenges the traditional tendency to 'abstract vision from its existential and embodied motility', Vivian Sobchack identifies four kinds of visual/visible movement in cinema: 'the movement of introspection and projection'; 'optical movement'; 'the movement of intentional objects'; and the movement of 'intentional subjects' (1990: 21, 22). Here, I will focus on Sobchack's second category, 'the optical movement of the camera lens from a fixed position [...] usually explored in a specific manifestation such as the "zoom"' (1990: 22). Sobchack uses this designation 'to distinguish between the literal movement of the film's "body" (and with it, the camera as the film's organs of visual perception) and the visible movement of the film's *attention*' (1990: 25). Sobchack thus urges us to reconsider the important ways in which film, or more specifically the camera lens, depicts attention as 'a lived-body movement', but one that 'does not involve the movement of the material body through space' (1990: 27).

Whilst attempting to thematise the experience of movement in attending, Sobchack's model nevertheless situates attention firmly within the realm of the mind, thus overlooking the role that *actual* movement plays in enabling attention. As suggested earlier, the distinction between 'consciousness' (conceptualised as active yet disembodied attention) and 'body' (conceived as static, passive embodiment) is untenable. Consciousness, however spatially and ontologically far-ranging its attentions, is always embodied: indeed, embodiment is the ground from which consciousness stems.

Notwithstanding these criticisms, Sobchack's discussion of attention not only provides a detailed account of how film uses the zoom lens to represent the attentional world as lived by the 'viewing subject' (1990: 27), but sheds considerable light on the phenomenal particularities of listening-in.

In exploring some of the ways in which the camera lens in film might be said to represent, or indeed frame, the phenomenon of attention, Sobchack provides an astute analysis of Hitchcock's *Vertigo* (1958). Starring James Stewart and Kim Novak, *Vertigo* follows the steps of a vertiginous detective, John 'Scottie' Ferguson, hired to trail a friend's suicidal wife, Madeleine Elster. The film employs the technique of the 'zoom' to both represent and manifestly mimic the acrophobic condition of the film's protagonist. This is achieved, most memorably, in a scene where Scottie is ascending a church tower in pursuit of his 'mark'. In suggesting that 'Hitchcock constitutes vertigo as the dizziness which emerges when the *attention of consciousness* and the *intention of the body* are at odds with each other', Sobchack provides the following description of this footage:

> Looking down from a stairwell, the protagonist's attention transcends the intervening space and locates itself at the stairwell's bottom – but his body, aware of the fatal fall through space this intention implicates, rebels and intends itself in opposition to the transcendence of attention. (1990: 26)

The 'zoom' of the camera lens, as Sobchack's description draws outs, *frames* the notion of attention as traditionally conceived (namely, as a disembodied yet firmly tethered intentional movement of consciousness in the world). Yet, not only is Sobchack's division between active/creative attention ('over there') and the passive intending body ('over here') too strict, but her account also overlooks the essential *particularity* of zooming-in as a species of attentional transformation. Zooming-in, in phenomenological terms, does not consist so much of grasping something at a distance, but of being *stretched* in different directions by opposing attentional motivations. The attending body is not separate from attending consciousness, but one and the same thing.

Through an ongoing process of embodied attending we find our way through the currents, flows and drifts of the 'weather world', or *atmosphere*, within which we are dynamically immersed. As well as referring to the medium or all-encompassing 'world' within which we exist, the word 'atmosphere' also refers to the specific mood, character or feeling

manifestly engendered by a given environment, place, or situation. Far from being born *ex nihilo*, however, atmospheres are in-between phenomena that reside on the margins of our attentional sphere and are only fully generated and conceived *in acts of attending*.

Attending atmospheres: shaping atmosphere in *Kursk*[29]

We often speak of noticing a particular 'atmosphere' when entering a room, or of places, such as churches, hospitals, concert halls, and theatres, being endowed with a particular atmospheric hue. Atmospheres, as the philosopher Gernot Böhme has remarked, are 'totalities', they 'imbue everything, they tinge the whole of the world or a view, they bathe everything in a certain light, unify a diversity of impressions in a single emotive state' (2013: 2). To speak of an atmosphere is to express something inexpressible, to sense a specific mood or feeling engendered by a particular place, context, or situation. Yet, what exactly *are* atmospheres, how do they come about, and what role, if any, does the percipient play in their manifestation? In responding to this set of questions and as a means of contributing to some of the important scholarly work already conducted in this area,[30] I present the following hypothesis: namely, that atmospheres only fully come into being as a consequence of their being *noticed* – to sense an atmosphere is to notice 'something in the air', an underlying feeling that you perceive but 'can't quite put your finger on'. Put differently, there would appear to be an inherent correspondence between the phenomenology of atmospheres and the act of attending. In developing this idea, I invoke three key theorists on the subject: Jean-Paul Thibaud, Kathleen Stewart and Gernot Böhme.

In examining the 'close links between ambiance and perception', Jean-Paul Thibaud defines 'ambiance' as 'a *sensory background* that specifies the conditions under which phenomena emerge and appear' (2011: 203, 212). An ambiance, in other words, is not an object of perception but rather establishes its terms: 'we do not perceive the ambiance, we perceive on the basis of the ambiance' (2011: 210). Furthermore, and in urging us to understand ambiance as 'a motor stimulation' that 'activates sensorimotor processes through which we engage with the world' (2011: 210), Thibaud touches teasingly upon the close-knit relationship between ambiance, action, and the phenomenon of attention:

> Subjects are always engaged in situations that demand their attention and mobilize their action to a greater or lesser degree.

Ambiance triggers a certain form of tension in the body that requires action [...]. (2011: 208)

In the above extract Thibaud draws our attention to the phenomenal ways in which ambiances 'trigger' or *motivate* particular modes of response or action. Yet, whilst seeking 'to emphasise that the perceiver is an actor in the world he or she perceives' (2011: 208), Thibaud neglects to consider the phenomenal ways in which ambiances are *themselves* motivated, sustained and maintained by the active responses that they set in motion. What role does the *percipient* play in the process of generating atmospheres? More specifically, how do atmospheres 'demand' our attention and what role does the act of attention play in the process of atmospheric attunement? The following extract from Kathleen Stewart sheds light on this:

An atmosphere is not an inert context but a force field in which people find themselves. It is not an effect of other forces but a *lived effect – a capacity to affect and to be affected* [...] It is an attunement of the senses, of labors, and imaginaries to potential ways of living in or living through things. (2011: 452)

Stewart's observation lends support to my claim that atmospheres not only affect and motivate certain attentional acts but are themselves shaped, maintained and altered by these enactments: as Stewart declares, 'What affects us – the sentience of a situation – is also a dwelling, a worlding born from an atmospheric attunement' (2011: 449). One of the most substantial attempts to thematise the phenomenon of atmosphere has been conducted by Gernot Böhme.

An atmosphere, as Böhme suggests, is a 'typical intermediate phenomenon, something between subject and object' (2013: 3). On the one hand, atmospheres are 'entirely subjective', since 'without the sentient subject, they are nothing' (Böhme 2013: 2). Yet, on the other hand, although atmospheres may not exist as 'things' in objective space, it is nevertheless 'possible to communicate about them intersubjectively' (Böhme 2013: 3). Atmosphere thus remains 'a familiar yet extremely vague phenomenon' (Böhme 2013: 2). This summary certainly seems to ring true with respect to the phenomenon of *theatrical* atmospheres.

Atmosphere is intrinsic to both theatre and its techne: 'nothing lives without atmosphere' (Brown 2010a: 143). When attending a performance we might notice a 'sombre atmosphere' descending

upon a particular scene or of a particular moment being tinged with a certain feeling. Undoubtedly, atmosphere in theatrical performance is especially shaped by the phenomenal particularities of designed sound, as well as by the architectural and acoustic specificities of a given theatrical environment.[31] However, it is my suggestion that theatrical atmospheres, indeed atmospheres at large, are not affected purely by the properties of design, or by the particular material characteristics of sound and space, but are brought into being as a result of the interplay between the attending body and its environment. In developing Böhme's proposal that atmospheres are not composed so much as 'generated' (2013: 3), I advance the hypothesis that theatrical atmospheres both shape and are shaped by the intersubjective attentional enactments of the audience. In order to explore this hypothesis, I return once again to my experience of attending Sound & Fury's *Kursk*.

As well as staging the sequence of events that led to the calamitous loss of Russian life in August 2000, *Kursk* also narrates the personal loss suffered by the ship's planesman, NewDadMike, whose baby daughter, Madeleine, tragically dies of cot death whilst he is away at sea. The piece ends with NewDadMike being airlifted from the deck by helicopter. Standing in his cabin, the ship's commander reads off the names of the dead Russian sailors. As he reads, we hear the sound of a helicopter, gradually approaching. Having packed Mike's bags, the navigator, Casanova Ken, accompanies him to the bottom of the lookout tower. My experience of attending this moment is described below.

The sound of the helicopter is so loud that it seems to place a wall between me and the scene to which my attention has hitherto been directed. Consequently, the ubiquitous noise of the helicopter momentarily mutes the utterances of the other crew members. As I peer into this silent world, I can see NewDadMike hugging his fellow submariners before climbing the ladder to freedom. As he climbs, the sound of the helicopter very slowly diminishes. Once at the top, and accompanied by the words 'Transfer Complete', the lights slowly fade from bright yellow to a reddish orangey hue. With the barrage of noise gone, the void is filled by a gentle, dreamy, tinkling sound and a flicker of light that I notice emanating from the elements of a child's mobile attached to the ceiling high up above, dangling around what appears to be a toy submarine. At this moment of hiatus, brought about by the sudden shift from the noisy, alien environment created by the helicopter to the intimate, gentle, soporific space of the baby's bedroom, I suddenly find myself witnessing a tender moment. This sense of intimacy is heightened by

the general lack of light which, compounded by the partial visual occlusions produced by the scaffolding, makes me readily aware of the felt presence of those around me. In the twilight, a hand appears, reaching for the toy submarine. Having grasped it, the hand slowly retreats and the toy submarine is laid to rest in the arms of NewDadMike. At this moment I become aware of a particular atmosphere, an atmosphere that arises from attending a grieving father – an atmosphere that attends grief. Then, as the sounds of the mobile soften and the lights slowly fade from twilight to blackout, I find myself imperceptibly placed not only in darkness but seemingly in silence. Within this moment of silence a new atmosphere manifests, an atmosphere of acute and collective attentiveness. I feel acutely aware of my surroundings and of existing as one of a number of beings in attendance. I can detect the sound of people breathing deeply, sighing, and making slight, though perceptible, alterations to their posture. This atmosphere is paradoxical, an atmosphere of both tension and release. 'Tension', since this silence needs to be maintained, cared for and attended. 'Release', since within this silence there is the comforting presence of others, the felt presence of a body of listeners.

As the above example makes clear, when sound is thrown at us to such an amplified, deafening extent, we not only become aware of our silence in the noise, but noise ceases to speak. Furthermore, being momentarily unable to hear the sounds of my environment (such as the sound of an actor moving across the set or the sound of the audience shuffling), I somehow lost my perceptual grip on visual space. The force of the sound distanced me from the scene, forcing me to stand back from the world of the submarine and to take note of the situation from the outside. Being muted, the set to which I had become attuned lost its sound, and, consequently, began to lose its sense. I became an *onlooker*. Far from feeling as if I were astride the deck of a submarine with a helicopter overhead, instead it felt as if I were somewhere else, not really here, nor there, but elsewhere – existing within that silent, strangely peaceful place of retreat that contradictorily seems to exist within abject noise. As opposed to feeling enclosed, engulfed or straightforwardly 'immersed' in the sound of the helicopter, I experienced an openness and a sense of being in the open. Importantly, this hiatus was attended by a particular kind of atmosphere that emanated from my mute attendance to a muted world. Although seemingly implacably encased within relentless noise, this 'noise', like the visual world, seemed to register as a blank; in existing within this noise-world I experienced an atmosphere of abstraction,

UNIVERSITY OF WINCHESTER
LIBRARY

an atmosphere of alienation. Then, with the noisy world of the helicopter gone, I was forced to reattune to my new sensory environment. When we move from an overwhelmingly loud sonic environment to a tender, soporific one we can feel lost or incomplete as we begin to reattune to these new conditions. In order to shed further light on the ontological and attentional effects of deafening sound, I invoke the following anecdote from G.E. Müller:

> When we first come out of a mill or factory, in which we have remained long enough to get wonted to the noise, we feel as if something were *lacking*. Our total feeling of existence is different from what it was when we were in the mill [...]. (1873: 128; cited in James 2007: 456)

Similarly, when attending *Kursk*, the relatively sudden shift from abject noise to solemn stillness meant that every sound in this new space registered acutely, piquing audience attention. Furthermore, the tender atmosphere of care, respect and intimacy that attended this poignant transition in the performance was brought about, at least in part, by the intersubjective act of reattunement that this moment of hiatus manifestly motivated. Before going any further, I must say a little more about how my theory of atmospheric generation builds on the work of Gernot Böhme.

In considering the phenomenology of atmospheres, Böhme advances one overriding hypothesis: that to understand how atmospheres are *made* we must turn our attention to the art of the stage set; in other words, that there is an inherent relationship between atmospheric generation and the act of *staging* (see 2013). For Böhme, the purpose of the stage set is 'to provide the atmospheric background to the action, to attune the spectators to the theatrical performance and to provide the actors with a sounding board for what they present' (2013: 3). Importantly, and in resonance with the findings of phenomenological enquiry, this definition not only conceptualises the stage set in sonic as well as visual terms but seems to suggest an inherent link between the generation of atmosphere and the act of attunement. Of equal importance, and in moving away from a model of perception where subject and object are clearly and unambiguously positioned in opposition, Böhme proposes that atmospheres are brought about by *ekstases*, that is, by the phenomenal ways in which things, people, and the elements of any given environment *express themselves* and act as 'generators of atmospheres' (2013: 5).

However, whilst providing us with an invaluable starting point for a phenomenological consideration of theatrical atmospheres, Böhme says very little about the particular and peculiar role played by the listener-spectator in this process of atmospheric generation. As Böhme has identified and as Ross Brown suggests, the relationship between atmosphere and audience is indeed dynamic: 'we feel it around us and it affects what we do, but we also affect it' (Brown 2010a: 144). Yet, how precisely do we 'affect' atmospheres and how might we begin to *thematise*, as well as to account for, our affective and dynamic involvement in the process of generating atmospheres? By way of response, I propose that we begin to explore the phenomenal relationship between atmospheres and the intersubjective, embodied act of attending.

Atmospheres, by their nature, tend to lie in the background, as an underlying, ambient phenomenon of feeling. Yet, by attending (or paying attention to) a particular atmosphere we motivate, enhance and intensify it; we allow it to show itself. Moreover, and as my experience of attending Sound & Fury's *Kursk* suggests, the various ways in which we affect a given atmosphere are invariably brought to our attention in moments of silence. Alison Oddey touches upon this relationship between silence, attention and the manifestation of theatrical atmosphere in the following statement:

> Though silence is supposedly an absence, the withdrawal of noise (in all its senses) is replaced by a louder phenomenon, a focusing of attention, an atmosphere, which we mistakenly describe as a silence. (2007: 195)

It is my suggestion that it is precisely *as a result of* this 'focusing of attention', in moments of theatrical silence, hiatus, or transition, that atmospheres are manifestly generated. Not only does the withdrawal of noise motivate us to listen or attend more acutely, but this attending (in) silence is attended by an 'atmosphere of attention'. The final moment of *Kursk*, when the audience was plunged in silent darkness, was tinged with a distinct atmosphere which was created as much by the 'felt presence', or '*parousia*', of those in the audience as by the sounds or images intended by the piece.[32] For a moment, the audience was not only responsible for attending/tending a moment of theatrical silence, but, in so doing, simultaneously became generators and custodians of atmosphere. Whilst the material conditions of this particular moment were intended to produce a particular atmosphere

of conclusion and reflection, the responsibility for sustaining and fine-tuning this *tuned* space was almost exclusively placed in the hands of the audience.

In moments of lull, silence, or stillness, not only is the context and margin of our attentional sphere stretched, but, as a result, thematic attention will tend to focus on the particular kind of atmosphere thus generated, namely, the atmosphere of attention. In the theatre, particularly during moments of hiatus or transition, we must *reattune* to the environment within which we are dynamically immersed. This reattunement consists of a bodily, proprioceptive, and intersensorial rearrangement of ourselves in space. Thus, far from being settled spherically at the centre of a plenum, the body is continually 'polarized by its tasks' (Merleau-Ponty 2002: 115). This corporeal polarity is not experienced as a simple binary, as exemplified in the familiar distinctions between attention and distraction, embodiment and disembodiment, but rather entails a sense of being stretched: in stretching out upon the world we experience ourselves to be 'wherever there is something to be done' (Merleau-Ponty 2002: 291). In *sensing*, or in making sense of, the world within which we are dynamically immersed, we are here, there, and everywhere.

Walter J. Ong has maintained that *'Sound situates man in the middle of actuality and in simultaneity, whereas vision situates man in front of things and in sequentiality'* (1967: 128). Yet, such an account of the senses fails to tally with the actualities of lived experience. First, the visual world is not perceived *objectively*, from a distance, but is enlivened and embodied by our lived, dynamic engagement with bodily space. Second, and as we have seen, the presence of sound in vision can radically affect our experience of looking: designed sound not only enhances but affects the theatregoer's perception of the *seen*/scene in surprising and unusual ways. Lastly, not only is vision, under normal circumstances, tinged with a sense of touch, but our experience of being in sound is not one of straightforward, three-dimensional centredness. Indeed, as an act of *stretching*, listening is as spatially polymorphous as it is attentionally dynamic: in sounding sound, in sensing the 'atmosphere', the listener sounds space and, in so doing, creates space.

To 'sense' an atmosphere is thus not only to express the inexpressible presence or 'feeling' of being in a particular space or place, but also to *feel* our way around that environment. Indeed, it is precisely as a result of this act of *sensing* that 'atmospheres' are brought into being. 'Atmosphere' in the theatre is neither thrust upon us, nor, indeed, is it something that we simply dream up or imagine. Rather, in attending,

or *sensing*, a given atmosphere, most acutely in moments of silence, lull or hiatus, we play a vital role in the intensification, maintenance and continual reshaping of this indeterminate and mutative phenomenon. Whilst sound, scenography, set design and lighting provide the initial stimulus for the manifestation of a particular kind of atmosphere, atmospheres are generated, maintained and mutated through the inter-subjective enactments of dynamic embodied attending.

Conclusion

'Philosophy,' as Merleau-Ponty once observed, 'is not the reflection of a pre-existing truth, but, like art, the act of bringing, truth into being' (2002: xxii–xxiii). Having conducted a phenomenological enquiry of theatre and aural attention, and having endeavoured to remain 'open' to the world of sound as staged by the theatrical event, what generalisations, or contingent 'truths', can be said to have emerged from such an enterprise?[1] How might this investigation of theatrical listening help us not only to reconsider the phenomenology of sound, but to re-evaluate our understanding of theatrical reception and the practice of theatrical attending? In what follows, I will strive to *presence* a number of themes, inferences, and hypotheses which, I hope, will not only provoke further discussion, but lead to new areas of phenomenological and philosophical enquiry.

This book set out to achieve three things: namely, to learn more about the phenomenon of listening, to learn more about the act of attending theatre by means of listening, and, consequently, to discover what it means to *attend* theatre. *Theatre and Aural Attention* thus aims to contribute to a number of fields of research, including studies in sound and the senses, theatre sound and aurality in theatre, theatre phenomenology, and performance philosophy.

In an attempt to shed light on the phenomenon of (theatrical) attention, this study has paid particular attention to the phenomenon of (theatrical) sound. This approach, which takes the unusual step of examining the aural, as opposed to the visual, dimensions of theatrical performance, is by no means incidental. Not only is attentiveness fundamental to the phenomenon of listening, but phenomenology consists of 'a particularizing mode of attention' (Garner 1994: 5). Listening, and the practice of listening *phenomenologically*, thus provides an effective means of elucidating what it means to attend.

Phenomenology, like theatre, draws attention to the perceptual object *as perceived*, and, in so doing, sheds light on the particularities of the perceptual act as act. As a particular way of doing philosophy, phenomenology consists of an ongoing (though nevertheless rigorous) attempt to bracket, describe, and thematise any given aspect of perceptual experience. Perception, however, like phenomenology, is an unfinished project, an ever-emerging field of possibility. The practice of conducting a phenomenological enquiry is thus not only highly specialised but necessarily provisional. However hard we try to isolate a given percept, this act of 'bracketing' is always, and necessarily, partial. There is, for example, no such thing as a complete reduction to listening (as my attempt to 'single out' the phenomenon of speech-as-sound in Beckett's *All That Fall* attests). Phenomenological description does not provide a complete or conclusive account of perceptual experience, nor, for that matter, does it claim to do so. Rather, it is precisely the 'messiness' of perception that phenomenology *attempts* to untangle.

The enterprise of placing listening over and against looking is not only phenomenologically untenable, but necessarily cloaks the common ground that lies between the senses. Furthermore, and as I have advanced, the familiar tendency to segment looking from listening can be navigated effectively by turning our attention to the phenomenon of attention.

Attention has tended to be conceptualised as a linear, one-dimensional faculty of the mind, or as an apparatchik of the disembodied gaze. According to this conception, attention, like a spotlight upon a stage, merely sheds light on perceptual content that, being pre-existent, merely requires illumination. Correspondingly, since attention, thus conceived, unambiguously seizes its objects, the phenomenon of distraction is necessarily left in the dark. Rather than setting up attention over and against distraction, I have proposed instead that we begin to explore the dynamics of embodied attending. More especially, and in urging us to reconsider (aural) attention in terms of *stretching*, I have advanced the following claims: first, that we should abandon the notion of attention as a 'spotlight', and begin to explore the phenomenal dynamics as played out within the attentional 'sphere': attention is not limited to theme, but is always affected by a wider attentional context. Second, that attention plays a key role in enacting perceptual content: *how* we attend shapes *what* we perceive. Third, that attention consists of an ongoing, intersensorial, bodily engagement with the affordances of any given environment or 'atmosphere'. Fourth, that attention is characterised, perhaps above all, by movement. Last, that

by reconceiving listening as a specialist mode of attention, not only can we navigate the sensory divide, but begin to examine the nuances of listening as an act.

As a means of demonstrating these broader hypotheses, and in an attempt to account for the spectrum of sonic experience (whether in the theatre or in the world at large), I have paid particular attention to the following aural phenomena: noise (Chapter 1), designed sound (Chapter 2), silence (Chapter 3), and atmosphere (Chapter 4). I will now summarise some of the principle inferences arising from each chapter, before going on to discuss some of the implications of these findings.

In paying attention to (theatre) noise, that is, to those (seemingly irrelevant) sounds that lie outside the frame of intended significance, I have sought to challenge a series of familiar binaries relating to sound and the senses, such as, signal versus noise, listening versus hearing, and attention versus distraction. To dismiss 'noise' as a troublesome 'distraction' necessarily forecloses an investigation of the attentional dynamics of listening as process. Indeed, the phenomenon of noise, which, by its nature, tends to *clamour* for our attention, presents itself as an effective, if surprising, starting point for a phenomenological analysis of aural attention.

Our perception of sound (whether defined as 'noise', 'sound', or 'silence') is always dependent on the particular sono-attentional context in which it is given to reside. For example, not all mobile phones that unexpectedly sound in the theatre are necessarily, and unequivocally, perceived as a noisy, annoying interruption. In accommodating such perceptual peculiarities, I have proposed that we reconsider listening (or aural attention) in *dynamic* terms. We always attend to *something*, whether that 'something' is unwanted sound, or any other percept. This process of attending, moreover, is not only highly complex, but inherently dynamic.

In continuing to investigate the dynamics of aural attention, and in exploring the nature of sound as an aesthetic object, I have also paid closer attention to the phenomenology of *designed* sound. Listening, as a playful act of attending, invariably subverts the intentions of design (cf. Goffman 1974: 306). Even when attending the scrupulously designed world of radio plays, where the form and content of what is 'given' is seemingly fixed, preordained, and immutable, the act of attention nevertheless 'shapes the phenomenology of perceptual experience' (Watzl 2010: 1). For example, whilst it is undeniably the case that the phenomenon of speech in radio plays takes centre stage, this does not necessarily accord with the perceptual realities of radio drama as

experienced: speech is not always the centre of attention. Furthermore, and as revealed by phenomenological enquiry, the act of looking, or rather of opening our eyes, seems to play a vital role in this ongoing process of perceptual enactment. That said, whilst the radio listener is able to alter their *perception* of the sound(s) they hear, the radiophonic 'soundscape' (so-called) is, nevertheless, and to all intents and purposes, materially immutable. By contrast, theatrical sound is materially, as well as perceptually, *mutable*.

In the theatre, the distinction between designed sound and unintended 'noise' is prone to confusion, and even collapse. Designed theatrical sound can often go awry, resulting in perceptual ambiguity, equivocality, and misperception. In short: sound in the theatre, unlike the designed 'fictional soundscapes' of radio plays, can never be fully contained, controlled, or conceived, and is always (and necessarily) susceptible to material, as well as perceptual, manipulation and alteration.

Designed sound directs the attention of the audience in various ways, and, in so doing, manifestly motivates varied acts of movement, both actual and imagined. Crucially, however, this sense of aural *manipulation* is not a one-way process. Attention, as Richard W. Lind confirms, is 'an articulation process' (1980: 132), and the intended 'meaning' of theatre sound as *designed* is invariably troubled and subverted by the creative articulations of theatrical sound as *attended*. Whilst sound designed to be perceived aesthetically demands our attention in particular ways, and is intended to elicit a particular experience, our perception of designed sound is nevertheless subject to considerable perceptual manipulation and *play*: 'the aesthetic object is completed only in the consciousness of the spectator' (Dufrenne 1973: 204).

As a further means of exploring the nature of aural attention as process, and in sounding out the wider parameters of the attentional sphere, I have also honed in on that surprisingly noisy phenomenon – silence. As a phenomenon, silence not only prompts us to listen more attentively, but motivates us to sound out our surroundings. The act of attending (in) silence, moreover, also impels us to attend to ourselves as attending subjects. In an attempt to accommodate this phenomenal complexity, I have advanced a broader conception of 'silence' that includes a consideration of absence, muteness, and listening-in. 'Listening-in', as I have proposed, is distinct from any other mode of aural attention in that it not only foregrounds a sense of movement, but is also characterised by a sense of self in attending, or, more specifically, of being silently present. Whilst defined as an absence of sound, silence is thus a phenomenon that we manifestly *perceive*.

In the theatre, silence is not only a phenomenon that we notice; our experience of theatrical silence will vary considerably depending on the material conditions and context within which it is perceived. Theatrical silence, more especially, and in contrast to its radiophonic equivalent, is shaped not only by the sophisticated techniques of theatre sound design, but by the sheer presence (or 'noise') of the audience.

The practice of attending theatre, unlike that of listening to a radio play, consists of an inter-subjective act of embodied participation. This collective act of attendance, moreover, plays a key role in shaping theatrical experience, an inference that has important implications not only for our understanding of theatrical silence but for our understanding of theatrical 'atmosphere'.

Rather than setting sound against scenography, and thereby segmenting the senses, I have proposed instead that we begin to explore the manifold ways in which theatregoers pay attention to (or make sense of) designed theatrical environments or atmospheres. Whilst theatrical performance usually strives to produce a particular kind of 'atmosphere', most notably through the careful use of designed sound, the responsibility for sustaining, tending, and fine-tuning this space is left in the hands of the audience. Atmospheres are generated, and continually *shaped*, as a result of a dynamic dance between the attending subject and the material affordances of a given environment: in *attending* atmospheres we play a vital role in their manifestation. To 'sense' an atmosphere, moreover, is not only to take note of the phenomenal particularities of any space or locality, but is also, and crucially, to feel our way around that environment: in sensing atmospheres we stretch ourselves.

There is, therefore, a great deal more to listening than meets the ear. Listening is not only something that we do, but is an 'act' that does something: *how* we listen phenomenally affects our perception of *what* we hear. Listening, moreover, is never alone: vision, or the act of looking, even in the case of radiophonic reception, plays a key role in shaping the phenomenology of auditory perception. Indeed, it is by means of looking that listening is *activated*. Lastly, to experience the *play* of listening is also to be aware of a sense of movement.

The sense in which listening entails movement in and through environmental space challenges the notion of aural immersion as straightforwardly conceived. We are not statically 'immersed' in sound, any more than we are detached, or removed, from the world of vision; sound does not intrude upon a passive subject, any more than the visual world is 'taken in' by the objectivising activity of a detached, disembodied eye.

Whilst the listener resides *in* the medium of sound, equally this medium must be attended, explored and travelled through. In short: listening, as an intersensorial act of stretching, involves paying attention to atmospheres. Such an inference, and the various hypotheses it promulgates, not only unsettles conventional wisdom and clichés concerning the phenomenology of sound and listening, but also, and more specifically, prompts us to reconsider the (aural) phenomenology of theatre.

'To experience a structure is not to receive it into oneself passively: it is to live it, to take it up, assume it and discover its immanent significance' (Merleau-Ponty 2002: 301). In resonance with this, and in conducting a phenomenological enquiry of theatrical listening, I have set out to discover the 'immanent significance' of theatre's 'aural phenomenology'. This investigation has not only revealed the ways in which theatre stages the phenomenon of sound, but has also disclosed the various ways in which the act of listening, as a dynamic embodied act of attending-in-the-world, manifests modes of experience and states of being that might be described as *theatrical*.

To listen is not merely to hear sound, but to grasp it. This act of grasping, however, consists of more than the mere attempt to establish meaning. Instead, when we listen, we *shape* meaning: in attending sounds, we set sound in play. The inherent theatricality of listening, moreover, is phenomenally presenced by the theatrical event: as well as theatricalising the *personal*ity of sound, theatre presences the *act* of listening. In staging sound, theatre invites the audience to engage in playful, adventuresome acts of listening, a fact exploited by contemporary sound design, which intensifies this sense of aural jouissance. Listening, as a dynamic act of attention, is thus not only theatrical, but theatre is arguably the place where this theatricality is most vividly played out. Furthermore, and perhaps of even greater import, this sense of aural performativity is only 'activated' as a result of the co-option of looking.

To attend the theatre does not mean to delimit or prioritise a particular sensory mode. Indeed, not only does what we see phenomenally affect what we hear, but our perception of sound is manifestly shaped by the sense of sight. *Where* we are positioned in the theatre, for example, can not only affect our perception of the dramaturgical voice, but also our ability to experience the *production* of sound(s). Theatre does not require 'a kind of binocular vision' in order to be received (cf. States 1985: 8). Nor, indeed, does the audience 'inhabit two worlds' (cf. Brown 2010a: 6). As a means of bypassing the seemingly intractable binaries of looking versus listening, signal versus noise, spectator versus audience, and significance versus sense, I have proposed a new paradigm of

theatrical reception that reconsiders the puzzle of 'theatre perception' from the perspective of attention. It is not simply that semiotics and phenomenology 'work together', as advanced by States (1985: 8), but that meaning is continually shaped, and manifestly embodied, *in* the act of 'attending' theatre.

The phenomenon of 'attention' not only tends to be taken for granted, but is also commonly misunderstood, and subject to considerable misrepresentation. Not only is it problematic to set up attention in diametric and simplistic opposition to distraction, but it is also untenable to associate attention (or attentiveness) with vision, whilst equating distraction (or distractedness) with audition. Attention is an essentially embodied, enactive, and *intersensorial* phenomenon. As an act of stretching, attention consists of an ongoing, embodied, and intersensorial engagement with the affordances of a given environment, a kind of perpetual tension, or dynamic dance, between body and world. Different attentional contexts, situations and environments motivate different attentional shifts and/or transformations, which, in turn, manifest an array of different sensations, states of being, and forms of lived spatiality. Furthermore, we should recognise that instead of being the mere vehicle of experience, or the mere conveyor of perception, attention plays a vital role in the enactment of perception and in the manifestation of experience. These inferences have important consequences for our understanding of theatrical reception.

'Theatre,' writes Bruce Wilshire, 'is to be construed neither as a pre-eminently visual, nor auditory, nor literary phenomenon, but as a perceptually induced mimetic phenomenon of participation – an imagined experience of total activity' (1982: 26). The particular kind of 'participation' that the act of theatregoing engenders, however, is not limited to detached acts of 'mimetic participation' between the audience and the actor/character. Theatre is not only a mere metaphor for life, a fictional analogue of 'real' experience, but is a place where experience is manifestly *enacted* by its participants. Whilst being fictional in form and content, although being a representation of reality, theatre is, above all, a phenomenal 'event' that we *attend*, and, as such, consists of an ongoing, dynamic and very *real* (as opposed to 'imagined') bodily engagement with the affordances of the theatrical environment. In attending theatre we not only *do* something, but also phenomenally 'participate' in shaping theatrical experience. Theatre is 'something perceived' (Styan 1975: 31), and theatre perception is manifestly shaped by the intersubjective attentional enactments of its 'participants' (cf. White 2013: 121–123). We should therefore steer clear of the tendency to conceive

theatrical experience as stemming exclusively from the actor/audience relationship, or from our engagement with the text-as-performed, and begin instead to reconsider theatre as a phenomenal 'event' which is received-and-perceived through and in the act of *attending*. For too long has theatre *reception* (and the process[es] of signification) been divorced from theatre *perception* (and the phenomenology of the senses). Instead, I propose that we not only begin to think of reception *as* perception, but attending *as* participation.[2]

In light of the above, what can now be said about the practice and phenomenology of theatre sound design? Are we entering a new era of the ear, an age where sound speaks to theatre 'as ontology'? Do contemporary sound design and the ways in which we are being invited to listen in theatre herald a new age of nonlinearity, immersivity, and distraction? In response, I make one overall point: if we are to discover the ontological significance and impact of sound in theatre, we must rigorously attempt to describe (and thematise) what it means to *be* in sound.

In the last decade or so we have undoubtedly witnessed some radical changes to the craft (and status) of theatre sound design. Yet, we must be cautious of over-emphasising the cultural and ontological significance of these technological and aesthetic shifts. Theatre sound design is *not* changing the way we listen or perceive. Nor is sound speaking to theatre 'as ontology' (cf. Sellars 2013: vii). Rather, the ontological significance of sound whispers and murmurs in the very practice of attending theatre.

Wilshire has spoken of the ways in which theatre invites us to 'stand-in' for the actors on stage, who themselves 'stand-in' for particular characters (see 1982). However, this model of theatrical reception overlooks the various ways in which the embodied attentional enactments of the theatregoer manifest ontological states and experiences that invariably coincide with meaning as staged and presented diegetically. For example, in attending that intensely poignant moment in Sound & Fury's *Kursk*, when the audience is plunged into pitch-black darkness and forced to share the same conditions as the absently present voices of the imperilled submariners, I had an acute sense of being a silently present, yet distant, witness to a scene of unfathomable tragedy. Embodied meaning, in other words, often resonates with 'meaning' as represented. In order to properly account for 'the ontological aurality of theatre' (Brown 2010a: 44) we must not only practice a phenomenology of theatrical listening, but learn to listen phenomenologically. To discover the immanent significance of (theatre) sound we must pay particular attention to the sonic environment within which we

are dynamically immersed: '*only as phenomenology is ontology possible*' (Heidegger 1962: 50).

Whilst recent developments in sound technology and the ever-emerging art of sound design invite us to attend more acutely to the aural dimensions of theatre, this does not therefore mean that we are suddenly at sea in a new world of implacable immersivity and noisy distraction. Nor, for that matter, does theatre sound design herald a new epoch of the ear. Instead, we might surmise that contemporary theatre manifestly invites us to attend to the processes by which we attend to things.

Being in the audience implies a passive, motionless attendance. Yet, the practice of attending theatre entails shifts of movement, yawns, and acts of stretching that (whilst appearing to be insignificant, the mere noise of a restless body) play a vital role in (theatre) perception. Moreover, not only do the phenomenal affordances of contemporary theatrical performance prompt us to make ever greater and more complex attentional manoeuvres, but also make us increasingly aware of our own embodied position within this phenomenal matrix. Indeed, and perhaps more than ever, theatre is inviting us to reflect upon the intricate connections between the senses and the role of the body in the perceptual event. Theatre not only presents us with a world to be perceived, but invites us to attend to the world of perception that this process of attending phenomenally enacts.

As I bring this book to a close, I am resoundingly aware that there is so much more work to be done, and so much more to explore. It would, for instance, be fascinating to discover how this research might deepen our understanding of other socio-cultural contexts (besides theatre) where the act of listening and the phenomenology of sound play an especially important role. Though the possibilities are manifold, the following topics present themselves as being particularly ripe for investigation: public spaces (such as waiting rooms and libraries) and the ethics of listening(-in); therapy and the (aural) phenomenology of attentiveness; meditation and the dynamics of (aural) attention; pedagogy and the politics of listening (or paying attention); business and the phenomenal (and political) dynamics of working environments or atmospheres; monasticism and the phenomenology of silence. I should, however, reiterate that questions (or speculation) relating to the socio-cultural, political, and ethical dimensions of listening as an inter-subjective act of attending lie beyond the parameters of this study. That said, it is my hope that the various disclosures arising from (and contained within) these pages may inform (and perhaps even inspire)

these associated fields of enquiry. In addition, the question of self in attending, together with the notion of attention as an inter-subjective act of perceptual enactment, also requires further consideration. Lastly, having sought to untangle the 'messy reality' of theatrical listening, and having laid the foundations for a theory of theatrical attending, it is my sincere hope that this book will not only act as a template for further phenomenological enquiry, but feed back into the practice of *making* theatre.

To *be* a listener-spectator is not to be statically immersed in the theatrical 'soundscape', but to feel our way around the designed theatrical environment or 'atmosphere' by means of an ongoing, intersensorial process of *dynamic embodied attending*. Crucially, however, this inter-subjective act of attending plays a key role in shaping this environment, not only in perceptual but also in material terms. Yet, there is more at stake than this. Not only is atmosphere central to the theatrical phenomenon, but theatre would seem to present itself as the readiest model for an aesthetics of atmosphere: 'In general, it can be said that atmospheres are involved wherever something is being staged, wherever design is a factor – and that now means: almost everywhere' (Böhme 2013: 2). In light of this, how might performance give back to philosophy by paying closer attention to theatrical atmospheres, and what might we learn about the phenomenon of theatre by exploring (in practical as well as theoretical terms) the complex ways in which audiences (not to mention actors) shape, interact with, and make sense of the designed theatrical environment? It is with this that I leave my reader, namely, with 'something in the air'.

Appendix

P. Sven Arvidson's 'Sphere of Attention'
(see 2006: p. 10; Figure 1).
Reproduced with the permission of Springer Press.

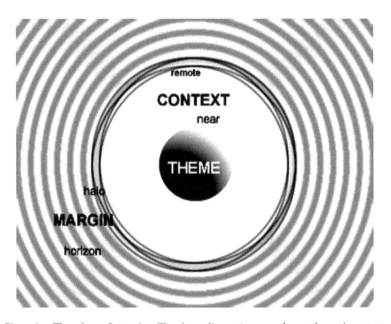

Figure 1. The sphere of attention. The three dimensions are *theme, thematic context,* and *margin.* Each is deep, not flat, and each names a function or process involved in human attending. Content in the thematic context can be more relevant (near) or less relevant (remote) to the theme. Content in the margin can be related to the theme (halo) but not relevant to it, or not related (horizon). The attending subject *is* the sphere of attention in these three dimensions. The sphere of attention is not an object *for* a subject. We do not have a sphere of attention, we live it in these three dimensions all the time, even in the special case of reflection or self-attention.

Notes

Introduction

1. See *Oxford English Dictionary* 1989, Volume I, p. 765.
2. *'The affordance of anything'*, as theorised by James Jerome Gibson, *'is a specific combination of the properties of its substance and its surfaces taken with reference to an animal'* (1977: 67). Moreover, and as he clarifies, 'an affordance is not what we call a "subjective" quality of a thing but neither is it what we call an "objective" property of a thing if by that we mean that a physical object has no reference to any animal' (Gibson 1977: 69–70).
3. See *Concise Oxford English Dictionary* 2002, p. 828.
4. For Nanay, theatre perception is not entirely 'action-oriented' since what we perceive is 'not really real' yet, on the other hand, theatre perception is not 'entirely detached since we do see the space of performance as containing actions, though not for us, for the character' (2006: 249).
5. For chapter-length works that broadly address the question of attention in theatre see: Prendergast 2004, Siegmund 2007, Bleeker 2008 (Chapter 9), Welton 2010, and Cull 2012 (Chapter 4). The notion of 'attention', 'attending', and 'attendance' is also often invoked in passing: see, for example, Kelleher on 'attendance' (2004: 111), McKinney and Butterworth on 'attention and distraction' (2009: 186–188), White on 'disattendance' (2013: 101–103) and Machon on 'attending' (2013: 81–85).
6. The question of attention in theatre has recently been investigated through the lens of cognitive science. This field has been pioneered by Bruce McConachie, whose book *Engaging Audiences: A Cognitive Approach to Spectating in the Theatre* (2008) has inspired further work in this area, such as Evelyn B. Tribble's *Cognition in the Globe: Attention and Memory in Shakespeare's Theatre* (2011), the first monograph (in English) to specifically focus on the question of 'theatre' and 'attention'. However, in conceptualising attention as a faculty of the mind or as a 'cognitive process' (see Tribble 2011: 36), this approach necessarily forecloses a consideration of the dynamics of *embodied* attending. My approach to the question of theatre and attention, by contrast, is specifically *phenomenological*.
7. In comparing the phenomenology of film to that of theatre, Noel Carroll touches on the question of attention. In film, '[e]verything outside the frame has been bracketed from attention' (Carroll 2003: 38). Film thus 'rivets the spectator to the screen more effectively than do stage dramas' (Carroll 2003: 29). Conversely, when attending the theatre 'we must ultimately locate and select the object of our attention; we have to find the objects that are most relevant to the ongoing narrative' (Carroll 2003: 40).
8. For a detailed discussion of presence and 'presencing' in theatrical performance see Power 2008.
9. For recent discussion on Sound Studies and its parameters see: Crook 2012, Pinch and Bijsterveld 2012, Sterne 2013, and Bull 2013.

10. A number of works have focused on how the practice and culture of listening has changed, both ethnographically and historically. See, for example, Thompson 2002, Sterne 2003, Drobnick 2004, and Erlmann 2004.

11. Bull and Back, for instance, assert that '[s]ound makes us re-think the meaning, nature and significance of our social experience' (2003: 4). Similarly, and in alignment with this sonocentric shift, Salomé Voegelin has spoken of the existence of a 'sonic subjectivity' (2010: 92 ff.), an idea which resonates, in some respects, with Steven Connor's notion of the 'auditory self' (see 1997). In investigating 'the importance of the auditory in the cultural, clinical and technological constitution of the modern self', Steven Connor postulates that 'the auditory self provides a way of positing and beginning to experience a subjectivity organised around the principle of openness, responsiveness and acknowledgement of the world rather than violent alienation' (see 1997: 219).

12. Veit Erlmann, for example, in *Hearing Cultures: Essays on Sound, Listening, and Modernity*, writes of seeking to avoid a 'countermonopoly of the ear' (2004: 4).

13. Steven Connor, for instance, in his important essay 'The Modern Auditory I', examines 'some of the defining importance in modernity and beyond of the sense of hearing' (1997: 204).

14. The purpose of the present study is *not* to engage with the various sociocultural and/or political debates concerning the 'hierarchy of the senses' (however important or interesting these may be), but rather to attend exclusively to that which is given in experience, and in so doing, to bring about a more nuanced account of how the senses (especially those of audition and vision) intersect.

15. Such an assumption fails to consider, or to account for, the alternative ways in which differently abled audience members experience theatrical performance. In particular, it is important to acknowledge the distinct ways in which hearing-impaired audience members may make sense (or not) of the theatrical event. Works dedicated to this line of enquiry are conspicuously lacking, Kanta Kochhar-Lindgren's important book *Hearing Difference: The Third Ear in Experimental, Deaf, and Multicultural Theater* (2006) being a notable exception. This area of investigation, which demands and deserves careful consideration, lies beyond the bounds of the present study. For now, I acknowledge the phenomenological particularity of my own subject position, and am readily aware that hearing-impaired audience members will likely have a strikingly different (though nevertheless valid) experience of theatrical sound and theatrical performance.

16. The notion and practice of 'attending' theatre is, of course, culturally and socially contingent, and thus subject to considerable variation. Whilst 'attention' has, I would argue, always been central to the phenomenon of theatre, it is important to note that different audiences, in different sociocultural contexts, at different historical moments, have attended theatre in different ways. The notion, for example, of paying resolute and unswerving attention to performers arguably only became normative for certain kinds of theatre in the late nineteenth century. However, and as interesting and important as these matters may be, such considerations (pertaining to sociality, history, and culture) lie beyond the scope of the present study, which

investigates the question of theatre and (aural) attention from an exclusively *phenomenological* perspective.

17. Recently we have witnessed a growing trend in contemporary theatre and performance to explore the sonorous dimensions of voice, speech and language. This shift would appear to be especially evident within the theatre of the avant-garde (see Primavesi 2003 and Curtin 2014). Moreover, it would seem that this move towards the aural is manifestly occurring in more 'mainstream' modes and genres of theatrical performance. For instance, within the last couple of years there have been a number of productions of Shakespeare that use foreign languages without the aid of subtitles, thus adumbrating the sonority of speech, voice and language, emblematic examples being Out of Joint's production of *Macbeth* (2004), performed in Yoruba, the Ninagawa Company's production of *Titus Andronicus* (2006), performed in Japanese, and Tim Supple's *A Midsummer Night's Dream* (2007), performed in seven different languages from the Indian subcontinent.

18. For works specialising in theatre sound design see: Napier 1936, Burris-Meyer 1959, Collison 1976, Walne 1990, Bracewell 1993, Leonard 2001, and Kaye and Lebrecht 2013. For a more extensive anthology see Brown 2010a.

19. Notable works focusing on 'aurality' in theatre and performance include Wichmann 1991, Meszaros 2005, a special edition of *Performance Research* (15.3, 2010), entitled 'On Listening', Kendrick and Roesner 2011, Ovadija 2013, Kassabian 2013, and Curtin 2014.

20. For works dedicated to the study of sound and voice in Shakespeare see: Folkerth 2002, Johnson 2005, and Bloom 2007.

21. '*Live Listening*' is the title of Chapter 7 of Ross Brown's book *Sound: A Reader in Theatre Practice*.

22. According to Willmar Sauter, for example, '"perception" carries connotations that tie it to phenomenology, while "reception" refers to Cultural Studies and the analysis of social values and mental worlds' (2000: 5).

23. 'Lose the sight of your phenomenal eye and you become a Don Quixote (everything becomes something else); lose the sight of your significative eye and you become Sartre's Roquentin ('everything is nothing but itself')' (States 1985: 8).

24. Notable works within the field of theatre/performance phenomenology include Maxine Sheets-Johnstone's *The Phenomenology of Dance* (1979); Bruce Wilshire's *Role Playing and Identity* (1982), the first monograph to approach the phenomenon of theatre *phenomenologically*; Bert O. States's *Great Reckonings in Little Rooms: On the Phenomenology of Theater* (1985), which uses phenomenology to take issue with semiotic approaches to theatre; and Stanton B. Garner's *Bodied Spaces: Phenomenology and Performance in Contemporary Drama* (1994). Whilst phenomenology has received relatively little attention in Theatre and Performance Studies there are signs that the tide might be changing. For other work, which either draws from or that (broadly speaking) is aligned with phenomenology, see: Bleeker 2008, Welton 2010, Wagner 2012, White 2013, and Grant 2013.

25. Bert O. States, for instance, provides an account of spectatorship that stems from 'a theater seat in [his] mind's eye' (1985: 14). Similarly, and although claiming to take a 'phenomenological path', Willmar Sauter merely invokes the idea of phenomenology in order to emphasise the emotional, sensory,

and felt aspects of performance without actually conducting a phenom-
enological enquiry as such (cf. 2000: 31). Whilst urging us to consider the
dynamics of theatrical semiosis, that is, to consider how the sensory ele-
ments of performance 'are vital in the formation of meaning', Sauter's enter-
prise tells us very little about the phenomenology of theatrical perception
per se (see 2000: 103).

26. For an introductory overview of phenomenology see Gallagher 2012. For
further reading see: Spiegelberg 1975, Moran 2000, and Ihde 2007 and 2012.

27. Existential phenomenology, for example, acknowledges that a complete
'bracketing' of the world is impossible by virtue of 'Being-in-the-world' (see
Heidegger 1962: 78).

28. 'To do phenomenology, on this integrated, natural conception, is not to
look inward. It is, rather, to seek to understand the ways in which reality
is disclosed in experience thanks to the person's (or animal's) involvement'
(Noë 2007: 238).

29. Importantly, phenomenology and feminism are not necessarily at odds.
Linda Fisher, for instance, has suggested that phenomenology and feminism
should 'work together' (2000: 14). Similarly, Carol Bigwood has suggested
that 'Merleau-Ponty's work can lead us to some methodological and philo-
sophical "grounding" for the feminist task of describing an incarnate gen-
derized body' (1998: 104).

30. The 'messy reality of listening': Catherine Laws's expression (see 2010: 2).

31. Here I refer to Martin Welton's notion of performance as epistemology
(2002; esp. 164 ff.). 'To perform or attend at a performance,' writes Welton,
'is not merely to acquire and possess, but, since this knowledge is inextri-
cable from the *act* itself, knowledge is located within this acquisition and
possession. "Knowing", in this instance, must be understood as necessarily
active' (2002: 10). Moreover, for Welton, 'it is in optimal acting that this
knowledge is most fully realised' (2002: 17).

32. My work on sound and listening began with a phenomenological investi-
gation of radio plays. The importance of these initial experiments for my
practice cannot be overstated. Indeed, this initial sounding out of sound and
aurality was, to all intents and purposes, where I 'cut my teeth' as a listening
phenomenologist. Radio drama not only lends itself to phenomenological
enquiry but, in some respects, *is itself* an exercise in phenomenology: consist-
ing solely of sound and being scrupulously designed, radio plays invite, as well
as *demand*, that we pay particular attention to the phenomenon of sound. This
initial exploration of sound (theatre) has also, in many ways, led my work
conceptually. Thus, it would seem strange *not* to preface a phenomenology of
sound in theatre with a phenomenological consideration of radio drama.

33. The work of Samuel Beckett offers a fertile starting point for a phenomeno-
logical consideration of sound and aural attention. 'In his later works', for
example, 'there emerges a particular focus on the conscious act of listening
in and for itself' (see Laws 2010: 1). This interest in staging the auditory act
is clearly evident in his radio works, of which *All That Fall* and *Embers* are
no exception. Throughout these plays Beckett allows us to experience sound
as *heard* by the play's protagonists.

34. To practice a phenomenology is to carry out a series of experiments over and
over again, being sure to bracket the phenomenon in question and, in acts

of reflection, to take note of the phenomenal structures that this manoeuvre discloses. For an excellent working guide to phenomenological method see Ihde 2007.

35. This interest in the phenomenology of speech-as-sound in theatre arose initially from my experience of attending Tim Supple's multi-lingual production of *A Midsummer Night's Dream*, which played at Camden's Roundhouse in 2007.

36. Cited from Sound & Fury's website: http://www.soundandfury.org.uk/ (accessed 16 April 2014).

37. Having secured funding from the British Council, *Kursk* went up to the Edinburgh Festival Fringe in August 2009, for a week's run at the University Drill Hall, before going on to tour the UK in 2010.

38. I have, for example, attended Sound & Fury's *Kursk* no fewer than seven times: three times in June 2009 at the Young Vic's Maria Studio; once at the University Drill Hall in Edinburgh (August 2009); once at the Bristol Old Vic (March 2010); and twice during the Young Vic's re-run of the piece in March 2010.

39. An 'assemblage', as Gilles Deleuze has suggested, 'is a multiplicity which is made up of many heterogeneous terms and which establish liaisons, relations between them' (2007: 69).

40. Whilst Sound & Fury's *Kursk* would appear to assemble all or most of the over-riding concerns of this book in one single example, it is important to clarify that the 'knowledge' gained from attending this performance, like any other act of attendance, did not arise from that encounter alone but rather was *accumulated* through an ongoing, embodied process of attentional accretion.

41. 'Everyone labors with attentions [...] All the sensing out and living through *worlds up* in gangly accruals, in the rendering of the something you're in as if it's a beginning or an end, as if it's all, or nothing' (Stewart 2011: 449–450).

42. The phenomenon of the *acousmêtre* not only discombobulates the workings of the attentional sphere in surprising ways, but it is precisely as a result of this attentional displacement that the 'uncanniness' of the *acousmêtre* is manifestly materialised.

1 Paying Attention to (Theatre) Noise

1. Paul Rodaway, for instance, states that '[h]earing may be described as the basic passive sensation, whilst listening implies an active attentiveness to auditory information and a desire to establish meaning' (1994: 89). Likewise, Blesser and Salter maintain that 'hearing' entails 'the detection of sound', whereas 'listening' involves the 'active attention or reaction to the meaning, emotions, and symbolism contained within sound' (2007: 5; see also Handel 1989: 3). This active/passive distinction is also evident in Roland Barthes's conception of aural experience: for Barthes, '[h]*earing* is a physiological phenomenon' whilst '*listening* is a psychological act' (1986: 245). Others have invoked the notion of intentionality as a means of forging this distinction: for Paul Carter, for instance, listening is 'intentional hearing' (1992: 44). However, in order to deepen our understanding of listening as process we should focus not so much on listening-as-intention, but rather on listening-as-attention.

2. Wolvin and Coakley, for example, maintain that 'listening always involves a basic process of receiving, attending to, and assigning meaning to messages' (1993: 18).

3. '[B]ackground listening [...] occurs when we are not listening for a particular sound, and when its occurrence has no special or immediate significance for us' (Truax 2001: 24).

4. See *Oxford English Dictionary* 1989, Volume X, pp. 464 and 254.

5. 'Noise', in its broadest valence, is the omnipresent yet quasi-absenced background within which meaning takes place: 'Background noise is the ground of our perception, absolutely uninterrupted, it is our perennial substance [...] No life without heat, no matter, neither; no warmth without air, no logos without noise' (Serres 1995: 7).

6. 'Sound – vocal, non-vocal, musical and non-musical – along with sound's absence – the ticking, anticipatory buzz of stage silence – are elemental to the phenomenal fabric of theatre' (Brown 2011: 1).

7. For an in-depth investigation of the question of 'noise' in theatre, see Kendrick and Roesner 2011.

8. The notion of 'soundscape', which is commonly used among theatre sound designers, is discussed in Ross Brown's benchmark essay 'The Theatre Soundscape and the End of Noise' (2005).

9. The sound for *The Cherry Orchard* was designed by Paul Arditti, whose reflections on theatre sound design are mentioned in Chapter 2.

10. The 'Bridge Project' was a transatlantic initiative orchestrated by Kevin Spacey and Sam Mendes. *The Cherry Orchard*, the inaugural production of this venture, was produced by the Brooklyn Academy of Music (BAM), the Old Vic, and Neal Street Productions. For further details see: http://www.bam.org/programs/the-bridge-project (accessed 16 December 2014).

11. The part of 'Anya' was played by Morven Christie.

12. In his doctoral dissertation, 'The Frequency of the Imagination', Pieter Verstraete 'investigates the practice of listening and the listener in contemporary music theatre performances' (2009: 235). In proposing a 'new approach to music theatre', Verstraete develops the concept of 'auditory distress' (2009: 2, 9). Verstraete advances the following overarching thesis: 'Sound – including music or any other sound experience in the theatre – produces a level of auditory distress. This distress calls for a response in the listener with which she or he tries to control the auditory distress' (2009: 12). Verstraete's model of auditory distress, in other words, consists of two 'aspects': namely, affect and response.

> On the one hand, auditory distress calls for an understanding of how today's music theatre works in the interplay of several crucial dramaturgical principles and the way sound or music causes this distress in the listener. On the other hand, through auditory distress I explain how the modes of listening help the listener to respond to the disturbances in her or his perception of these performances. (Verstraete 2009: 2)

More specifically, Verstraete suggests three means at the listener's disposal for 'coping' or dealing with 'the disturbing quality of sound' (2009: 2, 24): namely, different modes of listening, narrativisation, and auditory

imagination (2009: 18). Furthermore, Verstraete presents the notion of 'auditory distress' not only as a new conceptual approach to music theatre, but as a means of modelling the nature of sonic experience at large: for Verstraete, 'auditory distress' not only 'belongs to every auditory experience in the theatre', but 'forms the basis of listening' (2009: 15, 18). Whilst there would appear, at first sight, to be a variety of overlaps between Verstraete's work and mine, there are a number of important points of difference and points of dispute that I must draw to the reader's attention. For the purposes of brevity these can be summarised as follows.

First and foremost, and speaking generally, I take issue with Verstraete's approach, and the conclusions that such an approach necessarily begets. Although Verstraete has endeavoured to investigate the nature of listening in theatre and performance, he presents a one-size-fits-all approach to aurality that necessarily cloaks the embodied dynamics of listening-as-lived. More precisely, whilst Verstraete highlights the importance of attention for an understanding of listening, he fails to define, investigate, or elucidate what 'attention' *is*. Moreover, in taking the phenomenon of attention for granted, Verstraete reinstates and uncritically adopts that familiar binary: attention versus distraction. More especially, and whilst providing some clear, helpful and in-depth exposition of a wide range of scholarly works in the field of sound and aurality, Verstraete fails to consider, in any substantial detail, the phenomenon of listening as a specialised mode of attention. The act of looking, furthermore, is conspicuously absent from his account of theatre aurality. Finally, and perhaps most important of all, whilst I am not entirely against using the notion of 'auditory distress' as a means of describing *some* aspects, or occurrences, of auditory experience (such as, for example, moments of sonic 'incursion'), it is far-fetched, not to mention phenomenologically untenable, to use this concept as a starting point for modelling sonic experience at large.

My criticisms are thus both methodological and conceptual. If we are to account for the audience's 'experience' of sound, whether in the context of contemporary music theatre, or within theatrical performance in general, we must be specific and systematic in our approach. In developing the notion of 'stretching ourselves', my critics might accuse me of doing precisely that which I have cautioned against above. In response, I must clarify that the idea of *stretching*, by its nature, and in contrast to that of 'auditory distress', allows for dynamism, playfulness and possibility: the notion of stretching is less of an imposition, and more a means of weaving together a number of themes, propositions, and inferences, all of which have emerged as a result of phenomenological enquiry. By paying *particular* attention to the phenomenon of sound we can move *beyond* metaphor and begin to discover what it means to listen.

13. In many respects, the same criticism can be made of Wes Folkerth's analysis of sound in Shakespeare. Folkerth's concept of 'Shakespearience', a neologism that propounds a 'broader historical-phenomenological approach to the study of Shakespeare' (see 2002: 9), is necessarily removed from the practice of phenomenology. The same can also be said of Bruce Johnson's socio-sonic analysis of *Hamlet* (2005).

14. In drawing from Don Ihde's threefold taxonomy of the auditory field, namely that it is characterised by surroundability, directionality and continuity (see Ihde 2007: 76–81), Bruce R. Smith makes the following statement:

 > Sound immerses me in a world [...] Sound subsumes me: it is continuously present, pulsing within my body, penetrating my body from without, filling my perceptual world to the very horizons of hearing. The shape of the auditory field approximates a sphere. O defines the perceptual limits of reverberating sound. (1999: 9–10)

15. This commonly held conception (namely, 'sound is round') situates auditory experience in diametric and geometric opposition with the allegedly rectangular, perpendicular nature of visual perception. Moreover, within this conception of aural experience vision is active, directed, and individualised, whereas listening is passive, distracted, and essentially communal. The notion of 'immersion', unless conceived *dynamically*, implies a static, inactive, ideality that fails to correspond with the phenomenal realities of listening-as-lived.

16. *Sound: A Reader in Theatre Practice* is by far the most broad-ranging and progressive account of theatrical sound yet written. Notwithstanding the pioneering work of Bruce R. Smith, Brown's book is characterised by firsts: it offers one of the first major histories of sound in theatre; it is the first scholarly attempt to historicise, define, and conceptualise the progression of sound design; moving way beyond his predecessors, it develops the notion of sound-as-dramaturgy; last but not least, *Sound* attempts to account for theatre's 'aural phenomenology' (2010a: 138).

17. According to Brown, 'this synaesthetic, general background awareness of ambient environment, of noise, resonant space and *others* [or what he also refers to as the 'aural senses'], is the atmosphere within which perception is made, and modifies the meaning of any received communicative signal' (2010a: 214).

18. In conceptualising the nature of sonic experience in theatre, Ross Brown draws from Joachim-Ernst Berendt's somewhat misguided model of the senses. Developing the Indian analogy of *nada brahma*, a mantra meaning 'the world is sound', Berendt maintains that, before the age of reason, the non-linear, holistic thought processes of the ear took precedent over the linearity of looking; analogy preceded analysis (see Berendt 1987). However, with the dawn of postmodernity, Berendt suggests that eye processes may have run their course, unable to deal with the multiplicities of the postmodern condition. Concurring with Berendt, Brown suggests that theatre is a place where such an 'impasse' might be reconciled and where we may be witnessing (in the most striking of terms) the formation of '*ear-thinking*' postmodern subjects (see Brown 2005: 110–111; for more on the notion of 'eye-' versus 'ear-thinking' see Berendt 1988, p. 49 ff.). For Brown, the theatre soundscape signals the resurgence of aurality as the 'primary sense' where ear-thinking might once again predominate over eye-thinking, a world of sound (noise included) where Berendt's dictum 'all is one and to hear is to be' resounds (see Brown 2005: 111). I take issue with

Berendt, and consequently Brown, on a number of levels. First, Berendt's model makes a number of assumptions regarding the nature of aural and visual perception. Hearing is presented as a pure yet passive non-linear receptor of sound that creates self-presence and grounds Being, whilst vision is depicted as an objectifying act: in its relentless urge to gain a sense of the Other, vision becomes what it seeks: a sense of the Other. Moreover, if we accept the maxim 'all is one and to hear is to be' then, within this conception, listening *itself*, being a scrutinising *act* of perception, is necessarily excluded from the pure and primary domain of ear-thinking; since listening requires the enlistment of attention, a faculty which is said to belong to the processes of the eye, the act of listening is external to and in opposition to all things aural. Whilst Brown downplays this alignment in his more recent work, and has strived to offer a more nuanced model of theatre sound and aurality, Berendt's far-fetched ontology still lurks in the background.

19. This idea of listening as *playful* corresponds in some ways with Catherine Laws's concept of the 'performativity of listening' (2010: 1), as well as with what Caleb Stuart has referred to as 'aural performativity' (see 2011). Yet, whilst it is appropriate to consider the phenomenon of listening in terms of 'performativity', there is a spatial dimension to listening that more extended notions of performance begin to dilute. My intention here is not to dismiss but rather to develop this notion, that is, to work towards a broader model of listening that *accommodates* these nuances of auditory experience and allows the phenomenon of listening to speak on its own terms.

20. Cultural historian Michael Hagner, for instance, has pointed out that '[a]s a direct effect of the omnipresence of the new media, attention has become a central focus of interest' (2003: 670). Drawing from Georg Franck's notion of an 'economy of attention', Hagner suggests that in today's world the problem 'is how to acquire and manage more and more information in shorter and shorter periods of time' (2003: 670–671). Similarly, Maggie Jackson has upheld that '[t]he way we live is eroding our capacity for deep, sustained, perceptive attention – the building block of intimacy, wisdom and cultural progress' (2008: 13). Another notable discussion of attention within the field of Cultural Studies is that of art historian Jonathan Crary, whose benchmark work, *Suspensions of Perception*, aims to provide 'a genealogy of attention since the nineteenth century and to detail its role in the modernization of subjectivity' (1999: 2). Yet, whilst offering an extensive examination of how attention-as-a-concept has been used both as a means of personal freedom and as a means of collective and political control, Crary's account operates from a macro-level perspective that necessarily overlooks the nuances of attention as *lived*.

21. The category of 'attention' is conspicuously absent from *The Oxford Companion to Philosophy* (Hondrich 1995). That said, there are signs of a renewed interest in attention within philosophy (see, for example, Mole et al. 2011). Moreover, a growing number of scholars have begun to explore the phenomenology of attention (see, for example, Watzl 2010 and Waldenfels 2011).

22. This ocularcentric conceptualisation is well established. Augustine, for instance, talks of 'the attention of the mind', that is, 'the power that fixes the sense of sight on the object that is seen as long as it is seen' (Book 11: Chapter 2; in Matthews 2002: 62). Similarly, for Descartes, as Matthew Riley

explains, attention is 'a kind of intellectual illumination, a source of light which brings our ideas out of obscurity and elevates them to the clarity and distinctness required by certainty' (2004: 11).

23. Such an opposition is clearly evident in Descartes, who believed that by cultivating an attentive state of mind it is possible to dampen the prejudices of the body, thus allowing truth to come into being. Descartes's rationalism and concern for the body/mind problem finds its apotheosis in the thought of Nicholas Malebranche. For Malebranche, as Riley explains, '[a]ttending is a matter of silencing the clamour of the passions and the senses and listening for the soft, but distinct, voice of God' (2004: 11).

24. In demonstrating her allegiance to a Cartesian notion of attention, Maggie Jackson has declared that we are 'slipping toward a new dark age' (2008: 14), where '[f]ocus slides into diffusion, judgement slips into skimming, and awareness slips into detachment' (2008: 238).

25. According to Husserl, 'attention of every sort is nothing else than a fundamental species of *intentive* modifications': thus, for Husserl, 'intentionality' is none other than 'the radically first *beginning* of the theory of attention' (1983: 226, footnote 32).

26. Arvidson's 'sphere of attention' — the main concept and title of his book (see 2006) — is inspired by the work of Aron Gurwitsch (1901–1973), whose magnum opus, *The Field of Consciousness* (1964), 'analyses human conscious life from the perspective of phenomenology and Gestalt psychology' (see Arvidson 2006: 2). Although a student of Husserl, Gurwitsch diverges from Husserlian phenomenology in important ways. Most notably, he promotes a model of 'embodied consciousness' (1964: 26), where the notion of intentionality is replaced by the embodied practice and lived dynamics of attentionality: 'Absorbed though our attention may be with our problem, we never lose sight of our actual surroundings nor of ourselves as situated in those surroundings' (Gurwitsch 1964: 1). Moreover, by considering the 'totality of co-present data', namely, the 'field of consciousness', Gurwitsch provides a pioneering account of co-presence that comprises 'not only data which are experienced as simultaneous, but also those which are simultaneously experienced, though not as simultaneous' (1964: 1–2).

 Building on these foundations, Arvidson goes one step further by proposing that attention is 'the central feature of human life and of Gurwitsch's work, and [uses] attention as the touchstone [when interpreting and advancing] Gurwitsch's findings about consciousness' (2006: 2). In short, and as the following extract makes clear, Arvidson expands Gurwitsch's 'philosophy of consciousness' into a 'philosophy of attention' (2006: 3):

 > Human subjectivity is attending activity. This way of speaking may sound dramatic and even strange, but I think it is a clear way of saying what we are and what we do, and I believe it captures the spirit of Gurwitsch's phenomenology of consciousness, except that it all becomes oriented around a phenomenology of attention. Noting Husserl's *Ideas I* (1982), Gurwitsch (1964, 419) writes 'Considered as to its specific nature, consciousness is a domain closed in itself, a domain into which nothing can enter and from which nothing can escape.' Such a 'domain' is all that is meaningful in human life. I have called this the sphere of attention. (2006: 115)

For Arvidson, then, since 'one can only define attention by taking account of (contextual and marginal) consciousness, and one can only define consciousness by taking account of attention' (2006: 13), it is perhaps more useful (and more accurate) to think of consciousness (or rather the totality of conscious/attentional life) not so much as a 'field' but as a 'sphere'.

> [T]he sphere metaphor better acknowledges the depth of dynamic attentional processes than a field and [...] accounts better for the peculiarities of subjectivity and attentional life. It is a sphere of attention rather than a field of consciousness because I take attending to be the center of experience, and consciousness to be part of the sphere of attention, as context and margin. (Arvidson 2010: 100)

27. 'The spotlight metaphor allows only on/off, illuminated/unilluminated. This one-dimensional interpretation of the sphere of attention as either focal attention or marginal 'non-attention' squeezes out the phenomenon of context. [...] Not only is context denied a place in attentional processing but it becomes impossible to account for the general richness of attention processes, such as transformations in attending. Following Gurwitsch, I believe that attention is more about the content of what is attended to, its organization and transformation of organization, than about the on/off illumination of a target area' (Arvidson 2006: 19).
28. 'Margin to theme succession *is* thematic attention capture' (Arvidson 2006: 81; emphasis added).
29. The word 'acousmatic' stems from the Greek word *akoustikos,* itself derived from the verb *akouein,* meaning 'to hear' (*Concise Oxford English Dictionary* 2002: 11).
30. An emblematic example of this inherently theatrical phenomenon occurred during my attendance of Dominic Cooke's revival of Eugène Ionescu's *Rhinoceros,* starring Benedict Cumberbatch, which premiered at the Royal Court Theatre in September 2007. At the climactic moment when the rhinoceroses break through the brick walls onto the stage I detected a mysterious rumbling noise that seemed eerily balanced between the world of the play and the world at large. Then, suddenly, it became clear that these ominous vibrations were neither an explicit component of the sound design nor the product of an experiment that attempted to play with the ambiguity of sound events, but were, in fact, the otherwise unmistakable sounds of the underground, emanating from several hundred feet below the theatre itself. I had witnessed a moment of sono-perceptual coincidence or *sonic serendipity*: the unintended, random sounds of the environment momentarily provided the perfect sonic accompaniment for a particularly dramatic moment in the play.
31. '*Enlargement* is when the thematic context for the theme grows or expands in significance while the theme remains essentially unchanged' (Arvidson 2006: 59; see also Gurwitsch 1966: 223–227).
32. The 'lived body', as Drew Leder has suggested, can be characterised 'as an ecstatic/recessive being, engaged both in a leaping out and a falling back. Through its sensorimotor surface it projects outward to the world. At the same time it recedes from its own apprehension into anonymous visceral depths' (1990: 103).

UNIVERSITY OF WINCHESTER LIBRARY

33. Patrice Pavis, for instance, proclaims that '[w]e spend our lives faced with images: they stand in our way, they guide us, and they absorb us. But we live inside the world of sound: it encompasses us, mothers us, feeds and greets us with sound and meaning' (2011: x).

34. For a critical analysis of Euclid's concept of space, see Janich 1992.

35. 'Like light, sound exists neither on the inner nor on the outer side of an interface between mind and world. It is rather generated as the experiential quality of an ongoing engagement between the perceiver and his or her environment. Sound is the underside of hearing just as light is the underside of vision; we hear in one as we see in the other' (Ingold 2000: 268).

36. This lends weight to James Gibson's proposition that 'the world is ordinarily perceived by *scanning*' (1950: 29).

37. Theories of spectatorship and enactment, as Stanton B. Garner has suggested, are invariably modelled according to an Aristotelian conception of (theatre) perception 'in which the theater plays its meaning before the gaze of a privileged spectator who stands (or sits, as it were) outside the conditions of spectacle' (1994: 45).

38. The question of 'visuality' in theatre has been explored, at length, by Maaike Bleeker. Urging us to reconsider the 'spectator as body perceiving (rather than a disembodied eye/I)', Bleeker points out that 'far from being "the noblest of the senses" [...], [vision] appears to be irrational, inconsistent, and undependable' (2008: 6, 2). Another scholar who has done much to draw our attention to the phenomenal complexities of visual perception in theatrical performance is Aoife Monks, whose book, *The Actor in Costume*, explores 'the double visions engendered by the act of dressing-up at the theatre' (2010: 3). As Monks points out, 'sometimes costume remains stubbornly in view *as* costume, refusing to be meaningful, or exerting a power beyond its role in the fictional event' (2010: 6).

39. Derrida's notion of 'phonocentrism', as James K.A. Smith explains, refers to 'the determination of being as presence or ideality and the valorization of *speech* as the site of presence (in contrast to writing) and therefore immediacy' (2005: 33; Derrida 1973: 74–75).

40. 'The voice is the being which is present to itself in the form of universality, as consciousness; the voice *is* consciousness' (Derrida 1973: 79–80).

41. Arguing that gendered differences in motility are acquired as opposed to being innate, the philosopher Iris Marion Young has urged us to reconsider the familiar assumption that '[g]irls throw in a way different from boys because girls are "feminine"' (1998: 259). Similarly, Jillian Canode has maintained that Merleau-Ponty 'neglects to offer a female point of reference for sexuality and is therefore saying that all human sexual reference is the same, just as his account of motility and spatiality is a universal one' (2002: 34). Correspondingly, in examining the question of sexual difference Judith Butler has proposed that '[n]ot only does Merleau-Ponty fail to acknowledge the extent to which sexuality is culturally constructed, but his descriptions of the universal features of sexuality reproduce certain cultural constructions of sexual normalcy' (1989: 92).

42. For feminist criticism of Merleau-Pontian phenomenology see Butler 1989, Young 1990, Allen 1993, Sullivan 1997 and 2000, and Canode 2002.

43. Using Merleau-Ponty's account as the touchstone for phenomenology in general, Allen asserts that phenomenology is '*neuter*' and that '*neutral*

thinking [...] rests on an androcentric bias' (1993: 244–245). This position has been developed by Shannon Sullivan (1997) and subsequently critiqued by Silvia Stoller (2000). In accusing Merleau-Ponty of introspectionism, Sullivan claims that 'Merleau-Ponty's intersubjective dialogue often turns out to be a solipsistic subject's monologue that includes an elimination of others in its very "communication" with them' (1997: 1). However, as Stoller makes clear, 'anonymous corporeality is not "neutral" for Merleau-Ponty' (2000: 176). In other words, 'anonymous does not mean that subjects face each other "neutrally," nor does it mean that their bodily identity is completely "unknown"' (Stoller 2000: 176; citing Sullivan 1997: 5). Moreover, '[g]iven the fact that for Merleau-Ponty the human subject is always a *situated subject* – and this applies also to the anonymous mode of being – such a conclusion is unfounded' (Stoller 2000: 176; emphasis added). Indeed, and as Stoller goes on to point out, Merleau-Ponty 'questions the conditions for the possibility of differences' (2000: 178). Sullivan's argument thus 'fails by presupposing what in fact needs to be explained: the particularities' (Stoller 2000: 175). As she reveals in her subsequent reply to Stoller, Sullivan's grievance with Merleau-Ponty centres on his notion of 'projective intentionality' (2000: 184), that is to say, the assertion that '[c]onsciousness is being-toward-the-thing through the intermediary of the body' (see Merleau-Ponty 2002: 159–160). For Sullivan, 'Merleau-Ponty's phenomenology still retains the notion of a solitary self (now in the form of a body, rather than the transcendental ego) whose own projection is its primary preoccupation' (2000: 184). However, what Sullivan fails to realise is that Merleau-Ponty's understanding of intentionality, like that of Heidegger, is a radical departure from Husserl. Far from being solipsistic, Merleau-Ponty's notion of intentionality consists of a dynamic tension between body and world. The percipient does not simply exist 'towards-the-thing' but this existence is motivated 'through the intermediary of the body'; the percipient does not simply 'take aim' at objects in the world but rather this process of aiming is itself motivated by their 'call' (see Merleau-Ponty 2002: 160–161).

44. '[A] phenomenon-for-me', as Casey explains, is 'an appearance whose actuality is held in abeyance and whose essential structure is revealed only in and to my conscious apprehension of it' (2000: 23).

45. 'Singling out,' as Arvidson explains, 'is more radical than restructuring since the changes are not simply accomplished within one dimension (intra-thematic) but are inter-dimensional (theme and context)' (2006: 75).

46. '[I]t is no mean task to speak about sounds in themselves, if the listener is forced to describe them independently of any cause, meaning, or effect' (Chion 1994: 29).

2 Paying Attention to Designed Sound

1. 'In English the word *design* is both a noun and a verb [...] As a noun, it means – among other things – "intention", "plan", "intent", "aim", "scheme", "motif", "basic structure", all these (and other meanings) being connected with "cunning" and "deception". As a verb ("to design"), meanings include "to concoct", "to have designs on something"' (Flusser 1999: 17).

2. See *Concise Oxford English Dictionary* 2002: 2812.
3. Publications of radio drama generally fall within four categories: 1) practical handbooks and guides providing information on how to write, produce, or perform radio drama (see, for example, Richards 1991 and Beck 1997); 2) critical accounts that discuss the range of possible meanings and interpretations inherent within the plays themselves (such as, Zilliacus 1976, Esslin 1980, and Guralnick 1996); 3) cultural histories of radio drama and its reception (see Drakakis 1981 and Hendy 2000); and 4) theoretical studies that attempt to explain the 'nature' of radio drama and how it 'works' (see, for example, Esslin 1971 and Gray 1981). Between the 1920s and 50s most works on radio drama were written by practitioners offering introductory accounts of the medium, its methods and production. Early handbooks, such as Gordon Lea's *Radio Drama* (1926), Lance Sieveking's *The Stuff of Radio* (1934), and Felix Felton's technically driven study, *The Radio-Play* (1949), offer practical information for anyone interested in writing, producing or listening to what was then, at least, a new and ever-developing art form. By the 1950s, radio drama was well established, possessing its own technical vocabulary and aesthetic style. Apart from Val Gielgud's historical survey, *British Radio Drama 1922–1956* (1957), the most influential work of this period is Donald McWhinnie's *The Art of Radio* (1959). In the early 1980s a series of publications developed the field to such an extent that they too became established within the canon of radio drama. These are: John Drakakis's *British Radio Drama* (1981), a collection of essays covering the main dramatists, Peter Lewis's *Radio Drama* (1981), a collection offering more practical and theoretical approaches, and Andrew Crisell's seminal work *Understanding Radio* (1994). Recent additions to the canon include Tim Crook's *Radio Drama: Theory and Practice* (1999), Dermot Rattigan's discussion of radio and the dramatic imagination (2002), Hugh Chignell's *Key Concepts in Radio Studies* (2009), and a new handbook by Hand and Traynor (2011). A small though significant number of scholars have approached radio drama from the perspective of phenomenology (Powlick 1974, Scannell 1996, and Cazeaux 2005). Whilst these precursory accounts of radio drama and phenomenology have broken ground, they cannot, strictly speaking, be described as examples of phenomenological enquiry per se. Scannell's use of phenomenology, for example, is purely theoretical: he *applies* phenomenological philosophy, in particular that of Heidegger, in order to investigate the socio-cultural conditions of radio, as opposed to engaging in the rigours of phenomenological method.
4. The notion of a 'soundscape', as I elaborate in more detail in Chapter 4, is conceptually and phenomenologically problematic. Here I use the term radiophonic 'soundscape' to refer simply to the designed sonic composition that characterises the radio play, and, by placing it in quotation marks, draw attention to its familiar use within Radio Studies and academic discourse at large. Whilst the concept of a 'soundscape' may, at first glance, seem like an apposite means of describing the designed, autonomous, and seemingly fixed 'sound-world' of radio drama, one must question the extent to which the term provides an accurate (or indeed useful) depiction of what it means to listen to, attend, and perceive these scrupulously conceived works of sound. Such matters pertaining to the *radiophonic* 'soundscape', however,

lie beyond the scope of this book, my critique of the notion of 'soundscape' being primarily concerned with the nature of sonic experience in general, and the phenomenology of theatre sound in particular (see Chapter 4).

5. To emphasise the radio plays' existence as a phenomenon of *sound*, I prefer to classify these elements as speech (which itself is a phenomenon of sound), sound (whether atmospheric sound, sound effects or music) and silence.

6. 'The first is that of foreground sound, or that sound which gets one's prompt attention. A noise, such as a fire siren, may reside as a background sound until one smells smoke [...] Contextual sounds are those taking place in the vicinity of the foreground sound. Given the sound of the fire siren, one may also hear related sounds such as shouting, crackling fire, and the chaos of great commotion [...] The background field is the ambient soundscape against which the first two sound planes are contrasted' (Ferrington 1994: see 'The Soundscape' section, n.p.).

 There would appear to be a close correspondence between Ferrington's concept of a 'soundscape' and the three dimensions of the attentional sphere, namely, theme (foreground), context, and margin (background). Yet, one must question the extent to which such a neatly segmented conception of sonic experience tallies with the perceptual dynamics of attentional life. Whilst it is useful to map out attention in this way, our principle task should be to investigate the manifold ways in which these three dimensions of attending are manifestly and dynamically interrelated.

7. When producing radio plays 'a strict hierarchy of sound is constructed, whereby music and sound effects (S/FXs) are balanced in importance well below the character's dialogue and rarely share the same space for long' (see Beck 1997: section 1.4).

8. Perhaps this is what Beckett was referring to when speaking of 'the tension present in the act of listening' (cited in Beckerman 1986: 151).

9. This sense of perceived spatial and corporeal intimacy is implied in the expression '*close* listening'.

10. [F]or a radio play', as Rudolf Arnheim explains, 'the manuscript must be composed so as to make quite clear the requisite spatial situation' (1936: 58). '[In radio] the sound does not come from all directions: only loud and faint, vague and distant sounds are heard, and all within a single acoustic extension in depth. The question of spatial direction [...] is therefore obviously reduced to one of spatial distance' (Arnheim 1936: 58–59). For further discussion on the nature of point of listening/audition see Beck (1998) and Rodero Antón (2009).

11. This assumption is well established. Writing in the 1920s, radio pioneer Gordon Lea upheld that radio drama is limited to a 'single sense', in contrast to 'stage plays', which involve 'multiple-sense reception' (1926: 70). More recently, Andrew Crisell has maintained that radio 'communicates through only one of our five senses' (1994: 14).

12. Adherents to this concept of radiophonic reception include Lea 1926, Arnheim 1936, Zilliacus 1976, Lewis 1981, Guralnick 1985, Crisell 1994, Shingler and Wieringa 1998, and Dunn 2005.

13. Such an assumption is long-established. In the 1930s, for instance, Lance Sieveking exhorted that in order to 'get full value' from a play, and to 'know

what radio-drama is', one must adhere to six 'rules of the game', such as, shutting out 'extraneous noise' and 'turn[ing] down the lights' (1934: 107).

14. To be more precise, I engaged in a mode of attention referred to by Arvidson as 'restructuring' (2006: 72). Attentional restructuring brings about 'a substantial change in the function of the formative constituents of the theme' (Arvidson 2006: 72). Moreover, in the case of attentional restructuring '[t]he almost instantaneous transformation or transition into another appearance is experienced as a *movement* or motion in attending' (Arvidson 2006: 84; emphasis added). Similarly, my ability to reshape my perception of designed spatial distance in attending the Slocum scene resulted not so much from the mere fact of opening my eyes per se, but rather was brought about by my capacity to engage with the affordances of the environment.

15. For a succinct and definitive history of sound effects in theatre see Brown 2005.

16. Paul Arditti, who designed the sound for Sam Mendes's production of *The Cherry Orchard*, is an award-winning sound designer who regularly designs sound for theatrical productions at the National Theatre, the Old Vic, and other major theatrical venues. Gareth Fry, chair of the newly founded Association of Sound Designers, has worked extensively with Complicite, designing the sound for *Shun-kin*. Fry has also worked with Sound & Fury, whose production of *Kursk* was co-directed and designed by Dan Jones. With a background in music and composition, Jones approaches theatrical sound design with an awe-inspiring attention to detail and in a manner that purposely aims to heighten the aural sense.

17. For example, the sound system of the newly opened Curve, in Leicester, forms an integral part of the building's design and function.

18. 'Sound Design' is now recognised as a category in the Laurence Olivier Awards (since 2004).

19. 'It is not possible to design for Complicite in the sense of developing and executing a concept [...] you have to create a very crude design' (Fry and Home-Cook 2009: n.p.).

20. When I asked Gareth Fry what he considered to be the most important development in the practice of theatre sound design he remarked that 'thirty years ago we didn't have the sophistication to be that manipulative' (2009: n.p.).

21. As Jones explains, there is an important distinction between creating the 'sound canvas' and creating 'the events or objects within it' (2009: n.p.). See Chapter 4 for further details.

22. The words of the Commander taken from the rehearsal script of *Kursk* (p. 88), kindly lent to the author by Dan Jones.

23. Further details of the visual, as well as the aural, design of *Kursk* are given in Chapter 4.

24. Sound & Fury's *Kursk* was a promenade performance. The audience was thus free to roam.

25. For the 2010 tour of *Kursk* the following changes were made to the cast: Keir Charles replaced Bryan Dick as Casanova Ken and Jonah Russell replaced Gareth Farr as Donnie Mac.

26. 'The sound of the sea, for instance, is ubiquitous, but since we know that there is not [a] localizable source, it does not produce a ubiquity effect' (Augoyard and Torgue 2006: 131; *sic*).

27. An extract from the Association of Sound Designers website: http://www.associationofsounddesigners.com/whatis [under 'What is a Sound Designer?'] (accessed 20 March 2014).
28. The notion of *techne* as 'craft' or 'art', and subsequently as 'craftiness', resonates with the underhandedness implied by the related concept of 'design'. This definition is taken from the online Stanford Encyclopedia of Philosophy. http://plato.stanford.edu/entries/episteme-techne/ (accessed 26 June 2012).
29. See *Oxford English Dictionary* 1989, Volume XI, p. 700.
30. 'Stuff that was considered to be unacceptable noise is being brought back into the frame and is working, as one, with elements such as written dialogue that were once considered to be of a higher order of purity, but which are not just other stuff' (Brown 2005: 115). In many ways, *Purgatorio* is emblematic of this move to accommodate the unintended 'noise' of theatrical performance.
31. '[T]he realism of the scene competes with the one of the dream, to the extent that it raises the doubt whether what you see is true or not, in order to confuse the conscience' (Castellucci 2009: programme notes to *Purgatorio*; n.p.).
32. This acute and inherently troubled aural space, the 'purgatory of listening', is discussed in Chapter 3 (see also Home-Cook 2011a).
33. The act of drawing attention to the sonorousness of the voice is further evidenced by the use of the *persona*. Literally meaning 'through-sounding', the *persona* was a mask worn by actors that, as Ross Brown has suggested, 'might be regarded as a prototype of that characteristically modern form of sonic performer persona, the stage microphone' (2010a: 160). As well as acting as an amplifier, however, the *persona* also served to 'mask' the voice. The *persona* functioned as a physical and visual obstruction that prevented the audience from being able to see not only the actor's face but also the source of the voice, sound and words they heard, namely, the actor's mouth. The *persona* thus allowed the *persona*lity of sound to *sound through* by functioning both as a veil and as an ancient equivalent of the microphone.
34. Tim Supple's acclaimed production of *A Midsummer Night's Dream* provides a particularly pertinent example of this trend to *sonify* speech, voice and language.
35. An extract from an interview with Robert Lepage and Christine Charette (cited in Monteverdi 2007: n.p.).
36. Susannah Clapp of the *Guardian*, for instance, describes *Lipsynch* as 'an epic for the ear'. As she goes on to proclaim: 'Lepage has for years given his audience new eyes; now he gives them new ears' (2008).
37. Lepage, as Aleksandar Dundjerovic points out, 'is attracted to words as sound; he believes the musicality of the text has advantages over intellectual textual analysis' (2007: 119).
38. 'What elevates *Lipsynch* above the ordinary is the spectator who gives it a whole day. The spectator trusts – not that *Lipsynch* is worth the money, but that it is worth the time [...] it is *torture*' (Reynolds 2008: 132).
39. According to Reynolds, 'Lepage seeks to make the spectator active in the production of meaning, but in doing so, the spectator is actually handed responsibility for meaning' (2008: 132). 'Meaning', however, is not manifested purely by the abstract workings of the mind, nor through a process

of rigorous concentration, but is embodied in the dynamic act of theatrical attendance, or, in the case of sound, by means of the co-optive dynamic act of listening as attention.

40. The idea of 'playing attention' was first coined by Paul Thom. Thom suggests that to engage in an act of 'playful attention' is 'to place oneself in a position where substantive interpretation was called for, as a means of integrating the disparate data provided by one's *playing attention*' (1993: 205; emphasis added). Crucially, however, Thom neglects to investigate, or, indeed, to mention, how the act of attention itself plays with and manipulates perceptual content.

41. The sound for *Lipsynch* was designed and directed by Jean-Sébastien Côté.

42. The role of 'Marie' was played by Frédérike Bédard.

43. Liz Mills defines the 'acoustic image' as 'an image that relates to the ear, a composition evoked through the hearing-imagining and the physical sensation that sonic stimulus can and does produce in the hearer' (2009: 389). An acoustic image 'is created or evoked when the vocalised sound "has meaning" and "makes meaning" beyond or in addition to the syntactical and semantic meaning of a spoken text' (Mills 2009: 391).

44. The following observation from Rick Altman sheds light on the motile spatiality of theatrical sound: 'Radiating out like a cone from the actress's mouth, the sound pressure soon films up the entire auditorium, bouncing off the walls, the floor, and the ceiling, and bending around the audience members, chairs, and posts until it is finally completely absorbed. The notion that sound travels in a straight line from sound event to hearing ear is radically incomplete' (1992: 21; *sic*).

45. 'There is a difference between, on one hand, hearing a sound as coming from the same place as an event one sees and, on the other, the kind of experience one has of the ventriloquism effect or, more generally, the experience one has of seeing someone speak. In general, when we perceive someone speaking whose voice we hear, we do not simply hear their voice as coming from the same place that we see them to be. What does it mean to experience the production of sounds? When we see a dog bark and hear the sound it makes we don't just hear a sound as coming from the same place we see the dog barking; we perceive the dog to be producing the sound we hear' (Nudds 2001: 218).

46. Attention, as Arvidson has disclosed, is often evanescent, a fact exemplified by Jean-Paul Sartre's memorable anecdote of 'looking for Pierre'. When looking for his friend, Pierre, in a café, Sartre noted that 'everything in the cafe that is attended to is Pierre *presented as absent* against the contextual background of the cafe [...] The content in thematic attention is not nothing, it is something' (see Arvidson 2006: 72; *sic*).

47. '[A]ttention is neither an association of images, nor the return to itself of thought already in control of its objects, but the active constitution of a new object which makes explicit and articulate what was until then presented as no more than an indeterminate horizon. At the same time as it sets attention in motion, the object is at every moment recaptured and placed once more in a state of dependence on it. It gives rise to the "knowledge bringing event", which is to transform it, only by means of the still ambiguous meaning which it requires that event to clarify; it is therefore the motive and not the cause of the event' (Merleau-Ponty 2002: 35–36).

48. Gareth Fry's description of this moment from *Shun-kin* (2011: n.p.).

3 Sounding Silence

1. See *Oxford English Dictionary* 1989, Volume VIII, p. 1023.
2. The 'eavesdrop' being 'the space of ground which is liable to receive the rain-water thrown off by the eaves of a building' (*Oxford English Dictionary* 1989, Volume V, p. 45).
3. See *Oxford English Dictionary* 1989, Volume V, p. 45.
4. For further information on 'selective focus' see Ferrington 1993.
5. 'Silence', as George Prochnik has elucidated, is manifestly associated with the notion of *hiatus*, namely, a 'break' or 'gap' in the 'action': 'Among the word's antecedents is the Gothic verb *anasilan*, a word that denotes the wind dying down, and the Latin *dēsinere*, a word meaning "stop." Both of these etymologies suggest the way that silence is bound up with the idea of interrupted action [...] a kind of listening that only occurs after a break in the circuit of busyness [...] We might think of sound, by way of contrast, as a force that stitches us in time and space' (2010: 12–13).
6. This sense of being ontologically, as well as spatially, *distant* from the object of our attention lies at the heart of the notion of 'intentionality', namely, that consciousness is always consciousness *of* something (see Brentano 1995). However, the notion of intentionality, being purely conceptual, is necessarily abstracted from matters of embodiment. Furthermore, and as Arvidson has upheld, 'the phenomena that the term intentionality is meant to address are really a matter of attending': in short, '*[a]ttentionality replaces intentionality*' (see 2006: 185 ff.).
7. This sense of being aware not only of the object of consciousness but the attentional relationship between consciousness and world (which, I suggest, is a key feature of the phenomenon of listening-in) has been noted by Eric Prieto. As part of a wider discussion of music and modernist narrative, Prieto defines 'listening-in' as that 'inwardly directed mode of mimesis [...] where the primary object of representation is not the outside world but the subtlely modulating interactions between consciousness and world' (2002: x).
8. 'If the visual signposts have been stripped from the construction of the imaginative spectacle [...] [then] the potential for intrigue and "listener guessing" is still there' (Crook 1999: 86).
9. In his important essay 'Hearing Silence', Sorensen argues that '[c]hallenges to the [p]ossibility of [s]ilence are [m]isguided' (2009: the title and argument of Section 10, pp. 142–144).
10. 'Hearing silence is successful perception of an absence of sound. It is not a failure to hear sound' (Sorensen 2009: 126).
11. Commenting on the ways in which *A Slight Ache* explores the theme of indeterminacy, Sorensen makes the following remark: '[o]ne cannot hear the difference between silence from a source and silence from an absent source' (2009: 140).
12. This, perhaps, is the ultimate message of *A Slight Ache*: the paranoia and sense of uncertainty that can so often result from the interplay between perception and reality.
13. Andrew Crisell maintains that silence in radio drama – '[m]uch more than in the theatre or cinema' – 'is a quality that is noticed, heard, *listened* to' (1994: 159). Yet, such an account overlooks the nuances of theatrical silence as experienced.

14. '[W]hat we speak of as the "phenomenal object" [...] is in fact subject to multiple, even competing modes of disclosure' (Garner 1994: 43).

15. Jean Chothia, for example, has suggested that the practice of darkening the auditorium began, at least in Paris, with André Antoine's 1888 production of *La mort du Duc'd'Enghien*: 'The darkening of the house is a significant gesture in the creation of illusionist theatre, establishing once and for all the claims of the stage over the auditorium as the centre of attention' (Chothia 1991: 64). In concurrence with this position, Nicholas Ridout remarks that '[a]t the time of the founding of the Moscow Arts Theatre in 1897, the stage is almost certainly more brightly lit than ever before, and the auditorium darker' (2006: 50).

16. 'Paradoxically, the increase of darkness in the auditorium has [...] involved the increased stasis and silence of the audience' (Welton 2012: 57).

17. In *Kursk*, all the actors were fitted with high-specification pick-up microphones.

18. Parts of this section, 'The Purgatory of Listening', have appeared (under the same title) in French (see Home-Cook 2011a).

19. 'When part of a silent crowd, whether in a memorial or a theatrical setting, one's body bristles in omnidirectional attentiveness to the strangeness of the environment' (Brown 2011: 9).

20. Here, I draw from Arvidson's concept of 'context enlargement' (see 2006: 59 ff.).

4 Sensing Atmospheres

1. The word 'atmosphere' derives from the Greek word *atmosphaera*, meaning 'sphere' or 'ball' (*sphaera*) of 'vapour' (*atmos*). See *Oxford English Dictionary* 1989, Volume I, p. 750.

2. The verb 'to immerse', etymologically speaking, means to 'dip' or 'plunge' into a liquid (see *Oxford English Dictionary* 1989, Volume VII, p. 684).

3. 'Immersion' has been discussed in Gaming Studies, Museum Studies, education, and film theory, to name but a few.

4. Immersive theatre overlaps with site-specific theatre in a number of ways. Site-specific theatre either utilises an existing, purpose-built space in innovative and unusual ways or, more radically, takes place in an undesignated space or environment such as a street, cellar, or, indeed, anywhere that is not a theatre (see Wilkie 2002). Site-specific performance does away with conventional models of theatrical spectatorship, where the audience are placed in a fixed position perpendicular to the action that takes place on a stage, and, instead, claims to afford a more dynamic, performative mode of reception where the division between audience and actor, spectator and performer, is blurred. Beyond anything else, however, site-specific theatre is about *space*. By adapting a pre-existent performance space or by resituating a performance within an alien or undesignated environment, site-specific theatre aims to bring into relief the phenomenal reciprocity that exists between the materiality of a particular place and the manifestation of theatrical experience. Since site-specific theatre is said to afford a greater degree of experiential authenticity and intimacy, the notion of immersion naturally lends itself to such a conception. Yet, crucially, whilst immersive theatre

is often site-specific, this does not make it a sub-category of site-specific theatre. First, immersive theatre, both in theory and in practice, moves way beyond the material confines of space. Moreover, and perhaps above all else, immersive theatre is about manifesting an experience of 'being immersed'.

5. Encapsulating this diversity, Gareth White provides the following summary:

> Work designated as immersive theatre [...] includes performances that are intensely intimate, as exemplified by Ontroerend Goed's repertoire, as well as those that allow a little distance between spectator and performance, as with Slung Low. The work may contain a coherent narrative, as with Zecora Ura and Para-Active in their *Hotel Medea* (2010), or may be as dreamlike as shows by *You Me Bum Bum Train* [...] The work may take place in everyday spaces, in the manner of Blast Theory's *Uncle Roy All Around You* (2003), or in other found spaces, theatres or galleries. It is likely to be multi-sensory, making use of exploratory experiences of space and relationships to performers, but sometimes also in addressing the senses of touch and smell – as in Mark Storer's *A Tender Subject* (2012) – which are not normally significantly part of the semiotic equipment of theatre. (2012: 1)

6. In many respects, 'immersive theatre' might be said to be *immersed* in its own rhetoric. Helplessly set adrift within a sea of clichés, bathed by self-affirming yet homogenising presuppositions, and enveloped within a seemingly impenetrable atmosphere of authenticity, the notion of 'immersion' has become a convenient means of bypassing the rigours of reason, and, hence, critical reflection at large. Recently, however, a growing number of theatre and performance scholars have sought to redress this situation. Important works within this newly emerging field include Josephine Machon's survey of immersion, immersivity and immersive practice (2013) and Gareth White's work on immersion and audience participation (see 2012 and 2013). My approach, by contrast, attends exclusively to the micro-level dynamics of immersive experience. In particular, I maintain that in order to begin to untangle the ebbs and flows of (aural) immersion as lived we should pay closer attention to the phenomenal dynamics of embodied attending.

7. I refer here to Charles Brewer's description of *Kursk* (2009: n.p.).

8. The verb 'to sound' stems from the French *sonder*, being a combination of the Latin prefix *sub-* ('below') and *unda* ('wave'). See *Shorter Oxford English Dictionary* 2007, p. 2928.

9. Michael Billington, for instance, writes: 'I cannot recall a theatre event offering us total immersion in a sub's strange, confined world' (2009: n.p.).

10. In *Kursk*, as Benedict Nightingale comments, there is 'a documentary authenticity to everything you see' (2009: n.p.).

11. In her review for *This Is London Online* Fiona Mountford describes *Kursk* as being 'full-on immersive' (2009: n.p.). Similarly, Michael Billington remarks that *Kursk* offers 'total immersion' within the 'strange, confined world' of a submarine (2009: n.p.). Yet, the notion of 'total immersion', which has recently been developed by Josephine Machon (see 2013), remains somewhat suspect. Indeed, one could even go so far as to posit

that 'total immersion' is a myth that resonates closely with another popular belief, namely, that 'sound is round'.

12. The use of designed sound in *Kursk* was not only highly sophisticated, but pioneering. In recognition of this, *Kursk* was awarded the Special Jury Prize for Excellence in Sound Design at the Prague Quadrennial 2010, the first time that 'sound' has ever been included as a category in their awards.

13. Sound and Fury website, http://www.soundandfury.org.uk/kursk.html (accessed 16 April 2014).

14. 'Realism' has always played a key role in the work of Sound & Fury and in Dan Jones's conception and use of designed sound, *Kursk* being emblematic of this.

> The sound design starts primarily with realism that can always be heightened. One particular moment in *Kursk* where this became apparent was where Donnie Mac, acting as 'DJ Sonar', creates his own dreamlike portrait of the oceans that allowed the calls of seals, whales and the fizz of arctic snow falling on icy water to transport everybody aboard away from the confinement of the submarine, the entire sound system working in concert, as each species moved through the space. Bryony had spotted in her writing how our 'plumbing system' – as she called it – might be turned to the needs of such magical realism. (Jones and Home-Cook 2009: n.p.)

15. Similarly, Fiona Mountford speaks of how *Kursk*'s 'echoing soundscape, make[s] us believe absolutely in this underwater limbo land of zero privacy' (2009: n.p.). Likewise, Jasper Rees speaks of 'the disembodied roar and hiss, growls and grunts both made and heard by the gigantic listening device' (Rees 2009: n.p.).

16. The idea of immersion as consisting of a dynamic 'tension' or 'paradox' is implied in Maria Walsh's theorisation of immersive experience in film. In developing a 'phenomenological hybrid' approach to film phenomenology, Walsh attempts to 'combine the usually distinct categories of immersion and spectatorship to theorise a state where a viewer is enveloped by a moving-image scenario, yet, at the same time, is aware of shifting bodily coordinates in relation to the image flow' (2004: 170). For Walsh, immersion consists of a state where 'the body is both immersed in, yet informing, the flow of images' (2004: 183), where 'one is captivated by/in an image, yet dynamically moving within that incorporation' (2004: 179).

17. See *Oxford English Dictionary* 1989, Volume VII, p. 684.

18. This idea resonates with Merleau-Ponty's notion of consciousness as 'being-toward-the-thing through the intermediary of the body' (2002: 159–160).

19. Imaginal content, in other words, is both the embroidery and the means by which we embroider the world with meaning.

20. The phenomenon of 'objects in motion' has been extensively explored by Maxine Sheets-Johnstone (see 1979).

21. Here I draw from Ingold's theory of sensory 'co-option' (see Ingold 2000: 253 ff.).

22. 'The world of sound, when it is confronted and combined with the visual and the visible, consciously and unconsciously plays with visuality, as if the better to promote its own uncontrollable subjectivity' (Pavis 2011: xi).

23. Here I borrow from Edward S. Casey's notion of a 'phenomenon-for-me' (see 2000: 23).

24. Indeed, the body is not only at the centre of this 'ambiguity', but is its very embodiment (see Garner 1994: 4 ff.).

25. This idea has also been developed by Martin Welton (see 2012). The central focus of Welton's work, as the title to his book suggests, is the question/ phenomenon of feeling in theatre. My work, by contrast, investigates the question of (aural) *attention* in theatre. Moreover, I draw from Ingold's notion of a 'weather world' with a specific purpose in mind: namely, to develop a model of (aural) immersion that attends to the dynamics of embodied attending, thus navigating the sensory divide. The phenomenon of attention, or rather the act of *theatrical attending*, is thus what is ultimately at stake here. In short, understanding the theatrical environment as an atmosphere or 'weather world' provides a useful means of articulating the model of theatrical reception that this book strives to advance: namely, to attend the theatre is to *stretch ourselves*.

26. Paul Rodaway, for instance, maintains that '[t]he hearer, or listener, is at the centre of the soundscape', the 'soundscape' being defined as 'the sonic environment which surrounds the sentient' (1994: 86). Similarly, according to Wikipedia a soundscape 'is a sound or combination of sounds that forms or arises from an immersive environment'. See http://en.wikipedia.org/wiki/Soundscape (accessed 16 April 2014).

27. For an overview of this work see Kelman 2010.

28. In 'ordinary perceptual practice' the sensory registers 'cooperate so closely, and with such overlap of function, that their respective contributions are impossible to tease out' (Ingold 2007: 10).

29. An earlier version of this section ('Attending atmospheres') has appeared in German (see Home-Cook 2015).

30. The majority of the extant work devoted to atmospheres has been undertaken by German scholars working within the field of aesthetics (see Böhme 1993). More generally, the notion of 'atmosphere', 'aura', or 'ambiance' has been discussed, either in passing, or in chapter/article form, in philosophy (Dufrenne 1973 and Casey 2009), critical theory (Benjamin 1968: esp. 223 ff.), psychiatry (Tellenbach 1981), architecture (Thibaud 2011, Pallasmaa 2012, and Albertsen 2012), geography (Anderson 2009, Stewart 2011), Sound Studies (Csepregi 2004), as well as in Theatre and Performance Studies (see, for example, Smith 1999; Brown 2010a; Welton 2012; Grant 2013; and Home-Cook 2015). Scholarly works devoted to theatre and the phenomenon of atmosphere are, however, surprisingly scarce. Furthermore, the phenomenal relationship between atmospheric generation and the act of attending remains relatively unexplored.

31. Romeo Castellucci, for example, is well known for his use of atmosphere as a means of shaping an audience's perceptual disposition towards a given performance. Scott Gibbons, Castellucci's designer, tends to generate atmospheres that materialise a certain kind of threat. As exemplified by *Inferno* (Barbican 2009), Gibbons tends to use high-pitched, insistent, electro-acoustic sounds, often taking the form of static, in relation to flickering light and overhead neon lighting, to produce an 'atmosphere' that, almost subliminally, unsettles your sensibility towards the work and puts you on edge.

In *Purgatorio* this sense of underlying menace was manifested with greater subtlety through the contrapuntal use of sound, voice and silence.
32. Here I draw from Böhme's notion of 'felt presence' (see 2013: 5).

Conclusion

1. 'The world is what I perceive [...] The world is not what I think, but what I live through [...] I am open to the world' (Merleau-Ponty 2002: xviii).
2. The notion of 'participation', or rather *audience* participation, has recently been reconsidered by Gareth White (2013). Rather than focusing on participation per se, White hones in on the 'aesthetics of invitation', that is, he invites us to attend to the specific question of what it means to be 'invited' to participate. In order to achieve this, White adopts a hybrid methodology that draws from aesthetics, sociology, and cognitive science, as well as phenomenology (2013: 121–123). By contrast, and in adopting a perspective that is *strictly* phenomenological, here I propose the notion of attending *as* participation.

Bibliography

Albertsen, Niels. 2012. 'Gesturing atmospheres'. Published in: *Ambiances in Action/ Ambiances en acte(s) – International Congress on Ambiances. Montreal 2012, Montreal: Canada (2012)* (pp. 69–74). http://halshs.archives-ouvertes.fr/docs/00/74/50/28/ PDF/ambiances2012_albertsen.pdf (accessed 5 January 2015).

Allen, Jeffner. 1993. 'Through the wild region: an essay in phenomenological feminism'. In Keith Hoeller (ed.), *Merleau-Ponty and Psychology* (pp. 241–256). Atlantic Highlands, NJ: Humanities Press.

Allison, David. 1973. 'Translator's introduction'. In Jacques Derrida, *Speech and Phenomena and Other Essays on Husserl's Theory of Signs* (pp. xxxi–xlii), trans. David B. Allison. Evanston: Northwestern University Press.

Altman, Rick (ed.). 1992. *Sound Theory/Sound Practice*. London: Routledge.

Anderson, Ben. 2009. 'Affective atmospheres'. *Emotion, Space and Society* 2, 77–81.

Arnheim, Rudolf. 1936. *Radio: The Art of Sound*, trans. Margaret Luding and Herbert Read. London: Faber & Faber.

Arvidson, P. Sven. 2006. *The Sphere of Attention: Context and Margin*. Dordrecht: Springer.

Arvidson, P. Sven. 2010. 'Attention in context'. In Shaun Gallagher and Daniel Schmicking (eds), *Handbook of Phenomenology and Cognitive Science* (pp. 99–121). Dordrecht: Springer.

Augoyard, Jean-François, and Henry Torgue (eds). 2006. *Sonic Experience: A Guide to Everyday Sounds*, trans. Andra McCartney and David Paquette. Montreal: McGill-Queens University Press.

Augustine. 2002. *On the Trinity: Books 8–15*, ed. Gareth B. Matthews, trans. Stephen McKenna. Cambridge: Cambridge University Press.

Auslander, Philip. 2008. *Liveness: Performance in a Mediatized Culture* (2nd Edition). Abingdon: Routledge.

Baars, Bernard J. 1997. *In the Theater of Consciousness: The Workspace of the Mind*. Oxford: Oxford University Press.

Balme, Christopher B. 2008. *The Cambridge Introduction to Theatre Studies*. Cambridge: Cambridge University Press.

Banes, Sally, and André Lepecki. 2007. 'Introduction'. In Sally Banes and André Lepecki (eds), *The Senses in Performance* (pp. 1–7). London: Routledge.

Barthes, Roland. 1986. 'Listening'. In *The Responsibility of Forms: Essays on Music, Art, Representation* by Roland Barthes (pp. 245–266), trans. Richard Howard. Oxford: Basil Blackwell.

Beck, Alan. 1997. 'Listening to radio plays: fictional soundscapes'. http://jcp. proscenia.net/publications/articles_mlr/beck/Listentoradio.html (accessed 3 April 2014).

Beck, Alan. 1998. 'Point of listening in radio plays'. *Sound Journal.* https://www. kent.ac.uk/arts/sound-journal/beck981.html (accessed 3 April 2014).

Beckerman, Bernhard. 1986. 'Beckett and the act of listening'. In Enoch Brater (ed.), *Beckett at 80/Beckett in Context* (pp. 149–167). Oxford: Oxford University Press.

Beckett, Samuel. 2006. *The Complete Dramatic Works of Samuel Beckett*. London: Faber & Faber.

Benjamin, Walter. 1968. 'The work of art in the age of mechanical reproduction'. In Hannah Arendt (ed.), *Illuminations: Essays and Reflections* (pp. 219–253). London: Fontana.

Bennett, Susan. 1997. *Theatre Audiences: A Theory of Production and Reception* (2nd Edition). London: Routledge.

Berendt, Joachim-Ernst. 1987. *Nada Brahma: The World of Sound: Music and the Landscape of Consciousness*, trans. Helmut Bredigkeit. Rochester, VT: Destiny Books.

Berendt, Joachim-Ernst. 1988. *The Third Ear: On Listening to the World*, trans. Tim Nevill. Shaftesbury: Element.

Bigwood, Carol. 1998. 'Renaturalizing the body (with the help of Merleau-Ponty)'. In Donn Welton (ed.), *Body and Flesh: A Philosophical Reader* (pp. 99–114). Oxford: Blackwell.

Billington, Michael. 2009. '*Kursk*'. *Guardian*, 9 June. http://www.guardian.co.uk/stage/2009/jun/09/kursk-young-vic (accessed 3 April 2014).

Bleeker, Maaike. 2008. *Visuality in the Theatre: The Locus of Looking*. Basingstoke: Palgrave Macmillan.

Blesser, Barry, and Linda-Ruth Salter. 2007. *Spaces Speak, Are You Listening?: Experiencing Aural Architecture*. Cambridge, MA: MIT Press.

Bloom, Gina. 2007. *Voice in Motion: Staging Gender, Shaping Sound in Early Modern England*. Philadelphia, PA: University of Pennsylvania Press.

Böhme, Gernot. 1993. 'Atmosphere as the fundamental concept of a new aesthetics'. *Thesis Eleven* 36, 113–126.

Böhme, Gernot. 2013. 'The art of the stage set as a paradigm for an aesthetics of atmospheres'. *Ambiances* (online). http://ambiances.revues.org/315 (accessed 3 January 2015).

Bracewell, John. 1993. *Sound Design in the Theatre*. Englewood Cliffs, NJ: Prentice Hall.

Brentano, Franz. 1995. In Linda L. McAlister (ed.), *Psychology from an Empirical Standpoint*, trans. Oscar Kraus, Antos C. Rancurello, D.B. Terrell, and Linda L. McAlister. London: Routledge.

Brewer, Charles. 2009. '*Kursk*'. *What's on Stage*, 20 June. http://www.whatsonstage.com/index.php?pg=207&story=E8831244538723 (accessed 15 April 2014).

Brown, Deborah. 2007. 'Augustine and Descartes on the function of attention in perceptual awareness'. In Sara Heinämaa, Vili Lähteenmäki, and Pauliina Remes (eds), *Consciousness: From Perception to Reflection in the History of Philosophy* (pp. 153–176). Dordrecht: Springer.

Brown, Ross. 2005. 'The theatre soundscape and the end of noise'. *Performance Research* 10(4), 105–119.

Brown, Ross. 2010a. *Sound: A Reader in Theatre Practice*. Basingstoke: Palgrave Macmillan.

Brown, Ross. 2010b. 'Sound design: the scenography of engagement and distraction'. In Jane Collins and Andrew Nisbet (eds), *Theatre and Performance Design: A Reader in Scenography* (pp. 340–347). London: Routledge.

Brown, Ross. 2011. 'Towards theatre noise'. In Lynne Kendrick and David Roesner (eds), *Theatre Noise: The Sound of Performance* (pp. 1–13). Cambridge: Cambridge Scholars Publishing.

Bull, Michael. 2013. *Sound Studies: Critical Concepts in Media and Cultural Studies.* London: Routledge.

Bull, Michael, and Les Back (eds). 2003. *The Auditory Culture Reader.* Oxford: Berg.

Burris-Meyer, Harold. 1959. *Sound for Theatre.* Mineola: New York Radio Magazines.

Butler, Judith. 1989. 'Sexual ideology and phenomenological description: a feminist critique of Merleau-Ponty's phenomenology of perception'. In Jeffner Allen and Iris Marion Young (eds), *The Thinking Muse: Feminism and Modern French Philosophy* (pp. 85–100). Bloomington and Indianapolis: Indiana University Press.

Calvi, Nuala. 2009. '*Kursk*'. *The Stage* (online), 10 June. http://www.thestage. co.uk/reviews/review.php/24672/kursk (accessed 5 January 2015).

Canode, Jillian. 2002. 'Thinking the body: sexual difference in philosophy – an examination of Merleau-Ponty's account of embodiment in phenomenology of perception. *McNair Scholars Journal* 6(1), 31–36.

Carroll, Noel. 2003. *Engaging the Moving Image.* New Haven, CN: Yale University Press.

Carter, Paul. 1992. *The Sound In Between: Voice, Space, Performance.* Kensington, NSW: New South Wales University Press.

Casey, Edward S. 2000. *Imagining: A Phenomenological Study* (2nd Edition). Bloomington and Indianapolis: Indiana University Press.

Casey, Edward S. 2004. 'Attention and glancing'. *Continental Philosophy Review* 37(1), 83–126.

Casey, Edward S. 2007. *The World at a Glance.* Bloomington: Indiana University Press.

Casey, Edward S. 2009. *Getting Back into Place: Toward a Renewed Understanding of the Place-World* (2nd Edition). Bloomington and Indianapolis: Indiana University Press.

Castellucci, Claudia. 2004. 'Ethics of voice: Claudia Castellucci and Chiara Guidi in conversation with Joe Kelleher'. *Performance Research* 9(4), 111–115.

Castellucci, Romeo. 2009. 'Purgatorio (the interval)'. In the Programme Notes for *Purgatorio*, trans. Giulia Frances Campolmi Davidson.

Cazeaux, Clive. 2005. 'Phenomenology and radio drama'. *British Journal of Aesthetics* 45(4), 157–174.

Chignell, Hugh. 2009. *Key Concepts in Radio Studies.* London: Sage Publications.

Chion, Michel (ed.). 1994. *Audio-Vision: Sound on Screen*, trans. Claudia Gorbman. New York: Columbia University Press.

Chion, Michel. 1999. *The Voice in Cinema*, trans. Claudia Gorbman. New York: Columbia University Press.

Chothia, Jean. 1991. *André Antoine.* Cambridge: Cambridge University Press.

Clapp, Susannah. 2008. 'Stage breaks the sound barrier'. *Observer*, 15 September. http://www.guardian.co.uk/stage/2008/sep/14/theatre (accessed 13 June 2014).

Collison, David. 1976. *Stage Sound.* London: Studio Vista.

Connor, Steven. 1997. 'The modern auditory I'. In Roy Porter (ed.), *Rewriting the Self: Histories from the Renaissance to the Present* (pp. 203–223). London: Routledge.

Coveney, Michael. 2009. '*Kursk*'. *Independent*, 11 June. http://www.independent. co.uk/arts-entertainment/theatre-dance/reviews/kursk-young-vic-london-1702088.html (accessed 22 June 2014).

Coyne, Richard, and Martin Parker. 2009. 'Voice and space: agency of the acous-mêtre in spatial design'. In Phil Turner, Susan Turner and Elizabeth Davenport (eds), *Exploration of Space, Technology and Spatiality: Interdisciplinary Perspectives* (pp. 102–112). Hershey, PA: Information Science Reference.

Crary, Jonathan. 1999. *Suspensions of Perception: Attention, Spectacle and Modern Culture*. Cambridge, MA: MIT Press.

Crisell, Andrew. 1994. *Understanding Radio* (2nd Edition). London: Routledge.

Crook, Tim. 1999. *Radio Drama: Theory and Practice*. London: Routledge.

Crook, Tim. 2012. *The Sound Handbook*. London: Routledge.

Csepregi, Gabor. 2004. 'On sound atmospheres'. In Jim Drobnick (ed.), *Aural Cultures* (pp. 169–178). New York: YYZ Books.

Csordas, Thomas. 1993. 'Modes of somatic attention'. *Cultural Anthropology* 8(2), 135–156.

Cull, Laura. 2012. *Theatres of Immanence: Deleuze and the Ethics of Performance*. Basingstoke: Palgrave Macmillan.

Curtin, Adrian. 2014. *Avant-Garde Theatre Sound: Staging Sonic Modernity*. London: Palgrave Macmillan.

Deleuze, Gilles. 2007. 'On the superiority of Anglo-American literature'. In Gilles Deleuze and Claire Parnet (eds), *Dialogues II* (pp. 36–76), trans. Hugh Tomlinson and Barbara Habberjam. New York: Columbia University Press.

Deleuze, Gilles, and Félix Guattari. 2004. *A Thousand Plateaus: Capitalism and Schizophrenia*. New York: Continuum.

Derrida, Jacques. 1973. *Speech and Phenomena and Other Essays on Husserl's Theory of Signs*, trans. David B. Allison. Evanston: Northwestern University Press.

Derrida, Jacques. 1976. *Of Grammatology*, trans. Gayatri Chakravorty Spivak. Baltimore: John Hopkins University Press.

Douglas, Susan J. 2004. *Listening In: Radio and the American Imagination*. Minneapolis: University of Minnesota Press.

Drakakis, John. 1981. *British Radio Drama*. Cambridge: Cambridge University Press.

Drobnick, Jim (ed.). 2004. *Aural Cultures*. New York: YYZ Books.

Dufrenne, Mikel. 1973. *The Phenomenology of Aesthetic Experience*, trans. Edward S. Casey. Evanston: Northwestern University Press.

Dundjerovic, Aleksandar Sasha. 2007. *The Theatricality of Robert Lepage*. Montreal: McGill-Queens University Press.

Dunn, Anne. 2005. 'Structures of radio drama'. In Helen Fulton (ed.), *Narrative and Media* (pp. 191–202). Cambridge: Cambridge University Press.

Erlmann, Veit (ed.). 2004. *Hearing Cultures: Essays on Sound, Listening and Modernity*. Oxford: Berg.

Esslin, Martin. 1971. 'The mind as stage'. *Theatre Quarterly*, 1(3), 5–11.

Esslin, Martin (ed.). 1980. *Mediations: Essays on Brecht, Beckett and the Media*. London: Eyre Methuen.

Felton, Robert F. 1947. *The Radio-Play: Its Technique and Possibilities*. London: Sylvan Press.

Ferrington, Gary. 1993. 'Audio design: creating multi-sensory images for the mind'. *Journal of Visual Literacy*, 14(1), 61–67. Reproduced at: http://wfae.proscenia.net/library/articles/ferrington_design.pdf (accessed 8 January 2015).

Ferrington, Gary. 1994. 'Keep your ear-lids open'. *Journal of Visual Literacy* 14(2), 51–61. Reproduced at: http://wfae.proscenia.net/library/articles/ferrington_earlids.pdf (accessed 8 January 2015).

Fisher, Linda. 2000. 'Feminist phenomenology' (Introduction). In Linda Fisher and Lester Embree (eds), *Feminist Phenomenology* (pp. 1–16). Dordrecht: Kluwer.

Flusser, Vilém. 1999. *The Shape of Things: A Philosophy of Design.* London: Reaktion Books.

Folkerth, Wes. 2002. *The Sound of Shakespeare.* London: Routledge.

Frost, Everett C. 1987. 'Why sound art works and the German Hörspiel', *The Drama Review: TDR* 31(4), 109–124.

Gallagher, Shaun. 2012. *Phenomenology.* Basingstoke: Palgrave Macmillan.

Garner, Stanton B. 1994. *Bodied Spaces: Phenomenology and Performance in Contemporary Drama.* Ithaca, NY: Cornell University Press.

Garner, Stanton B. 2001. 'Theatre and phenomenology'. In *Degrés: Revue de synthèse à orientation sémiologique* 29(107–108), b1–17.

Gibson, James Jerome. 1950. *The Perception of the Visual World.* Cambridge, MA: Riverside Press.

Gibson, James Jerome. 1966. *The Senses Considered as Perceptual Systems.* Boston: Houghton Mifflin.

Gibson, James Jerome. 1977. 'The theory of affordances'. In Robert E. Shaw and John Bransford (eds), *Perceiving, Acting, and Knowing: Toward an Ecological Psychology* (pp. 67–82). Hillsdale, NJ: Lawrence Erlbaum Associates.

Gielgud, Val. 1957. *British Radio Drama, 1922–1956: A Survey.* London: George G. Harrap.

Goffman, Erving. 1974. *Frame Analysis: An Essay on the Organisation of Experience.* London: Harper & Row.

Grant, Stuart. 2013. 'Performing an aesthetics of atmospheres'. *Aesthetics* 23(1), 12–32.

Gray, Frances. 1981. 'The nature of radio drama'. In Peter Lewis (ed.), *Radio Drama* (pp. 48–77). London: Longman.

Guralnick, Elissa S. 1985. 'Radio drama: the stage of the mind'. *Virginia Quarterly Review* 61(1), 79–94.

Guralnick, Elissa S. 1996. *Sight Unseen: Beckett, Pinter, Stoppard, and Other Contemporary Dramatists on Radio.* Athens, OH: Ohio University Press.

Gurwitsch, Aron. 1964. *The Field of Consciousness.* Pittsburgh: Duquesne University Press.

Gurwitsch, Aron. 1966. *Studies in Phenomenology and Psychology.* Evanston: Northwestern University Press.

Gurwitsch, Aron. 1979. *Human Encounters in the Social World*, ed. Alexandre Metraux, trans. Fred Kersten. Pittsburgh, PA: Duquesne University Press.

Hagner, Michael. 2003. 'Toward a history of attention in culture and science'. *Modern Language Notes (German Issue)* 118(3), 670–687.

Hand, Richard J., and Mary Traynor. 2011. *The Radio Drama Handbook.* New York: Continuum.

Handel, Stephen. 1989. *Listening: An Introduction to the Perception of Auditory Events.* Cambridge, MA: MIT Press.

Heidegger, Martin. 1962. *Being and Time*, trans. John Macquarrie and Edward Robinson. London: SCM Press.

Hemming, Sarah. 2009. '*Kursk* at the Young Vic'. *Financial Times*, 6 June. http://www.ft.com/cms/s/2/e24d470c-515f-11de-84c3-0144feabdc0.html (accessed 15 September 2014)

Hendy, David. 2000. *Radio in the Global Age.* Cambridge: Polity Press.

Hendy, David. 2013. *Noise: A Human History of Sound and Listening.* London: Profile Books.

Home-Cook, George. 2011a. 'Le purgatoire de l'écoute: Le son, le silence et l'atmosphère de l'attention dans *Purgatorio* de Castellucci', trans. Marie-Madeleine Mervant-Roux and Jean-Marc Larrue. *Théâtre/Public* 199, 104–107.

Home-Cook, George. 2011b. 'Aural acts: theatre and the phenomenology of listening'. In Lynne Kendrick and David Roesner (eds), *Theatre Noise: The Sound of Performance* (pp. 97–110). Cambridge: Cambridge Scholars Publishing.

Home-Cook, George. 2015. 'Wahrnehmen von Atmosphären: Zuhören, Stille und die Atmo-Sphäre von Aufmerksamkeit in Sound and Fury's *Kursk*', trans. Arnd Federspiel. In Wolf-Dieter Ernst, Anno Mungen, Nora Niethammer, and Berenika Szymanski (eds), *Sound und Performance.* Wurzburg: Königshausen & Neumann.

Hondrich, Ted (ed.). 1995. *The Oxford Companion to Philosophy.* Oxford: Oxford University Press.

Howarth, Jane. 1998. 'Epistemic issues in phenomenology'. In Edward Craig (ed.), *The Routledge Encyclopedia of Philosophy* (pp. 343–348). London: Routledge.

Howes, David. 2005. *Empire of the Senses: The Sensual Culture Reader.* Oxford: Berg.

Hughes, Richard. 1934. 'Introduction'. In Lance Sieveking, *The Stuff of Radio* (pp. 7–8). London: Cassell.

Hull, John. 1990. *Touching the Rock: An Experience of Blindness.* London: SPCK Press.

Husserl, Edmund. 1929. 'Phenomenology'. In *Encyclopaedia Britannica: A New Survey of Universal Knowledge*, 14th Edition, Volume 17 (pp. 699–702). London: Encyclopaedia Britannica Company.

Husserl, Edmund. 1983. *Ideas Pertaining to a Pure Phenomenology and to a Phenomenological Philosophy* (First Book), trans. F. Kersten. Hague: Martinus Nijhoff.

Husserl, Edmund. 1999. *The Idea of Phenomenology: A Translation of Die Idee der Phänomenologie Husserliana II*, trans. Lee Hardy. Dordrecht: Kluwer.

Ihde, Don. 1970. 'Parmenidean meditations'. In *Journal of the British Society for Phenomenology* 1(3), 16–23.

Ihde, Don. 2003. 'If phenomenology is an albatross, is postphenomenology possible?' In Don Ihde and Evan Selinger (eds), *Chasing Technoscience: Matrix of Materiality* (pp. 131–146). Bloomington and Indianapolis: Indiana University Press.

Ihde, Don. 2006. *Listening and Voice: Phenomenologies of Sound* (2nd Edition). Albany, NY: State University of New York Press.

Ihde, Don. 2012. *Experimental Phenomenology: Multistabilities.* Albany, NY: State University of New York Press.

Ingold, Tim. 2000. 'Stop, look, listen'. In Tim Ingold (ed.), *The Perception of the Environment: Essays in Livelihood, Dwelling and Skill* (pp. 243–287). London: Routledge.

Ingold, Tim. 2005. 'The eye of the storm: visual perception and the weather'. *Visual Studies* 20(2), 97–104.

Ingold, Tim. 2007. 'Against soundscape'. In Angus Carlyle (ed.), *Autumn Leaves: Sound and the Environment in Artistic Practice* (pp. 10–13). Paris: Double Entendre.

Ingold, Tim. 2011. 'Landscape or weather world?'. In Tim Ingold (ed.), *Being Alive: Essays on Movement, Knowledge and Description* (pp. 126–135). London: Routledge.

Jackson, Maggie. 2008. *Distracted: The Erosion of Attention and the Coming of the Dark Age*. New York: Prometheus Books.

James, William. 2007. *The Principles of Psychology (Volume 1)*. New York: Cosimo.

Janich, Peter. 1992. *Euclid's Heritage: Is Space Three-Dimensional?* Dordrecht: Kluwer.

Johnson, Bruce. 2005. 'Hamlet: voice, music, sound'. *Popular Music* 24(2), 257–267.

Kassabian, Anahid. 2013. *Ubiquitous Listening: Affect, Attention, and Distributed Subjectivity*. Berkeley: University of California Press.

Kaye, Deena, and James Lebrecht (eds). 2013. *Sound and Music for the Theatre: The Art and Technique of Design* (3rd Edition). Oxford: Focal Books.

Kelleher, Joe. 2004. 'Ethics of voice: Claudia Castellucci and Chiara Guidi in conversation with Joe Kelleher'. *Performance Research* 9(4), 111–115.

Kelman, Ari Y. 2010. 'Rethinking the soundscape: a critical genealogy of a key term in sound studies'. *Senses & Society* 5(2), 212–234.

Kendrick, Lynne, and David Roesner (eds). 2011. *Theatre Noise: The Sound of Performance*. Cambridge: Cambridge Scholars Publishing.

Kochhar-Lindgren, Kanta. 2006. *Hearing Difference: The Third Ear in Experimental, Deaf and Multicultural Theater*. Washington, DC: Gallaudet University Press.

Kostelanetz, Richard. 2003. *Conversing with Cage*. New York: Routledge.

Lamos, Mark. 2013. 'Introduction to the third edition'. In Deena Kaye and James Lebrecht (eds), *Sound and Music for the Theatre: The Art and Technique of Design* (xvii–xviii). Oxford: Focal Books.

Larrue, Jean-Marc. 2011. 'Sound reproduction techniques in theatre: a case of mediatic resistance'. In Lynne Kendrick and David Roesner (eds), *Theatre Noise: The Sound of Performance* (pp. 14–22). Cambridge: Cambridge Scholars Publishing.

Laws, Catherine. 2010. 'Editorial', for special issue 'On Listening'. *Performance Research* 15(3), 1–3.

Lea, Gordon. 1926. *Radio Drama and How To Write It*. London: George Allen & Unwin.

Leder, Drew. 1990. *The Absent Body*. Chicago: University of Chicago Press.

Lehmann, Hans-Thies. 2006. *Postdramatic Theatre*, trans. Karen Jurs-Munby. London: Routledge.

Leonard, John A. 2001. *Theatre Sound*. London: A&C Black.

Lewis, Peter (ed.). 1981. *Radio Drama*. London: Longman.

Lind, Richard W. 1980. 'Attention and the aesthetic object'. *Journal of Aesthetics and Art Criticism* 39(2), 131–142.

Machon, Josephine. 2013. *Immersive Theatres: Intimacy and Immediacy in Contemporary Performance*. Basingstoke: Palgrave Macmillan.

Maeterlinck, Maurice. 1897. *The Treasure of the Humble*, trans. Alfred Sutro. London: George Allen.

McAuley, Gay. 2007. 'Performance studies' (long entry). In *Semiotics Encyclopedia Online*. http://www.semioticon.com/seo/P/performance.html# (accessed 14 October 2014).

McConachie, Bruce. 2008. *Engaging Audiences: A Cognitive Approach to Spectating in the Theatre*. Basingstoke: Palgrave Macmillan.

McKinney, Joslin, and Philip Butterworth. 2009. *The Cambridge Introduction to Scenography*. Cambridge: Cambridge University Press.

McWhinnie, Donald. 1959. *The Art of Radio*. London: Faber & Faber.

Merleau-Ponty, Maurice. 1964. *The Primacy of Perception: And Other Essays on Phenomenological Psychology, the Philosophy of Art, History and Politics*, edited and introduced by James M. Edie. Chicago: Northwestern University Press.

Merleau-Ponty, Maurice. 2002. *Phenomenology of Perception*, trans. Colin Smith. London: Routledge.

Meszaros, Beth. 2005. 'Infernal sound cues: aural geographies and the politics of noise'. *Modern Drama* 48(1), 118–131.

Metzinger, Thomas. 2003. *Being No One: The Self-Model Theory of Subjectivity*. Cambridge, MA: MIT Press.

Mills, Liz. 2009. 'When voice itself is image'. *Modern Drama* 52(4), 389–404.

Mole, Christopher, Declan Smithies, and Wayne Wu (eds). 2011. *Attention: Philosophical and Psychological Essays*. Oxford: Oxford University Press.

Monks, Aoife. 2010. *The Actor in Costume*. Basingstoke: Palgrave Macmillan.

Monteverdi, Annamaria. 2007. '*Lipsynch*, theatre of voice'. *Digimag*, 25 June. http://www.digicult.it/digimag/issue-025/lipsynch-theatre-of-voice/ (accessed 18 January 2012).

Moran, Dermot. 2000. *Introduction to Phenomenology*. London: Routledge.

Mountford, Fiona. 2009. '*Kursk* is gripping tragedy under the sea'. *This Is London* (online), 10 June. http://www.thisislondon.co.uk/theatre/review-23705884-kursk-is-gripping-tragedy-under-the-sea.do (accessed 27 December 2014).

Müller, G.E. 1873. *Zur Theorie der sinnlichen Aufmerksamkeit*. Leipzig: Edelmann.

Nanay, Bence. 2006. 'Perception, action, and identification in the theater'. In David Krasner and David Z. Saltz (eds), *Staging Philosophy: Intersections of Theater, Performance, Philosophy* (pp. 244–254). Michigan: University of Michigan Press.

Nancy, Jean-Luc. 2007. *Listening*, trans. Charlotte Mandell. New York: Fordham University Press.

Napier, Frank. 1936. *Noises Off: A Handbook of Sound Effects*. London: Frederick Muller.

Nelson, Robin. 2006. 'Practice-as-research and the problem of knowledge'. *Performance Research* 11(4), 105–116.

Neofytou-Georgiou, Stamatia. 2010. 'The semiotics of images in Romeo Castellucci's theatre'. http://www.inter-disciplinary.net/wp-content/uploads/2010/10/stneofytoupaper.pdf (accessed 20 March 2012).

Nightingale, Benedict. 2009. '*Kursk* at the Young Vic'. *The Times*, 10 June. http://entertainment.timesonline.co.uk/tol/arts_and_entertainment/stage/theatre/article6464388.ece (accessed 3 April 2014).

Noë, Alva. 2004. *Action in Perception*. Cambridge, MA: MIT Press.

Noë, Alva. 2006. 'Experience without the head'. In Tamar Szaro Gendler and John Hawthorne (eds), *Perceptual Experience* (pp. 411–433). Oxford: Clarendon Press.

Noë, Alva. 2007. 'The critique of pure phenomenology'. *Phenomenology and Cognitive Science* 6, 231–245.

Nudds, Matthew. 2001. 'Experiencing the production of sounds'. *European Journal of Philosophy* 9(2), 210–229.

O'Callaghan, Casey. 2010. 'Perceiving the location of sounds'. *Review of Philosophy and Psychology* 1, 123–140.

Oddey, Alison. 2007. *Re-Framing the Theatrical: Interdisciplinary Landscapes in Performance*. Basingstoke: Palgrave Macmillan.

Ong, Walter J. 1967. *The Presence of the Word: Some Prolegomena for Cultural and Religious History*. New Haven, CN: Yale University Press.

Ong, Walter J. 1982. *Orality and Literacy: The Technologizing of the Word*. London: Methuen.

Ovadija, Mladen. 2013. *Dramaturgy of Sound in the Avant-garde and Postdramatic Theatre*. Montreal: McGill-Queens University Press.

Pallasmaa, Juhani. 2012. *The Eyes of the Skin: Architecture and the Senses* (2nd Edition). Chichester: Wiley.

Pavis, Patrice. 2011. 'Preface', trans. Joel Anderson. In Lynne Kendrick and David Roesner (eds), *Theatre Noise: The Sound of Performance* (x–xiii). Cambridge: Cambridge Scholars Publishing.

Petit, Jean-Luc. 2003. 'On the relation between recent neurobiological data on perception (and action) and the Husserlian theory of constitution'. *Phenomenology and the Cognitive Sciences* 2, 281–289.

Phelan, Peggy. 1993. *Unmarked: The Politics of Performance*. London: Routledge.

Pinch, Trevor, and Karin Bijsterveld. 2012. *The Oxford Handbook of Sound Studies*. Oxford: Oxford University Press.

Pinter, Harold. 1991. *Plays One*. London: Faber & Faber.

Power, Cormac. 2008. *Presence in Play: A Critique of Theories of Presence in the Theatre*. Amsterdam: Rodopi.

Powlick, Leonard. 1974. 'A phenomenological approach to Harold Pinter's *A Slight Ache*'. *Quarterly Journal of Speech* 60(1), 25–32.

Prendergast, Monica. 2004. '"Playing attention": contemporary aesthetics and performing arts education'. *Journal of Aesthetic Education* 38(3), 36–51.

Prieto, Eric. 2002. *Listening In: Music, Mind, and the Modernist Narrative*. Lincoln, NE: University of Nebraska Press.

Primavesi, Patrick. 2003. 'A theatre of multiple voices: works on Einar Schleef, Christoph Marthaler and Rene Pollesch'. *Performance Research* 8(11), 61–73.

Prochnik, George. 2010. *In Pursuit of Silence: Listening for Meaning in a World of Noise*. New York: Doubleday.

Rattigan, Dermot. 2002. *Theatre of Sound: Radio and the Dramatic Imagination*. Dublin: Carysfort Press.

Rayner, Alice. 1993. 'The audience: subjectivity, community and the ethics of listening'. *Journal of Dramatic Theory and Criticism* 7(2), 3–24.

Rayner, Alice. 2006. *Ghosts: Death's Double and the Phenomena of Theatre*. Minneapolis: University of Minneapolis.

Read, Alan. 2010. 'Romeo Castellucci: the director on this earth'. In Maria M. Delgado and Dan Rebellato (eds), *Contemporary European Theatre Directors* (pp. 249–262). London: Routledge.

Rees, Jasper. 2009. 'Theatrical realism in *Kursk*'. *The Times*, 1 June. http://historynewsnetwork.org/article/89117 (accessed 5 Jan 2015).

Reynolds, James. 2008. 'Hard work: Robert Lepage's *Lipsynch* and the pleasures of responsibility'. *Platform* 3(2), 130–135.

Richards, Keith. 1991. *Writing Radio Drama*. Sydney: Currency Press.

Ridout, Nicholas. 2006. *Stage Fright, Animals and Other Theatrical Problems*. Cambridge: Cambridge University Press.

Ridout, Nicholas. 2007. 'The theatre is not our home: a conversation about space, stage, and audience'. In Claudia Castellucci, Romeo Castellucci, Chiara Guidi, Joe Kelleher, and Nicholas Ridout (eds), *The Theatre of Societas Raffaello Sanzio* (pp. 203–212). London: Routledge.

Ridout, Nicholas. 2008. 'Welcome to the vibratorium'. *The Senses and Society* 3(2), 221–232.

Riley, Matthew. 2004. *Musical Listening in the German Enlightenment*. Aldershot: Ashgate.

Rodaway, Paul. 1994. *Sensuous Geography: Body, Sense and Place*. London: Routledge.

Rodero Antón, Emma, 2009. 'Point of audition in a radio fiction: the eternal problem'. *Observatorio Journal* 10, 242–252. http://cistib.academia.edu/EmmaRodero/Papers/330131/Point_of_listening_in_a_radio_fiction the_eternal_problem (accessed 20 June 2012).

Sauter, Willmar. 2000. *The Theatrical Event: Dynamics of Performance and Perception*. Iowa City: University of Iowa Press.

Scannell, Paddy. 1996. *Radio, Television and Modern Life: A Phenomenological Approach*. Oxford: Blackwell Publishers.

Schafer, R. Murray. 1985. 'Auditory space'. In David Seamon and Robert Mugerauer (eds), *Dwelling, Place and Environment: Towards a Phenomenology of Person and World* (pp. 87–98). Dordrecht: Martinus Nijhoff.

Schafer, R. Murray. 1994. *The Soundscape: Our Sonic Environment and the Tuning of the World* (2nd Edition). Rochester, VT: Destiny Books.

Schafer, R. Murray. 2004. 'The music of the environment'. In Christopher Cox and Daniel Warner (eds), *Audio Culture: Readings in Modern Music* (pp. 29–39). New York: Continuum.

Schaeffer, Pierre. 1977. *Traité des Objets Musicaux: Essai Interdisciplines*. Paris: Édition Seuil.

Schivelbusch, Wolfgang. 1988. *Disenchanted Night: The Industrialisation of Light in the Nineteenth Century*, trans. Angela Davies. Berkeley: University of California Press.

Sellars, Peter. 2013. 'Foreword'. In Deena Kaye and James Lebrecht (eds), *Sound and Music for the Theatre: The Art and Technique of Design* (3rd Edition) (pp. viii–x). Oxford: Focal Books.

Serres, Michel. 1995. *Genesis*, trans. Genevieve James and James Nielson. Ann Arbor: University of Michigan Press.

Serres, Michel. 2008. *The Five Senses: A Philosophy of Mingled Bodies (I)*, trans. Margaret Sankey and Peter Cowley, with an introduction by Steven Connor. London: Continuum.

Sheets-Johnstone, Maxine. 1979. *The Phenomenology of Dance* (2nd Edition). London: Dance Books.

Shingler, Martin, and Cindy Wieringa. 1998. *On Air: Methods and Meanings of Radio*. London: Arnold.

Siegmund, Gerald. 2007. 'Apparatus, attention and the tody: the theatre machines of Boris Charmatz'. *Theatre and Drama Review* 51(3), 124–139.

Sieveking, Lance. 1934. *The Stuff of Radio*. London: Cassell.

Smith, Bruce R. 1999. *The Acoustic World of Early Modern England – Attending to the O Factor*. London: University of Chicago Press.

Smith, F. Joseph. 1979. *The Experiencing of Musical Sound: Prelude to a Phenomenology of Music*. New York: Gordon and Breach.

Smith, James K.A. 2005. *Jacques Derrida: Live Theory*. London: Continuum.

Sobchack, Vivian. 1990. 'The active eye: a phenomenology of cinematic vision'. *Quarterly Review of Film and Video* 12(3), 21–36.

Sobchack, Vivian. 1992. *The Address of the Eye: A Phenomenology of Film Experience*. Princeton, NJ: Princeton University Press.

Sobchack, Vivian. 2005. 'When the ear dreams: Dolby Digital and the imagination of sound'. *Film Quarterly* 58(4), 2–15.

Sorensen, Roy. 2009. 'Hearing silence: the perception and introspection of absences'. In Matthew Nudds and Casey O'Callaghan (eds), *Sounds and Perception: New Philosophical Essays* (pp. 126–145). New York: Oxford University Press.

Spiegelberg, Herbert. 1975. *Doing Phenomenology: Essays on and in Phenomenology*. Hague: Martinus Nijhoff.

Stanton, William. 2004. 'The invisible theatre of radio drama'. *Critical Quarterly* 46(4), 94–107.

States, Bert O. 1985. *Great Reckonings in Little Rooms: On the Phenomenology of Theater*. California: University of California Press.

Steinbock, Anthony J. 2004a. 'Introduction to this special issue'. *Continental Philosophy Review* (Special Issue on Attention) 37(1), 1–3.

Steinbock, Anthony J. 2004b. 'Affection and attention: on the phenomenology of becoming aware'. *Continental Philosophy Review* 37(1), 21–43.

Sterne, Jonathan. 2003. *The Audible Past: The Cultural Origins of Sound Reproduction*. Durham, NC: Duke University Press.

Sterne, Jonathan. 2013. *The Sound Studies Reader*. London: Routledge.

Stewart, David, and Algis Mickunas. 1990. *Exploring Phenomenology: A Guide to the Field and Its Literature*. Athens: Ohio University Press.

Stewart, Kathleen. 2011. 'Atmospheric attunements'. *Environment and Planning D: Society and Space* 29(3), 445–453.

Stoller, Silvia. 2000. 'Reflections on feminist Merleau-Ponty skepticism'. *Hypatia* 15(1), 175–182.

Strahler Holzapfel, Amy. 2011. 'Auditory traces: the medium of the telephone in Ariana Reine's *Telephone* and Sarah Ruhl's *Dead Man's Cell Phone*'. *Contemporary Theatre Review* 21(2), 112–125.

Stuart, Caleb. 2003. 'The object of performance: aural performativity in contemporary laptop music'. *Contemporary Music Review* 22(4), 59–65.

Studlar, Gaylyn. 1990. 'Reconciling feminism with phenomenology: notes on problems and possibilities'. *Quarterly Review of Film and Video* 12(3), 69–78.

Styan, J.L. 1975. *Drama, Stage, and Audience*. Cambridge: Cambridge University Press.

Sullivan, Shannon. 1997. 'Domination and dialogue in Merleau-Ponty's phenomenology of perception'. *Hypatia* 12(1), 1–19.

Sullivan, Shannon. 2000. 'Feminism and phenomenology: a reply to Silvia Stoller'. *Hypatia* 15(1), 183–188.

Szalwinska, Maxie. 2008. 'Now hear this: theatre's revolution in sound design'. *Guardian*, 3 October. http://www.guardian.co.uk/stage/theatreblog/2008/oct/03/theatre.sound.design (accessed 30 July 2009).

Szendy, Peter. 2008. *Listen: A History of Our Ears*, trans. Charlotte Mandell. New York: Fordham University Press.

Tellenbach, Hubertus. 1981. 'Tasting and smelling – taste and atmosphere – atmosphere and trust'. *Journal of Phenomenological Psychology* 12(2), 221–230.

Thibaud, Jean-Paul. 2011. 'The sensory fabric of urban ambiances'. *The Senses and Society* 6(2), 203–215.

Thom, Paul. 1993. *For an Audience: A Philosophy of the Performing Arts*. Philadelphia: Temple University Press.

Thompson, Emily. 2002. *The Soundscape of Modernity: Architectural Acoustics and the Culture of Listening in America 1900–1933*. Cambridge, MA: MIT Press.

Toop, David. 2010. *Sinister Resonance: The Mediumship of the Listener*. London: Continuum.

Tribble, Evelyn B. 2011. *Cognition in the Globe: Attention and Memory in Shakespeare's Theatre*. Basingstoke: Palgrave Macmillan.

Truax, Barry. 2001. *Acoustic Communication* (2nd Edition). Westport, CT: Ablex Publishing.

Van Oene, Germaine Muriel Baril. 1978. *The Dramatic Form in an Aural Medium: A Semiological Comparison of Radio and Stage Plays by Beckett, Pinget and Obaldia*. Unpublished doctoral thesis, University of Michigan.

Verstraete, Pieter. 2009. *The Frequency of the Imagination: Auditory Distress and Aurality in Contemporary Music Theatre*. Unpublished PhD thesis, University of Amsterdam. http://dare.uva.nl/document/2/65302 (accessed 2 January 2015).

Vitruvius. 1914. *Ten Books on Architecture*, trans. Morris Hicky Morgan. Cambridge, MA: Harvard University Press.

Voegelin, Salomé. 2010. *Listening to Silence: Towards a Philosophy of Sound Art*. London: Continuum.

Wagner, Matthew. 2012. *Shakespeare, Theatre, and Time*. London: Palgrave Macmillan.

Waldenfels, Bernhard. 2009. 'The phenomenology of attention'. Unpublished lecture notes (pp. 1–4), from a lecture given at Boston College, Massachusetts on 12 February 2009.

Waldenfels, Bernhard. 2011. *Phenomenology of the Alien: Basic Concepts*, trans. Alexander Kozin and Tanja Stähler. Evanston: Northwestern University Press.

Walne, Graham. 1990. *Sound for the Theatre*. London: A&C Black.

Walsh, Maria. 2004. 'The immersive spectator: a phenomenological hybrid'. *Angelaki: Journal of the Theoretical Humanities* 9(9), 169–186.

Watzl, Sebastian. 2010. *The Philosophical Significance of Attention*. Unpublished PhD Thesis, Columbia University. https://www.academia.edu/762860/The_significance_of_attention (accessed 29 December 2014).

Welton, Donn (ed.). 1998. *Body and Flesh: A Philosophical Reader*. Oxford: Blackwell.

Welton, Martin. 2002. *Sense and Self: Towards an Embodied Epistemology of Acting*. Unpublished PhD thesis, University of Surrey.

Welton, Martin. 2007. 'Seeing nothing: now hear this'. In André Lepecki and Sally Banes (eds), *The Senses in Performance* (pp. 146–155). London: Routledge.

Welton, Martin. 2010. 'Listening-as-touch: paying attention to Rosemary Lee's *Common Dance*'. *Performance Research* 15(3), 47–54.

Welton, Martin. 2012. *Feeling Theatre*. London: Palgrave Macmillan.

White, Alan R. 1964. *Attention*. Oxford: Basil Blackwell.

White, Gareth. 2012. 'On immersive theatre'. http://crco.cssd.ac.uk/143/2/TRI_37_3_article_2_white.pdf (accessed 20 October 2012).

White, Gareth. 2013. *Audience Participation in Theatre: Aesthetics of the Invitation*. Basingstoke: Palgrave Macmillan.

Wichmann, Elizabeth. 1991. *Listening to Theatre: The Aural Dimension of Beijing Opera*. Honolulu: University of Hawaii Press.

Wilcher, Donald. 1987. 'Out of the dark: Beckett's texts for radio'. In James Acheson and Kateryna Arthur (eds), *Beckett's Later Fiction and Drama: Texts for Company* (pp. 8–10). Basingstoke: Palgrave Macmillan.

Wilkie, Fiona. 2002. 'Mapping the terrain: a survey of site-specific performance in Britain'. *New Theatre Quarterly* 18(2), 140–160.

Wilshire, Bruce. 1982. *Role Playing and Identity: The Limits of Theatre as Metaphor.* Bloomington and Indianapolis: Indiana University Press.

Wilson, Keith. 2007. 'Does attention exist?'. *British Journal of Undergraduate Philosophy* 2(2), 153–168.

Wolvin, Andrew D., and Carolyn Gwynn Coakley (eds). 1993. *Perspectives on Listening.* Norwood, NJ: Ablex Publishing.

Worth, Katharine. 1981. 'Beckett and the radio medium'. In John Drakakis (ed.), *British Radio Drama* (pp. 191–217). Cambridge: Cambridge University Press.

Young, Iris Marion. 1998. 'Throwing like a girl'. In Donn Welton (ed.), *Body and Flesh: A Philosophical Reader* (pp. 259–273). Oxford: Blackwell.

Zilliacus, Clas. 1976. *Beckett and Broadcasting: A Study of the Works of Samuel Beckett for and in Radio and Television.* Åbo: Åbo Akademi.

Zuckerkandl, Viktor. 1956. *Sound and Symbol: Music and the External World.* Volume 1. London: Routledge & Kegan Paul.

Dictionaries

Concise Oxford English Dictionary (10th Edition). 2002. Revised and edited by Judy Pearsall. Oxford: Oxford University Press.

Oxford English Dictionary (2nd Edition). 1989. Prepared by J.A. Simpson and E.S.C. Weiner. Oxford: Clarendon Press.

Shorter Oxford English Dictionary (6th Edition). 2007. Oxford: Oxford University Press.

Stanford Encyclopedia of Philosophy (online). http://plato.stanford.edu/entries/episteme-Techne/ (accessed 26 June 2012).

Unpublished interviews

Arditti, Paul, and George Home-Cook. 2009. Old Vic Theatre, London, 26 May.

Fry, Gareth, and George Home-Cook. 2009. National Theatre, London, 15 May.

Fry, Gareth, and George Home-Cook. 2011. National Theatre, London, 7 July.

Jones, Dan, and George Home-Cook. 2009. Young Vic, London, 20 June.

Recordings and audio material

BBC Sound Archive

Beckett, Samuel. 1957. *All That Fall.* Writer, Samuel Beckett. Producer, Donald McWhinnie. Ref: 1CD0256186 D1.

Beckett, Samuel. 1959. *Embers.* Writer, Samuel Beckett. Producer, Donald McWhinnie. Ref: 1LP0151042–1LP0151043 D1–2.

Pinter, Harold. 1959. *A Slight Ache.* Writer, Harold Pinter. Producer, Donald McWhinnie. Ref: T11062/01 TR1.

CD

Samuel Beckett: Works for Radio. 1996. British Broadcasting Corporation.
All That Fall (Disk One; Track 1).
Embers (Disk Two; Track 2).

Index

UNIVERSITY OF WINCHESTER
LIBRARY

Printed and bound by CPI Group (UK) Ltd, Croydon, CR0 4YY